100 *Artists' Manifestos*

Alex Danchev is the author of a number of acclaimed biographies, including *Cézanne: A Life* and *Georges Braque: A Life*. He has also translated and edited a collection of Cézanne's letters. He writes regularly for the *Times Literary Supplement* and *Times Higher Education*. He has held Fellowships at the Wilson Center in Washington, DC, St Antony's College, Oxford and Queen Mary, London. He is currently Professor of International Relations at the University of St Andrews.

100 *Artists' Manifestos*

Edited with an Introduction by Alex Danchev

PENGUIN BOOKS

PENGUIN CLASSICS

Published by the Penguin Group
Penguin Books Ltd, 80 Strand, London WC2R ORL, England
Penguin Group (USA) Inc., 375 Hudson Street, New York, New York 10014, USA
Penguin Group (Canada), 90 Eglinton Avenue East, Suite 700, Toronto, Ontario, Canada M4P 2Y3
(a division of Pearson Penguin Canada Inc.)
Penguin Ireland, 25 St Stephen's Green, Dublin 2, Ireland (a division of Penguin Books Ltd)
Penguin Group (Australia), 707 Collins Street, Melbourne, Victoria 3008, Australia
(a division of Pearson Australia Group Pty Ltd)
Penguin Books India Pvt Ltd, 11 Community Centre, Panchsheel Park,
New Delhi – 110 017, India
Penguin Group (NZ), 67 Apollo Drive, Rosedale, Auckland 0632, New Zealand
(a division of Pearson New Zealand Ltd)
Penguin Books (South Africa) (Pty) Ltd, Block D, Rosebank Office Park, 181 Jan Smuts
Avenue, Parktown North, Gauteng 2193, South Africa

Penguin Books Ltd, Registered Offices: 80 Strand, London WC2R ORL, England

www.penguin.com

First published in Penguin Classics 2011

010

Introduction and editorial matter copyright © Alex Danchev, 2011
All rights reserved
The acknowledgements on pp. xiii constitute an extension of this copyright page

The moral right of the editor has been asserted

Set in Dante MT Std 10/12.5 pt
Typeset by Palimpsest Book Production Limited, Falkirk, Stirlingshire
Printed in Great Britain by Clays Ltd, St Ives plc

ISBN: 978–0–141–19179–9

www.greenpenguin.co.uk

For D

Contents

Contents

Acknowledgements

For permission to use the manifestos collected here, we are most grateful to the following:

'The Foundation and Manifesto of Futurism', 'Against Traditionalist Venice', 'The Futurist Manifesto Against English Art' and 'Manifesto of Futurist Cuisine', from *Critical Writings* by F. T. Marinetti, edited by Günter Berghaus, translated by Doug Thompson. Copyright © 2006 by Luce Marinetti, Vittoria Marinetti Piazonni and Ala Marinetti Clerici. Translation, compilation, editorial work, foreword, preface and introduction copyright © 2006 by Farrar, Straus and Giroux, LLC.

'Manifesto of the Futurist Painters' by Umberto Boccioni and others, translated by Robert Brain; 'Futurist Painting: Technical Manifesto' by Boccioni and others, translated by Robert Bruin; 'Futurist Manifesto of Lust' by Valentine de Saint-Point, translated by J. C. Higgitt; 'The Painting of Sounds, Noises and Smells' by Carlo Carrà, translated by Robert Brain; 'Futurist Manifesto of Men's Clothing' by Giacomo Balla, translated by Robert Brain; 'Manifesto of Futurist Architecture' by Antonio Sant'Elia, translated by Caroline Tisdall; and 'Warpainting' by Carlo Carrà, translated by Robert Brain, from *Futurist Manifestos* (Viking, 1973), edited by Umbro Apollonio, by permission of Thames & Hudson Ltd, London.

'A Green Sun' by Takamura Kōtarō, from *A Brief History of Imbecility: Poetry and Prose of Takamura Kōtarō* (University of Hawai'i Press, 1992), edited and translated by Hiroaki Sato, by permission of University of Hawai'i Press.

'Manifesto of Futurist Woman' by Valentine de Saint-Point, 'L'antitradition futuriste' by Apollinaire, 'We Must Create' by Vicente Huidobro, 'Dimensionist Manifesto' by Károly (Charles) Sirató and

others, from *Manifesto: A Century of Isms* (University of Nebraska Press, 2001), edited and translated by Mary Ann Caws, by permission of Mary Ann Caws.

'Preface to *Der Blaue Reiter Almanac*' by Wassily Kandinsky and Franz Marc, from *The Blaue Reiter Almanac* © 1974 by Thames & Hudson Ltd; *Der Blaue Reiter* © 1965 by R. Piper & Co. Verlag, edited by Wassily Kandinsky and Franz Marc, translated by Henning Falkenstein, by permission of Viking Penguin, a division of Penguin Group (USA), Inc.

'On the Subject in Modern Painting' by Apollinaire, from *Apollinaire on Art: Essays and Reviews 1902–1918*, edited by L. C. Breunig, translated by Susan Suleiman, translation © 1972 by the Viking Press, Inc., by permission of Viking Penguin, a division of the Penguin Group (USA), Inc.

'Feminist Manifesto' and 'Aphorisms on Futurism', from *The Lost Lunar Baedeker* by Mina Loy. Works of Mina Loy copyright © 1996 by the Estate of Mina Loy. Introduction and edition copyright © 1996 by Roger L. Conover. By permission of Roger L. Conover, Farrar, Straus and Giroux, LLC, and Carcanet Press Limited.

'Rayonists and Futurists: A Manifesto' by Mikhail Larionov and Natalya Goncharova, 'Suprematist Manifesto' by Kasimir Malevich, and 'The Realistic Manifesto' by Naum Gabo and Anton Pevzner, from *Russian Art of the Avant-Garde: Theory and Criticism 1902–1934*, edited and translated by John E. Bowlt © 1976 and 1988 John Bowlt, by permission of Thames & Hudson Ltd, London.

'Manifesto' and 'Our Vortex' by Wyndham Lewis, from *BLAST* 1 © 1914 Wyndham Lewis, © 1981 The Estate of Mrs G. A. Wyndham Lewis, © 2008 Wyndham Lewis Memorial Trust (a registered charity), by permission of Thames & Hudson Ltd, London.

'L'Art cerebriste' by Ricciotto Canudo, from *Les Manifestes littéraires de la belle époque* (Éditions Seghers, 1966), edited by Bonner Mitchell, by permission of Éditions Seghers; translated for this book by Emily Haves.

'Futurist Synthesis of the War' by Boccioni and others, 1914 (litho) by Private Collection/The Bridgeman Art Library.

'A Drop of Tar' by Vladimir Mayakovsky, from *Words in Revolution: Russian Futurist Manifestoes 1912–1928* (New Academia Publishing, 2005), edited by Anna Lawton, translated by Anna Lawton and Herbert Eagle, by permission of Anna Lawton.

'Manifesto of Suprematists and Non-Objective Painters' and

'Manifesto of the Constructivist Group' by Aleksandr Rodchenko and others, from *Rodchenko: Experiments for the Future. Diaries, Essays, Letters and Other Writings* © 2005 The Museum of Modern Art, New York, edited by Aleksandr Lavrentiiev, translated by Jamey Gambrell, by permission of the Estate of Aleksandr Rodchenko, the Russian Authors' Society (RAO), and the Museum of Modern Art, New York.

'Dada Manifesto' by Tristan Tzara, translated by Ralph Manheim, and 'Dada Manifesto' by Francis Picabia, translated by Michelle Owoo, from *The Dada Reader: A Critical Anthology* © Tate 2006, edited by Dawn Ades, by permission of Tate Trustees.

'What is Architecture?' by Walter Gropius, from *Programmes and Manifestoes on 20th-Century Architecture* (Lund Humphries, 1970), edited by Ulrich Conrads, translated by Michael Bullock, by permission of the Bauhaus Photo Archiv, Berlin.

'Dada Excites Everything' by Tristan Tzara and others, from *Dadas on Art* (Prentice Hall, 1971), edited and translated by Lucy R. Lippard, by permission of Lucy R. Lippard.

'First German Dada Manifesto' by Richard Huelsenbeck, from *The Dada Painters and Poets* (Harvard University Press, 1989), edited by Robert Motherwell, translated by Ralph Manheim, by permission of Harvard University Press and Alan Wofsy Fine Arts.

'A Strident Prescription' by Manuel Maples Arce, 'Manifesto of the Union of Mexican Workers, Technicians, Painters and Sculptors' by David Alfaro Siqueiros and others, 'Art, Revolution and Decadence' by José Carlos Mariátegui, 'Cannibalist Manifesto' by Oswald de Andrade, 'Inventionist Manifesto' by Edgar Bayley and others, and 'Neo-Concrete Manifesto' by Ferreira Gullar, from *Art in Latin America* (Yale University Press, 1989), edited by Dawn Ades, translated by Polyglossia, by permission of Yale University Press.

'Mavo Manifesto' by Tomoshoi Murayama and others, translated by Gennifer Weisenfeld, from *Mavo: Japanese Artists and the Avant-Garde 1905–1931* (University of California Press, 2002), by Gennifer Weisenfeld, by permission of Gennifer Weisenfeld and University of California Press.

'Manifesto' by the Red Group, translated by M. Kay Flavell, from *George Grosz* (Yale University Press, 1988), by M. Kay Flavell, by permission of Yale University Press.

'Manifesto of Surrealism' and 'Second Manifesto of Surrealism' by

André Breton, from *Manifestoes of Surrealism* (University of Michigan Press, 1969), edited and translated by Richard Seaver and Helen R. Lane, by permission of the University of Michigan Press.

'Yellow Manifesto' by Salvador Dalí and others, from *Salvador Dalí: The Early Years* (South Bank, 1994), edited by Michael Raeburn, translated by John London, by permission of Dr John London and the Fundació Gala-Salvador Dalí, Figueres.

'Concrete Art' by Jean (Hans) Arp, from *Arp on Arp: Poems, Essays, Memories* by Jean Arp, edited Marcel Jean, translated by Joachim Neugroschel, copyright © 1969, 1972 by The Viking Press, Inc. Used by permission of Viking Penguin, a division of Penguin Group (USA) Inc.

'The Sublime is Now' by Barnett Newman © 2009 Barnett Newman Foundation/Artists' Rights Society (ARS), New York, by permission of the Artists' Rights Society.

'Fluxus Manifesto' by George Maciunus, by permission of The Museum of Modern Art, New York. The Gilbert and Lila Silverman Fluxus Collection Gift, 2008. Acc. n.: FC1080 © 2010. Digital image, The Museum of Modern Art, New York/Scala, Florence.

'Metaphors on Vision' by Stan Brakhage from Bruce R. McPherson (ed.), *Essential Brakhage* (McPherson & Co., 2001), by permission of Bruce R. McPherson.

'Manifesto' by Derek Jarman © The Estate of Derek Jarman, from the Derek Jarman Papers, British Film Institute Special Collections, London, by permission of BFI Special Collections.

'Non-Straightforward Architecture: A Gentle Manifesto' by Robert Venturi, from *Complexity and Contradiction in Architecture* © 1966, 1977 The Museum of Modern Art, New York, by Robert Venturi, by permission of the Museum of Modern Art, New York.

'Maintenance Art Manifesto' (an excerpt) by Mierle Laderman Ukeles, from *Six Years: The Dematerialization of the Art Object from 1966 to 1972* (University of California Press, 1973), edited by Lucy R. Lippard, by permission of Mierle Laderman Ukeles, Ronald Feldman Fine Arts, New York, and University of California Press.

'Delirious New York: A Retroactive Manifesto for Manhattan' by Rem Koolhaas, from *Delirious New York* © 1994 Rem Koolhaas and The Monacelli Press, a division of Random House, Inc, by permission of Rem

Koolhaas, Office for Metropolitan Architecture, and Monacelli Press, a division of Random House, Inc.

'Architecture Must Blaze' by Coop Himmelb(l)au, by permission of Coop Himmelb(l)au.

'First Diasporist Manifesto' by R. B. Kitaj, from *First Diasporist Manifesto* © 1989 R. B. Kitaj, by permission of Thames & Hudson Ltd, London.

'The ――――――― Manifesto' by Michael Betancourt, by permission of Michael Betancourt.

'13 Propositions of Post-Modern Architecture' by Charles Jencks, from *Theories and Manifestoes of Contemporary Architecture* (John Wiley, 2006), edited by Charles Jencks and Karl Kropf, by permission of Charles Jencks.

'Minnesota Declaration' by Werner Herzog © Werner Herzog, 1999 by permission of Werner Herzog Film GmbH.

'The Stuckist Manifesto' and 'The Remodernist Manifesto' by Billy Childish and Charles Thomson, and 'The Founding, Manifesto and Rules of The Other Muswell Hill Stuckists' by The Other Muswell Hill Stuckists, by permission of Charles Thomson and The Stuckists (and The Other Muswell Hill Stuckists).

'Second Diasporist Manifesto' by R. B. Kitaj, from *Second Diasporist Manifesto* (Yale University Press, 2007), by permission of Yale University Press.

'Manifesto: Towards a New Humanism in Architecture' by Austin Williams and others, by permission of Austin Williams at the Future Cities Project.

Despite our best efforts, some copyright holders have eluded us. With apologies for any omissions, we should be very glad to make amends in any future editions.

Introduction

Manifesto, Manifestoed, Manifestoing

'I am to be manifestoed against, though no prince.'

Samuel Richardson, *Clarissa* (1747–8)

'George Wilhelm followed his old scheme, peace at any price . . .
and except complaining, petitioning, and manifestoing, studiously
did nothing.'

Thomas Carlyle, *Frederick the Great* (1872)

MANIFESTOS
MANIFESTO
MANIFEST
MANIFES
MANIFE
MANIF
MANI
MAN
MA
M

Vicente Huidobro, *MANIFESTOS manifest* (1925)

'On or about December 1910,' according to Virginia Woolf, 'human char-
acter changed.'[1] Modernism took hold. Manifestoism can be dated a little
more precisely. On or about 20 February 1909, when 'The Foundation and
Manifesto of Futurism' (M1 in this book) was splashed across the front
page of *Le Figaro*, manifestoing began in earnest. That celebrated document
not only announced a new movement but started a new trend, effectively
a new genre, an adventure in artistic expression.

Once upon a time the manifesto was the province of kings and princes. In the seventeenth century it was hijacked by the Poor Oppressed People of England, also known as the Diggers and the Levellers, the radical dissenters of their day. In 1848 Karl Marx and Friedrich Engels made it their own: *The Communist Manifesto* is the ur-manifesto of the modern period, 'the archetype of a century of modernist manifestos and movements to come'.[2] *The Communist Manifesto* was first and foremost a political manifesto – a call to arms in the service of the revolution. That was the point. Thus the famous peroration:

The Communists disdain to conceal their views and aims. They openly declare that their ends can be attained only by the forcible overthrow of all existing conditions. Let the ruling classes tremble at a Communistic revolution. The proletarians have nothing to lose but their chains. They have a world to win.
WORKERS OF THE WORLD, UNITE![3]

Yet Marx himself was deeply interested in 'the poetry of the revolution' – the forms and the phrases that would make it sing – so much so that the rhetorical strategy of *The Communist Manifesto* is as highly developed as the political analysis.[4] As Marshall Berman has underlined, 'the *Manifesto* is remarkable for its imaginative power, its expression and grasp of the luminous and dreadful possibilities that pervade modern life. Along with everything else that it is, it is the first great modernist work of art.'[5] Curiously enough, Bertolt Brecht wanted to make a 'versification' of it, in hexameters, just as Sergei Eisenstein wanted to make a film of *Das Kapital*. The original seems to be proof against adaptation, but the preamble is already a kind of prose poem and the dramatic opening positively theatrical. 'A spectre is haunting Europe – the spectre of Communism. All the Powers of old Europe have entered into a holy alliance to exorcize this spectre: Pope and Czar, Metternich and Guizot, French radicals and German police spies.'[6] Much of this is proleptic, or futuristic; in 1848 the spectre of Communism haunted the pages of the *Manifesto* rather more effectively than it did the chancelleries of Europe. Its time would come. The poetry of the revolution is unforgettable.

Constant revolutionizing of production, uninterrupted disturbance of all social conditions, everlasting uncertainty and agitation distinguish the bourgeois epoch

from all earlier ones. All fixed, fast-frozen relations, with their train of ancient and venerable prejudices and opinions are swept away, all new-formed ones become antiquated before they can ossify. All that is solid melts into air, all that is holy is profaned, and man is at last compelled to face with sober senses, his real conditions of life, and his relations with his kind.[7]

These strategies – these very phrases – would be recast and recycled time and again in the artists' manifestos of the twentieth century. 'Workers of the mind, unite!' mimicked the author of the Futurist Manifesto. With artists, the life of the mind is a dazzling and voluptuous operation. A hundred years after Marx appeared in English translation, the architect Lebbeus Woods, a dedicated experimentalist, wrote a manifesto-versification of his own (M90):

> I declare war on all icons and finalities, on all histories that would
> chain me with my own falseness, my own pitiful fears.
> I know only moments, and lifetimes that are as moments, and
> forms that appear with infinite strength, then 'melt into air'.
> I am an architect, a constructor of worlds, a sensualist who worships
> the flesh, the melody, a silhouette against the darkening sky. I cannot
> know your name. Nor can you know mine.
> Tomorrow, we begin together the construction of a city.

Anyone who manifestoed after Marx had the spectre of that sainted longhair hovering somewhere nearby.

To manifesto is to perform. The Futurists may be described as the original performance artists. In print, on stage, showering leaflets from the top of the nearest tall building, their pronouncements performed their principles. The founding of Futurism was a boisterous affair. One of its sharpest observers was Leon Trotsky, organizer of the Russian Revolution. Trotsky had a brilliant mind and an acid pen. 'Futurism arose,' he wrote later, 'as a protest against the art of petty realists who sponged on life.'[8] The introduction to the Futurist Manifesto did not disappoint:

It is from Italy that we hurl at the whole world this utterly violent, inflammatory manifesto of ours, with which we today are founding 'Futurism', because we

wish to free our country from the stinking canker of its professors, archaeologists, tour guides and antiquarians.

For far too long Italy has been a marketplace for junk dealers. We want our country free from the endless number of museums that everywhere cover her like countless graveyards. Museums, graveyards! . . . They're the same thing, really, because of their grim profusion of corpses that no one remembers.

The Futurist Manifesto itself was of a piece with this magniloquence. Its author was F. T. Marinetti (1876–1944), philosopher, novelist, playwright, poet, propagandist and self-publicist, the Napoleon of the Futurist legions yet unborn, the Trotsky of the Futurist revolt yet unachieved. Its tenets were a marinade of Marinetti and his influences, poetical and political, acknowledged and unacknowledged, among them Walt Whitman's 'Song of Myself' and Émile Zola's 'J'accuse', Henri Bergson's notion of *élan vital* and Georges Sorel's *Reflections on Violence*, Stéphane Mallarmé's lyrical experimentalism and Friedrich Nietzsche's philosophical iconoclasm.[9] Nietzsche in particular was an inspiration, as much for the dramatic quality of his writing as for the prophetic character of his thought. Nietzsche is at once unsettling and unsparing. His very titles send a shiver down the spine – *Beyond Good and Evil* (1886), subtitled 'Prelude to a Philosophy of the Future'. Marinetti, a light-fingered borrower and a true original, seems to have made free with certain passages of his other works. 'The desire to destroy, to change, to create something new, can be an expression of an abundant force, pregnant with Future.'[10] The Futurist Manifesto neatly bottles Nietzsche along with all the rest:

1. We want to sing about the love of danger, about the use of energy and recklessness as common, daily practice.
2. Courage, boldness and rebellion will be essential elements in our poetry.
3. Up to now, literature has extolled a contemplative stillness, rapture and reverie. We intend to glorify aggressive action, a restive wakefulness, life at the double, the slap and the punching fist.
4. We believe that this wonderful world has been further enriched by a new beauty, the beauty of speed. A racing car, its bonnet decked with exhaust pipes like serpents with galvanic breath . . . a roaring motor car, which seems to race on like machine-gun fire, is more beautiful than the Winged Victory of Samothrace.

5. We wish to sing the praises of the man behind the steering wheel, whose sleek shaft traverses the Earth, which itself is hurtling at breakneck speed along the racetrack of its orbit.

6. The poet will have to do all in his power, passionately, flamboyantly, and with generosity of spirit, to increase the delirious fervour of the primordial elements.

And more, much more, until finally, 'Standing tall on the roof of the world, yet again, we hurl our defiance at the stars!'

We now know that Marinetti had a plan of campaign: the Futurist Manifesto had been extensively trialled in Italy before it appeared in *Le Figaro*.[11] Its inflammatory rhetoric was not spontaneous but carefully rehearsed. No less disingenuous was the disclaimer from the newspaper's editors which prefaced it:

Mr Marinetti, the young Italian and French poet, whose remarkable and fiery talent has been made known throughout the Latin countries by his notorious demonstrations and who has a galaxy of enthusiastic disciples, has just founded the school of 'Futurism', whose theories surpass in daring all previous and contemporary schools. The *Figaro* . . . today offers its readers the Manifesto of the Futurists. Is it necessary to say that we assign to the author himself full responsibility for his singularly audacious ideas and his frequently unwarranted extravagance in the face of things that are eminently respectable and, happily, everywhere respected? But we thought it interesting to reserve for our readers the first publication of this manifesto, whatever their judgement of it will be.[12]

Futurist teaching (or preaching) has always been too much for the unconverted. 'Futurism, as preached by Marinetti, is largely Impressionism up-to-date,' rejoined Wyndham Lewis. 'To this is added his Automobilism and Nietzsche stunt.'[13] But the withering Wyndham Lewis was out of touch with the times. The Manifesto caused a sensation. With the beauty of speed, the French text was turned into a leaflet and all Europe leafleted. Excerpts appeared in newspapers and magazines the world over. 'Futurism' was launched. So too was the talented Mr Marinetti. Overnight, as it seemed, the artist's manifesto had come of age. For the next twenty years it was all the rage.

For Marinetti, the secret of the successful manifesto lay in its violence and its precision ('l'accusation *précise*, l'insulte bien *définie*'), to which we

can add its bombast and its wit.[14] This was the Marinetti model, encapsulated in the notorious paragraph 9, with its provocative, almost gratuitous, concluding flourish: 'We wish to glorify war – the sole cleanser of the world – militarism, patriotism, the destructive act of the libertarian, beautiful ideas worth dying for, and scorn for women.'

It is interesting to find that Marinetti had a clear idea of what would do and what would not. The art of making manifestos, as he put it, called for a certain rigour, a verve (or perhaps a nerve), and a sense of style, or form, analogous to the work of art itself. A few years later, Gino Severini, one of a handful of founding Futurists but a little semi-detached, sent Marinetti the manuscript of a projected manifesto. With Napoleonic self-assurance, he replied:

I have read with great attention your manuscript, which contains extremely interesting things. But I must tell you that there is nothing of the *manifesto* in it.

First of all, the title ['The Painting of Light, Depth and Dynamism'] absolutely won't do because it is too generic, too derivative of the titles of other manifestos. In the second place, you must take out the part in which you restate the *merde* and *rose* of Apollinaire, this being, in absolute contrast to our type of manifesto, a way of praising a single artist by repeating his own eulogies and insults. Moreover . . . you must not repeat what I have already said, in *Futurism* [the Manifesto] and elsewhere, about the Futurist sensibility. The rest of the material is very good and important, but to publish it as it is would be to publish an article that is excellent but not yet a manifesto. I therefore advise you to take it back and reword it, removing all that I have already mentioned, and intensifying and tightening it, recasting the whole new part in the form of a *manifesto* and not in that of a review article about Futurist painting . . .

I think I shall persuade you by all that I know about the art of making manifestos, which I possess, and by my desire to place in *full* light, not in *half* light, your own remarkable genius as a Futurist.[15]

'The *merde* and *rose* of Apollinaire' was a reference to a manifesto composed by that astonishing figure, 'L'antitradition futuriste' (M11), as like as not solicited by Marinetti, and edited – manifestoed – according to strict Marinettian principles. Apollinaire himself, it appears, was not exempt from the treatment. 'L'antitradition futuriste' manifests a number of features common to the genre. The Marinetti model became a kind

of template. Marinetti's *mots* and Marinetti's antics resonate throughout the century. The composer Karl-Heinz Stockhausen's scandalous comment on the destruction of New York's twin towers on 11 September 2001 – 'the greatest work of art imaginable for the whole cosmos' – was pure Marinetti. Tristan Tzara, the capo of Dadaism, and André Breton, the pope of Surrealism, deliberately followed in his footsteps. Every art movement commander-in-chief is a mini-Marinetti.

Novel as it seems (and self-proclaims), Apollinaire's manifesto is in fact derivative of other manifestos, notwithstanding Marinetti's strictures. The artist's manifesto is a thievish pursuit, with cannibalistic tendencies. (Suggestively, perhaps, there are Cannibalist Manifestos – see M35 and M53.) In other words, it is a highly self-conscious and self-referential form. The art of making manifestos is also the art of appropriation. If the bad poet borrows, and the good poet steals, as T. S. Eliot said, then artist-manifestoists are very good poets indeed.

It is also polarizing, or, to put it more delicately, self-differentiating. Artists' movements and artists' manifestos typically define themselves *against*. Intellectually, this causes them no trouble: it is not hard to identify who or what they are against – usually their rivals and predecessors. In this respect the Futurists were unusual only in the sheer comprehensiveness of their condemnation: they were against the past. To specify what they are *for*, on the other hand, is a good deal more difficult. Many manifestos resolve the difficulty into a crude dichotomy, or a round of name-calling, where brickbats and bouquets are tossed at the selected candidates. Apollinaire's manifesto offers an extravagant example, possibly a parody, throwing *merde* at Montaigne, Wagner, Beethoven, Poe, Whitman and Baudelaire, among many others, and *rose* at a long list of the notable and not-so-notable, beginning with Marinetti, Picasso, Boccioni, and Apollinaire himself. Wyndham Lewis's Vorticist version of this procedure was trumpeted in the very title of the journal he created, *BLAST* (M17), which *blasts* some things, Futurist-fashion ('France, sentimental Gallic gush, sensationalism, fussiness . . .'), and *blesses* others ('cold, magnanimous, delicate, gauche, fanciful, stupid Englishmen . . .').

Artists' manifestos are strong on remonstration. 'Long live –!' and 'Down with –!' are two of its most familiar tropes. In this mood, they are at once vigorous and reductive. Other features of the manifesto, however, are sophisticated indeed. The Futurist revolt was effectively

thwarted, but one thrust carried forward: 'words-in-freedom', to use Marinetti's language, and a 'typographical revolution' aimed at exploding 'the harmony of the page'. Just as they were against right-angles, the Futurists were against adjectives. 'Words-in-freedom' promoted an emancipatory orthography, where the old rules of spelling and syntax could be abandoned, where the typeface flips merrily from one font to another, where letters are repeated as often as you please – 'reds, rrrrreds, the rrrrrredest rrrrrreds that shouuuuuuut' – and there is word-play all day long in the grammatical Garden of Eden. Not coincidentally, Futurist manifestos resemble modernist poems. Ghosted or otherwise, Apollinaire's manifesto has the look of his famous 'calligrammes' or word-pictures, composed at around the same time.[16]

Word-play is not the only play involved. Some artists' manifestos are deadly serious. Some are not. In the immortal words of the self-styled living sculptures, Gilbert and George (M80), 'The lord chisels still, so don't leave your bench for long.' Some waver between the incendiary and the buffoonery; some are outlandish; some are gibberish. The artist as author is full of surprises. Painters in particular are often supposed to be either stupid or vapid, and in any event inarticulate, unable or unwilling to explain themselves. In fact, many painters are capable writers and – whisper it softly – subtle thinkers. Barnett Newman is a great exemplar (see M64). 'The artist is approached not as an original thinker in his own medium,' he noted caustically, 'but, rather, as an instinctive, intuitive executant who, largely unaware of what he is doing, breaks through the mystery by the magic of his performance to "express" truths the professionals think they can read better than he can himself.'[17] The artists represented here give the lie to such condescension. Making manifestos engages the thinker-practitioner; and in this sphere the thinker-performer is by no means a contradiction in terms. Art and thought are not incompatible after all.

It is only to be expected that the thinking is not in straight lines. Artists' manifestos are full of quirks and foibles. Charles Jencks has proposed an arresting typology or tropology of 'the volcano and the tablet', which might crush the fun out of them, but which captures very well the deep-seated emotion and semi-scriptural injunction so often on display.[18] Despite the clowning, much manifestoing is fiercely engaged. Like the face of 'the other' in Emmanuel Levinas's philosophy, the manifesto is a

demand. It demands something from us, and it demands it now. That something may be no more than our attention – our full attention – or it may be our adherence to a certain world-view, and as like as not a certain programme. The programme and the world-view are often political – intensely political. Perhaps the most striking feature of the artist's manifesto is the frequency with which it outruns art to embrace life.

For the manifestos of the first half of the twentieth century especially, *the revolution* was their unavoidable preoccupation: their subtext and sometimes their pretext. Futurist manifestos raved about 'the multicoloured polyphonic tides of revolution'. The last words of Le Corbusier's influential 'Toward an Architecture' (M45) posed the question, 'Architecture or revolution', and offered the answer (or the prayer), 'Revolution can be avoided.'

Others felt differently. In 1919 Raoul Hausmann and Johannes Baader 'founded' a Dada republic by manifesto (see M29), in which they instructed the Mayor of Berlin to hand over the treasury and commanded the city's employees to obey only the orders of the joint authors. Sadly, the Dada republic was still-born. The quest continued. In 1938 Breton and Trotsky concluded their manifesto, 'Towards a Free Revolutionary Art' (M59), with a ringing declaration:

Our aims:
The independence of art – for the revolution.
The revolution – for the complete liberation of art!

In the 1960s, the Situationists gave their own rather prim expression to a similar yearning (see M70).

The revolutionary preoccupation might be called the manifesto obbligato. It is exhilarating, even elevating, but it also tends to find them out. Trotsky himself published a devastating critique of the artist's limitations in the sphere of 'moral and social revolt'. The critique centred on the feckless Futurists and their half-baked ideas, their political posturing and their artistic shortcomings. It was an awful warning.

The connection of the aesthetic 'revolt' with the moral and social revolt is direct; both enter entirely and fully into the life experience of the active, new, young, and untamed section of the intelligentsia of the Left, the creative Bohemia.

Disgust against the limitations and the vulgarity of the old life produces a new artistic style as a way of escape, and thus the disgust is liquidated. In different combinations, and on different historic bases, we have seen the disgust of the intelligentsia form more than one new style. But that was always the end of it. This time, the proletarian revolution caught Futurism at a certain stage of its growth and pushed it forward. Futurists became Communists. By this very act they entered the sphere of more profound questions and relationships, which far transcended the limits of their own little world, and which were not quite worked out organically in their soul. That is why Futurists . . . are weakest artistically at those points where they finish as Communist . . . That is why they are frequently subject to artistic and psychological defeats, to stilted forms and to making much noise about nothing.[19]

Revolution or no revolution, artists manifestoed, undeterred. There is something of the incorrigible optimist about the manifestoist. To make a manifesto is to imagine or hallucinate the Promised Land, wherever that might be. It is in its own way a utopian project. It is certainly not an undertaking for the faint-hearted. In this sense, perhaps, it is apt for the artist. The characteristic stance of the artist-manifestoist is a sort of spiritual resilience, an uprightness, amid the general flux and flex. Artists strive to make headway in a resistant medium (and a hostile environment, as it may be). With the exception of the latter-day Stuckists (see M95), who stand proudly on the wrong side of history, the Futurists and their successor-ists are in every sense forward movements. They wager on progress as they see it. Their battle cry is *towards*. The Moses of modernism for so many of these artists is Paul Cézanne, who died just as the manifesto was being conceived. As Cézanne knew, the artist's work is never finished. Nor yet the manifesto.

Beyond the catfights, therefore, artists' manifestos tap into a larger vision, shared by many of the movements who make their presence felt in the pages that follow. An exchange in Roberto Bolaño's extraordinary novel, *The Savage Detectives*, affords a glimpse of the vision, and the movements:

You're a Stridentist, body and soul. You'll help us build Stridentopolis, Cesárea, I said. And then she smiled, as if I was telling her a good joke but one she already knew, and she said that she had quit her job a week ago and that anyway she'd

always been a Visceral Realist, not a Stridentist. And so am I, I said or shouted, all of us Mexicans are more Visceral Realists than Stridentists, but what does it matter? Stridentism and Visceral Realism are just two masks to get us where we really want to go. And where is that? she said. To modernity, Cesárea, I said, to goddamned modernity.[20]

The artists' manifesto is a passport to modernity. To goddamned modernity.

And then to post-modernity. To poor, put-upon post-modernity. And beyond.

Notes

1. See Peter Stansky, *On Or About December 1910* (Cambridge, MA: Harvard University Press, 1996), quoting from *Mr Bennett and Mrs Brown* (1924).
2. Karl Marx and Friedrich Engels, trans. Samuel Moore, *The Communist Manifesto* [1848] (London: Penguin, 2002); Marshall Berman, *All That Is Solid Melts Into Air* (London: Verso, 1983), p. 89.
3. *Communist Manifesto*, p. 258 (translation modified).
4. 'The poetry of the revolution', an idea drawn originally from *The 18th Brumaire of Louis Bonaparte* (1852), is the master concept of Martin Puchner's penetrating study, *Poetry of the Revolution: Marx, Manifestos, and the Avant-Gardes* (Princeton: Princeton University Press, 2006). The poetic qualities of *The Communist Manifesto* are also explored in a classic work by Marjorie Perloff, *The Futurist Moment: Avant-Garde, Avant-Guerre, and the Language of Rupture* [1986] (Chicago: University of Chicago Press, 2003).
5. Berman, *All That Is Solid*, p. 102.
6. *Communist Manifesto*, p. 218.
7. Ibid., p. 223.
8. Leon Trotsky, trans. Rose Strunsky, *Literature and Revolution* [1925] (Chicago: Haymarket, 2005), pp. 120–21.
9. Marinetti was steeped in Mallarmé, who is quoted and disparaged (sometimes in the same breath) throughout his work. He was especially fond of a line from 'The Windows': 'In the former sky where Beauty flourished', which features in at least two manifestos: see F. T. Marinetti, trans. Doug Thompson, *Critical Writings* (New York: Farrar, Straus and Giroux, 2006), pp. 43 and 142. But it may be that Mallarmé is more important for what is not quoted, or admitted, e.g. 'The Phenomenon of the Future', a suggestive text in the celebrated collection

Divagations (1896). See Stéphane Mallarmé, trans. Henry Weinfield, *Collected Poems* (Berkeley: University of California Press, 1994).

10. Marinetti, *Critical Writings*, p. 428, quoting from *The Gay Science* (1882).

11. See Giovanni Lista, trans. Daniel Katz, 'Genesis and Analysis of Marinetti's "Manifesto of Futurism", 1908–1909', in Didier Ottinger (ed.), *Futurism* (London: Tate, 2009), pp. 78–83.

12. In Perloff, *Futurist Moment*, p. 82.

13. Wyndham Lewis, 'The Melodrama of Modernity', in *BLAST* 1 [1914] (Santa Barbara: Black Sparrow, 1981), p. 143. See M17 below.

14. Marinetti to the Belgian painter Henry Maassen, *c*. 1909–10, quoted in Perloff, *Futurist Moment*, pp. 81–2. Perloff's treatment is exemplary. See also Puchner, *Poetry of the Revolution*, ch. 5.

15. Perloff, *Futurist Moment*, p. 81 (her translation, slightly modified), dated to 1913. Cf. Gino Severini, trans. Jennifer Franchina, *The Life of a Painter* [1983] (Princeton: Princeton University Press, 1995), pp. 138–9, an account rather more favourable to the author.

16. See Guillaume Apollinaire, trans. Anne Hyde Greet, *Calligrammes* (Berkeley: University of California Press, 1980), e.g. 'Ocean-Letter' [1914], pp. 58–65. The manifesto predates this particular example, but the earliest calligrammes were written at the turn of the year 1912–13, a few months before 'L'antitradition futuriste'.

17. Barnett Newman, unpublished review of Thomas B. Hess, *Abstract Painting* (1951), in *Selected Writings and Interviews* (Berkeley: University of California Press, 1990), pp. 121–2.

18. Charles Jencks and Karl Kropf (eds), *Theories and Manifestoes of Contemporary Architecture* [1997] (Chichester: John Wiley, 2006), pp. 2–11.

19. Trotsky, *Literature and Revolution*, p. 126.

20. Roberto Bolaño, trans. Natasha Wimmer, *The Savage Detectives* [1998] (London: Picador, 2007), p. 433. If the Stridentists seem to be a step too far, see M40.

Further Reading

Ades, Dawn (ed.), *Art in Latin America: The Modern Era 1820–1980* (New Haven: Yale University Press, 1989)

— *The Dada Reader: A Critical Anthology* (London: Tate, 2006)

Apollonio, Umbro (ed.), trans. Robert Brain et al., *Futurist Manifestos* [1973] (Boston: Museum of Fine Arts, 2001)

Asholt, Wolfgang and Walter Fähnders (eds), *Manifeste und Proklamationen der europäischen Avantgarde 1909–1938* (Stuttgart: Metzler, 1995)

Bowlt, John E. (ed. and trans.), *Russian Art of the Avant-Garde: Theory and Criticism 1902–1934* [1976] (London: Thames & Hudson, 1988)

Breton, André, trans. Richard Seaver and Helen R. Lane, *Manifestoes of Surrealism* (Ann Arbor, MI: University of Michigan Press, 1969)

Caws, Mary Ann (ed.), *Manifesto: A Century of Isms* (Lincoln, NE: University of Nebraska Press, 2001)

Chipp, Herschel B. (ed.), *Theories of Modern Art* (Berkeley: University of California Press, 1968)

Codrescu, Andrei, *The Posthuman Dada Guide* (Princeton: Princeton University Press, 2009)

Conrads, Ulrich (ed.), trans. Michael Bullock, *Programs and Manifestoes on 20th-Century Architecture* [1970] (Cambridge, MA: Massachusetts Institute of Technology, 1976)

Demers, Jeanne and Line McMurray, *L'enjeu du manifeste / Le Manifeste en jeu* (Quebec: Préambule, 1986)

Harrison, Charles (ed.), *Art in Theory 1900–2000* (Oxford: Blackwell, 2003)

Herbert, Robert L. (ed.), *Modern Artists on Art* [1965] (New York: Dover, 2000)

Jencks, Charles and Karl Kropf (eds), *Theories and Manifestoes of Contemporary Architecture* [1997] (Chichester: John Wiley, 2006)

Lavrentiev, Alexander N. (ed.), trans. Jamey Gambrell, *Rodchenko: Experiments for the Future* (New York: Museum of Modern Art, 2005)

Lawton, Anna (ed.), trans. Anna Lawton and Herbert Eagle, *Words in Revolution: Russian Futurist Manifestos 1912–1928* (Washington DC: New Academia, 2005)

Lista, Giovanni (ed.), *Futurisme: Manifestes, documents, proclamations* (Lausanne: L'Age d'Homme, 1973)

Lyon, Janet, *Manifestoes: Provocations of the Modern* (Ithaca: Cornell University Press, 1999)

Marinetti, F. T., trans. R. W. Flint and Arthur A. Coppotelli, *Let's Murder the Moonshine: Selected Writings* [1972] (Los Angeles: Sun and Moon, 1991)

— ed. Günter Berghaus, trans. Doug Thompson, *Critical Writings* (New York: Farrar, Straus and Giroux, 2006)

Marx, Karl and Friedrich Engels, trans. Samuel Moore, *The Communist Manifesto* [1848] (London: Penguin, 2002)

Motherwell, Robert (ed.), trans. Ralph Manheim, *The Dada Painters and Poets* [1951] (Cambridge, MA: Harvard University Press, 1989)

Perloff, Marjorie, *The Futurist Moment: Avant-Garde, Avant-Guerre, and the Language of Rupture* [1986] (Chicago: University of Chicago Press, 2003)

Puchner, Martin, *Poetry of the Revolution: Marx, Manifestos, and the Avant-Gardes* (Princeton: Princeton University Press, 2006)

Serpentine Gallery Manifesto Marathon (London: Koenig, 2009)

Somigli, Luca, *Legitimizing the Artist: Manifesto Writing and European Modernism 1885–1915* (Toronto: University of Toronto Press, 2003)

Stiles, Kristine and Peter Selz (eds), *Theories and Documents of Contemporary Art* (Berkeley: University of California Press, 1996)

Unruh, Vicky, *Latin American Vanguards* (Berkeley: University of California Press, 1994)

Weisenfeld, Gennifer, *Mavo: Japanese Artists and the Avant-Garde 1905–1931* (Berkeley: University of California Press, 2002)

Winkiel, Laura, *Modernism, Race and Manifestos* (Cambridge: Cambridge University Press, 2008)

A Note on the Texts

The manifestos in this book are published whole, except in a very small number of cases where prolixity and indigestibility make it unsustainable. In such cases – notably the 'Manifesto of Surrealism' (M50) and the 'Second Manifesto of Surrealism' (M54) – the excisions are marked by an ellipsis in square brackets [. . .]. Any other ellipses are an integral part of the original text. (The Futurists were excessively fond of them . . .) Occasional editorial interpolations are also contained in square brackets.

The source of the texts is given in full in the Acknowledgements. Readers familiar with the founding Manifesto of Futurism (M1) may find that the translation used here varies from the one they are used to: it comes from a new edition of Marinetti's writings, translated by Doug Thompson. Other influential texts have also been recently retranslated, for example Le Corbusier's *Toward an Architecture* (M45) by John Goodman, a significant advance on its dated and inaccurate predecessor. Others again have materialized in an authoritative English translation as if for the first time. American spelling has been Anglicized throughout, but American usage has been (reluctantly) retained.

The manifestos appear in chronological order, according to the date of first publication. They often refer to one another, or bounce off one another. Their conversation is one of the most interesting things about them; it can be overheard more clearly if they are presented chronologically, rather than by movement or -ism.

Each manifesto is preceded by a headnote on its provenance – in particular, when and where it was first published – its context and, most importantly, its author(s). The headnotes are separated from the manifesto itself by three asterisks. Otherwise, editorial interference has been kept to a minimum.

The Introduction seeks to identify a kind of genealogy for the artist's manifesto, to highlight its common features, and to call attention to its quirks and foibles.

M1 F. T. Marinetti
The Foundation and Manifesto of Futurism
(1909)

This historic document announced not only the founding of Futurism, but also the beginning of the very idea of the artist's manifesto. It was at once a new genre and a reinvention (or a remix) of the political original, *The Communist Manifesto* (1848), the ur-manifesto of the modern age. The Futurist Manifesto had an impact that was both immediate and long-lasting. It loosened tongues, shortened tempers and emboldened imitators of every nation and persuasion. It triggered an avalanche of artists' manifestos – fifty more over the next few years from the Futurists alone, many of them composed or inspired by the irrepressible Marinetti. The manifesto was a continuation of art by other means. Over the next twenty years, the art wars of the avant-garde produced the canonic manifestos of the classic movements – the Futurists, the Dadaists, the Surrealists and their brothers and sisters and splinters – all of them owing something to this founding text and fundamental example. One hundred years after its first publication, it has not ceased to provoke.

The announcement was suitably spectacular: it was splashed on the front page of *Le Figaro* on 20 February 1909. We now know that it had been extensively trailed in Italy before being launched upon the world. After it appeared in *Le Figaro* there was no stopping it. As if in conformity with Futurist principles, the French text was speedily published as a leaflet and all Europe leafleted. It was translated into English, German, Spanish, Russian, Czech and other languages. It appeared as a preface to Enrico Cavacchioli, *La Rannochie turchine* [*The Turquoise Frogs*] and *Enquête internationale sur le vers libre* (1909). The definitive Italian version was published in the Futurist house journal *Poesia* in February–March 1909 in Milan. It was declaimed soon afterwards by Marinetti himself from the stage of the Alfieri Theatre, Turin, and then in other theatres in other cities. Its dissemination, too, was a model for its successors.

F. T. MARINETTI (1876–1944), philosopher, novelist, playwright, poet, propagandist and self-publicist, might be called the first artist of the manifesto. He was not a painter, but he was a figure. The pioneers of Dadaism (the next big thing) were full of admiration for Apollinaire, Kandinsky and Marinetti as 'the greatest figures in modern art'. Tristan Tzara, the capo of Dadaism, and André Breton, the pope of Surrealism, knowingly followed in his footsteps (see M28 and M50). As manifestoists and strategists, artists and revolutionists, such men were in many ways mini-Marinettis. For all his borrowing, Marinetti was a true original. Not only did he instigate something that could credibly be called an artistic movement; as mobilizer, organizer and proselytizer, he was as important in the history of European modernism as Trotsky in the history of the Russian Revolution.

* * *

My friends and I stayed up all night, sitting beneath the lamps of a mosque, whose star-studded, filigreed brass domes resembled our souls, all aglow with the concentrated brilliance of an electric heart. For many hours, we'd been trailing our age-old indolence back and forth over richly adorned, oriental carpets, debating at the uttermost boundaries of logic and filling up masses of paper with our frenetic writings.

Immense pride filled our hearts, for we felt that at that hour we alone were vigilant and unbending, like magnificent beacons or guards in forward positions, facing an enemy of hostile stars, which watched us closely from their celestial encampments. Alone we were, with the stokers working feverishly at the infernal fires of great liners; alone with the black spectres that rake through the red-hot bellies of locomotives, hurtling along at breakneck speed; alone with the floundering drunks, with the uncertain beating of our wings, along the city walls.

Suddenly we were startled by the terrifying clatter of huge double-decker trams jolting by, all ablaze with different-coloured lights, as if they were villages in festive celebration, which the River Po, in full spate, suddenly shakes and uproots to sweep them away down to the sea, over the falls and through the whirlpools of a mighty flood.

Then the silence became more sombre. Yet even while we were listening to the tedious, mumbled prayers of an ancient canal and the creaking

bones of dilapidated palaces on their tiresome stretches of soggy lawn, we caught the sudden roar of ravening motor cars, right there beneath our windows.

'Come on! Let's go!' I said. 'Come on, my lads, let's get out of here! At long last, all the myths and mystical ideals are behind us. We're about to witness the birth of a Centaur and soon we shall witness the flight of the very first Angels! . . . We shall have to shake the gates of life itself to test their locks and hinges! . . . Let's be off! See there, the Earth's very first dawn! Nothing can equal the splendour of the sun's red sword slicing through our millennial darkness, for the very first time!'

We approached the three panting beasts to stroke their burning breasts, full of loving admiration. I stretched myself out on my car like a corpse on its bier, but immediately I was revived as the steering wheel, like a guillotine blade, threatened my belly.

A furious gust of madness tore us out of ourselves and hurled us along roads as deep and plunging as the beds of torrents. Every now and then a feeble light, flickering behind some windowpane, made us mistrust the calculations of our all-too-fallible eyes. I cried out, 'The scent, nothing but the scent! That's all an animal needs!'

And we, like young lions, chased after Death, whose black pelt was dotted with pale crosses, as he sped away across the vast, violet-tinted sky, vital and throbbing.

And yet we had no idealized Lover whose sublime being rose up into the skies; no cruel Queen to whom we might offer up our corpses, contorted like Byzantine rings! Nothing at all worth dying for, other than the desire to divest ourselves finally of the courage that weighed us down!

But we sped on, squashing beneath our scorching tyres the snarling guard dogs at the doorsteps of their houses, like crumpled collars under a hot iron. Death, tamed by this time, went past me at each bend, only to offer me his willing paw; and sometimes he would lie down, his teeth grinding, eyeing me with his soft, gentle look from every puddle in the road.

'Let's leave wisdom behind as if it were some hideous shell, and cast ourselves, like fruit, flushed with pride, into the immense, twisting jaws of the wind! . . . Let's become food for the Unknown, not out of desperation, but simply to fill up the deep wells of the Absurd to the very brim!'

I had hardly got these words out of my mouth when I swung the car around sharply, with all the crazy irrationality of a dog trying to bite its

own tail. Then suddenly a pair of cyclists came towards me, gesticulating that I was on the wrong side, dithering about in front of me like two different lines of thought, both persuasive but for all that, quite contradictory. Their stupid uncertainty was in my way . . . How ridiculous! What a nuisance! . . . I braked hard and to my disgust the wheels left the ground and I flew into a ditch . . .

O mother of a ditch, brimful with muddy water! Fine repair shop of a ditch! How I relished your strength-giving sludge that reminded me so much of the saintly black breast of my Sudanese nurse . . . When I got myself up – soaked, filthy, foul-smelling rag that I was – from beneath my overturned car, I had a wonderful sense of my heart being pierced by the red-hot sword of joy!

A crowd of fishermen, with their lines, and some gouty old naturalists were already milling around this wondrous spectacle. Patiently, meticulously, they set up tall trestles and laid out huge iron-mesh nets to fish out my car, as if it were a great shark that had been washed up and stranded. Slowly the car's frame emerged, leaving its heavy, sober bodywork at the bottom of the ditch as well as its soft, comfortable upholstery, as though they were merely scales.

They thought it was dead, that gorgeous shark of mine, but a caress was all it needed to revive it, and there it was, back from the dead, darting along with its powerful fins!

So, with my face covered in repair-shop grime – a fine mixture of metallic flakes, profuse sweat and pale-blue soot – with my arms all bruised and bandaged, yet quite undaunted, I dictated our foremost desires to all men on Earth who are truly alive:

THE FUTURIST MANIFESTO

1. We want to sing about the love of danger, about the use of energy and recklessness as common, daily practice.
2. Courage, boldness and rebellion will be essential elements in our poetry.
3. Up to now, literature has extolled a contemplative stillness, rapture and reverie. We intend to glorify aggressive action, a restive wakefulness, life at the double, the slap and the punching fist.

4. We believe that this wonderful world has been further enriched by a new beauty, the beauty of speed. A racing car, its bonnet decked with exhaust pipes like serpents with galvanic breath . . . a roaring motor car, which seems to race on like machine-gun fire, is more beautiful than the Winged Victory of Samothrace.

5. We wish to sing the praises of the man behind the steering wheel, whose sleek shaft traverses the Earth, which itself is hurtling at breakneck speed along the racetrack of its orbit.

6. The poet will have to do all in his power, passionately, flamboyantly, and with generosity of spirit, to increase the delirious fervour of the primordial elements.

7. There is no longer any beauty except the struggle. Any work of art that lacks a sense of aggression can never be a masterpiece. Poetry must be thought of as a violent assault upon the forces of the unknown with the intention of making them prostrate themselves at the feet of mankind.

8. We stand upon the furthest promontory of the ages! . . . Why should we be looking back over our shoulders, if what we desire is to smash down the mysterious doors of the Impossible? Time and Space died yesterday. We are already living in the realms of the Absolute, for we have already created infinite, omnipresent speed.

9. We wish to glorify war – the sole cleanser of the world – militarism, patriotism, the destructive act of the libertarian, beautiful ideas worth dying for, and scorn for women.

10. We wish to destroy museums, libraries, academies of any sort, and fight against moralism, feminism, and every kind of materialistic, self-serving cowardice.

11. We shall sing of the great multitudes who are roused up by work, by pleasure, or by rebellion; of the many-hued, many-voiced tides of revolution in our modern capitals; of the pulsating, nightly ardour of arsenals and shipyards, ablaze with their violent electric moons; of railway stations, voraciously devouring smoke-belching serpents; of workshops hanging from the clouds by their twisted threads of smoke; of bridges which, like giant gymnasts, bestride the rivers, flashing in the sunlight like gleaming knives; of intrepid steamships that sniff out the horizon; of broad-breasted locomotives, champing on the wheels like enormous steel horses, bridled with pipes; and of the lissom flight of the aeroplane,

whose propeller flutters like a flag in the wind, seeming to applaud, like a crowd excited.

It is from Italy that we hurl at the whole world this utterly violent, inflammatory manifesto of ours, with which we today are founding 'Futurism', because we wish to free our country from the stinking canker of its professors, archaeologists, tour guides and antiquarians.

For far too long Italy has been a marketplace for junk dealers. We want our country free from the endless number of museums that everywhere cover her like countless graveyards. Museums, graveyards! . . . They're the same thing, really, because of their grim profusion of corpses that no one remembers. Museums. They're just public flophouses, where things sleep on forever, alongside other loathsome or nameless things! Museums: ridiculous abattoirs for painters and sculptors, who are furiously stabbing one another to death with colours and lines, all along the walls where they vie for space.

Sure, people may go there on pilgrimage about once a year, just as they do to the cemetery on All Souls Day – I'll grant you that. And yes, once a year a wreath of flowers is laid at the feet of the *Gioconda* [the *Mona Lisa*] – I'll grant you that too! But what I won't allow is that our miseries, our fragile courage, or our sickly anxieties get marched daily around these museums. Why should we want to poison ourselves? Why should we want to rot?

What on earth is there to be discovered in an old painting other than the laboured contortions of the artist, trying to break down the insuperable barriers which prevent him from giving full expression to his artistic dream? . . . Admiring an old painting is just like pouring our purest feelings into a funerary urn, instead of projecting them far and wide, in violent outbursts of creation and of action.

Do you really want to waste all your best energies in this unending, futile veneration for the past, from which you emerge fatally exhausted, diminished, trampled down?

Make no mistake, I'm convinced that for an artist to go every day to museums and libraries and academies (the cemeteries of wasted effort, calvaries of crucified dreams, records of impulses cut short! . . .) is every bit as harmful as the prolonged over-protectiveness of parents for certain young people who get carried away by their talent and ambition. For

those who are dying anyway, for the invalids, for the prisoners – who cares? The admirable past may be a balm to their worries, since for them the future is a closed book . . . but we, the powerful young Futurists, don't want to have anything to do with it, the past!

So let them come, the happy-go-lucky fire-raisers with their blackened fingers! Here they come! Here they come! . . . Come on then! Set fire to the library shelves! Divert the canals so they can flood the museums! . . . Oh, what a pleasure it is to see those revered old canvases, washed out and tattered, drifting away in the water! . . . Grab your picks and your axes and your hammers and then demolish, pitilessly demolish, all venerated cities!

The oldest among us are thirty: so we have at least ten years in which to complete our task. When we reach forty, other, younger and more courageous men will very likely toss us into the trash can, like useless manuscripts. And that's what we want!

Our successors will rise up against us, from far away, from every part of the world, dancing on the winged cadenzas of their first songs, flexing their hooked, predatory claws, sniffing like dogs at the doors of our academies, at the delicious scent of our decaying minds, already destined for the catacombs of libraries.

But we won't be there . . . Eventually they will find us, on a winter's night, in a humble shed, far away in the country, with an incessant rain drumming upon it, and they'll see us huddling anxiously together beside our aeroplanes, warming our hands around the flickering flames of our present-day books, which burn away beneath images as they take flight.

They will rant and rave around us, gasping in outrage and fury, and then – frustrated by our proud, unwavering boldness – they will hurl themselves upon us to kill us, driven by a hatred made all the more implacable because their hearts overflow with love and admiration for us.

Strong, healthy Injustice will flash dazzlingly in their eyes. Art, indeed, can be nothing but violence, cruelty and injustice.

The oldest among us are only thirty. And yet we have squandered fortunes, a thousand fortunes of strength, love, daring, cleverness and of naked willpower. We have tossed them aside impatiently, in anger, without thinking of the cost, without a moment's hesitation, without ever resting, gasping for breath . . . Just look at us! We're not exhausted

yet! Our hearts feel no weariness, for they feed on fire, on hatred, and on speed! . . . Does that surprise you? That's logical enough, I suppose, as you don't even remember having lived! Standing tall on the roof of the world, yet again we fling our challenge at the stars!

Do you have any objections? – All right! Sure, we know what they are . . . We have understood! . . . Our sharp duplicitous intelligence tells us that we are the sum total and extension of our forebears. Well, maybe! . . . Be that as it may! . . . But what does it matter? We want nothing to do with it! . . . Woe betide anybody whom we catch repeating these infamous words of ours!

Look around you!

Standing tall on the roof of the world, yet again, we hurl our defiance at the stars!

M2 Umberto Boccioni and others

Manifesto of the Futurist Painters (1910)

According to legend, this manifesto was composed by Boccioni, Carrà and Russolo in a single day – rather laboriously, says Carrà – at the Porta Vittoria café in Milan, with Marinetti joining them in the evening to add the finishing touches. It was launched in late February 1910, and first published as a leaflet in *Poesia*, backdated to 11 February 1910. (Futurist manifestos are always dated 11; Marinetti had a superstitious regard for that number.) It was declaimed from the stage of the Chiarella Theatre, Turin, on 18 March 1910, and from the Mercedante Theatre, Naples, on 20 April 1910.

It is hardly an exaggeration to say that the Futurist movement consisted initially of five men and a dynamic dog: Giacomo Balla, Umberto Boccioni, Carlo Carrà, Luigi Russolo and Gino Severini. It was they who collaborated on the seminal manifestos of 1910–14, and on an exhibition, 'The Italian Futurist Painters', at the Galerie Bernheim-Jeune in Paris and the Sackville Gallery in London in 1912, an exhibition recreated in Paris, Rome and London in 2008–9, in centenary celebration.

UMBERTO BOCCIONI (1882–1916) was a true believer, an aggressive nationalist (he once set fire to an Austrian flag at an evening in the theatre, a typical Futurist stunt) and something of a theorist. His painting *The Laugh* (1911) borrows the title of a book by the philosopher Henri Bergson, a favourite of the Futurists. For all his partisan fervour, he was not above a little borrowing from the opposition – he appears to have reworked *The Laugh* to give it a Cubist look, after discovering Picasso and Braque in Paris in the autumn of 1911.

For Boccioni, modernity was not enough: he spoke of 'modernolatry', and painted a fiercely Futurist *Modern Idol* (1910–11). It was he who laid down that the spectator must be at the centre of the action of the work

(a precept emphasized in M3). 'If we paint the phases of a riot, the crowd bustling with uplifted fists and the noisy onslaught of the cavalry are translated upon the canvas in sheaves of lines corresponding to the conflicting forces, following the general law of violence of the picture. These force-lines must encircle and involve the spectator so that he will in a manner be forced to struggle himself with the persons in the picture.' His own treatment of *The Forces in the Street* (1911) illustrates this Futurist force-field very well, as does Carrà's exemplary subject, *The Funeral of the Anarchist Galli* (1910–11), a composition reminiscent of Uccello with a Futurist twist.

Boccioni was also a sculptor – his virile Futurist figure in a force-field of its own, *Unique Forms of Continuity in Space* (1913), was used by the Berlusconi government, appropriately enough, on one of the new Euro coins in 2002 – and a soldier. He died on active service, not as he might have wished, Futuristically, but ironically, from injuries sustained after his horse shied at a car.

* * *

TO THE YOUNG ARTISTS OF ITALY!

The cry of rebellion which we utter associates our ideals with those of the Futurist poets. These ideals were not invented by some aesthetic clique. They are an expression of a violent desire which boils in the veins of every creative artist today.

We will fight with all our might the fanatical, senseless and snobbish religion of the past, a religion encouraged by the vicious existence of museums. We rebel against that spineless worshipping of old canvases, old statues and old bric-a-brac, against everything which is filthy and worm-ridden and corroded by time. We consider the habitual contempt for everything which is young, new and burning with life to be unjust and even criminal.

Comrades, we tell you now that the triumphant progress of science makes profound changes in humanity inevitable, changes which are hacking an abyss between those docile slaves of past tradition and us free moderns, who are confident in the radiant splendour of our future.

We are sickened by the foul laziness of artists, who, ever since the sixteenth century, have endlessly exploited the glories of the ancient Romans.

In the eyes of other countries, Italy is still a land of the dead, a vast Pompeii, white with sepulchres. But Italy is being reborn. Its political resurgence will be followed by a cultural resurgence. In the land inhabited by the illiterate peasant, schools will be set up; in the land where doing nothing in the sun was the only available profession, millions of machines are already roaring; in the land where traditional aesthetics reigned supreme, new flights of artistic inspiration are emerging and dazzling the world with their brilliance.

Living art draws its life from the surrounding environment. Our forebears drew their artistic inspiration from a religious atmosphere which fed their souls; in the same way we must breathe in the tangible miracles of contemporary life – the iron network of speedy communications which envelops the earth, the transatlantic liners, the dreadnoughts, those marvellous flights which furrow our skies, the profound courage of our submarine navigators and the spasmodic struggle to conquer the unknown. How can we remain insensible to the frenetic life of our great cities and to the exciting new psychology of nightlife; the feverish figures of the bon viveur, the cocotte, the apache and the absinthe drinker?

We will also play our part in this crucial revival of aesthetic expression: we will declare war on all artists and all institutions which insist on hiding behind a façade of false modernity, while they are actually ensnared by tradition, academicism and, above all, a nauseating cerebral laziness.

We condemn as insulting to youth the acclamations of a revolting rabble for the sickening reflowering of a pathetic kind of classicism in Rome; the neurasthenic cultivation of hermaphroditic archaism which they rave about in Florence; the pedestrian, half-blind handiwork of '48 which they are buying in Milan; the work of pensioned-off government clerks which they think the world of in Turin; the hotchpotch of encrusted rubbish of a group of fossilized alchemists which they are worshipping in Venice. We are going to rise up against all superficiality and banality – all the slovenly and facile commercialism which makes the work of most of our highly respected artists throughout Italy worthy of our deepest contempt.

Away then with hired restorers of antiquated incrustations. Away

with affected archaeologists with their chronic necrophilia! Down with the critics, those complacent pimps! Down with gouty academics and drunken, ignorant professors!

Ask these priests of a veritable religious cult, these guardians of old aesthetic laws, where we can go and see the works of Giovanni Segantini [1858–99] today. Ask them why the officials of the Commission have never heard of the existence of Gaetano Previati [1852–1920]. Ask them where they can see Medardo Rosso's [1858–1928] sculpture, or who takes the slightest interest in artists who have not yet had twenty years of struggle and suffering behind them, but are still producing works destined to honour their fatherland?

These paid critics have other interests to defend. Exhibitions, competitions, superficial and never disinterested criticism, condemn Italian art to the ignominy of true prostitution.

And what about our esteemed 'specialists'? Throw them all out. Finish them off! The Portraitists, the Genre Painters, the Lake Painters, the Mountain Painters. We have put up with enough from these impotent painters of country holidays.

Down with all marble-chippers who are cluttering up our squares and profaning our cemeteries! Down with the speculators and their reinforced concrete buildings! Down with laborious decorators, phoney ceramicists, sold-out poster painters and shoddy, idiotic illustrators!

These are our final CONCLUSIONS:

With our enthusiastic adherence to Futurism, we will:

1. Destroy the cult of the past, the obsession with the ancients, pedantry and academic formalism.
2. Totally invalidate all kinds of imitation.
3. Elevate all attempts at originality, however daring, however violent.
4. Bear bravely and proudly the smear of 'madness' with which they try to gag all innovators.
5. Regard art critics as useless and dangerous.
6. Rebel against the tyranny of words: 'Harmony' and 'good taste' and other loose expressions which can be used to destroy the works of Rembrandt, Goya, Rodin . . .
7. Sweep the whole field of art clean of all themes and subjects which have been used in the past.

8. Support and glory in our day-to-day world, a world which is going to be continually and splendidly transformed by victorious Science.

The dead shall be buried in the earth's deepest bowels! The threshold of the future will be swept free of mummies! Make room for youth, for violence, for daring!

M3 Umberto Boccioni and others

Futurist Painting: Technical Manifesto (1910)

First published as a leaflet in *Poesia*, 11 April 1910, and in *Comœdia* (Paris), 18 May 1910, with cartoons by André Warnod; republished in *Der Sturm* (Berlin) in March 1912 and *Soŭz Molodëži* (Petersburg) in June 1912. This version is from the catalogue of the 'Exhibition of Works by the Italian Futurist Painters' at the Sackville Gallery, London, in March 1912 (see headnote to M2).

Futurist perceptions as colourists, as they put it, make as if to sympathize with Takamura Kōtarō's 'A Green Sun' (M4).

* * *

On the 18th of March 1910, in the limelight of the Chiarella Theatre of Turin, we launched our first manifesto to a public of three thousand people – artists, men of letters, students and others; it was a violent and cynical cry which displayed our sense of rebellion, our deep-rooted disgust, our haughty contempt for vulgarity, for academic and pedantic mediocrity, for the fanatical worship of all that is old and worm-eaten.

We bound ourselves there and then to the movement of Futurist Poetry which was initiated a year earlier by F. T. Marinetti in the columns of the *Figaro*.

The battle of Turin has remained legendary. We exchanged almost as many knocks as we did ideas, in order to protect from certain death the genius of Italian Art.

And now, during a temporary pause in this formidable struggle, we come out of the crowd in order to expound with technical precision our programme for the renovation of painting, of which our Futurist Salon at Milan was a dazzling manifestation.

Our growing need of truth is no longer satisfied with Form and Colour as they have been understood hitherto.

The gesture which we would reproduce on canvas shall no longer be a fixed *moment* in universal dynamism. It shall simply be the *dynamic sensation* itself.

Indeed, all things move, all things run, all things are rapidly changing. A profile is never motionless before our eyes, but it constantly appears and disappears. On account of the persistency of an image upon the retina, moving objects constantly multiply themselves; their form changes like rapid vibrations, in their mad career. Thus a running horse has not four legs, but twenty, and their movements are triangular.

All is conventional in art. Nothing is absolute in painting. What was truth for the painters of yesterday is but a falsehood today. We declare, for instance, that a portrait must not be like the sitter, and that the painter carries in himself the landscapes which he would fix upon his canvas.

To paint a human figure you must not paint it; you must render the whole of its surrounding atmosphere.

Space no longer exists: the street pavement, soaked by rain beneath the glare of electric lamps, becomes immensely deep and gapes to the very centre of the earth. Thousands of miles divide us from the sun; yet the house in front of us fits into the solar disk.

Who can still believe in the opacity of bodies, since our sharpened and multiplied sensitiveness has already penetrated the obscure manifestations of the medium? Why should we forget in our creations the doubled power of our sight, capable of giving results analogous to those of the X-rays?

It will be sufficient to cite a few examples, chosen amongst thousands, to prove the truth of our arguments.

The sixteen people around you in a rolling motor bus are in turn and at the same time one, ten, four, three; they are motionless and they change places; they come and go, bound into the street, are suddenly swallowed up by the sunshine, then come back and sit before you, like persistent symbols of universal vibration.

How often have we not seen upon the cheek of the person with whom we are talking the horse which passes at the end of the street.

Our bodies penetrate the sofas upon which we sit, and the sofas penetrate our bodies. The motor bus rushes into the houses which it passes,

and in their turn the houses throw themselves upon the motor bus and are blended with it.

The construction of pictures has hitherto been foolishly traditional. Painters have shown us the objects and the people placed before us. We shall henceforward put the spectator in the centre of the picture.

As in every realm of the human mind, clear-sighted individual research has swept away the unchanging obscurities of dogma, so must the vivifying current of science soon deliver painting from academism.

We would at any price re-enter into life. Victorious science has nowadays disowned its past in order the better to serve the material needs of our time; we would that art, disowning its past, were able to serve at last the intellectual needs which are within us.

Our renovated consciousness does not permit us to look upon man as the centre of universal life. The suffering of a man is of the same interest to us as the suffering of an electric lamp, which, with spasmodic starts, shrieks out the most heart-rending expressions of colour. The harmony of the lines and folds of modern dress works upon our sensitiveness with the same emotional and symbolical power as did the nude upon the sensitiveness of the Old Masters.

In order to conceive and understand the novel beauties of a Futurist picture, the soul must be purified; the eye must be freed from its veil of atavism and culture, so that it may at last look upon Nature and not upon the museum as the one and only standard.

As soon as ever this result has been obtained, it will be readily admitted that brown tints have never coursed beneath our skin; it will be discovered that yellow shines forth in our flesh, that red blazes, and that green, blue and violet dance upon it with untold charms, voluptuous and caressing.

How is it possible still to see the human face pink, now that our life, redoubled by noctambulism, has multiplied our perceptions as colourists? The human face is yellow, red, green, blue, violet. The pallor of a woman gazing in a jeweller's window is more intensely iridescent than the prismatic fires of the jewels that fascinate her like a lark.

The time has passed for our sensations in painting to be whispered. We wish them in future to sing and re-echo upon our canvases in deafening and triumphant flourishes.

Your eyes, accustomed to semi-darkness, will soon open to more radiant

visions of light. The shadows which we shall paint shall be more luminous than the highlights of our predecessors, and our pictures, next to those of the museums, will shine like blinding daylight compared with deepest night.

We conclude that painting cannot exist today without Divisionism. This is no process that can be learned and applied at will. Divisionism, for the modern painter, must be *an innate complementariness* which we declare to be essential and necessary.

Our art will probably be accused of tormented and decadent cerebralism. But we shall merely answer that we are, on the contrary, the primitives of a new sensitiveness, multiplied hundredfold, and that our art is intoxicated with spontaneity and power.

WE DECLARE:

1. That all forms of imitation must be despised, all forms of originality glorified.
2. That it is essential to rebel against the tyranny of the terms 'harmony' and 'good taste' as being too elastic expressions, by the help of which it is easy to demolish the works of Rembrandt, of Goya and of Rodin.
3. That the art critics are useless or harmful.
4. That all subjects previously used must be swept aside in order to express our whirling life of steel, of pride, of fever and of speed.
5. That the name of 'madman' with which it is attempted to gag all innovators should be looked upon as a title of honour.
6. That innate complementariness is an absolute necessity in painting, just as free metre in poetry or polyphony in music.
7. That universal dynamism must be rendered in painting as a dynamic sensation.
8. That in the manner of rendering Nature the first essential is sincerity and purity.
9. That movement and light destroy the materiality of bodies.

WE FIGHT:

1. Against the bituminous tints by which it is attempted to obtain the patina of time upon modern pictures.
2. Against the superficial and elementary archaism founded upon flat tints, and which, by imitating the linear technique of the Egyptians, reduces painting to a powerless synthesis, both childish and grotesque.

3. Against the false claims to belong to the future put forward by the secessionists and the independents, who have installed new academies no less trite and attached to routine than the preceding ones.

4. Against the nude in painting, as nauseous and as tedious as adultery in literature.

We wish to explain this last point. Nothing is *immoral* in our eyes; it is the monotony of the nude against which we fight. We are told that the subject is nothing and that everything lies in the manner of treating it. That is agreed; we too admit that. But this truism, unimpeachable and absolute fifty years ago, is no longer so today with regard to the nude, since artists obsessed with the desire to expose the bodies of their mistresses have transformed the Salons into arrays of unwholesome flesh!

We demand, for ten years, the total suppression of the nude in painting.

M4 Takamura Kōtarō

A Green Sun (1910)

First published in the literary magazine *Subaru* (Tokyo) in April 1910. Much discussed as the first Japanese 'Impressionist Manifesto', though it is more an attempt by the author to clarify his thoughts, and perhaps to master himself. Its titular affirmation became famous: 'Even if someone paints a "green sun", I will not say it is wrong.'

A few months later, the painter and sculptor Takamura Kōtarō (1883–1956) wrote a short poem called 'The Country of Netsuke' which continues to affect older Japanese very powerfully:

> Cheekbones protruding, lips thick, eyes triangular, with a face
> > like a netsuke carved by the master Sangorō
> blank, as if stripped of his soul
> not knowing himself, fidgety
> life-cheap
> vainglorious
> small and frigid, incredibly smug
> monkey-like, fox-like, flying-squirrel-like, mudskipper-like,
> > minnow-like, gargoyle-like, chip-from-a-cup-like
> > Japanese.

Kōtarō had returned from a four-year sojourn in New York, London and Paris – especially Paris – with an acute racial inferiority complex vis-à-vis white Westerners. 'I'm *Japonais*, Mongol, le jaune!' He had gone to learn and to be seduced, in both of which he had succeeded. He was first smitten by Rodin, and by Camille Mauclair's study of Rodin, which he read so many times he knew it almost by heart. As his writing demonstrates, he was artistically well educated but emotionally mixed up. 'A Green Sun' is at once a passionate declaration and a meandering excogitation. As an

Impressionist Manifesto, it was both early and late: in 1910 the Japanese were only just beginning their discovery of the pivotal figure of Cézanne – a discovery which led to a deep veneration – while the French were trying to come to terms with the *bizarreries cubiques* of Braque and Picasso. As for the Futurists, Impressionism was passé, of course, not to say passéist. Their slighting perspective is well captured in 'The Painting of Sounds, Noises and Smells' (1913) by Carlo Carrà (M12). The interest of Kōtarō's foray into greenness, Japaneseness and artistic self-consciousness lies in its cross-cultural transmission and its continuing reverberation.

See also Takashi Murakami's 'Super flat Manifesto' (M96).

* * *

People become stuck in an unexpectedly insignificant place and suffer.

The so-called Japanese-style painters can't move forward, marked by the term 'Japanese-style.' The so-called Western-style painters can't either, weighed down by oil paint on their backs. Sometimes you end up being more protective of a pawn than of the knight. Your *motiv* for that may be funny if you think about it, but when you magnify with a lens a situation where you can't move forward, and contemplate it, you may be persuaded that it *is* cruel. Meaningless confusion and the abuse of the dangerous *sonde* [probe] are the heavy tolls exacted of every artist at such a moment. In this sense, no other artists than the Japanese today place such expensive but useless stamps on their works, or have done. In revolt against these heavy taxes, there may yet ensue *Anarchismus* in the art world. But the *Anarchismus* that ensues from such a situation will be reactionary. It won't be the *Anarchismus* of the *Anarchists*.

I seek absolute *Freiheit* [freedom] in the art world. Therefore, I want to recognize an infinite authority in the artist's *Persönlichkeit* [personality]. In every sense, I'd like to think of the artist as a single human being. I'd like to regard his *Persönlichkeit* as the starting point and *schätzen* [appreciate] his work. I want to study and appreciate his *Persönlichkeit* as it is, and do not want to throw too much doubt into it. If someone sees what I think is blue as red, I'd like to start on the basis that *he* thinks it's red, and *schätzen* how he treats it as red. About the fact that he sees it as red, I wouldn't want to complain at all. Rather, I'd like to take as an *angenehmer Überfall* [pleasant invasion] the fact that there is a view of nature different from mine, and

would contemplate the extent to which he has peered into the core of nature, the extent to which his *Gefühl* [feeling] has been fulfilled. That done, I then would like to savour his *Gemütsstimmung* [frame of mind]. This desire of my mind drives me so that it has minimized the value of *local colour* which is on people's lips these days. (The expression, in English, has a couple of meanings; here, it will denote the usual one of the character of natural colours of a particular region.) It is my view that for a painter to think and suffer about something like *local colour* is just another way of paying for an expensive but useless stamp of the kind I mentioned before.

If my demand for absolute *Freiheit* were wrong as an attitude, all my thoughts that arise from it would be valueless. But this happens to belong in the category where there can't be any mistake. For it is not a theory, but my own feeling. Even if someone says it is wrong, I won't be able to do anything about it as long as my brain exists. So I'd like to put in words at least what I think.

I am born Japanese. Just as a fish can't live out of water, so I can't live as a non-Japanese, even if I remain quiet about it. At the same time, just as a fish isn't conscious that he's wet in the water, so at times I'm not conscious that I'm Japanese. 'At times' isn't the right expression. I'm more often unconscious than not. I often think I'm Japanese when I'm dealing with someone. The thought doesn't occur much when I face nature. That is, I think of it when I think of my own turf. Such a thought can't possibly occur when I have my own self thrown into an object.

My psychological state while making art is, therefore, where only one human being exists. Thoughts of things like Japan don't exist at all. I simply go ahead, thinking, seeing and feeling as I do, regardless. The work, when you look at it later, may turn out to be so-called Japanesey. It may not. Either way, it won't bother me, the artist, at all. Even the existence of local colour, in such an instance, will mean nothing.

There are quite a number of people in today's painting world who think highly of the value of local colour. There seems to be even some who think that the fate of Japanese oil paints will be determined by the way the painters compromise with the local colour of Japan. There also seem to be not a few people who take a step or two, then hesitate, thinking that nature in Japan has a certain inviolable set of colours peculiar to it, so that if they infringe on it, their works will immediately lose their *raison d'être* – all this prompting them to try to suppress the flaming colours

and dreamlike *ton* [tone] in their hearts. Others put themselves in a harshly rigid attitude that doesn't tolerate even the view of according simple *Abschätzung* [evaluation], while they give an absolute value to local colour and treat as something out of the question all the works that have recognized different colours to any degree. And the value of local colour seems to be recognized by the general public. This you can tell from the fact that the expression 'There's no such colour in Japan' is accepted as a condemnatory pronouncement. I'd like to ignore this local colour. Needless to say, I am saying this from the standpoint of an artist.

Even if someone paints a 'green sun', I will not say it is wrong. This is because there may be a time when the sun looks that way to me too. Simply because a painting has a 'green sun' in it, I will not be able to overlook the overall value of the painting. The good or bad of the painting has nothing to do with whether the sun is green or flaming scarlet. In such a case, too, as I said before, I'd like to savour the tone of the green sun as part of the work. I will not compare the Buddhist statues of the Fujiwara Era, which are truly like 'Japanese' buddhas, with those of the Tempyō Era, which have a great deal of foreign flavour added to them, and then take the former over the latter from the viewpoint of *local colour*. I'd like to place one work above or below another on the basis of the amount of *Das Leben* [life]. I'd like to allow the *Persönlichkeit* of the artist who has painted a green sun to have absolute authority. [. . .]

I'd like the artist to forget that he's Japanese. I'd like him to rid himself entirely of the idea that he is reproducing nature in Japan. And I'd like him to express on his canvas the tone of nature as he sees it, freely, indulgently, wilfully. Even if his finished work produces what is the opposite of the local colour of Japan that we think we see in our eyes, I will not want to reject it on that account. To the eye of someone with Chinese feelings, even nature in Japan will at times appear Chinese-style. To the eye of someone *exotisch*, even the torii of a fox shrine may appear tinged with exotic colours. A bystander has no right to complain of something with which he has nothing to do. An appreciator facing a work of art has no need to question the fact that it is different. He should simply recognize that it is different, and then try to see on the basis of the work whether the artist's sentiments are based on something false or on his innate sincerity. The goodness or badness of the work must come into his mind as a separate issue.

From this standpoint, I am hoping that Japanese artists will use all the

möglich [possible] techniques without any reservation. I pray that they will follow their inner urges of the moment and not be necessarily afraid that they may produce something non-Japanese. No matter how non-Japanese, a work made by a Japanese can't avoid being Japanese. Gauguin went as far as Tahiti and created non-French colours, but his works are, when you think of it, not in the Tahitian style but in the Parisian style. Whistler lived in France and for a while indulged in *nostalgie* for Japan, but he is indisputably *angelsächsisch* [Anglo-Saxon]. Turner painted the streets of London in Italian colours, but when you think of it now, the colours with which he painted Italian nature were in the end English in style.

Monet did not try to reproduce the local colour of France; he tried to recreate nature. Of course, the public did not accept his as French colours. Worse, they did not accept them as natural colours, either. He was denounced because he had painted tree leaves sky-blue. Nevertheless, when you look at his works now, they have an unmistakably French touch of the sort that no one from any other country could have. All this is like a fish having a watery touch. Something like that is not gained by effort, but comes with the thing in itself. When you try to obtain something like that through effort, the degradation of art begins.

While I think the shrine fence painted scarlet beautiful, sometimes I am also entranced by the electric advertisements of Jintan. That's when creative fervour is boiling in my head. When there is no creative fervour, I am irritated to no end by the random confusion of the city today. There always lives in my mind bugs of these two different stripes. Similarly, while I admire so-called Japanese taste, I am also captivated by non-Japanese tastes. Also, while I regard Japan's local colour to some extent as other people do, in my heart of hearts I reduce its value to zero. So when I look at things Westernized, I do not in the least feel repelled by their Westernization. Even if I see a green sun, I do not feel offended.

I have ended up writing down my thoughts in their confused state. All I wanted to do was to say a word on local colour, which I think is of little import but of which the world at large makes a big deal. I passionately hope that Japanese artists will see not Japan but nature, will not give a damn about local colour that has been turned into a set rule, but will express recalculated colour tones as they please.

No matter what wilful things we may do, all we'll have left after our death will be works only Japanese can make.

M5 F. T. Marinetti

Against Traditionalist Venice (1910)

According to Marinetti, 'on 8 July 1910, 800,000 leaflets containing this manifesto were hurled by the Futurist poets and painters from the top of the Clock Tower [in the Piazza San Marco] onto the crowds returning from the Lido. Thus began the campaign which, for three years, the Futurists waged against traditional Venice.' He also boasted that a speech against the Venetians, 'extemporized by Marinetti at the Fenice Theatre, provoked a terrible battle', a Futurist affray in which 'the Traditionalists were beaten up'. This account has been investigated by scholars, who have found little to corroborate it. It seems that a shortened version of the original manifesto was printed in Italian, French and English ('Venezia futurista', 'Venise futuriste' and 'Futurist Venice'), for distribution from the Clock Tower, to advertise a Futurist *serata* (performance) at the Fenice Theatre and a Boccioni exhibition opening at the Ca'Pesaro on 15 July 1910. However, the *serata* was postponed; it took place at short notice on 1 August 1910, attracting little attention (and no affray).

Another puzzle is the title, which is in the original 'Contro Venezia passatista'. The standard English edition of Marinetti's writings offers 'Against Past-Loving Venice'; and its recent successor, used here, 'Against Traditionalist Venice'. Neither does justice to the Futurist usage, or mindset, the charged feeling behind that troublesome *passatista*. What the Futurists were against was what they saw as an infatuation with the presence of the past, a debilitating condition possibly more familiar from the French *passé* or *passéisme*, and perhaps in the final analysis untranslatable.

This version of the manifesto was published as a leaflet by *Poesia*, dated 27 April 1910, and in French in *Comœdia* on 17 June 1910, with cartoons by André Warnod.

★ ★ ★

We turn our backs on the ancient Venice, worn out and brought to ruin by centuries of pleasure-seeking, although once even we loved that city and took it to our hearts, in a great nostalgic dream.

We reject the Venice of foreigners, this marketplace of fake antique dealers, this magnet for universal snobbism and imbecility, this bed worn out by endless droves of lovers, this bath adorned with jewels for cosmopolitan whores, this immense sewer of traditionalism.

We wish to cure and begin the healing process of this putrescent city, this magnificent carbuncle from the past. We want to bring the Venetian people back to life, to ennoble them, fallen as they are from their former greatness, stupefied by a sickening spinelessness and humiliated by their habitual, shady little businesses.

We wish to prepare for the birth of an industrial and military Venice which can dominate the Adriatic, this great Italian lake.

We rush to fill in its stinking little canals, with the rubble of its crumbling, pock-marked palaces.

We'll set fire to the gondolas, rocking chairs for cretins, and we'll raise up to the skies the imposing geometry of metal bridges and factories plumed with smoke, so as to abolish the drooping curves of its ancient architecture.

Let the reign of divine Electric Light begin at last, to liberate Venice from the whorish moonlight of its furnished bedrooms.

M6 Guillaume Apollinaire

On the Subject in Modern Painting (1912)

Originally published as the lead article in the first issue of *Les Soirées de Paris*, 1 February 1912. In its brief life, *Les Soirées de Paris* (1912–14) was one of the most important periodicals of the avant-garde. Apollinaire republished it in modified form in his collection *Les Peintres cubistes* (1913), and in this version in *Il y a* (1925).

GUILLAUME APOLLINAIRE (Wilhelm-Apollinaris de Kostrowitski, 1880–1918), the poet who so loved art that he joined the artillery, as he said, was a tonic to all who knew him, a lyric magician, and a one-man artistic community: under his dispensation, painters, poets and musicians marched together under the same banner, destined to seize the day. When it came to art, and artists, his critical judgement was often suspect, but he was a magnificent moral support, a passionate advocate and a great impresario, splendidly unafraid of the new. He took Cubism in his stride, at a time when it was widely derided as either unintelligible or unconscionable, or both. He considered that 'the most prominent personalities among the young new painters' of 1911–12 were Derain, Dufy, Laurencin, Matisse and Picasso, a list as surprising for its inclusion of Laurencin (his lover) as for its exclusion of Braque (his friend). His writings draw on an intimate acquaintance with these artists, their outlook, their practice and their talk. Apollinaire makes a manifesto for them.

* * *

The new painters paint works that do not have a real subject, and from now on the titles in catalogues will be like names that identify a man without describing him.

Just as there are some very skinny people named Portly and some

very dark-haired people named Fair, I have seen paintings entitled *Solitude* that show several figures.

Painters sometimes still condescend to use vaguely explanatory words such as *portrait*, *landscape*, or *still-life*; but many young painters simply employ the general term *painting*.

If painters still observe nature, they no longer imitate it, and they carefully avoid the representation of natural scenes observed directly or reconstituted through study. Modern art rejects all the means of pleasing that were employed by the greatest artists of the past: the perfect representation of the human figure, voluptuous nudes, carefully finished details, etc. . . . Today's art is austere, and even the most prudish senator could find nothing to criticize in it.

Indeed, it is well known that one of the reasons Cubism has enjoyed such success in elegant society is precisely this austerity.

Verisimilitude no longer has any importance, for the artist sacrifices everything to the composition of his picture. The subject no longer counts, or if it counts, it counts for very little.

If the aim of painting has remained what it always was – namely, to give pleasure to the eye – the works of the new painters require the viewer to find in them a different kind of pleasure from the one he can just as easily find in the spectacle of nature.

An entirely new art is thus being evolved, an art that will be to painting, as painting has hitherto been envisaged, what music is to literature.

It will be pure painting, just as music is pure literature.

In listening to a concert, the music-lover experiences a joy qualitatively different from that which he experiences in listening to natural sounds, such as the murmur of a stream, the rushing of a torrent, the whistling of the wind in the forest or the harmonies of a human language founded on reason and not on aesthetics.

Similarly, the new painters provide their admirers with artistic sensations due exclusively to the harmony of lights and shades and independent of the subject depicted in the picture.

We all know the story of Apelles and Protogenes, as it is told by Pliny. It provides an excellent illustration of aesthetic pleasure independent of the subject treated by the artist and resulting solely from the contrasts I have just mentioned.

Apelles arrived one day on the island of Rhodes to see the works of

Protogenes, who lived there. Protogenes was not in his studio when Apelles arrived. Only an old woman was there, keeping watch over a large canvas ready to be painted. Instead of leaving his name, Apelles drew on the canvas a line so fine that one could hardly imagine anything more perfect.

On his return, Protogenes noticed the line and, recognizing the hand of Apelles, drew on top of it another line in a different colour, even more subtle than the first, thus making it appear as if there were three lines on the canvas.

Apelles returned the next day, and the subtlety of the line he drew then made Protogenes despair. That work was for a long time admired by connoisseurs, who contemplated it with as much pleasure as if, instead of some barely visible lines, it had contained representations of gods and goddesses.

The young painters of the avant-garde schools, then, wish to do pure painting. Theirs is an entirely new plastic art. It is only at its beginnings, and is not yet as abstract as it would like to be. The new painters are in a sense mathematicians without knowing it, but they have not yet abandoned nature, and they examine it patiently.

A Picasso studies an object the way a surgeon dissects a corpse.

If this art of pure painting succeeds in disengaging itself entirely from the traditional way of painting, the latter will not necessarily disappear. The development of music, after all, did not cause the disappearance of the various literary genres, nor did the acrid taste of tobacco replace the savour of food.

M7 Valentine de Saint-Point

Manifesto of Futurist Woman (1912)

(Response to F. T. Marinetti)

VALENTINE DE SAINT-POINT (1875–1953), formerly a model for
Mucha and Rodin, latterly a performance artist, dancer, writer, activist
and theorist, was an intellectual, a creative force and an object of desire.
By 1904 she was living with Ricciotto Canudo, the future author of the
manifesto of 'Cerebrist Art' (M15); by 1905 she met Marinetti, whose
notorious 'scorn for women' in the founding 'Manifesto of Futurism'
(M1) she took as the point of departure for her 'Manifesto of Futurist
Woman', first published on 25 March 1912. At a public reading in the Salle
Gaveau in Paris, on 27 June 1912, Boccioni, Severini and Marinetti himself
acted as bodyguards as she took hostile questions from the floor. 'At what
age, Madam, should we teach lust to our daughters?' asked one elderly
gentleman. 'Not yours, of course!' she rejoined, adding for good measure,
'Bring them anyway, we'll give you the answer afterwards!' She was
indeed an expert on the subject. Her 'Futurist Manifesto of Lust' (M9)
appeared the following year.

Saint-Point was nothing if not versatile. (As if to underline the
message, Anne-Jeanne Desglans de Cessiat-Vercell took her pseudonym
from her ancestor, the romantic poet, politician and revolutionary
Alphonse de Lamartine, whose château was situated in the village of
Saint-Point in Burgundy.) As part of her 'art of flesh', she initiated a
multi-media performance called *metachory*, meaning 'beyond the dance'.
The first *metachory* was staged in Paris in 1913, complete with theoretical
explanation, followed by a solo from Saint-Point, veiled and almost naked,
accompanied by words from her own *Poems of War and Love*, light projec-
tions of mathematical equations and an effusion of perfumes. The music
was deliberately disconnected from the movement, anticipating the

experiments of John Cage and Merce Cunningham some fifty years later.

Saint-Point broke with the Futurists in 1914. Make lust not war, she might have said. She left Paris for Cairo in 1924, after the death of Canudo. Visionary to the end, she was intensely interested in the reunion of Christian and Islamic civilizations through art and culture. She published *The Truth about Syria* in 1929, and acted as a mediator in negotiations between France and Syria in 1933 – to no avail – before relapsing into serene disillusion, consoled by Sufism and the desert sands.

* * *

We wish to glorify war – the sole cleanser of the world – militarism, patriotism, the destructive act of the libertarian, beautiful ideas worth dying for, and scorn for women.

Marinetti, 'The Foundation and Manifesto of Futurism'

Humanity is mediocre. The majority of women are neither superior nor inferior to the majority of men. They are all equal. They all merit the same scorn.

The whole of humanity has never been anything but the terrain of culture, source of the geniuses and heroes of both sexes. But in humanity as in nature there are some moments more propitious for such a flowering. In the summers of humanity, when the terrain is burned by the sun, geniuses and heroes abound.

We are at the beginning of a springtime; we are lacking in solar profusion, that is, a great deal of spilled blood.

Women are no more responsible than men for the way the really young, rich in sap and blood, are getting mired down.

It is absurd to divide humanity into men and women. It is composed only of *femininity* and *masculinity*. Every superman, every hero, no matter how epic, how much of a genius or how powerful, is the prodigious expression of a race and an epoch only because he is composed at once of feminine and masculine elements, of femininity and masculinity: that is, a complete being.

Any exclusively virile individual is just a brute animal; any exclusively feminine individual is only a female.

It is the same way with any collectivity and any moment in humanity, just as it is with individuals. The fecund periods, when most heroes and geniuses come forth from the terrain of culture in all its ebullience, are rich in masculinity and femininity.

Those periods that had only wars, with few representative heroes because the epic breath flattened them out, were exclusively virile periods; those that denied the heroic instinct and, turning towards the past, annihilated themselves in dreams of peace, were periods in which femininity was dominant.

We are living at the end of one of these periods. *What is most lacking in women as in men is virility.*

That is why Futurism, even with all its exaggerations, is right.

To restore some virility to our races so benumbed in femininity, we have to train them in virility even to the point of brute animality. But we have to impose on everyone, men and women who are equally weak, a new dogma of energy in order to arrive at a period of superior humanity.

Every woman ought to possess not only feminine virtues but virile ones, without which she is just a female. Any man who has only male strength without intuition is only a brute animal. But in the period of femininity in which we are living, only the contrary exaggeration is healthy: *we have to take the brute animal for a model.*

Enough of those women whose 'arms with twining flowers resting on their laps on the morning of departure' should be feared by soldiers; women as nurses perpetuating weakness and age, domesticating men for their personal pleasures or their material needs! . . . Enough of women who create children just for themselves, keeping them from any danger or adventure, that is, any joy; keeping their daughter from love and their son from war! . . . Enough of those women, the octopuses of the hearth, whose tentacles exhaust men's blood and make children anaemic, *women in carnal love who wear out every desire so it cannot be renewed!*

Women are Furies, Amazons, Semiramis, Joans of Arc, Jeanne Hachettes, Judith and Charlotte Cordays, Cleopatras and Messalinas: combative women who fight more ferociously than males, lovers who arouse, destroyers who break down the weakest and help select through pride or despair, 'despair through which the heart yields its fullest return'.

Let the next wars bring forth heroines like that magnificent Catherine Sforza, who, during the sack of her city, watching from the ramparts as her enemy threatened the life of her son to force her surrender, heroically pointing to her sexual organ, cried loudly: 'Kill him, I still have the mould to make some more!'

Yes, 'the world is rotting with wisdom', but by instinct woman is not wise, is not a pacifist, is not good. Because she is totally lacking in measure, she is bound to become too wise, too pacifist, too good during a sleepy period of humanity. Her intuition, her imagination are at once her strength and her weakness.

She is the individuality of the crowd: she parades the heroes, or if there are none, the imbeciles.

According to the apostle, the spiritual inspirer, woman, the carnal inspirer, immolates or takes care, causes blood to run or staunches it, is a warrior or a nurse. It's the same woman who, in the same period, according to the ambient ideas grouped around the day's event, lies down on the tracks to keep the soldiers from leaving for the war or then rushes to embrace the victorious champion.

So that is why no revolution should be without her. That is why, instead of scorning her, we should address her. She's the most fruitful conquest of all, the most enthusiastic, who, in her turn, will increase our followers.

But no feminism. Feminism is a political error: Feminism is a cerebral error of woman, an error that her instinct will recognize.

We must not give woman any of the rights claimed by feminists. To grant them to her would bring about not any of the disorders the Futurists desire but on the contrary an excess of order.

To give duties to woman is to have her lose all her fecundating power. Feminist reasonings and deductions will not destroy her primordial fatality: they can only falsify it, forcing it to make itself manifest through detours leading to the worst errors.

For centuries the feminine instinct has been insulted, only her charm and tenderness have been appreciated. Anaemic man, stingy with his own blood, asks only that she be a nurse. She has let herself be tamed. But shout a new message at her, or some war cry, and then, joyously riding her instinct again, she will go in front of you towards unsuspected conquests.

When you have to use your weapons, she will polish them.

She will help you choose them. In fact, if she doesn't know how to discern genius because she relies on passing renown, she has always known how to rewarm the strongest, the victor, the one triumphant by his muscles and his courage. She can't be mistaken about this superiority imposing itself so brutally.

Let woman find once more her cruelty and her violence that make her attack the vanquished because they are vanquished, to the point of mutilating them. Stop preaching spiritual justice to her of the sort she has tried in vain. *Woman, become sublimely injust once more, like all the forces of nature!*

Delivered from all control, with your instinct retrieved, you will take your place among the Elements, opposite fatality to the conscious human will. Be the egoistic and ferocious mother, *jealously watching over her children*, have what are called all the rights over and duties towards them, *as long as they physically need your protection.*

Let man, freed from his family, lead his life of audacity and conquest, as soon as he has the physical strength for it, and in spite of his being a son and a father. The man who sows doesn't stop on the first row he fecunds.

In my *Poems of Pride* and in *Thirst and Mirages*, I have renounced Sentimentalism as a weakness to be scorned because it knots up the strength and makes it static.

Lust is a strength, because it destroys the weak, excites the strong to exert their energies, thus to renew themselves. Every heroic people is sensual. Woman is, for them, the most exalted trophy.

Woman should be mother or lover. Real mothers will always be mediocre lovers, and lovers, insufficient mothers, through their excess. Equal in front of life, these two women complete each other. The mother who receives the child makes the future with the past; the lover gives off desire, which leads towards the future.

LET'S CONCLUDE:

Woman who retains man through her tears and her sentimentality is inferior to the prostitute who incites her man, through braggery, to retain his domination over the lower depths of the cities with his revolver at the ready: at least she cultivates an energy that could serve better causes.

Woman, for too long diverted into morals and prejudices, go back to your sublime instinct, to violence, to cruelty.

For the fatal sacrifice of blood, while men are in charge of wars and battles, procreate, and among your children, as a sacrifice to heroism, take Fate's part. Don't raise them for yourself, that is, for their diminishment, but rather, in a wide freedom, for a complete expansion.

Instead of reducing man to the slavery of those *execrable sentimental needs*, incite your sons and your men to surpass themselves.

You are the ones who make them. You have all power over them.

You owe humanity its heroes. Make them!

M8 Wassily Kandinsky and Franz Marc

Preface to Der Blaue Reiter Almanac *(1912)*

Der Blaue Reiter (The Blue Rider) was the name taken (from a painting by Kandinsky) by a group of German artists that flourished for a short period, 1911–14, before the First World War. They included Wassily Kandinsky, Franz Marc, August Macke, Alexei von Jawlensky, Marianne von Werefkin, Gabriele Münter, Lyonel Feininger and Albert Bloch; and they looked to Kandinsky and Marc for leadership. This was broadly speaking the Munich wing of the German Expressionist movement. Der Blaue Reiter by no means rejected the past, but they believed in the promotion of modern art. By formation and inclination they were notably cosmopolitan; following their encounters with the Fauvists, Cubists, Futurists and Rayonists (M10) they moved towards abstraction. They were hot on the artistic expression of spiritual truth – no one more than Kandinsky, a thinker-painter of formidable erudition. The ghost of Schopenhauer hovers over his first theoretical work, *On the Spiritual in Art* (1911), a deeply influential statement.

Der Blaue Reiter Almanac was conceived in 1911 and published in 1912, in Munich, in an edition of 1,100. It was edited by Kandinsky and Marc, and underwritten by the industrialist and art collector Bernhard Koehler, a relative of Macke's. The Preface below is a draft, dated October 1911, first published only in a much later edition. It is at once an editorial and an artist's manifesto; one or two passages of editorial practice have been omitted. The almanac itself contains over 140 illustrations, including children's drawings, German woodcuts, Chinese paintings, Robert Delaunay's *The Window on the City* (1910–11), and Picasso's *Woman with Mandolin at the Piano* (1911): Der Blaue Reiter were broad-minded. The almanac also contains facsimiles of song settings by Alban Berg and Anton Webern, an article by Arnold Schoenberg, and another on Alexander Scriabin's symphonic work *Prometheus* (1910–11), which made use of a

colour organ. Art knows no boundaries, the almanac seems to say; the frontier with music, in particular, is there to be crossed. Baudelaire himself had spoken of the musical properties of colour, and the musicalization of colour through sound became a driving force in Kandinsky's aesthetics. He praised Scriabin's search for 'equivalent tones in colour and music', and his own play, *The Yellow Sound*, found its place in these pages.

Der Blaue Reider Almanac and the philosophy behind it may well have influenced Wyndham Lewis and his collaborators in the combative Vorticist review *BLAST* (see M17).

WASSILY KANDINSKY (1866–1944) might be described as a Russian-German-French abstract painter, and one of the founding fathers of twentieth-century modernism. His paintings combine a certain superabundance with an almost clinical control; his *oeuvre* is at once impenetrable and indispensable to an understanding of 'the search for the absolute' in abstract art.

FRANZ MARC (1880–1916), a lesser painter and a humbler intellect, echoed Kandinsky in making the case for a new art of 'mystical inner construction'. He had his moment in Der Blaue Reiter. He met his end at the battle of Verdun.

* * *

A great era has begun: the spiritual 'awakening', the increasing tendency to regain 'lost balance', the inevitable necessity of spiritual plantings, the unfolding of the first blossom.

We are standing at the threshold of one of the greatest epochs that mankind has ever experienced, the epoch of great spirituality.

In the nineteenth century just ended, when there appeared to be the most thoroughgoing flourishing – the 'great victory' – of the material, the first 'new' elements of a spiritual atmosphere were formed almost unnoticed. They will give and have given the necessary nourishment for the flourishing of the spiritual.

Art, literature, even 'exact' science are in various stages of change in this 'new' era; they will all be overcome by it.

Our [first and] most important aim is to reflect phenomena in the field of art that are directly connected with this change and the essential facts that shed light on these phenomena in other fields of spiritual life.

Therefore, the reader will find works in our volumes that in this respect show an *inner* relationship although they may appear unrelated on the surface. We are considering or making note not of work that has a certain established, orthodox, external form (which usually is all there is), but of work that has an *inner* life connected with the great change.

It is only natural that we want not death but life. The echo of a living voice is only a hollow form, which has not arisen out of a distinct *inner necessity*; in the same way, there have always been created and will increasingly be created, works of art that are nothing but hollow reverberations of works rooted in this inner necessity. They are hollow, loitering lies that pollute the spiritual air and lead wavering spirits astray. Their deception leads the spirit not to life but to death. With all means available we want to try to unmask the hollowness of this deception. This is our second goal.

It is only natural that in questions of art the artist is called upon to speak first. Therefore the contributors to our volumes will be primarily artists. Now they have the opportunity to say openly what previously they had to hide. We are therefore asking those artists who feel inwardly related to our goals to turn to us as *brethren*. We take the liberty of using this great word because we are convinced that in our case the establishment automatically ceases to exist . . .

It should be almost superfluous to emphasize specifically that in our case the principle of internationalism is the only one possible. However, in these times we must say that an individual nation is only one of the creators of all art; one alone can never be a whole. As with a personality, the national element is automatically reflected in each great work. But in the last resort this national coloration is merely incidental. The whole work, called art, knows no borders or nations, only humanity.

M9 Valentine de Saint-Point

Futurist Manifesto of Lust (1913)

First published by the Direzione del Movimento Futurista (Futurist Head-quarters), Milan, on 11 January 1913. The declaration that 'ART AND WAR ARE THE GREAT MANIFESTATIONS OF SENSUALITY; LUST IS THEIR FLOWER' riveted the attention of the avant-garde. As late as 1917, none other than Ezra Pound wrote an admiring (but pseudonymous) review in *The Egoist*: 'What she attacks most vigorously is *clair de lune* [moonlight] sentimentality. Love, she holds, should be of *women's* life ([and] also) a thing apart: not "'tis women's whole existence".
. . . Valentine de Saint-Point carries her revolt against weeping sentiment startlingly far, for it drives her to glorify *la luxure* [lust].'

Saint-Point had never fought shy of *la luxure*. In her modern tragedy, *The Imperial Soul – The Agony of Messalina* (staged in 1908), the Empress in her death agony discourses on lust and force, desire and despair, in a kind of proto-manifesto free verse:

> Once more I will see you pale from voluptuousness
> Or from the obscure desire of my hot beauty
> Once more I will exhaust your sons, your brothers,
> Your lovers, your husbands!
> My insatiable flesh still reigns over all . . .

Saint-Point is strong stuff. Marinetti's 'African novel', *Mafarka the Futurist* (1909), was banned for obscenity when it first appeared. Saint-Point is as bold, less crude and more erotic.

In its conception and its expression, 'The Futurist Manifesto of Lust' anticipates certain aspects of Surrealism (see M50). It may also be compared with Mina Loy's 'Feminist Manifesto' (M21).

(For biographical details about Saint-Point, see the headnote to M7.)

* * *

A reply to those dishonest journalists who twist phrases to make the Idea seem ridiculous;
to those women who only think what I have dared to say;
to those for whom Lust is still nothing but a sin;
to all those who in Lust can only see Vice, just as in Pride they see only vanity.

Lust, when viewed without moral preconceptions and as an essential part of life's dynamism, is a force.

Lust is not, any more than pride, a mortal sin for the race that is strong. Lust, like pride, is a virtue that urges one on, a powerful source of energy.

Lust is the expression of a being projected beyond itself. It is the painful joy of wounded flesh, the joyous pain of a flowering. And whatever secrets unite these beings, it is a union of flesh. It is the sensory and sensual synthesis that leads to the greatest liberation of spirit. It is the communion of a particle of humanity with all the sensuality of the earth. It is the panic shudder of a particle of the earth.

LUST IS THE QUEST OF THE FLESH FOR THE UNKNOWN, just as Celebration is the spirit's quest for the unknown. Lust is the act of creating, it is Creation.

Flesh creates in the way that the spirit creates. In the eyes of the Universe their creation is equal. One is not superior to the other and creation of the spirit depends on that of the flesh.

We possess body and spirit. To curb one and develop the other shows weakness and is wrong. A strong man must realize his full carnal and spiritual potentiality. The satisfaction of their lust is the conquerors' due. After a battle in which men have died, IT IS NORMAL FOR THE VICTORS, PROVEN IN WAR, TO TURN TO RAPE IN THE CONQUERED LAND, SO THAT LIFE MAY BE RECREATED.

When they have fought their battles, soldiers seek sensual pleasures, in which their constantly battling energies can be unwound and renewed. The modern hero, the hero in any field, experiences the same desire and the same pleasure. The artist, that great universal medium, has the same need. And the exaltation of the initiates of those religions still sufficiently new to contain a tempting element of the unknown, is no more than sensuality diverted spiritually towards a sacred female image.

ART AND WAR ARE THE GREAT MANIFESTATIONS OF SENSUALITY; LUST IS THEIR FLOWER. A people exclusively spiritual or a people exclusively carnal would be condemned to the same decadence – sterility.

LUST EXCITES ENERGY AND RELEASES STRENGTH. Pitilessly it drove primitive man to victory, for the pride of bearing back to a woman the spoils of the defeated. Today it drives the great men of business who direct the banks, the press and international trade to increase their wealth by creating centres, harnessing energies and exalting the crowds, to worship and glorify with it the object of their lust. These men, tired but strong, find time for lust, the principal motive force of their action and of the reactions caused by their actions affecting multitudes and worlds.

Even among the new peoples where sensuality has not yet been released or acknowledged, and who are neither primitive brutes nor the sophisticated representatives of the old civilizations, woman is equally the great galvanizing principle to which all is offered. The secret cult that man has for her is only the unconscious drive of a lust as yet barely woken. Amongst these peoples as amongst the peoples of the north, but for different reasons, lust is almost exclusively concerned with procreation. But lust, under whatever aspects it shows itself, whether they are considered normal or abnormal, is always the supreme spur.

The animal life, the life of energy, the life of the spirit, sometimes demand a respite. And effort for effort's sake calls inevitably for effort for pleasure's sake. These efforts are not mutually harmful but complementary, and realize fully the total being.

For heroes, for those who create with the spirit, for dominators of all fields, lust is the magnificent exaltation of their strength. For every being it is a motive to surpass oneself with the simple aim of self-selection, of being noticed, chosen, picked out.

Christian morality alone, following on from pagan morality, was fatally drawn to consider lust as a weakness. Out of the healthy joy which is the flowering of the flesh·in all its power it has made something shameful and to be hidden, a vice to be denied. It has covered it with hypocrisy, and this has made a sin of it.

WE MUST STOP DESPISING DESIRE, this attraction at once delicate and brutal between two bodies, of whatever sex, two bodies that

want each other, striving for unity. We must stop despising Desire, disguising it in the pitiful clothes of old and sterile sentimentality.

It is not lust that disunites, dissolves and annihilates. It is rather the mesmerizing complications of sentimentality, artificial jealousies, words that inebriate and deceive, the rhetoric of parting and eternal fidelities, literary nostalgia – all the histrionics of love.

WE MUST GET RID OF THE ILL-OMENED DEBRIS OF ROMANTICISM, counting daisy petals, moonlight duets, heavy endearments, false hypocritical modesty. When beings are drawn together by a physical attraction, let them – instead of talking only of the fragility of their hearts – dare to express their desires, the inclinations of their bodies, and to anticipate the possibilities of joy and disappointment in their future carnal union.

Physical modesty, which varies according to time and place, has only the ephemeral value of a social virtue.

WE MUST FACE UP TO LUST IN FULL CONSCIOUSNESS. We must make of it what a sophisticated and intelligent being makes of himself and of his life; WE MUST MAKE LUST INTO A WORK OF ART. To allege unwariness or bewilderment in order to explain an act of love is hypocrisy, weakness and stupidity.

We should desire a body consciously, like any other thing.

Love at first sight, passion or failure to think, must not prompt us to be constantly giving ourselves, nor to take beings, as we are usually inclined to do due to our inability to see into the future. We must choose intelligently. Directed by our intuition and will, we should compare the feelings and desires of the two partners and avoid uniting and satisfying any that are unable to complement and exalt each other.

Equally consciously and with the same guiding will, the joys of this coupling should lead to the climax, should develop its full potential, and should permit to flower all the seeds sown by the merging of two bodies. Lust should be made into a work of art, formed like every work of art, both instinctively and consciously.

WE MUST STRIP LUST OF ALL THE SENTIMENTAL VEILS THAT DISFIGURE IT. These veils were thrown over it out of mere cowardice, because smug sentimentality is so satisfying. Sentimentality is comfortable and therefore demeaning.

In one who is young and healthy, when lust clashes with sentimentality,

lust is victorious. Sentiment is a creature of fashion; lust is eternal. Lust triumphs, because it is the joyous exaltation that drives one beyond oneself, the delight in possession and domination, the perpetual victory from which the perpetual battle is born anew, the headiest and surest intoxication of conquest. And as this certain conquest is temporary, it must be constantly won anew.

Lust is a force, in that it refines the spirit by bringing to white heat the excitement of the flesh. The spirit burns bright and clear from a healthy, strong flesh, purified in the embrace. Only the weak and the sick sink into the mire and are diminished. And lust is a force in that it kills the weak and exalts the strong, aiding natural selection.

Lust is a force, finally, in that it never leads to the insipidity of the definite and the secure, doled out by soothing sentimentality. Lust is the eternal battle, never finally won. After the fleeting triumph, even during the ephemeral triumph itself, reawakening dissatisfaction spurs a human being, driven by an orgiastic will, to expand and surpass himself.

Lust is for the body what an ideal is for the spirit – the magnificent Chimera, that one ever clutches at but never captures, and which the young and the avid, intoxicated with the vision, pursue without rest.

LUST IS A FORCE.

M10 Mikhail Larionov and Natalya Goncharova

Rayonists and Futurists: A Manifesto (1913)

'Luchisty i budushchniki. Manifest' was first published in the miscellany
Oslinyi khvost i mishen [*Donkey's Tail and Target*] (Moscow) in July 1913.
It was also signed by Timofei Bogomazov (a sergeant-major and amateur
painter befriended by Larionov during his military service), and the
artists Morits Fabri, Ivan Larionov (brother of Mikhail), Mikhail
Le-Dantiyu, Vyacheslav Levkievsky, Vladimir Obolensky, Sergei
Romanovich, Aleksandr Shevchenko and Kirill Zdanevich. The use of
the Russian neologism *budushchniki*, rather than the European borrow-
ing *futuristy*, underlined the current rejection of the West and the
orientation towards Russian and Eastern cultural traditions. ('Long live
the beautiful East!') If there was a cosmopolitan and internationalist
dimension to the avant-garde, there was also an intensely nationalistic
strain. For Marinetti and his merry men, Futurism was by definition
Italian. For Larionov and his compatriots, it was Russian. In art as in
politics, as they saw it, they needed no instruction from interloper Ital-
ians in how to make a revolution.

The manifesto is a polemical intervention in a heated conversation.
It heaps scorn on rival groups. Russian modernism was a fractious affair.
Of those mentioned here, the Egofuturists were primarily literary, the
Neofuturists primarily imitative. Larionov and Goncharova broke with
the Knave of Diamonds group after its first exhibition in 1910–11, thereby
alienating David Burliuk (1882–1967), 'the father of Russian Futurism',
and others prominent in it. 'A Slap in the Face of Public Taste' was a
famous manifesto published earlier in 1913, signed by Burliuk, Alexei
Kruchenykh, Velimir Khlebnikov and Vladimir Mayakovsky (see M23),
leading progressive writers and painters. 'Throw Pushkin, Dostoevsky,
Tolstoy et al. overboard from the ship of modernity,' it declared. 'He
who does not forget his *first* love will not recognize his last.' The Union

of Youth was regarded by Larionov as a hotbed of Symbolism, and therefore hopelessly dated, though he continued to contribute to its exhibitions.

There is an interesting, positive, reference to a Russian movement that sounds like a joke but was not: *vsechestvo* or Everythingism, an extension of Neo-Primitivism. Everythingism argued for a deliberate multiplicity – of cultural traditions, period styles, decorative practices and even religious images. ('We acknowledge all styles as suitable for the expression of our art, styles existing both yesterday and today.') This meant a hybrid Russian modernism, mixing French and Italian avant-garde painting with Russian and Byzantine traditions. As if to demonstrate the point, Goncharova, who achieved an enviable notoriety as a radical painter, produced both *The Evangelists* and *The Bicyclist* in the period 1911–13. In 1914 she drafted a letter to Marinetti accusing the Italian Futurists of creating a new academy; and in later years Larionov often returned to the argument that successive modernist movements tended to become the new orthodoxy, only to lose their radical edge. Multiplicity is against orthodoxy.

The concluding paragraphs are virtually identical to another of Larionov's manifestos, 'Rayonist Painting' (1913). There he declares: 'Rayonism is concerned with spatial forms that can arise from the intersection of the reflected rays of different objects, forms chosen by the artist's will.' This 'self-sufficient' painting, in Larionov's language, is not yet completely abstract; the object remains, but it is seen in Rayonist terms – a mélange of Impressionist notions of light, Cubist geometric fragmentation and Italian Futurist force lines, stirred with some ideas of Cézanne's, and later, a seasoning of the spiritual or the mystical. This admitted both Larionov's *Rayonist Sausage and Mackerel* (1912) and Goncharova's *Rayonist Perception – Blue and Brown* (1913).

Predictably, Larionov claimed too much. Rayonism liberated neither the word nor the world – though the collaboration of avant-garde painters and poets did its bit for the former. Just as so much Futurist painting did not live up to the spectacular promise of its manifestos, so Larionov's own work was a good deal more derivative than he cared to admit: the paintings told of Monet and Boccioni, the manifestos of 'Futurist Painting' (M3) and the Futurist declarations of 1912.

MIKHAIL LARIONOV (1881–1964) was a central figure in the pre-Revolutionary Russian avant-garde, and his partnership with NATALYA

GONCHAROVA (1881–1962) a signal relationship in those circles. He was more important as organizer and instructor, she as artist and example. They lived long lives as émigrés in Paris, painting and repainting, waiting and hoping and, perhaps, despairing of the Motherland.

* * *

We, Rayonists and Futurists, do not wish to speak about new or old art, and even less about modern Western art.

We leave the old art to die and leave the 'new' art to do battle with it; and incidentally, apart from a battle and a very easy one, the 'new' art cannot advance anything of its own. It is useful to put manure on barren ground, but this dirty work does not interest us.

People shout about enemies closing in on them, but in fact, these enemies are, in any case, their closest friends. Their argument with old art long since departed is nothing but a resurrection of the dead, a boring, decadent love of paltriness and a stupid desire to march at the head of contemporary, philistine interests.

We are not declaring any war, for where can we find an opponent our equal?

The future is behind us.

All the same we will crush in our advance all those who undermine us and all those who stand aside.

We don't need popularization – our art will, in any case, take its full place in life – that's a matter of time.

We don't need debates and lectures, and if we sometimes organize them, then that's by way of a gesture to public impatience.

While the artistic throne is empty, and narrow-mindedness, deprived of its privileges, is running around calling for battle with departed ghosts, we push it out of the way, sit up on the throne, and reign until a regal deputy comes and replaces us.

We, artists of art's future paths, stretch out our hand to the Futurists, in spite of all their mistakes, but express our utmost scorn for the so-called Egofuturists and Neofuturists, talentless, banal people, the same as the members of the Knave of Diamonds, Slap in the Face of Public Taste, and Union of Youth groups.

We let sleeping dogs lie, we don't bring fools to their senses, we call

trivial people trivial to their faces, and we are ever ready to defend our interests actively.

We despise and brand as artistic lackeys all those who move against a background of old or new art and go about their trivial business. Simple, uncorrupted people are closer to us than this artistic husk that clings to modern art, like flies to honey.

To our way of thinking, mediocrity that proclaims new ideas of art is as unnecessary and vulgar as if it were proclaiming old ideas.

This is a sharp stab in the heart for all who cling to so-called modern art, making their names in speeches against renowned little old men – despite the fact that between them and the latter there is essentially not much difference. These are true brothers in spirit – the wretched rags of contemporaneity, for who needs the peaceful renovating enterprises of those people who make a hubbub about modern art, who haven't advanced a single thesis of their own, and who express long-familiar artistic truths in their own words!

We've had enough Knaves of Diamonds whose miserable art is screened by this title, enough slaps in the face given by the hand of a baby suffering from wretched old age, enough unions of old and young! We don't need to square vulgar accounts with public taste – let those indulge in this who on paper give a slap in the face, but who, in fact, stretch out their hands for alms.

We've had enough of this manure; now we need to sow.

We have no modesty – we declare this bluntly and frankly – we consider ourselves to be the creators of modern art.

We have our own artistic honour, which we are prepared to defend to the last with all the means at our disposal. We laugh at the words 'old art' and 'new art' – that's nonsense invented by idle philistines.

We spare no strength to make the sacred tree of art grow to great heights, and what does it matter to us that little parasites swarm in its shadow – let them, they know of the tree's existence from its shadow.

Art for life and even more – life for art!

We exclaim: the whole brilliant style of modern times – our trousers, jackets, shoes, trolleys, cars, aeroplanes, railways, grandiose steamships – is fascinating, is a great epoch, one that has known no equal in the entire history of the world.

We reject individuality as having no meaning for the examination of

a work of art. One has to appeal only to a work of art, and one can examine it only by proceeding from the laws according to which it was created.

The tenets we advance are as follows:

Long live the beautiful East! We are joining forces with contemporary Eastern artists to work together.

Long live nationality! We march hand in hand with our ordinary house-painters.

Long live the style of Rayonist painting that we created – free from concrete forms, existing and developing according to painterly laws!

We declare that there has never been such a thing as a copy and recommend painting from pictures painted before the present day. We maintain that art cannot be examined from the point of view of time.

We acknowledge all styles as suitable for the expression of our art, styles existing both yesterday and today – for example, Cubism, Futurism, Orphism, and their synthesis, Rayonism, for which the art of the past, like life, is an object of observation.

We are against the West, which is vulgarizing our forms and Eastern forms, and which is bringing down the level of everything.

We demand a knowledge of painterly craftsmanship.

More than anything else, we value intensity of feeling and its great sense of uplifting.

We believe that the whole world can be expressed fully in painterly forms:

Life, poetry, music, philosophy.

We aspire to the glorification of our art and work for its sake and for the sake of our future creations.

We wish to leave deep footprints behind us, and this is an honourable wish.

We advance our works and principles to the fore; we ceaselessly change them and put them into practice.

We are against art societies, for they lead to stagnation.

We do not demand public attention and ask that it should not be demanded from us.

The style of Rayonist painting that we advance signifies spatial forms arising from the intersection of the reflected rays of various objects, forms chosen by the artist's will.

The ray is depicted provisionally on the surface by a coloured line.

That which is valuable for the lover of painting finds its maximum expression in a Rayonist picture. The objects that we see in life play no role here, but that which is the essence of painting itself can be shown here best of all – the combination of colour, its saturation, the relation of coloured masses, depth, texture; anyone who is interested in painting can give his full attention to all these things.

The picture appears to be slippery; it imparts a sensation of the extra-temporal, of the spatial. In it arises the sensation of what could be called the fourth dimension, because its length, breadth, and density of the layer of paint are the only signs of the outside world – all the sensations that arise from the picture are of a different order; in this way painting becomes equal to music while remaining itself. At this juncture, a kind of painting emerges that can be mastered by following precisely the laws of colour and its transference onto the canvas.

Hence the creation of new forms whose meaning and expressiveness depend exclusively on the degree of intensity of tone and the position that it occupies in relation to other tones. Hence the natural downfall of all existing styles and forms in all the art of the past – since they, like life, are merely objects for better perception and pictorial construction.

With this begins the true liberation of painting and its life in accordance only with its own laws, a self-sufficient painting, with its own forms, colour and timbre.

M11 Guillaume Apollinaire

L'antitradition futuriste (1913)

First published in *Gil Blas* (Paris), 3 August 1913, and then in the Futurist journal *Lacerba* (Florence), 15 September 1913. It is considered by some to be a parody or spoof of the founding Manifesto of Futurism (M1); the typography is alleged by others to have been devised by Marinetti himself, after the fact, for the Italian version in *Lacerba*, and it is true that the French version in *Gil Blas* did not have this layout. Marinetti for his part testified that it was drafted by Apollinaire in good faith ('with his explicit support of the Italian Futurist Movement'), adding the convincing circumstantial detail that their understanding was sealed with plenty of burgundy and 'a delightful goose' at the Restaurant Lapérouse in Paris. It is certainly plausible to think that the crafty Marinetti would have done his best to enlist the celebrated Apollinaire to the Futurist cause. If he was indeed present at the creation, as this account suggests, it may have been 20 or 21 June, a few days earlier than the date on the manuscript (29 June), which appears to have been altered.

Long afterwards, Carrà provided some corroboration of Marinetti's account. 'Marinetti told me: "You know, Apollinaire's going to write a manifesto which will be very important for our movement because of the repercussions it will certainly have." In fact Apollinaire's manuscript arrived a few days later . . . Marinetti read the manuscript with great enthusiasm and after a brief pause added: "The ideas expressed are very interesting but we must give the manuscript the form of a manifesto." He grabbed a large sheet of paper and transcribed Apollinaire's words, lingering over the spacing as in the previous manifestos. Having altered a few words, he took it to the printers, enjoining urgency, and the proof arrived towards evening the next day. It was immediately sent to Apollinaire in Paris. After three or four days the author sent his permission, highly pleased with the typographical form Marinetti had given his

manuscript. Printed in many thousands of copies, Apollinaire's manu-
script had great influence in artistic and literary circles.'

Carrà's story is a believable one, especially as to Marinetti's firm views
and interventionist stance on the requirements of a manifesto. However
that may be, this one is full of linguistic tricks and word-games. The
headline phrase 'ABAS LEPominir Aliminé SSkorsusuotalo EIScramir
MEnigme' is an acrostic whose capital letters spell the fundamental
Futurist cry 'À bas le passéisme' ('Down with passéism'); the nonsense
words subsume some real ones. There is something here of the Futurist
mantra, 'words-in-freedom', defined by Marinetti as TELEGRAPHIC
IMAGES ... COMPRESSED ANALOGIES ... MOVEMENTS IN
TWO, THREE, FOUR, FIVE DIFFERENT RHYTHMS, or 'multi-
linear lyricism', to be achieved by a 'typographical revolution' exploding
the passéist 'harmony of the page'. It also bears a distinct resemblance
to Apollinaire's famous calligrammes, such as 'Lettre-Océan' ('Ocean
Letter') (1914).

'MER ... DE ... aux ...' (*merde aux*, or shit on) and 'ROSE aux ...'
seem to anticipate the BLAST and BLESS categorization of Wyndham
Lewis's review *BLAST* (1914) (see M17).

For biographical details about Apollinaire, see the headnote to M6.

* * *

L'ANTITRADITION FUTURISTE

Manifeste-synthèse

ABAS LEPomtnir Attminé SS korsusu
otnin EIS cramir ME nigme

ce moteur à toutes tendances impressionnisme fauvisme cubisme expressionnisme pathétisme dramatisme orphisme paroxysme DYNAMISME PLASTIQUE MOTS EN LIBERTÉ INVENTION DE MOTS

DESTRUCTION

Suppression de la douleur poétique
des exotismes snobs
de la copie en art
des syntaxes
de l'adjectif
de la ponctuation
de l'harmonie typographique
des temps et personnes des verbes
de l'orchestre
de la forme théâtrale
du sublime artiste
du vers et de la strophe
des maisons
de la critique et de la satire
de l'intrigue dans les récits
de l'ennui

Pas de regrets

SUPPRESSION DE L'HISTOIRE

INFINITIF

CONSTRUCTION

1 Techniques sans cesse renouvelées ou rythmes

Continuité
simultanéité
en opposition
au
particularisme
et à la
division

LA PURETÉ

Littérature pure **Mots en liberté Invention de mots**
Plastique pure (5 sens)
Création invention prophétie
Description onomato-pétique
Musique totale et **Art des bruits**
Mimique universelle et Art des lumières
Machinisme Tour Eiffel Brooklyn et gratte-ciels
Polyglottisme
Civilisation pure
Nomadisme épique exploratorisme urbain **Art des voyages** et des promenades
Antigrâce
Frémissements directs à grands spectacles libres cirques music-halls etc.

LA VARIÉTÉ

2 Intuition vitesse ubiquité

Coups
et
blessures

Livre ou vie captivée ou phonocinématographie ou **Imagination sans fil**
Trémolisme continu ou onomatopées plus inventées qu'imitées
Danse travail ou chorégraphie pure
Langage véloce caractéristique impressionnant chanté sifflé mimé marché couru
Droit des gens et guerre continuelle
Féminisme intégral ou différenciation innombrable des sexes
Humanité et appel à l'outr'homme
Matière ou transcendentalisme physique
Analogies et calembours tremplin lyrique et seule science des langues calicot Calicut Calcutta taffa Sophia la Sophi suffisant Uffizi officiel officiel ô ficelles Aficionado Dona-Sol Donatello Donateur donne à tort torpilleur

ou ou ou flûte crapaud naissance des perles epremine

MER........ DE........

AUX
Critiques
Pédagogues
Professeurs
Musées
Quattrocentistes
Dixseptièmesiècleistes
Ruines
Patines
Historiens
Venise Versailles Pompei Bruges Oxford Nuremberg Tolède Bénarès etc.
Défenseurs de paysages
Philologues

Essayistes
Néo et post
Bayreuth Florence Montmartre et Munich
Lexiques
Bongoûtismes
Orientalismes
Dandysmes
Spiritualistes ou réalistes (sans sentiment de la réalité et de l'esprit)
Académismes

Les frères siamois D'Annunzio et Rostand
Dante Shakespeare Tolstoï Goethe
Dilettantismes merdoyants
Eschyle et théâtre d'Orange
Inde Egypte Fiesole et la théosophie
Scientisme
Montaigne Wagner Beethoven Edgard Poe Walt Whitman et Baudelaire

ROSE

aux
Marinetti Picasso Boccioni Apollinaire Paul Fort Mercereau Max Jacob Carrà Delaunay Henri-Matisse Braque Depaquit Séverine Severini Derain Russolo Archipenko Pratella Balla F. Divoire N. Beaudoin T. Varlet Buzzi Palazzeschi Maquaire Papini Soffici Folgore Govoni Montfort R. Fry Cavacchioli D'Alba Altomare Tridon Metzinger Gleizes Jastrebzoff Royère Canudo Salmon Castiaux Laurencin Aurel Agero Léger Valentine de Saint-Point Delmarle Kandinsky Strawinsky Herbin A. Billy G. Sauvebois Picabia Marcel Duchamp B. Cendrars Jouve H. M. Barzun G. Polti Mac Orlan F. Fleuret Jaudon Mandin R. Dalize M. Brésil F. Caroo Rubiner Bétuda Manzella-Frontini A. Mazza T. Derème Giannattasio Tavolato De Gonzagues-Frick C. Larronde etc.

PARIS, le 29 Juin 1913, jour du Grand Prix, à 65 mètres au-dessus du Boul. S.-Germain

GUILLAUME APOLLINAIRE
(202, BOULEVARD SAINT-GERMAIN - PARIS)

DIRECTION DU MOUVEMENT FUTURISTE
Corso Venezia 61 - MILAN

M12 Carlo Carrà
The Painting of Sounds, Noises and Smells
(1913)

Dated 11 August 1913, first published in *Lacerba*, 1 September 1913. The Futurists proclaimed: 'With our pictorial dynamism true painting is born.' As Carlo Carrà makes crushingly clear, pictorial dynamism was an assault on the senses. It was strong on the swirl, the spiral, the welter of sensation. Futurist canvases are as if amplified; the chromatic volume is turned right up. 'Reds,' hymns Carrà, 'the rrrrredest rrrrrreds that shouuuuuuut.' Freely expressive orthography was a crucial element of words-in-freedom. Their manifestos performed that principle. Futurist phrase-making is arrrresting. Futurist painting is deafening.

In the penultimate paragraph, Carrà makes interesting use of the 'vortex', a term soon to be much in vogue, associated chiefly with Ezra Pound and with the contributors to *BLAST* (see M17 and 18) – giving rise to another band of the avant-garde, the Vorticists.

CARLO CARRÀ (1881–1966) was part of the Futurist inner circle in the heroic pre-war period. He painted a striking *Portrait of the Poet Marinetti* (1910), whom he admired. First an anarchist, he grew steadily more reactionary, working his way through nationalism and irredentism to fascism and, late in life, a kind of quietism.

* * *

Before the nineteenth century, painting was a silent art. Painters of antiquity, of the Renaissance, of the seventeenth and eighteenth centuries, never envisaged the possibility of rendering sounds, noises and smells in painting, even when they chose flowers, stormy seas or wild skies as their themes.

The Impressionists in their bold revolution made some confused and hesitant attempts at sounds and noises in their pictures. Before them – nothing, absolutely nothing!

Nevertheless, we should point out at once, that between the Impressionist mumblings and our Futurist paintings of sounds, noises and smells there is an enormous difference, as great as that between a misty winter morning and a scorching summer afternoon, or – even better – between the first breath of life and an adult man in full development of his powers. In their canvases, sounds and noises are expressed in such a thin and faded way that they seem to have been perceived by the eardrum of a deaf man. Here we do not wish to present a detailed account of the principles and experiments of the Impressionists. There is no need to enquire minutely into all the reasons why the Impressionists never succeeded in painting sounds, noises and smells. We shall only mention here the kind of thing they would have had to destroy if they had wanted to obtain results:

1. The extremely vulgar perspectives of *trompe-l'oeil*, a game worthy of an academic of the Leonardo da Vinci sort or an idiot designer of *verismo* operas.
2. The concept of colour harmonies, a characteristic defect of the French which inevitably forced them into the elegant ways of Watteau and his like, and, as a result, led to the abuse of light blues, pale greens, violets and pinks. We have already said very many times how we regret this tendency towards the soft, the effeminate, the gentle.
3. Contemplative idealism, which I have defined as a *sentimental mimicry of apparent nature*. This contemplative idealism is contaminating the pictorial construction of the Impressionists, just as it contaminated those of their predecessors, Corot and Delacroix.
4. All anecdote and detail, which (although it is a reaction, an antidote, to false academical construction) almost always demeans painting to the level of photography.

As for the Post- and Neo-Impressionists, such as Matisse, Signac and Seurat, we maintain that, far from perceiving the problem and facing up to the difficulties of sounds, noises and smells in their paintings, they have preferred to withdraw into static representations in order to obtain

a greater synthesis of form and colour (Matisse) and a systematic application of light (Signac, Seurat).

We Futurists state, therefore, that in bringing the elements of sound, noise and smell to painting we are opening fresh paths.

We have already evolved, as artists, a love of modern life in its essential dynamism – its sounds, noises and smells – thereby destroying the stupid passion for the solemn, the bombastic, the serene, the hieratic and the mummified: everything purely intellectual, in fact. IMAGINATION WITHOUT STRINGS, WORDS-IN-FREEDOM, THE SYSTEMATIC USE OF ONOMATOPOEIA, ANTIGRACEFUL MUSIC WITHOUT RHYTHMIC QUADRATURE, AND THE ART OF NOISES. These have derived from the same sensibility that has generated the painting of sounds, noises and smells.

It is indisputably true that (1) silence is static and sounds, noises and smells are dynamic, (2) sounds, noises and smells are none other than different forms and intensities of vibration, and (3) any continued series of sounds, noises and smells imprints on the mind an arabesque of form and colour.

We should therefore measure this intensity and perceive these arabesques.

THE PAINTING OF SOUNDS, NOISES AND SMELLS REJECTS
1. All subdued colours, even those obtained directly and without the help of tricks such as patinas and glazes.
2. The banality of velvets, silks, flesh tints which are too human, too fine, too soft, along with flowers which are excessively pale and drooping.
3. Greys, browns and all mud colours.
4. The use of pure horizontal and vertical lines, and all other dead lines.
5. The right angle, which we consider passionless.
6. The cube, the pyramid and all other static shapes.
7. The unities of time and place.

THE PAINTING OF SOUNDS, NOISES AND SMELLS DESIRES
1. Reds, rrrrreds, the rrrrreddest rrrrrreds that shouuuuuuut.
2. Greens, that can never be greener, greeeeeeeeeeeeens that screeeeeeeam, yellows, as violent as can be: polenta yellows, saffron yellows, brass yellows.

3. All the colours of speed, of joy, of carousings and fantastic carnivals, fireworks, cafés and singing, of music-halls; all colours which are seen in movement, colours experienced in time and not in space.

4. The dynamic arabesque, as the sole reality created by the artist from the depths of his sensibilities.

5. The clash of all acute angles, which we have already called the angles of will.

6. Oblique lines which affect the soul of the observer like so many bolts from the blue, along with lines of depth.

7. The sphere, ellipses which spin, the upside-down cones, spirals and all those dynamic forms which the infinite powers of an artist's genius are able to uncover.

8. Perspectives obtained not as the objectivity of distances but as a subjective interpenetration of hard and soft, sharp and dull forms.

9. As a universal subject and as the sole reason for a painting's existence; the significance of its dynamic construction (polyphonic architectural whole). When we talk of architecture, people usually think of something static; this is wrong. What we are thinking of is an architecture similar to the dynamic and musical architecture achieved by the Futurist musician Pratella. Architecture is found in the movement of colours, of smoke from a chimney, and in metallic structures, when they are expressed in states of mind which are violent and chaotic.

10. The inverted cone (the natural shape of an explosion), the slanting cylinder and cone.

11. The collision of two cones at their apexes (the natural shape of a water spout) with floating and curving lines (a clown jumping, dancers).

12. The zig-zag and the wavy line.

13. Ellipsoidal curves seem like nets in movement.

14. Lines and volumes as part of a plastic transcendentalism, that is according to their special kind of curving or obliqueness, determined by the painter's state of mind.

15. Echoes of lines and volumes in movement.

16. Plastic complementarism (for both forms and colours), based on the law of equivalent contrast and on the clash of the most contrasting colours of the rainbow. This complementarism derives from a disequilibrium of form (therefore they are forced to keep moving). The consequent destruction of the complements of the *pendants* of volumes.

We must reject these *pendants* since they are no more than a pair of crutches, allowing only a single movement, forward and then backward, that is, not a total movement, which we call the spherical expansion of space.

17. The continuity and simultaneity of the plastic transcendency of the animal, mineral, vegetable and mechanical kingdoms.

18. Abstract plastic wholes, that is those which correspond not to the artist's vision but to sensations which derive from sounds, noises and smells, and all the unknown forces involved in these. These plastic polyphonic, polyrhythmic and abstract wholes correspond to the necessity of an inner disharmony which we Futurist painters believe to be indispensable for pictorial sensibility.

These plastic wholes are, because of their mysterious fascination, much more suggestive than those created by our visual and tactile senses, being closer to our pure plastic spirit.

We Futurist painters maintain that sounds, noises and smells are incorporated in the expression of lines, volumes and colours just as lines, volumes and colours are incorporated in the architecture of a musical work.

Our canvases therefore express the plastic equivalent of the sounds, noises and smells found in theatres, music-halls, cinemas, brothels, railway stations, ports, garages, hospitals, workshops, etc., etc.

From the form point of view: there are sounds, noises and smells which are concave, convex, triangular, ellipsoidal, oblong, conical, spherical, spiral, etc.

From the colour point of view: sounds, noises and smells which are yellow, green, dark blue, light blue, violet.

In railway stations and garages, and throughout the mechanical or sporting world, sounds, noises and smells are predominantly red; in restaurants and cafés they are silver, yellow and violet. While the sounds, noises and smells of animals are yellow and blue, those of a woman are green, blue and violet.

We do not exaggerate and claim that smell alone is enough to determine in our minds arabesques of form and colour which could be said to constitute the motive and justify the necessity of a painting.

But it is true in the sense that if we are shut up in a dark room (so

that our sense of sight no longer works) with flowers, petrol or other things with a strong smell, our plastic spirit will gradually eliminate the memory sensation and construct a very special plastic whole which corresponds perfectly, in its quality of weight and movement, with the smells found in the room.

These smells, through some kind of obscure process, have become environment-force, determining that state of mind which for us Futurist painters constitutes a pure plastic whole.

This bubbling and whirling of forms and light, composed of sounds, noises and smells, has been partly achieved by me in my *Anarchical Funeral* [*Funeral of the Anarchist Galli*] and in my *Jolts of a Taxi-cab*, by Boccioni in *States of Mind* and *Forces of a Street*, by Russolo in *Revolt* and Severini in *Bang Bang*, paintings which were violently discussed at our first Paris Exhibition in 1912. This kind of bubbling over requires a great emotive effort, even delirium, on the part of the artist, who in order to achieve a vortex, must be a vortex of sensation himself, a pictorial force and not a cold multiple intellect.

Know therefore! In order to achieve this *total painting*, which requires the active cooperation of all the senses, *a painting which is a plastic state of mind of the universal*, you must paint, as drunkards sing and vomit, sounds, noises and smells!

M13 Giacomo Balla

Futurist Manifesto of Men's Clothing (1913)

Drafted in December 1913; unpublished at the time.

GIACOMO BALLA (1871–1958) was older and wiser than the other
Futurist painters, at least at the beginning. He was something of a father-
figure to them, and as Wyndham Lewis remarked, a better painter. Both
Boccioni and Severini studied briefly with him in his pre-Futurist days,
when he practised a personal kind of Divisionism. Balla was also perhaps
a better socialist than he was a Futurist. He signed the manifestos, but
in the heroic early years of the movement he seems to have been more
in it than of it. Later he wrote wryly of his own involvement: 'Little by
little acquaintances vanished, the same thing happened to his income,
and the public labelled him mad. At home his mother begged the
Madonna for help, his wife was in despair, his children perplexed . . . but
without further ado he put all his *passéiste* works up for auction, writing
on a sign between two black crosses: FOR SALE – THE WORKS OF
THE LATE BALLA.'

As war came, Balla went off the rails. The buffoonery of the 'Futur-
ist Manifesto of Men's Clothing' was followed by the stupidity of the
'Futurist Manifesto of Anti-Neutral Clothing' (1914) – 'Futurist shoes will
be dynamic, different one from the other in shape and colour, ready
joyfully to kick all the neutralists' – and the grandiosity of 'The Futurist
Reconstruction of the Universe' (1915), a joint effort with the young Fortu-
nato Depero (1892–1960), creator of the Cabaret del Diavolo in Rome.
Balla's art went the same way. He could still turn a trick with sets for
Stravinsky's *Firebird* (1917), but he began to decorate everything in sight
in bright and often tasteless colour schemes. Finally he was reduced to
producing Futurist flowers, some angular and spiky, some lumpy and
curvaceous. For the rest of their lives his two elderly daughters, suitably

named Luce and Elica (Light and Propeller, both of them 'readymades' in the Duchamp sense), preserved the Futurist wonderland that was his Roman home.

<p style="text-align:center">* * *</p>

We Futurists, in those brief gaps between our great struggles for renewal, have spent the time discussing, as is our wont, very many subjects. For quite some time now we have been convinced that today's clothes, while they may be somewhat simplified to suit certain modern requirements, are still atrociously passéist.

WE MUST DESTROY ALL PASSÉIST CLOTHES, and everything about them which is tight-fitting, colourless, funereal, decadent, boring and unhygienic. As far as *materials* are concerned, we must *abolish*: wishy-washy, pretty-pretty, gloomy and neutral colours, along with patterns composed of lines, checks and spots. *In cut and design*: the abolition of static lines, all uniformities such as ridiculous turn-ups, vents, etc. *Let us finish with the humiliating and hypocritical custom of wearing mourning.* Our crowded streets, our theatres and cafés are all imbued with a depressingly funereal tonality, because clothes are made only to reflect the gloomy and dismal moods of today's passéists.

WE MUST INVENT FUTURIST CLOTHES, hap-hap-hap-hap-happy clothes, daring clothes with brilliant colours and dynamic lines. They must be simple, and above all they must be made to last for a short time only in order to encourage industrial activity and to provide constant and novel enjoyment for our bodies. USE materials with forceful MUSCULAR colours – the reddest of reds, the most purple of purples, the greenest of greens, intense yellows, orange, vermilion – and SKELETON tones of white, grey and black. And we must invent dynamic designs to go with them and express them in equally dynamic shapes: triangles, cones, spirals, ellipses, circles, etc. The cut must incorporate dynamic and asymmetrical lines, with the left-hand sleeve and the left side of a jacket in circles and the right in squares. And the same for waistcoats, stockings, topcoats etc. The consequent merry dazzle produced by our clothes in the noisy streets, which we shall have transformed with our FUTURIST architecture, will mean that everything will begin to sparkle like the glorious prism of a jeweller's gigantic

glass-front, and all around us we shall find acrobatic blocks of colours set out like the following word-shapes:

Coffeecornhou Rosegreebastocap transpomotocar legcutshop blue blackwhitehouses aerocigarend skyrooflityellight anomoviesphot barbebbenpurp.

Human beings, until now, have dressed (more or less) in black mourning.

We are fighting against:

(a) *the timidity and symmetry* of colours, colours which are arranged in wishy-washy patterns of idiotic spots and stripes;
(b) all forms of *lifeless* attire which make a man feel tired, depressed, miserable and sad, and which restrict movement producing a triste wanness;
(c) so-called 'good taste' and harmony, which weaken the soul and take the spring out of the step.

We want Futurist clothes to be comfortable and practical.

Dynamic
Aggressive
Shocking
Energetic
Violent
Flying (i.e. giving the idea of flying, rising and running)
Peppy
Joyful
Illuminating (in order to have light even in the rain)
Phosphorescent
Lit by electric lamps

Pattern changes should be available by pneumatic dispatch; in this way anyone may change his clothes according to the needs of the mood.
 Available modifications will include:

Loving
Arrogant
Persuasive

Diplomatic
Unitonal
Multitonal
Shaded
Polychrome
Perfumed.

As a result we shall have the necessary variety of clothes, even if the people of a given city lack the imagination themselves.

The happiness of our *Futurist clothes* will help to spread the kind of good humour aimed at by my great friend Palazzeschi in his manifesto *against sadness*.

M14 Mina Loy

Aphorisms on Futurism (1914)

First published in the ground-breaking journal *Camera Work* 45 (January 1914). *Camera Work* (1902–17) was the creation of the pioneer photographer Alfred Stieglitz in New York. It featured the work of the movement he founded, the Photo-Secession, and also the avant-garde artists he exhibited in the Little Galleries of the Photo-Secession, otherwise known as '291'; it was the first to publish the prose of Gertrude Stein – and the writing of Mina Loy.

MINA LOY (Mina Gertrude Löwry, 1882–1966) exhibited at the Salon d'Automne in Paris and the First Free Exhibition of International Futurist Art in Florence. She was also a poet – 'Aphorisms on Futurism' has been described as a manifesto set like a long poem – and a dramatist, satirist, novelist, watercolourist, collagist, Futurist, Christian Scientist, and all-round modernist. She had a knack for titles (*The Sacred Prostitute, The Pamperers*); her work was first collected in the *Lunar Baedeker* (1923), the title of an early poem:

> A silver Lucifer
> serves
> cocaine in cornucopia
>
> To some somnambulists
> of adolescent thighs
> draped
> in satirical draperies . . .

She could trade words with the best of them ('the eye-white sky-light white-light district of lunar lusts' is vintage Loy). In brief, she was

fascinating. Before 1914 was out, she had an unfulfilling affair with Marinetti himself, and another with Giovanni Papini, the political editor of *Lacerba*. Thereafter, Futurism lost its sheen and Mina Loy moved on. The move was marked by a sharp satire of Marinetti-men who see no conflict between speed and passion: 'My love is eternal and my train leaves in fifteen minutes.' She had a sense of humour.

Flitting from continent to continent – 'free feet – free love – free woman' – Loy fell for the 'poet-pugilist' Arthur Cravan; his disappearance left her distraught. In later life she lived in Aspen, Colorado, and described herself as 'a sort of moral hermit'.

See also her 'Feminist Manifesto' (M21).

* * *

DIE in the Past
Live in the Future.

THE velocity of velocities arrives in starting.

IN pressing the material to derive its essence, matter becomes deformed.

AND form hurtling against itself is thrown beyond the synopsis of vision.

THE straight line and the circle are the parents of design, form the basis of art; there is no limit to their coherent variability.

LOVE the hideous in order to find the sublime core of it.

OPEN your arms to the dilapidated, to rehabilitate them.

YOU prefer to observe the past on which your eyes are already opened.

BUT the Future is only dark from outside.
Leap into it – and it EXPLODES with *Light*.

FORGET that you live in houses, that you may live in yourself–

FOR the smallest people live in the greatest houses.

BUT the smallest person, potentially, is as great as the Universe.

WHAT can you know of expansion, who limit yourselves to compromise?

HITHERTO the great man has achieved greatness by keeping the people small.

BUT in the Future, by inspiring the people to expand their fullest capacity, the great man proportionately must be tremendous – a God.

LOVE of others is the appreciation of oneself.

MAY your egotism be so gigantic that you compromise mankind in your self-sympathy.

THE Future is limitless – the past a trail of insidious reactions.

LIFE is only limited by our prejudices. Destroy them, and you cease to be at the mercy of yourself.

TIME is the dispersion of intensiveness.

THE Futurist can live a thousand years in one poem.

HE can compress every aesthetic principle in one line.

THE mind is a magician bound by assimilations; let him loose and the smallest idea conceived in freedom will suffice to negate the wisdom of all forefathers.

LOOKING on the past you arrive at 'Yes', but before you can act upon it you have already arrived at 'NO'.

THE Futurist must leap from affirmative to affirmative, ignoring inter- mittent negations – must spring from stepping-stone to stone of creative exploration; without slipping back into the turbid stream of accepted facts.

THERE are no excrescences on the absolute, to which man may pin his faith.

TODAY is the crisis in consciousness.

CONSCIOUSNESS cannot spontaneously accept or reject new forms, as offered by creative genius; it is the new form, for however great a period of time it may remain a mere irritant – that moulds consciousness to the necessary amplitude for holding it.

CONSCIOUSNESS has no climax.

LET the Universe flow into your consciousness, there is no limit to its capacity, nothing that it shall not recreate.

UNSCREW your capability of absorption and grasp the elements of Life – *whole.*

MISERY is the disintegration of Joy.
Intellect, of Intuition;
Acceptance, of Inspiration.

CEASE to build up your personality with the ejections of irrelevant minds.

NOT to be a cipher in your ambiente,
But to colour your ambiente with your preferences.

NOT to accept experience at its face value.

BUT to readjust activity to the peculiarity of your own will.

THESE are the primary tentatives towards independence.

MAN is a slave only to his own mental lethargy.

YOU cannot restrict the mind's capacity.

THEREFORE you stand not only in abject servitude to your perceptive consciousness–

BUT also to the mechanical re-actions of the subconsciousness, that the rubbish heap of race-tradition–

AND believing yourself free – your least conception is coloured by the pigment of retrograde superstitions.

HERE are the fallow-lands of mental spatiality that Futurism will clear.

MAKING place for whatever you are brave enough, beautiful enough to draw out of the realized self.

TO your blushing we shout the obscenities, we scream the blasphemies, that you, being weak, whisper alone in the dark.

Mina Loy

THEY are empty except of your shame.

AND so these sounds shall dissolve back to their innate senselessness.

THUS shall evolve the language of the Future.

THROUGH derision of Humanity as it appears –

TO arrive at respect for man as he shall be –

ACCEPT the tremendous truth of Futurism
Leaving all those
 – Knick-knacks.–

M15 Ricciotto Canudo

Cerebrist Art (1914)

First published in *Le Figaro*, 9 February 1914, and, like the founding Futurist Manifesto (M1), prefaced by a note from the editors of the newspaper:

Here is a manifesto in which several young artists, desirous of expressing a new way of thinking and an anxiety that is yet to be felt, have put their hopes and ambitions into words. We feel honoured by the trust they have shown in us by soliciting the publicity of *Le Figaro* in order to make themselves heard. Admittedly, it is not our place to take sides in the battle for which some, who wish to contend for their faith, are preparing. But this newspaper has always been committed to offering the hospitality of its columns to those who want to communicate with the general public. Therefore we gladly welcome the 'Cerebrist Art' manifesto. 'All anxieties are interesting,' said a great artist. 'Often they are fruitless, but sometimes they herald and pave the way for great progress.'

The term 'cerebrist' was surely not a happy one. Artists have always fought shy of the cerebral – the Futurists poured scorn on 'a tormented and decadent cerebralism' (see M3) – and highlighting it in this way was only asking for trouble. Predictably, it did not catch on.

RICCIOTTO CANUDO (1879–1923), the director of the journal *Montjoie*, was for a time the lover of Valentine de Saint-Point, author of the Manifesto of Futurist Woman (M7) and creator of 'metachory' (a kind of multi-media dance), mentioned here.

<p style="text-align:center">★ ★ ★</p>

Never has an age been so favourable to artistic debates. Five or six times a year the Athenian republic of modern times becomes fascinated

and passionate, it judges and condemns – at exhibitions, concerts and performances.

The echoes of our modern artistic life, sustained over the whole gamut of the Absurd, cross the defences of the city that is the Face of the World, pass the banks of the suburbs, and disappear beyond the borders to spark off identical debates in Germany, Russia and England. The Absurd is the Real not yet born, or not yet understood. Phalanxes of artists all over the world live sumptuously on the Parisian Absurd.

The nineteenth century was, in all spiritual matters, the real century of the French renaissance. But for several decades France has been so imperiously at the head of modern artistic evolution that even the most hostile nations give in to its dominance.

This dominance is, it has been said, absolutely cerebral. Over at least the past thirty years art has progressively, intensely, become *cerebralized*. Baudelaire was the pioneer of this subtly cerebral aesthetic, which found its best expression in the two precursors of today's and tomorrow's lyricism: Rimbaud and Mallarmé. These men stood on the tomb of the last romantics and dug a wide pit in front of the Parnassians and the Symbolists, whose cerebral art was impure, weakened by all the sentimental and cerebral visions of the past they cherished. Rimbaud and Mallarmé were the first to use prosody to elicit a new emotion; one capable of making the brain tremble, rather than the heart. The haughty intellectualism of Gabriele d'Annunzio or Oscar Wilde has also pushed lyricism towards today's 'cerebrist' channels – inseparably intellectual and sensual. The internal psychology of Gabriele Tarde's crowds gave rise to the most thoughtful literature, that of the collective soul.

Modern music, in liberating itself from the soft and viscous chains of sentimental melodies, in the Italian style, and from Wagner's grand sentimental symbolism, has become 'intellectualized' in the work of Debussy, Paul Dukas and Erik Satie. The young composers' aesthetic is dominated by lyrical preoccupations that are completely cerebral, and by a Symbolism or Impressionism that is perfectly intellectual, in which sensuality is cerebralized, in which cerebrality becomes entirely sensual. And if, several decades ago, the harmony was somehow raised above the counterpoint through all the harmonious research of the 'Debussyists' and their immediate expression of feelings chosen by the brain, the counterpoint

re-enters the fray with Igor Stravinsky, enriched with a new component, sensual and cerebrally modern.

The fine arts have followed the same evolutionary path. When Whistler and Fantin-Latour timidly admitted that in order to give painting new life 'the line must be distorted' they accepted a principle of caricature, that of 'looking for character through distortion', and they opened the golden doors through which Cézanne, Gauguin and Van Gogh all passed.

Cézanne insisted that there is a 'photographic eye' and an 'aesthetic eye', and that he had the right to disregard the exact measurements of a model's shoulders in relation to his head because it was the head that he wanted to emphasize, by way of diminishing the size of the shoulders as he liked. 'The eye only sees what the spirit draws its attention to,' said Rodin, another great 'distorter'. He also sacrificed the slavish reproduction of shape in favour of a completely free and cerebral idea that he made of a subject, as he conceived it.

The aesthetic eye, the pure and simple reasoning of that voluntary harmonizer of nature that is the artist, determined the expressive innovation of the Impressionists' colour. And it pushed following generations progressively to 'distort' form, to break it, to recompose it, away from linear surfaces, to find the depth of volume; to lead, with a view to who knows what new synthesis, to Fauvism and, more courageously, to Cubism.

An emotion too oft repeated loses its charm and its value, and in the end stops being an emotion. This is true in the realm of sentiment as well as that of art. What artists ask of the evolution of art are new emotions, through the discovery of new modes of expressing the artistic emotionalism of a time. Each era has, therefore, rejected the preceding one. In the succession of styles there is as much will and arbitrariness between the well-defined and detailed style of Donatello or Botticelli and the violent and pompous style of a great distorter, Michelangelo, as there is between Ingres' paste and the further devotions of the Impressionists. The bias towards plumpness (the soul of the style) inherited from the Venetians, which inflated the inspiration of the eighteenth century, and towards the pictorial representation of dresses and feminine gestures, equals Titian's bias towards opulence, or the bias of some modern artists towards skeletal thinness.

In art, as on the battlefield, 'to stop advancing is to retreat'. Every

artistic innovation must revolt the eye and the ear, because both the eye and the ear require time to get used to new harmonizations of colours, forms, words and sounds. The drift of contemporary innovation is in the transposition of artistic emotion from the sentimental to the cerebral domain. We want no more painting that merely 'represents' whatever it may be, in the manner of a documentary illustration. We want no more paintings which are only words in the form of images. We are looking for new varieties of form and colour, we want the pleasure of painting for its own sake and not for the literary or sentimental idea that it has to illustrate. This is how the Arabs designed their architecture.

Formerly – up until our time – great mythical and religious sentiments dominated all the arts. Artists kept ready-made feelings to hand, which every one could understand. Myths and religion ruled. In our age of excessive individualism, every artist has to create his interior world and his exterior representation. He has an obligation to give concrete expression to his particular vision of life and the right to express it. Thirty years ago modern art was born from this obligation; liberated, determined and rebelling against all dogmatism of the school: free verse and general post-Mallarméan art in poetry; Impressionist, Fauvist, Cubist, Futurist, Synchromist and Simultaneist, in the plastic arts; Debussyist or post-Debussyist in music; metachoric in dance.

This modern art marks the funerary limit of all sentimental art: banal, facile; in other words intolerable because it is insufficient. We know more and more that the melodrama at which Margot wept [a reference to a work by Musset] is without doubt a stupid melodrama which evokes the same emotion – superficial, hollow, diminishing – as an inconsequential news headline. There is no exaltation for the individual, no elevation of the spirit. In contrast, against all sentimentalism in art and in life, we want an art that is nobler and more pure, which does not touch the heart but which moves the brain, *which does not charm, but makes us think*.

The new generation of artists, indifferent to Margot's tears, strives for heroism. They continue to reform the different arts through their research, which is dominated by the brain. This is why modern art is tremendously cerebral.

This is why we are Cerebrists.

M16 F. T. Marinetti and C. R. W. Nevinson
The Futurist Manifesto Against English Art
(1914)

First published as 'Vital English Art' in the *Observer*, 7 June 1914, and in this version, in both English and Italian, in *Lacerba*, 15 July 1914. A French edition appeared as a broadsheet dated 11 June 1914. It seems clear enough that Marinetti was the author of this manifesto, and Nevinson his accompanist.

Marinetti has left an account of precisely that function, during a recital of his famous *Zang Tumb Tumb: Adrianopli* (1914) at the Doré Galleries in London. This work was an extended 'sound poem' telling of the assault on Adrianopolis (Edirne) during the Bulgarian–Turkish conflict of 1912, an operation in which Marinetti participated. The last chapter, 'Bombardment of Adrianopolis', became the *pièce de résistance* of his poetry recitations:

On a table, arranged in front of me, I had a telephone, some boards, and the right sort of hammers so that I could act out the orders of the Turkish general and the sounds of rifle and machine-gun fire. At three different points in the room, three blackboards had been set up, and these I approached, each in its turn, either walking or running, so as to make rapid chalk sketches of some analogy or other. My audience, continually turning so as to follow all of my movements, was utterly enthralled, their bodies alight with emotion at the violent effects of the battle described in my Words-in-Freedom. In a room some distance away, two great drums were set, and with these the painter Nevinson, who was assisting me, produced the thunder of cannon, when I telephoned him to do so. The growing interest of the English audience turned into frenzied enthusiasm when I arrived at the peak of the dynamic performance, alternating the Bulgarian song 'Sciumi Maritza' with my dazzling images and the rumble of my onomatopoeic artillery.

C. R. W. NEVINSON (1889–1946) became a Futurist after meeting Severini in Paris in 1913. He was said to be the only orthodox Futurist in England. He was fervent, for a while, but his discipleship was short. He joined the (Quaker) Friends' Ambulance Unit, and turned out to be a better war artist than a Futurist. *Returning to the Trenches* (1914–15) was reproduced as a wood engraving in the second issue of *BLAST*, in 1915, signalling a reconciliation with Wyndham Lewis and the Vorticists. Lewis was magnanimous in victory.

* * *

I am an Italian Futurist poet and I love England passionately. I want to cure English Art of the worst of all maladies: traditionalism. I thus have every right to speak out loud, without mincing my words, and together with my friend Nevinson, the English Futurist painter, to signal the start of the struggle.

Against

1. The cult of tradition, the conservatism of the academies, the commercial obsession of English painters, the effeminacy of their art and their efforts, which are purely, exclusively decorative.
2. The pessimistic, sceptical, and nostalgic tastes of the English public, which stupidly adores, to the point of ecstasy, everything that is affected, moderate, softened and mediocre, such as petty reconstructions of things medieval – the graceless Garden Cities, maypoles, Morris dances, Fairy stories, aestheticism, Oscar Wilde, the Pre-Raphaelites, the Neo-primitives, and Paris.
3. A badly focused snobbery that ignores and despises every English attempt at boldness, originality and invention, and which hurries off to venerate the boldness and originality of foreigners. It should never be forgotten that England had its innovators, such as Shakespeare and Swinburne in poetry; Turner and Constable (who was the very first of the Impressionists and of the school of Barbizon) in painting; Watt, Stephenson, Darwin and so on, in the sciences.
4. The false revolutionaries of the New English Art Club, which destroyed

the prestige of the Royal Academy and which is now vulgarly hostile to the vanguard movements.

5. The indifference of the King, the State, and the politicians towards art.

6. The English perception of art as an idle pastime, good only for women and girls, while artists are regarded as poor madmen in need of protection and art is seen as a bizarre illness that anyone can talk about.

7. The right of absolutely anyone to discuss and pass judgements where art is concerned.

8. The grotesque, outmoded ideal of the drunken genius who is dirty, unkempt and classless, given to much drinking, which is synonymous with art; and Chelsea, seen as the Montmartre of London; the sub-Rossettis with long hair beneath their sombreros, and other kinds of traditionalist rubbish.

9. The sentimentalism with which your paintings are loaded to make up for (and here you are plainly mistaken) your lack of tenderness and feeling for life.

10. Innovators who are held back by weariness, by well-being, by desperation. Innovators lounging about on their islands or in their oases, who refuse to move forward. Innovators who declare; 'Oh yes, we desire what is new, but not what you call new!' The tired old innovators who say: 'We admire and follow the Post-Impressionists; but we mustn't venture beyond a certain desirable *naïveté* (Gauguin, etc.).' These innovators demonstrate not only that they have stopped dead in their tracks, but that they have never understood how art evolves. If in painting and sculpture *naïveté*, with its deformations and archaisms, has been the goal at all costs, that has been because of the need to break violently free from the academic and the pretty, prior to advancing toward the plastic dynamism of Futurist painting.

11. The mania for immortality. The masterpiece must die with its author. Immortality – so far as art is concerned – is infamy. With their power of construction and their immortality, our forebears in Italian art have enclosed us in a prison of timidity, imitation and subjugation. They are always with us on their high-backed chairs, these venerable grandfathers of ours, telling us what to do. Their marble brows weigh heavily in the anguish of our youth: 'Avoid motorcars, my children! Wrap up warm! Avoid draughts! Be careful of the lightning!'

12. Enough! Enough! . . . Long live the motorcar! Hurray for the drafts! Hurray for the lightning.

We desire!

1. A strong English art, virile and unsentimentalized.
2. That English artists strengthen their art through regenerative optimism, with a courageous desire for adventure and a heroic instinct for exploration, with a cult of strength and with moral and physical courage, the strong virtues of the English race.
3. That sport be considered as an essential element in art.
4. To create a great Futurist avant-garde which is the only thing that can save English art, threatened with death as it is, through the traditional conservatism of the academies and the habitual indifference of the public. It will prove a heady alcohol and a relentless goad for creative genius, and maintain a constant preoccupation with keeping the furnaces of invention and art aflame, thereby avoiding the laborious task and expense of clearing the blockages of slag and of continually relighting them.

England, a country that is rich and powerful, will have to uphold, defend and glorify absolutely its artistic, most revolutionary and most advanced avant-gardes, if it wishes to save its art from certain death.

M17 Wyndham Lewis and others

Manifesto (1914)

This manifesto appeared in *BLAST* 1, dated 20 June 1914. *BLAST* was edited by Wyndham Lewis and subtitled 'REVIEW OF THE GREAT ENGLISH VORTEX'. It is therefore a Vorticist manifesto; strictly speaking Manifesto II, following a long litany of things to BLAST (France, sentimental Gallic gush, sensationalism, fussiness . . .) or on the other hand to BLESS (cold, magnanimous, delicate, gauche, fanciful, stupid Englishmen . . .). It was written by Lewis, with assistance from Ezra Pound, and co-signed by Richard Aldington, Malcolm Arbuthnot, Lawrence Atkinson, Henri Gaudier Brzeska, Jessica Dismorr, Cuthbert Hamilton, William Roberts, Helen Sanders and Edward Wadsworth.

Lewis's project has been called a British (or English) rear-guard action against the Futurist incursion – the arrière-garde against the avant-garde – in particular, the irrepressible Marinetti, who seemed to be everywhere, even in the most unlikely places: reading the Futurist Manifesto at the Lyceum Club, hosting 'Futurist Evenings' at the Poetry Bookshop, reciting 'The Siege of Adrianople' at the Florence Restaurant, sponsoring twelve Futurist *intonarumori* (noise-making) concerts at the Coliseum and the Albert Hall . . . truly there was no end to Marinetti. *BLAST* as reaction is indeed very plausible, not only for its tone of voice, but also for its attitude. 'Futurism, as preached by Marinetti, is largely Impressionism up-to-date,' Lewis wrote witheringly of the founding manifesto. 'To this is added his Automobilism and Nietzsche stunt.'

To specify what Vorticism was and what it stood for is not easy. It had its roots in Futurism, Cubism and the much-mocked Bloomsbury Group, led by Roger Fry, against whom it rebelled. It embraced the modern, the dynamic and the typographical revolution (to which *BLAST* bears witness); it was big on bold lines, harsh colours, sharp contrasts. Vorticism

according to Ezra Pound emphasized energy. Vorticism according to Wyndham Lewis emphasized Wyndham Lewis. Thirty years later he wrote: 'Vorticism . . . was what I, personally, did, and said, at a certain period.' Which was not so far from the truth.

BLAST (1914–15) was short-lived, outdone by the war. It had ambition, and a certain conception of modernism. It may have taken something of both from *Der Blaue Reiter Almanac* (see M8), especially in its blasting of the boundaries between the arts. Exceptionally, the first issue carried extracts from Kandinsky's *On the Spiritual in Art*, translated by Edward Wadsworth, lauding both the book ('a most important contribution to the psychology of modern art') and the author ('a psychologist and a metaphysician of rare intuition and inspired enthusiasm') – 'fine artists as a rule being extremely reluctant to, or incapable of, expressing their ideas in more than one medium' – high praise from that quarter.

See also 'Our Vortex' (M18).

WYNDHAM LEWIS (1882–1957) was a phenomenon, a man 'of *dangerous* vision', and there was always something dangerous about him, as artist, novelist, essayist and controversialist, not least because he so completely slipped the bounds of convention or tradition. Intransigent, suspect, disappointed and latterly blind, he was among other things a brilliant commentator on the European avant-garde. For the 'unmusical, anti-artistic, unphilosophic country' that was England, Lewis supplied the lack.

* * *

I

1. Beyond Action and Reaction we would establish ourselves.
2. We start from opposite statements of a chosen world. Set up violent structure of adolescent clearness between two extremes.
3. We discharge ourselves on both sides.
4. We fight first on one side, then on the other, but always for the SAME cause, which is neither side or both sides and ours.
5. Mercenaries were always the best troops.

6. We are Primitive Mercenaries in the Modern World.

7. Our *Cause* is NO-MAN'S.

8. We set Humour at Humour's throat. Stir up Civil War among peaceful apes.

9. We only want Humour if it has fought like Tragedy.

10. We only want Tragedy if it can clench its side-muscles like hands on its belly, and bring to the surface a laugh like a bomb.

II

1. We hear from America and the Continent all sorts of disagreeable things about England: 'the unmusical, anti-artistic, unphilosophic country.'

2. We quite agree.

3. Luxury, sport, the famous English 'Humour', the thrilling ascendancy and *idée fixe* of Class, producing the most intense snobbery in the World; heavy stagnant pools of Saxon blood, incapable of anything but the song of a frog, in home counties: these phenomena give England a peculiar distinction in the wrong sense, among the nations.

4. This is why England produces such good artists from time to time.

5. This is also the reason why a movement towards art and imagination could burst up here, from this lump of compressed life, with more force than anywhere else.

6. To believe that it is necessary for or conducive to art, to 'Improve' life, for instance – make architecture, dress, ornament, in 'better taste', is absurd.

7. The Art-instinct is permanently primitive.

8. In a chaos of imperfection, discord, etc., it finds the same stimulus in Nature.

9. The artist of the modern movement is a savage (in no sense an 'advanced', perfected, democratic, Futurist individual of Mr Marinetti's limited imagination): this enormous, jangling, journalistic, fairy desert of modern life serves him as Nature did more technically primitive man.

10. As the steppes and the rigours of the Russian winter, when the peasant has to lie for weeks in his hut, produces that extraordinary acuity of feeling and intelligence we associate with the Slav; so England is just now the most favourable country for the appearance of a great art.

III

1. We have made it quite clear that there is nothing Chauvinistic or pictur-esquely patriotic about our contentions.
2. But there is violent boredom with that feeble Europeanism, abasement of the miserable 'intellectual' before anything coming from Paris, Cosmo-politan sentimentality, which prevails in so many quarters.
3. Just as we believe that an Art must be organic with its Time,
so we insist that what is actual and vital for the South, is ineffectual and unactual in the North.
4. Fairies have disappeared from Ireland (despite foolish attempts to revive them) and the bull-ring languishes in Spain.
5. But mysticism on the one hand, gladiatorial instincts, blood and ascet-icism on the other, will be always actual, and springs of Creation for these two peoples.
6. The English Character is based on the Sea.
7. The particular qualities and characteristics that the sea always engen-ders in men are those that are, among the many diagnostics of our race, the most fundamentally English.
8. That unexpected universality as well, found in the completest English artists is due to this.

IV

1. We assert that the art for these climates, then, must be a northern flower.
2. And we have implied what we believe should be the specific nature of the art destined to grow up in this country, and models of whose flue decorate the pages of this magazine.
3. It is not a question of the characterless material climate around us.
Were that so the complication of the Jungle, dramatic Tropical growth, the vastness of American trees, would not be for us.
4. But our industries, and the Will that determined, face to face with its needs, the direction of the modern world, has reared up steel trees where the green ones were lacking; has exploded in useful growths, and found wilder intricacies than those of Nature.

V

1. We bring clearly forward the following points, before further defining the character of this necessary native art.
2. At the freest and most vigorous period of ENGLAND's history, her literature, then chief Art, was in many ways identical with that of France.
3. Chaucer was very much cousin of Villon as an artist.
4. Shakespeare and Montaigne formed one literature.
5. But Shakespeare reflected in his imagination a mysticism, madness and delicacy peculiar to the North, and brought equal quantities of Comic and Tragic together.
6. Humour is a phenomenon caused by sudden pouring of culture into Barbary.
7. It is intelligence electrified by flood of *naïveté*.
8. It is Chaos invading Concept and bursting it like nitrogen.
9. It is the Individual masquerading as Humanity like a child in clothes too big for him.
10. Tragic Humour is the birthright of the North.
11. Any great Northern Art will partake of this insidious and volcanic chaos.
12. No great ENGLISH Art need be ashamed to share some glory with France, tomorrow it may be with Germany, where the Elizabethans did before it.
13. But it will never be French, any more than Shakespeare was, the most catholic and subtle Englishman.

VI

1. The Modern World is due almost entirely to Anglo-Saxon genius – its appearance and its spirit.
2. Machinery, trains, steamships, all that distinguishes externally our time, came far more from here than anywhere else.
3. In dress, manners, mechanical inventions, LIFE that is, ENGLAND has influenced Europe in the same way that France has in Art.
4. But busy with this LIFE-EFFORT, she has been the last to become conscious of the Art that is an organism of this new Order and Will of Man.

5. Machinery is the greatest Earth-medium: incidentally it sweeps away the doctrines of a narrow and pedantic Realism at one stroke.

6. By mechanical inventiveness, too, just as Englishmen have spread themselves all over the Earth, they have brought all the hemispheres about them in their original island.

7. It cannot be said that the complication of the Jungle, dramatic tropic growths, the vastness of American trees, is not for us.

8. For, in the forms of machinery, Factories, new and vaster buildings, bridges and works, we have all that, naturally, around us.

VII

1. Once this consciousness towards the new possibilities of expression in present life has come, however, it will be more the legitimate property of Englishmen than of any other people in Europe.

2. It should also, as it is by origin theirs, inspire them more forcibly and directly.

3. They are the inventors of this bareness and hardness, and should be the great enemies of Romance.

4. The Romance peoples will always be, at bottom, its defenders.

5. The Latins are at present, for instance, in their 'discovery' of sport, their Futuristic gush over machines, aeroplanes, etc., the most romantic and sentimental 'moderns' to be found.

6. It is only the second-rate people in France and Italy who are thorough revolutionaries.

7. In England, on the other hand, there is no vulgarity in revolt.

8. Or, rather, there is no revolt, it is the normal state.

9. So often rebels of the North and South are diametrically opposed species.

10. The nearest thing in England to a great traditional French artist is a great revolutionary English one.

M18 Wyndham Lewis and others

Our Vortex (1914)

First published in *BLAST* 1, dated 20 June 1914. On the vortex, the review and the author, see the headnote to M17.

* * *

I

Our Vortex is not afraid of the Past: it has forgotten its existence.

Our Vortex regards the Future as sentimental as the Past.

The Future is distant, like the Past, and therefore sentimental.

The mere element 'Past' must be retained to sponge up and absorb our melancholy.

Everything absent, remote, requiring projection in the veiled weakness of the mind, is sentimental.

The Present can be intensely sentimental – especially if you exclude the mere element 'Past'.

Our Vortex does not deal in reactive Action only, nor identify the Present with numbing displays of vitality.

The new Vortex plunges to the heart of the Present.

The chemistry of the Present is different to that of the Past. With this different chemistry we produce a New Living Abstraction.

The Rembrandt Vortex swamped the Netherlands with a flood of dreaming.

The Turner Vortex rushed at Europe with a wave of light.

We wish the Past and Future with us, the Past to mop up our melancholy, the Future to absorb our troublesome optimism.

With our Vortex the Present is the only active thing.

Life is the Past and the Future.
The Present is Art.

II

Our Vortex insists on water-tight compartments.

There is no Present – there is Past and Future, and there is Art.

Any moment not weakly relaxed and slipped back, or, on the other hand, dreaming optimistically, is Art.

'Just Life' or *soi-disant* 'Reality' is a fourth quantity, made up of the Past, the Future and Art.

This impure Present our Vortex despises and ignores.

For our Vortex is uncompromising.

We must have the Past and the Future, Life simple, that is, to discharge ourselves in, and keep us pure for non-life, that is Art.

The Past and Future are the prostitutes Nature has provided.

Art is periodic escapes from this Brothel.

Artists put as much vitality and delight into this saintliness, and escape out, as most men do their escapes into similar places from respectable existence.

The Vorticist is at his maximum point of energy when stillest.

The Vorticist is not the Slave of Commotion but its Master.

The Vorticist does not suck up to Life.

He lets Life know its place in a Vorticist Universe!

III

In a Vorticist Universe we don't get excited at what we have invented.

If we did it would look as though it had been a fluke.

It is not a fluke.

We have no *Verbotens*.

There is one Truth, ourselves, and everything is permitted.

But we are not Templars.

We are proud, handsome and predatory.

We hunt machines, they are our favourite game.

We invent them and then hunt them down.

This is a great Vorticist age, a great still age of artists.

IV

As to the lean belated Impressionism at present attempting to eke out a little life in these islands:

> Our Vortex is fed up with your dispersals, reasonable chicken-men.
> Our Vortex is proud of its polished sides.
> Our Vortex will not hear of anything but its disastrous polished dance.
> Our Vortex desires the immobile rhythm of its swiftness.
> Our Vortex rushes out like an angry dog at your Impressionistic fuss.
> Our Vortex is white and abstract with its red-hot swiftness.

M19 Antonio Sant'Elia

Manifesto of Futurist Architecture (1914)

Dated 11 July 1914; expanded from the introduction to the catalogue of the exhibition 'Nuove Tendenze' (1914) in Milan, and published in *Lacerba*, 1 August 1914.

ANTONIO SANT'ELIA (1888–1916) was probably the most important creative force among the Futurists – Marinetti apart – and also the most ambitious, which is saying a lot. Sant'Elia had style. A dandy, he was provided with free clothes by the grandest Milanese tailor, as a walking advertisement for the wares. He built little, but he had influence. Le Corbusier's celebrated writing or proselytizing (see M45), more a flurry of axioms and assertions than continuous prose, was much indebted to Sant'Elia's manifesto. The two men shared a commitment to rejecting the past, revolutionizing the present, and making novel use of every structure, from attic to basement. 'Let us raise the level of the city,' said Sant'Elia. When it came to radical architectural ideas, he did not presumptuously put on monumental airs. He was a visionary. After his death, in the interminable battles of the Isonzo, Le Corbusier took on his mantle.

* * *

No architecture has existed since 1700. A moronic mixture of the most various stylistic elements used to mask the skeletons of modern houses is called modern architecture. The new beauty of cement and iron are profaned by the superimposition of motley decorative incrustations that cannot be justified either by constructive necessity or by our (modern) taste, and whose origins are in Egyptian, Indian or Byzantine antiquity and in that idiotic flowering of stupidity and impotence that took the name of NEOCLASSICISM.

These architectonic prostitutions are welcomed in Italy, and rapacious alien ineptitude is passed off as talented invention and as extremely up-to-date architecture. Young Italian architects (those who borrow originality from a clandestine and compulsive devouring of art journals) flaunt their talents in the new quarters of our towns, where a hilarious salad of little ogival columns, seventeenth-century foliation, Gothic pointed arches, Egyptian pilasters, rococo scrolls, fifteenth-century cherubs and swollen caryatids, take the place of style in all seriousness, and presumptuously put on monumental airs. The kaleidoscopic appearance and reappearance of forms, the multiplying of machinery, the daily increasing needs imposed by the speed of communications, by the concentration of population, by hygiene, and by a hundred other phenomena of modern life, never cause these self-styled renovators of architecture a moment's perplexity or hesitation. They persevere obstinately with the rules of Vitruvius, Vignola and Sansovino, plus gleanings from any published scrap of information on German architecture that happens to be at hand. Using these, they continue to stamp the image of imbecility on our cities, our cities which should be the immediate and faithful projection of ourselves.

And so this expressive and synthetic art has become in their hands a vacuous stylistic exercise, a jumble of ill-mixed formulae to disguise a run-of-the-mill traditionalist box of bricks and stone as a modern building. As if we who are accumulators and generators of movement, with all our added mechanical limbs, with all the noise and speed of our life, could live in streets built for the needs of men four, five or six centuries ago.

This is the supreme imbecility of modern architecture, perpetuated by the venal complicity of the academies, the internment camps of the intelligentsia, where the young are forced into the onanistic recopying of classical models instead of throwing their minds open in the search for new frontiers and in the solution of the new and pressing problem: THE FUTURIST HOUSE AND CITY – the house and the city that are ours both spiritually and materially, in which our tumult can rage without seeming a grotesque anachronism.

The problem posed in *Futurist* architecture is not one of linear rearrangement. It is not a question of finding new mouldings and frames for windows and doors, of replacing columns, pilasters and corbels with

caryatids, flies and frogs. Neither has it anything to do with leaving a façade in bare brick, or plastering it, or facing it with stone or in determining formal differences between the new building and the old one. It is a question of tending the healthy growth of the Futurist house, of constructing it with all the resources of technology and science, satisfying magisterially all the demands of our habits and our spirit, trampling down all that is grotesque and antithetical (tradition, style, aesthetics, proportion), determining new forms, new lines, a new harmony of profiles and volumes, an architecture whose reason for existence can be found solely in the unique conditions of modern life, and in its correspondence with the aesthetic values of our sensibilities. This architecture cannot be subjected to any law of historical continuity. It must be new, just as our state of mind is new.

The art of construction has been able to evolve with time, and to pass from one style to another, while maintaining unaltered the general characteristics of architecture, because in the course of history changes of fashion are frequent and are determined by the alternations of religious conviction and political disposition. But profound changes in the state of the environment are extremely rare, changes that unhinge and renew, such as the discovery of natural laws, the perfecting of mechanical means, the rational and scientific use of material. In modern life the process of stylistic development in architecture has been brought to a halt. ARCHITECTURE NOW MAKES A BREAK WITH TRADITION. IT MUST PERFORCE MAKE A FRESH START.

Calculations based on the resistance of materials, on the use of reinforced concrete and steel, exclude 'architecture' in the classical and traditional sense. Modern constructional materials and scientific concepts are absolutely incompatible with the disciplines of historical styles, and are the principal cause of the grotesque appearance of 'fashionable' buildings in which attempts are made to employ the lightness, the superb grace of the steel beam, the delicacy of reinforced concrete, in order to obtain the heavy curve of the arch and the bulkiness of marble.

The utter antithesis between the modern world and the old is determined by all those things that formerly did not exist. Our lives have been enriched by elements the possibility of whose existence the ancients did not even suspect. Men have identified material contingencies, and revealed spiritual attitudes, whose repercussions are felt in a thousand

ways. Principal among these is the formation of a new ideal of beauty that is still obscure and embryonic, but whose fascination is already felt even by the masses. We have lost our predilection for the monumental, the heavy, the static, and we have enriched our sensibility with a *taste for the light, the practical, the ephemeral and the swift*. We no longer feel ourselves to be the men of the cathedrals, the palaces and the podiums. We are the men of the great hotels, the railway stations, the immense streets, colossal ports, covered markets, luminous arcades, straight roads and beneficial demolitions.

We must invent and rebuild the Futurist city like an immense and tumultuous shipyard, agile, mobile and dynamic in every detail; and the Futurist house must be like a gigantic machine. The lifts must no longer be hidden away like tapeworms in the niches of stairwells; the stairwells themselves, rendered useless, must be abolished, and the lifts must scale the lengths of the façades like serpents of steel and glass. The house of concrete, glass and steel, stripped of paintings and sculpture, rich only in the innate beauty of its lines and relief, extra-ordinarily 'ugly' in its mechanical simplicity, higher and wider according to need rather than the specifications of municipal laws. It must soar up on the brink of a tumultuous abyss: the street will no longer lie like a doormat at ground level, but will plunge many storeys down into the earth, embracing the metropolitan traffic, and will be linked up for necessary interconnections by metal gangways and swift-moving pavements.

THE DECORATIVE MUST BE ABOLISHED. The problem of Futurist architecture must be resolved, not by continuing to pilfer from Chinese, Persian or Japanese photographs or fooling around with the rules of Vitruvius, but through flashes of genius and through scientific and technical expertise. Everything must be revolutionized. Roofs and underground spaces must be used; the importance of the façade must be diminished; issues of taste must be transplanted from the field of fussy mouldings, finicky capitals and flimsy doorways to the broader concerns of BOLD GROUPINGS AND MASSES, AND LARGE-SCALE DISPOSITION OF PLANES. Let us make an end of monumental, funereal and commemorative architecture. Let us overturn monuments, pavements, arcades and flights of steps; let us sink the streets and squares; let us raise the level of the city.

I COMBAT AND DESPISE:

1. All the pseudo-architecture of the avant-garde, Austrian, Hungarian, German and American;

2. All classical architecture, solemn, hieratic, scenographic, decorative, monumental, pretty and pleasing;

3. The embalming, reconstruction and reproduction of ancient monuments and palaces;

4. Perpendicular and horizontal lines, cubical and pyramidical forms that are static, solemn, aggressive and absolutely excluded from our utterly new sensibility;

5. The use of massive, voluminous, durable, antiquated and costly materials.

AND PROCLAIM:

1. That Futurist architecture is the architecture of calculation, of audacious temerity and of simplicity; the architecture of reinforced concrete, of steel, glass, cardboard, textile fibre, and of all those substitutes for wood, stone and brick that enable us to obtain maximum elasticity and lightness;

2. That Futurist architecture is not because of this an arid combination of practicality and usefulness, but remains art, i.e. synthesis and expression;

3. That oblique and elliptic lines are dynamic, and by their very nature possess an emotive power a thousand times stronger than perpendiculars and horizontals, and that no integral, dynamic architecture can exist that does not include these;

4. That decoration as an element superimposed on architecture is absurd, and that THE DECORATIVE VALUE OF FUTURIST ARCHITECTURE DEPENDS SOLELY ON THE USE AND ORIGINAL ARRANGEMENT OF RAW OR BARE OR VIOLENTLY COLOURED MATERIALS;

5. That, just as the ancients drew inspiration for their art from the elements of nature, we – who are materially and spiritually artificial – must find that inspiration in the elements of the utterly new mechanical world we have created, and of which architecture must be the most beautiful expression, the most complete synthesis, the most efficacious integration;

6. That architecture as the art of arranging forms according to pre-established criteria is finished;

7. That by the term architecture is meant the endeavour to harmonize the environment with Man with freedom and great audacity, that is to transform the world of things into a direct projection of the world of the spirit;

8. From an architecture conceived in this way no formal or linear habit can grow, since the fundamental characteristics of Futurist architecture will be its impermanence and transience. THINGS WILL ENDURE LESS THAN US. EVERY GENERATION MUST BUILD ITS OWN CITY. This constant renewal of the architectonic environment will contribute to the victory of Futurism which has already been affirmed by WORDS-IN-FREEDOM, PLASTIC DYNAMISM, MUSIC WITHOUT QUADRATURE AND THE ART OF NOISES, and for which we fight without respite against traditionalist cowardice.

M20 F. T. Marinetti and others

Futurist Synthesis of the War (1914)

First published by the Directory of the Futurist Movement, Milanese
Cell, 20 September 1914; reprinted the following year by the Futurist
imprint Poesia. Signed by Boccioni, Carrà, Marinetti, Piatti and Russolo.
Words-in-freedom. Manifesto-poster. Poster-politics.

* * *

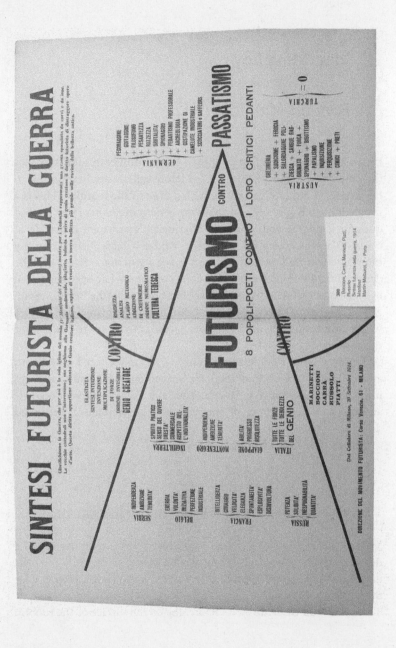

M21 Mina Loy

Feminist Manifesto (1914)

Dated November 1914; first published posthumously in 1982. Loy sent the only known copy of this text, evidently still a work in progress, to her friend Mabel Dodge Luhan, with a note in the margin: 'This is a rough draught beginning of an absolute resubstantiation of the feminist question – give me your opinion – of course it's easy to be proved fallacious – There is no truth – anywhere.' And in a subsequent letter: 'By the way – that fragment of Feminist tirade I sent you – flat? I find the destruction of virginity – <u>so</u> daring don't you think – had been suggested by some other woman years ago – see Havelock Ellis [the British sexologist] – I feel rather hopeless of devotion to the Woman-cause – slaves will believe that chains are protectors . . . they are the more efficient for the coward.'

Loy's 'Feminist Manifesto' was surely a slap in the face for Marinetti and the Futurists' notorious 'scorn for women' (see M1, point 9). Perhaps it was also an alternative to Valentine de Saint-Point's interventions (M7 and M9), a rival conception of 'the Woman-cause', feminism, virtue and desire.

See also her 'Aphorisms on Futurism' (M14).

<p align="center">* * *</p>

The feminist movement as at present instituted is <u>Inadequate</u>

<u>Women</u> if you want to realize yourselves – you are on the eve of a devastating psychological upheaval – all your pet illusions must be unmasked – the lies of centuries have got to go – are you prepared for the <u>wrench</u> – ?
There is no half measure – NO scratching on the surface of the rubbish

heap of tradition, will bring about <u>Reform</u>, the only method is <u>Absolute Demolition</u>.

Cease to place your confidence in economic legislation, vice-crusades & uniform education – you are glossing over <u>Reality</u>.
Professional and commercial careers are opening up for you – <u>Is that all you want</u>?

And if you honestly desire to find your level without prejudice – be <u>Brave</u> & deny at the outset – that pathetic clap-trap war cry <u>Woman is the equal of man</u> –
 For
She is <u>Not</u>!

The man who lives a life in which his activities conform to a social code which is a protectorate of the feminine element —— is no longer <u>masculine</u> The women who adapt themselves to a theoretical valuation of their sex as a <u>relative impersonality</u>, are not yet <u>Feminine</u>
Leave off looking to men to find out what you are <u>not</u> – seek within yourselves to find out what you <u>are</u>
As conditions are at present constituted – you have the choice between <u>Parasitism, & Prostitution</u> – or <u>Negation</u>

Men & women are enemies, with the enmity of the exploited for the parasite, the parasite for the exploited – at present they are at the mercy of the advantage that each can take of the other's sexual dependence. The only point at which the interests of the sexes merge – is the sexual embrace.

The first illusion it is to your interest to demolish is the division of women into two classes – <u>the mistress</u>, & <u>the mother</u> – every well-balanced & developed woman knows that it is not true. Nature has endowed the complete woman with a faculty for expressing herself through <u>all</u> her functions – there are <u>no restrictions</u> the woman who is so incompletely evolved as to be unselfconscious in sex, will prove a restrictive influence on the temperamental expansion of the next generation: the woman who is a poor mistress will be an incompetent mother – an inferior mentality – & will enjoy an inadequate apprehension of <u>Life</u>.

To obtain results you must make sacrifices & the first & greatest sacrifice you have to make is of your 'virtue'. The fictitious value of woman as identified with her physical purity – is too easy to stand by – rendering her lethargic in the acquisition of intrinsic merits of character by which she could obtain a concrete value – therefore, the first self-enforced law for the female sex, as a protection against the man made bogey of virtue – which is the principal instrument of her subjection, would be the unconditional surgical destruction of virginity throughout the female population at puberty –.

The value of a man is assessed entirely according to his use or interest to the community, the value of woman, depends entirely on chance, her success or insuccess in manoeuvring a man into taking the life-long responsibility of her – The advantages of marriage are too ridiculously ample – compared to all other trades – for under modern conditions a woman can accept preposterously luxurious support from a man (without return of any sort – even offspring) – as a thank offering for her virginity
The woman who has not succeeded in striking that advantageous bargain – is prohibited from any but surreptitious reaction to Life-stimuli – & entirely debarred maternity.
Every woman has a right to maternity –
Every woman of superior intelligence should realize her race-responsibility, in producing children in adequate proportion to the unfit or degenerate members of her sex –

Each child of a superior woman should be the result of a definite period of psychic development in her life – & not necessarily of a possibly irksome & outworn continuance of an alliance – spontaneously adapted for vital creation in the beginning but not necessarily harmoniously balanced as the parties to it – following their individual lines of personal evolution – For the harmony of the race, each individual should be the expression of an easy & ample interpenetration of the male & female temperaments – free of stress

Woman must become more responsible for the child than man –

Women must destroy in themselves, the desire to be loved –The feeling that it is a personal insult when a man transfers his attentions from her to another woman

The desire for comfortable protection instead of an intelligent curiosity & courage in meeting & resisting the pressure of life sex or so called love must be reduced to its initial element, honour, grief, sentimentality, pride & consequently jealousy must be detached from it.

Woman for her happiness must retain her deceptive fragility of appearance, combined with indomitable will, irreducible courage, & abundant health the outcome of sound nerves – Another great illusion that woman must use all her introspective clear-sightedness & unbiased bravery to destroy – for the sake of her <u>self-respect</u> is the impurity of sex the realization in defiance of superstition that there is <u>nothing impure in sex</u> – except in the mental attitude to it – will constitute an incalculable & wider social regeneration than it is possible for our generation to imagine.

M22 Carlo Carrà

Warpainting (1915)

Extracts from Carrà's *Guerrapittura* (Milan: Poesia, 1915).
For biographical details about Carrà, see the headnote to M12.

* * *

> *La peinture lâche est*
> *la peinture d'un lâche.*
>
> *Delacroix*

Illustrationism in Plastic Art

We Futurists have long meditated on many things (and we can do this
very well indeed, even in the company of tarts and to the merry sound
of night revellers, so please do not credit us with solemn Mazzini-like
posturing) and we have come to the conclusion that the Great and
Famous Art of the Past is, in fact, a very trivial thing.

Its major defect is a kind of *illustrationism* which has dominated all
art, without exception, from antiquity to our own days.

By the word 'illustrationism' I do not wish to refer to what commonly
goes under the name of 'illustration' (as in newspapers, novels, stories
etc.).

A painter who is affected by illustrationism never achieves, or even
tries for, the expression of his feelings in the plastic world of form and
colour, since for him lines, planes, colours, express nothing in themselves.
He accepts anything (and sometimes this amounts to very little) which
serves to materialize his own vision, his own allegorical, symbolic or

philosophical themes, which are *never purely pictorial*, and he is content to reproduce scenes of an eternal life, though he may see his subject within a contemporary framework.

He relies on a kind of traditional, conventional ideography, and he has an absolute horror of the humanized arabesque, that arabesque which encourages us to feel and to add greater value to expressions of light, of objects and beings in their attitudes of movement and stillness.

The painter who is basically an illustrator or decorator is content to make do with an explanatory tradition limited to purely external images, narrated on a single plane with the aid of colours.

So, the architectural and musical lyricism of form and colour, together with laws of tone and light and shade, have no significance for him. For us, on the other hand, *painting is just this*, and this is the only reason for its existence.

The error with which all plastic art, until now, has been affected, is not only found in Western art (although it is true that, from Courbet onwards, a few people have tried to wipe it out by timidly considering the painter's problem in relation to the search for pure plastic expression) but also is a notable failing in Oriental painting (the Chinese, Japanese, etc.), which is still completely fettered by it.

It is only this non-sense of illustrationism that has persuaded so many people that the Sistine Chapel and even Raphael's Loggia are works which are unsurpassed and unsurpassable.

They are all just stupid dictators, the literati, the philosophers, the journalists and those other people who fail to understand one iota of this and who refuse to see the basic difference between yesterday's painting and the painting of today.

With essential synthetic lyricism, with *imagination without strings* and *words in freedom, true poetry is born*, which never existed before.

With our pictorial Dynamism true painting is born, which also never existed before.

Unblinkered, as always, we Futurists will continue to demolish and to re-create, convinced that reason, as well as truth, is on our side.

The art of the past should be looked upon as a great joke based on moral, religious, ethical and political foundations. *It is only with us Futurists that true ART will be born.*

Carlo Carrà

Distortion in Painting

One of the most characteristic signs, common to all the trends in painting today – and one which makes the greatness of contemporary works of art – is without doubt the element of *distortion* which is the predominant factor in the construction of a painting.

Anyone who takes an intelligent interest in modern painting will know, anyway, that without the presence of this distorting element a work of art cannot exist.

The objective representation of things, so dear to the hearts of naturalists with their artistic *collectivism*, is henceforth confined to its legitimate field: photography.

The search for dynamic-plastic distortion in painting. The search for polytonal music without quadrature. The search for the art of sounds. The search for words-in-freedom.

We are happy to leave the job of explaining the meaning of these words to pedagogues; they are obscure only to idiots; they are crystal clear to anyone who has any familiarity with art.

Distortion is an *altimeter* which registers the degrees of plastic expression which a work of art can attain.

Adjectives like 'primitive', 'great', etc., are too vague, indeterminate and elastic to be used unequivocally.

With such vague, amorphous terminology, anyone can call the most moronic and bourgeois painting in the world 'primitive' or 'great'.

As usual the Italians do not know what has been happening in other countries for the past thirty years.

In the works of the old masters, including Giotto and Titian, any plastic element was the result of accidental intuition.

The plastic elements of their *pictorial illustrations* are to be found in the minor, unimportant sections of their paintings and have little significance for the artist; they are generally found only in the drapes, landscape backgrounds, etc.

And don't throw in our faces the works of old stay-at-home Rembrandt, or El Greco, both of whom attempted some kind of formal distortion, which, however, was ruined by filthy literary psychology.

Such attempts at formal and psychological-literary distortion must be disowned by us Futurists with vigour. Forms executed in an inert and

static way, derived from concepts far remote from any real feeling for life, the works of these old painters should be completely struck off our lists of objects worthy of preservation; they should be removed from the sight of everyone still uncontaminated by stupid idolatry, everyone who wants to become a real art lover.

Once more we return to the miraculous Bruno [sic] Courbet – the first plastic artist to refuse to have any truck with millenarian moralism or romantic sentimentalism in his painting.

The three major Post-Impressionist painters, Matisse, Derain and Picasso, have continued the traditions of their three great predecessors Manet, Renoir and Cézanne, and the distortionist aspect of the problem of plasticity in painting came to be applied with courage and greater awareness.

To this group of artists is due the great credit of having brought to painting an anti-episodic constructional synthesis which was entirely unknown amongst the old painters.

They have broken with perspective schemes, they have broadened and deepened their experiments with space and the plasticity of bodies and light, *distorting* all apparent reality; in this way these great precursors prepared the way for Futurist painting.

The need for more and more architectural distortion of objects and things made the painter Courbet take a stand against:

The pictorial distortion of the kind practised in a linear-static way by the Egyptians, the Ancient Greeks, Michelangelo and El Greco.

With Courbet, for the first time, we have plastic distortion accompanied by the principles of dynamism. We must give him the honour of being the first innovator of modern painting.

All these things have been discussed at great length by myself, Soffici and our friend Picasso in the latter's studio. Expounding our Futurist principles, we convinced Picasso of the necessity of starting – as far as distortion is concerned – with a passionate acceptance of modernity, as well as of popular art. We also showed him the absurdity of the kind of distortion which can take inspiration from a bygone sensibility inevitably static and false. This kind of distortion can only create works which have merely the appearance of modernity, where the life is merely illusory.

Carlo Carrà

Our dynamic distortion in painting will be used to fight:
Any tendency towards the 'pretty', the 'tender', 'the sentimental' (BOTTI-
CELLI, WATTEAU)
Any tendency towards 'literary heroicism' (DELACROIX)
Any tendency towards the 'bourgeois' or the 'academic' (RAPHAEL,
LEONARDO DA VINCI)
*Any tendency towards 'harmony', 'equilibrium', 'symmetry', the 'decorative',
'pure illustrationism'* (VERONESE)
*Any tendency towards the 'analytical', towards 'scientific or rationalist perspec-
tive', towards 'objectivism and natural probability'* (SEURAT, SIGNAC,
GROS)

While the paintings of our glorious predecessors, Courbet, Manet,
Cézanne and Renoir, exhibit a certain fragmentariness, nevertheless their
work was the *signal for a rebellion* against all gangrenous, millenarian,
artistic traditionalism.

The artistic revolt begun by these painters will be brought to full fruit
by us Futurist painters, and this new art, barely glimpsed by them, will
be realized by *US* for our own pleasure and for the pleasure of a few
like-minded people who find themselves capable of enjoying it.

M23 Vladimir Mayakovsky

A Drop of Tar (1915)

First published in the almanac *Seized* (Petrograd), 'the drum of the Futurists', in 1915, by the writer and critic Osip Brik (1888–1945).

VLADIMIR MAYAKOVSKY (1893–1930) was an inspirational figure of the revolutionary Russian avant-garde, whose personal and poetic style, flamboyant and declamatory, had a tremendous influence on twentieth-century Russian literature and the image of the Russian poet abroad. The much-imitated dictum 'Lenin lives, lived, and will live' is Mayakovsky, from his elegy 'Vladimir Ilyich Lenin' (1925). He joined the Bolshevik wing of the Social Democratic Labour Party in 1908, at the age of fifteen. Absorbing something of Futurist showmanship, Mayakovsky toured the provinces giving dramatic readings of his poems. Come the revolution, he worked for the People's Commissariat of Education and the Russian Telegraphic Agency. He was known in some quarters as the thirteenth apostle, for his agitprop activism. In the 1920s he co-founded and edited the radical modernist journal *LEF* (short for *Left Front of the Arts*), but became increasingly disillusioned with the direction of the Soviet Union under Stalin, and at the same time disappointed in his affair with Lili Brik (1893–1978), wife of Osip.

Mayakovsky committed suicide in 1930 – his last revolutionary act. After his death he was vilified as a 'formalist' and a 'fellow-traveller' (as opposed to an officially recognized 'proletarian poet'). When Lili Brik complained to Stalin about this calumny, in 1935, Stalin himself declared Mayakovsky 'still the best and the most talented poet of our Soviet epoch', adding, ominously, 'Indifference to his cultural heritage is a crime.' These words led to his official canonization. They also 'dealt him a second death', as his friend Boris Pasternak put it.

For many, participants and observers alike, Mayakovsky's suicide

symbolized the death of Russian Futurism and the dire predicament of the Russian avant-garde more generally. In the unforgiving climate of the Stalinist regime, association with the Italian Futurists, with Marinetti in particular, raised issues more fundamental than cultural precedence or intellectual independence. Mayakovsky's comrade and cuckold, Osip Brik, parodied the argument: 'What is *LEF*? Futurists. What are Futurists? Marinetti. Who is Marinetti? An Italian Fascist. Consequently . . . the conclusion is clear.' That may have been a parody, but it was also a crushing logic.

See also the 'Manifesto of the Flying Federation of Futurists' (M27).

* * *

'A speech to be delivered at the first convenient occasion'

Ladies and Gentlemen!
This year is a year of deaths: almost every day the newspapers sob loudly in grief about somebody who has passed away before his time. Every day, with syrupy weeping the brevier wails over the huge number of names slaughtered by Mars. How noble and monastically severe today's newspapers look. They are dressed in the black mourning garb of the obituaries, with the crystal-like tear of a necrology in their glittering eyes. That's why it has been particularly upsetting to see these same newspapers, usually ennobled by grief, note with indecent merriment one death that involved me very closely.

When the critics, harnessed in tandem, carried along the dirty road – the road of the printed word – the coffin of Futurism, the newspapers trumpeted for weeks: 'ho, ho, ho! serves it right! take it away! finally!' (Concerned alarm in the audience: 'What do you mean, died? Futurism died? You're kidding.')

Yes, it died.

For one year now, instead of Futurism, verbally flaming, barely manoeu-vring between truth, beauty and the police station, the most boring octogenarians of the Kogan-Aikhenvald type [literary critics with official positions] creep up on the stage of auditoriums. For one year now, the

auditoriums present only the most boring logic, demonstrations of trivial truths, instead of the cheerful sound of glass pitchers against empty heads.

Gentlemen! Do you really feel no sorrow for that extravagant young fellow with shaggy red hair, a little silly, a bit ill-mannered, but always, oh! always, daring and fiery? On the other hand, how can you understand youth? The young people to whom we are dear will not soon return from the battlefield; but you, who have remained here with quiet jobs in newspaper offices or other similar businesses; you, who are too rickety to carry a weapon, you, old bags crammed with wrinkles and grey hair, you are preoccupied with figuring out the smoothest possible way to pass on to the next world and not with the destiny of Russian art.

But, you know, I myself do not feel too sorry about the deceased, although for different reasons.

Bring back to mind the first gala publication of Russian Futurism, titled with that resounding 'slap in the face of public taste'. What remained particularly memorable of that fierce scuffle were the three blows, in the form of three vociferous statements from our manifesto.

1. Destroy the all-canons freezer which turns inspiration into ice.
2. Destroy the old language, powerless to keep up with life's leaps and bounds.
3. Throw the old masters overboard from the ship of modernity.

As you see, there isn't a single building here, not a single comfortably designed corner, only destruction, anarchy. This made philistines laugh, as if it were the extravagant idea of some insane individuals, but in fact it turned out to be 'a devilish intuition' which is realized in the stormy today. The war, by expanding the borders of nations and of the brain, forces one to break through the frontiers of what yesterday was unknown.

Artist! Is it for you to catch the onrushing cavalry with a fine net of contour lines? Repin! Samokish! [Realist painters] Get your pails out of the way – the paint will spill all over!

Poet! Don't place the mighty conflict of iambs and trochees in a rocking chair – the chair will flip over!

Fragmentation of words, word renewal! So many new words, and first among them Petrograd, and conductress! Die, Severyanin [cult Ego-futurist poet]! Is it really for the Futurists to shout that old literature is

forgotten? Who would still hear behind the Cossack whoop the trill of Bryusov's mandolin [precious Symbolist writer]! Today, everyone is a Futurist. The entire nation is Futurist.

FUTURISM HAS *SEIZED* RUSSIA IN A DEATH GRIP.

Not being able to see Futurism in front of you and to look into yourselves, you started shouting about its death. Yes! Futurism, as a specific group, died, but like a flood it overflows into all of you.

But once Futurism had died as the idea of select individuals, we do not need it anymore. We consider the first part of our programme of destruction to be completed. So don't be surprised if today you see in our hands architectural sketches instead of clownish rattles, and if the voice of Futurism, which yesterday was still soft from sentimental reverie, today is forged in the copper of preaching.

M24 Kasimir Malevich

Suprematist Manifesto (1916)

This manifesto went through a number of iterations: the first appeared
in December 1915, to coincide with the exhibition '0.10' at the Art Bureau
in Petrograd, organized by Ivan Puni (Jean Pougny, 1894–1956) and his
wife Ksenia Boguslavskaya (1892–1972); the second was also published in
Petrograd in January 1916; the third (this one), substantially rewritten
and now entitled 'From Cubism and Futurism to Suprematism: The New
Painterly Realism', appeared in Moscow in November 1916.

 Malevich was an intellectual revolutionary (or a revolutionary intel-
lectual) with a lot to say. This is his literary masterpiece. There are
Marinettian flourishes and homages here ('honour to the Futurists who
forbade the painting of female hams'), but the Suprematist Manifesto
has an oracular quality, a biblical grandeur, that eluded Marinetti. 'After
the old Testament came the new,' wrote Malevich's comrade-in-arms El
Lissitsky, 'and after the new the Communist and after the Communist
there follows finally the Testament of Suprematism.' The result is
exhilarating, but also baffling. Malevich delivers himself of some funda-
mental precepts ('a painted surface is a real, living form'); yet he is
difficult to follow. The Testament of Suprematism is aphoristic, fragmen-
tary, repetitive. Helpfully, John Golding has suggested that it becomes
more accessible if we read it not as a consistent aesthetic or philosophical
credo but as an apocalyptic speculation on the nature of painting, and
on how painting might develop in the hands of Malevich and his follow-
ers (who were soon to close ranks behind him): if we swallow its rhetoric
and wallow in its lyricism, as in an epic prose poem, rather than trying
always to parse its meaning.

KASIMIR MALEVICH (1879–1935) was a kind of messiah – the father
of minimal and conceptual art – the Lenin of his realm. (He had a

granddaughter called Ninel: Lenin backwards.) Someone said that 'he seemed with his hands to part the smoke'. He spoke in tongues. 'It is from zero, in zero, that the true movement of being begins,' seducing those who 'have turned aside the rays of yesterday's sun from their faces'. He made some of the boldest advances in modern art. His emblematic *Black Square* (1915) was a radical simplification, the most minimal canvas yet to be produced – condemned as 'a sermon of nothingness and destruction' – yet X-ray examination reveals that the impassive black square is painted over a composition of coloured shapes, and in fact Malevich speaks suggestively of 'the face' of the square as the face of the new art. 'The square is a living, regal infant. The first step of pure creation in art.'

Like many others, Malevich was gradually broken by the system. In a puzzling late turn, he reverted to figurative painting. This work was shown in an exhibition called 'Art from the Imperialist Epoch', a damning indictment. His death in 1935 was the occasion for a bizarre revival. His body was placed in a Suprematist coffin of his own design, but without the cross on the lid that he himself had indicated. The *Black Square* was positioned above his body for the wake. A second square was attached to the lorry that transported the coffin from Leningrad to Moscow for the cremation. His ashes were buried, as he had requested, in the countryside near the dacha where he had formulated the Suprematist doctrine. A monument was erected on which was inscribed a final square.

See also Rozanova, 'Cubism, Futurism, Suprematism' (M26).

* * *

Only when the conscious habit of seeing nature's little nooks, Madonnas and Venuses in pictures disappears *will we witness a purely painterly work of art*.

I have transformed myself *in the zero of form* and have fished myself out of the *rubbishy slough of academic art*.

I have destroyed the ring of the horizon and got out of the circle of objects, the horizon ring that has imprisoned the artist and the forms of nature. This accursed ring, by continually revealing novelty after novelty, leads the artist away from the *aim of destruction*.

And only *cowardly consciousness* and insolvency of creative power in an artist yield to this deception and establish *their art on the forms of nature*, afraid of losing the foundation on which the *savage and the academy* have based their art.

To produce favourite objects and little nooks of nature is just like a thief being enraptured with his shackled legs.

Only dull and impotent artists veil their work with *sincerity*. Art requires *truth*, not *sincerity*.

Objects have vanished like smoke; to attain the new artistic culture, art advances toward creation as an end in itself and towards domination over the forms of nature.

The Art of the Savage and Its Principles

The savage was the first to establish the principle of naturalism: in drawing a dot and five little sticks, he attempted to transmit his own image.
The first attempt laid the basis for the conscious imitation of nature's forms.
Hence arose the aim of approaching the face of nature as closely as possible.
And all the artist's efforts were directed towards the transmission of her creative forms.

The first inscription of the savage's primitive depiction gave birth to collective art, or the art of repetition.
Collective, because the real man with his subtle range of feelings, psychology and anatomy had not been discovered.
The savage saw neither his outward image nor his inward state.
His consciousness could see only the outline of a man, a beast, etc.
And as his consciousness developed, so the outline of his depiction of nature grew more involved.
The more his consciousness embraced nature, the more involved his work became, and the more his experience and skill increased.
His consciousness developed only in one direction, towards nature's creation and not towards new forms of art.

Therefore his primitive depictions cannot be considered creative work.

The distortion of reality in his depictions is the result of weak technique. Both technique and consciousness were only at the beginning of their development.

And his pictures must not be considered art.

Because unskilfulness is not art.

He merely pointed the way to art.

Consequently, his original outline was a framework on which the generations hung new discovery after new discovery made in nature.

And the outline became more and more involved and achieved its flowering in antiquity and the Renaissance.

The masters of these two epochs depicted man in his complete form, both outward and inward.

Man was assembled, and his inward state was expressed.

But despite their enormous skill, they did not, however, perfect the savage's idea: The reflection of nature on canvas, as in a mirror.

And it is a mistake to suppose that their age was the most brilliant flowering of art and that the younger generation should at all costs aspire towards this ideal.

This idea is false.

It diverts young forces from the contemporary current of life and thereby deforms them.

Their bodies fly in aeroplanes, but they cover art and life with the old robes of Neros and Titians.

Hence they are unable to observe the new beauty of our modern life.

Because they live by the beauty of past ages.

That is why the Realists, Impressionists, Cubism, Futurism and Suprematism were not understood.

The latter artists cast aside the robes of the past, came out into modern life, and found new beauty.

And I say:

That no torture chambers of the academies will withstand the days to come.
Forms move and are born, and we are forever making new discoveries.

And what we discover must not be concealed.

And it is absurd to force *our* age into the old forms of a bygone age.

The hollow of the past cannot contain the gigantic constructions and movement of our life.

As in our life of technology:

We cannot use the ships in which the Saracens sailed, and so in art we should seek forms that correspond to modern life.

The technological side of our age advances further and further ahead, but people try to push art further and further back.

This is why all those people who follow their age are superior, greater and worthier.

And the realism of the nineteenth century is much greater than the ideal forms found in the aesthetic experience of the ages of the Renaissance and Greece.

The masters of Rome and Greece, after they had attained a knowledge of human anatomy and produced a depiction that was to a certain extent realistic: were overrun by aesthetic taste, and their realism was pomaded and powdered with the taste of aestheticism.

Hence their perfect line and nice colours.

Aesthetic taste diverted them from the realism of the earth, and they reached the impasse of idealism.

Their painting is a means of decorating a picture.

Their knowledge was taken away from nature into closed studios, where pictures were manufactured for many centuries.

That is why their art stopped short.

They closed the doors behind them, thereby destroying their contact with nature.

And that moment when they were gripped by the idealization of form should be considered the collapse of real art.

Because art should not advance towards abbreviation or simplification, but towards complexity.

The Venus de Milo is a graphic example of decline. It is not a real woman, but a parody.

Angelo's David is a deformation.

His head and torso are modelled, as it were, from two incongruent forms.

A fantastic head and a real torso.

All the masters of the Renaissance achieved great results in anatomy.
But they did not achieve veracity in their impression of the body.
Their painting does not transmit the body, and their landscapes do not
transmit living light, despite the fact that bluish veins can be seen in the
bodies of their people.
The art of naturalism is the savage's idea, the aspiration to transmit what
is seen, but not to create a new form.
His creative will was in an embryonic state, but his impressions were
more developed, which was the reason for his reproduction of reality.
Similarly it should not be assumed that his gift of creative will was devel-
oped in the classical painters.
Because we see in their pictures only repetitions of the real forms of life
in settings richer than those of their ancestor, the savage.

Similarly their composition should not be considered creation, for in
most cases the arrangement of figures depends on the subject: a king's
procession, a court, etc.
The king and the judge already determine the places on the canvas for
the persons of secondary importance.

Furthermore, the composition rests on the purely aesthetic basis of nice-
ness of arrangement.
Hence arranging furniture in a room is still not a creative process.

In repeating or tracing the forms of nature, we have nurtured our
consciousness with a false conception of art.
The work of the primitives was taken for creation.
The classics also.
If you put the same glass down twenty times, that's also creation.
Art, as the ability to transmit what we see onto a canvas, was considered
creation.
Is placing a samovar on a table also really creation?
I think quite differently.
The transmission of real objects onto a canvas is the art of skilful repro-
duction, that's all.
And between the art of creating and the art of repeating there is a great
difference.

To create means to live, forever creating newer and newer things.

And however much we arrange furniture about rooms, we will not extend or create a new form for them.

And however many moonlit landscapes the artist paints, however many grazing cows and pretty sunsets, they will remain the same dear little cows and sunsets. Only in a much worse form.

And in fact, whether an artist is a genius or not is determined by the number of cows he paints.

The artist can be a creator only when the forms in his picture have nothing in common with nature.

For art is the ability to create a construction that derives not from the interrelation of form and colour and not on the basis of aesthetic taste in a construction's compositional beauty, *but on the basis of weight, speed and direction of movement.*

Forms must be given life and the right to individual existence.

Nature is a living picture, and we can admire her. We are the living heart of nature.

We are the most valuable construction in this gigantic living picture.

We are her living brain, which magnifies her life.

To reiterate her is theft, and he who reiterates her is a thief – a nonentity who cannot give, but who likes to take things and claim them as his own. (Counterfeiters.)

An artist is under a vow to be a free creator, but not a free robber.

An artist is given talent in order that he may present to life his share of creation and swell the current of life, so versatile.

Only in absolute creation will he acquire his right.

And this is possible when we free all art of philistine ideas and subject matter and teach our consciousness to see everything in nature not as real objects and forms, but as material, as masses from which forms must be made that have nothing in common with nature.

Then the habit of seeing Madonnas and Venuses in pictures, with fat, flirtatious cupids, will disappear.

Colour and texture are of the greatest value in painterly creation – they are the essence of painting; but this essence has always been killed by the subject.

And if the masters of the Renaissance had discovered painterly surface, it would have been much nobler and more valuable than any Madonna or Giaconda.

And any hewn pentagon or hexagon would have been a greater work of sculpture than the Venus de Milo or David.

The principle of the savage is to aim to create art that repeats the real forms of nature.

In intending to transmit the living form, they transmitted its corpse in the picture.

The living was turned into a motionless, dead state.

Everything was taken alive and pinned quivering to the canvas, just as insects are pinned in a collection.

But that was the time of Babel in terms of art.

They should have created, but they repeated; they should have deprived forms of content and meaning, but they enriched them with this burden.

They should have dumped this burden, but they tied it around the neck of creative will.

The art of painting, the word, sculpture, was a kind of camel, loaded with all the trash of odalisques, Salomes, princes and princesses.

Painting was the tie on the gentleman's starched shirt and the pink corset drawing in the stomach.

Painting was the aesthetic side of the object.

But it was never an independent end in itself.

Artists were officials making an inventory of nature's property, amateur collectors of zoology, botany and archaeology.

Nearer our time, young artists devoted themselves to pornography and turned painting into lascivious trash.

There were no attempts at purely painterly tasks as such, without any appurtenances of real life.

There was no realism of painterly form as an end in itself, and there was no creation.

The realist academists are the savage's last descendants.

They are the ones who go about in the worn-out robes of the past.

And again, as before, some have cast aside these greasy robes.

And given the academy rag-and-bone man a slap in the face with their proclamation of Futurism.

They began in a mighty movement to hammer at the consciousness as if at nails in a stone wall.

To pull you out of the catacombs into the speed of contemporaneity.

I assure you that whoever has not trodden the path of Futurism as the exponent of modern life is condemned to crawl forever among the ancient tombs and feed on the leftovers of bygone ages.

Futurism opened up the 'new' in modern life: the beauty of speed.

And through speed we move more swiftly.

And we, who only yesterday were Futurists, have reached new forms through speed, new relationships with nature and objects.

We have reached Suprematism, abandoning Futurism as a loophole through which those lagging behind will pass.

We have abandoned Futurism, and we, bravest of the brave, *have spat on the altar of its art.*

But can cowards spit on their idols –
As we did yesterday!!!

I tell you, you will not see the new beauty and the truth until you venture to spit.

Before us, all arts were old blouses, which are changed just like your silk petticoats.

After throwing them away, you acquire new ones.

Why do you not put on your grandmothers' dresses, when you thrill to the pictures of their powdered portraits?

This all confirms that your body is living in the modern age while your soul is clothed in your grandmother's old bodice.

This is why you find the Somovs, Kustodievs [members of the decorative 'World of Art' group], and various such rag merchants so pleasant.

And I hate these second-hand clothes dealers.

Yesterday we, our heads proudly raised, defended Futurism –
Now with pride we spit on it.

And I say that what we spat upon will be accepted.

You, too, spit on the old dresses and clothe art in something new.

We rejected Futurism not because it was outdated, and its end had come. No. The beauty of speed that it discovered is eternal, and the new will still be revealed to many.

Since we run to our goal through the speed of Futurism, our thought moves more swiftly, and whoever lives in Futurism is nearer to this aim and further from the past.

And your lack of understanding is quite natural. Can a man who always goes about in a cabriolet really understand the experiences and impressions of one who travels in an express or who flies through the air?

The academy is a mouldy vault in which art is being flagellated.

Gigantic wars, great inventions, conquest of the air, speed of travel, telephones, telegraphs, dreadnoughts are the realm of electricity.

But our young artists paint Neros and half-naked Roman warriors.

Honour to the Futurists who forbade the painting of female hams, the painting of portraits and guitars in the moonlight.

They made a huge step forward: they abandoned meat and glorified the machine.

But meat and the machine are the muscles of life.

Both are the bodies that give life movement.

It is here that two worlds have come together.

The world of meat and the world of iron.

Both forms are the mediums of utilitarian reason.

But the artist's relationship to the forms of life's objects requires elucidation.

Until now the artist always followed the object.

Thus the new Futurism follows the machine of today's dynamism.

These two kinds of art are the old and the new – Futurism: they are behind the running forms.

And the question arises: will this aim in the art of painting respond to its existence?

No!

Because in following the form of aeroplanes or motorcars, we shall always be anticipating the new cast-off forms of technological life . . .

And second:

In following the form of things, we cannot arrive at painting as an end in itself, at spontaneous creation.

Painting will remain the means of transmitting this or that condition of life's forms.

But the Futurists forbade the painting of nudity not in the name of the liberation of painting and the word, so that they would become ends in themselves.
But because of the changes in the technological side of life.
The new life of iron and the machine, the roar of motorcars, the brilliance of electric lights, the growling of propellers, have awakened the soul, which was suffocating in the catacombs of old reason and has emerged at the intersection of the paths of heaven and earth.
If all artists were to see the crossroads of these heavenly paths, if they were to comprehend these monstrous runways and intersections of our bodies with the clouds in the heavens, then they would not paint chrysanthemums.

The dynamics of movement has suggested advocating the dynamics of painterly plasticity.
But the efforts of the Futurists to produce purely painterly plasticity as such were not crowned with success.
They could not settle accounts with objectism, which would have made their task easier.
When they had driven reason halfway from the field of the picture, from the old calloused habit of seeing everything naturally, they managed to make a picture of the new life, of new things, but that is all.

In the transmission of movement, the cohesiveness of things *disappeared* as their flashing parts hid themselves among other running bodies.
And in constructing the parts of the running objects, they tried to transmit only the impression of movement.
But in order to transmit the movement of modern life, one must operate with its forms.
Which made it more complicated for the art of painting to reach its goal.

But however it was done, consciously or unconsciously, for the sake of movement or for the sake of transmitting an impression, the cohesion of things was violated.

And in this break-up and violation of cohesion lay the latent meaning that had been concealed by the naturalistic purpose.

Underlying this destruction lay primarily not the transmission of the movements of objects, but their destruction for the sake of pure painterly essence, i.e., towards attainment of non-objective creation.

The rapid interchange of objects struck the new naturalists – the Futurists – and they began to seek means of transmitting it.

Hence the construction of the Futurist pictures that you have seen arose from the discovery points on a plane where the placing of real objects during their explosion or confrontation would impart a sense of time at a maximum speed.

These points can be discovered independently of the physical law of natural perspective.

Thus we see in Futurist pictures the appearance of clouds, horses, wheels, and various other objects in places not corresponding to nature.

The state of the object has become more important than its essence and meaning.

We see an extraordinary picture.

A new order of objects makes reason shudder.

The mob howled and spat, critics rushed at the artist like dogs from a gateway. (Shame on them.)

The Futurists displayed enormous strength of will in destroying the habit of the old mind, in flaying the hardened skin of academism and spitting in the face of old common sense.

After rejecting reason, the Futurists proclaimed intuition as the subconscious.

But they created their pictures not out of the subconscious forms of intuition, but used the forms of utilitarian reason.

Consequently, only the discovery of the difference between the two lives of the old and the new art will fall to the lot of intuitive feeling.

We do not see the subconscious in the actual construction of the picture. Rather do we see the conscious calculation of construction.

In a Futurist picture there is a mass of objects. They are scattered about the surface in an order unnatural to life.

The conglomeration of objects is acquired not through intuitive sense, but through a purely visual impression, while the building, the construction, of the picture is done with the intention of achieving an impression.

And the sense of the subconscious falls away.
Consequently, we have nothing purely intuitive in the picture.
Beauty, too, if it is encountered, proceeds from aesthetic taste.

The intuitive, I think, should manifest itself when forms are unconscious and have no response.
I consider that the intuitive in art had to be understood as the aim of our sense of search for objects. And it followed a purely conscious path, blazing its decisive trail through the artist.
(Its form is like two types of consciousness fighting between themselves.)
But the consciousness, accustomed to the training of utilitarian reason, could not agree with the sense that led to the destruction of objectism.
The artist did not understand this aim and, submitting to this sense, betrayed reason and distorted form.
The art of utilitarian reason has a definite purpose.
But intuitive creation does not have a utilitarian purpose. Hitherto we have had no such manifestation of intuition in art.
All pictures in art follow the creative forms of a utilitarian order. All the naturalists' pictures have the same form as in nature.
Intuitive form should arise out of nothing.
Just as reason, creating things for everyday life, extracts them from nothing and perfects them.

Thus the forms of utilitarian reason are superior to any depictions in pictures.
They are superior because they are alive and have proceeded from material that has been given a new form for the new life.
Here is the divine ordering crystals to assume another form of existence.
Here is a miracle . . .
There should be a miracle in the creation of art, as well.

But the realists, in transferring living things onto canvas, deprive their life of movement.
And our academies teach dead, not living, painting.
Hitherto intuitive feeling has been directed to drag newer and newer forms into our world from some kind of bottomless void.
But there has been no proof of this in art, and there should be.
And I feel that it does already exist in a real form and quite consciously.

The artist should know what, and why, things happen in his pictures.
Previously he lived in some sort of mood. He waited for the moonrise and twilight, put green shades on his lamps, and all this tuned him up like a violin.
But if you asked him why the face on his canvas was crooked, or green, he could not give an exact answer.
'I want it like that, I like it like that . . .'
Ultimately, this desire was ascribed to creative will.
Consequently, the intuitive feeling did not speak clearly. And thereafter its state became not only subconscious, but completely unconscious.
These concepts were all mixed together in pictures. The picture was half-real, half-distorted.

Being a painter, I ought to say why people's faces are painted green and red in pictures.
Painting is paint and colour; it lies within our organism. Its outbursts are great and demanding.
My nervous system is coloured by them.
My brain burns with their colour.
But colour was oppressed by common sense, was enslaved by it. And the spirit of colour weakened and died out.
But when it conquered common sense, then its colours flowed onto the repellent form of real things.

The colours matured, but their form did not mature in the consciousness.
This is why faces and bodies were red, green and blue.
But this was the herald leading to the creation of painterly forms as ends in themselves.
Now it is essential to shape the body and lend it a living form in real life.
And this will happen when forms emerge from painterly masses; that is, they will arise just as utilitarian forms arose.

Such forms will not be repetitions of living things in life, but will themselves be a living thing.
A painted surface is a real, living form.
Intuitive feeling is now passing to consciousness; no longer is it subconscious.
Even, rather, vice versa – it always was conscious, but the artist just could not understand its demands.

The forms of Suprematism, the new painterly realism, already testify to the construction of forms out of nothing, discovered by intuitive reason. The Cubist attempt to distort real form and its break-up of objects were aimed at giving the creative will the independent life of its created forms.

Painting in Futurism

If we take any point in a Futurist picture, we shall find either something that is coming or going, or a confined space.
But we shall not find an independent, individual painterly surface.
Here the painting is nothing but the outer garment of things.
And each form of the object was painterly insofar as its form was necessary to its existence, and not vice versa.

The Futurists advocate the dynamics of painterly plasticity as the most important aspect of a painting.
But in failing to destroy objectivism, they achieve only the dynamics of things.
Therefore Futurist paintings and all those of past artists can be reduced from twenty colours to one, without sacrificing their impression.
Repin's picture of Ivan the Terrible could be deprived of colour, and it will still give us the same impressions of horror as it does in colour.
The subject will always kill colour, and we will not notice it.
Whereas faces painted green and red kill the subject to a certain extent, and the colour is more noticeable. And colour is what the painter lives by, so it is the most important thing.

And here I have arrived at pure colour forms.
And Suprematism is the purely painterly art of colour whose independence cannot be reduced to a single colour.
The galloping of a horse can be transmitted with a single tone of pencil.
But it is impossible to transmit the movement of red, green, or blue masses with a single pencil.
Painters should abandon subject-matter and objects if they wish to be pure painters.
The demand to achieve the dynamics of painterly plasticity points to the impulse of painterly masses to emerge from the object and arrive at colour as an end in itself, at the domination of purely painterly forms as

ends in themselves over content and things, at non-objective Suprematism – at the new painterly realism, at absolute creation.

Futurism approaches the dynamism of painting through the academism of form. And both endeavours essentially aspire to Suprematism in painting.

If we examine the art of Cubism, the question arises what energy in objects incited the intuitive feeling to activity; we shall see that painterly energy was of secondary importance.

The object itself, as well as its essence, purpose, sense, or the fullness of its representation (as Cubists thought), was also unnecessary.

Hitherto it seemed that the beauty of objects is preserved when they are transmitted whole onto the picture, and moreover, that their essence is evident in the coarseness or simplification of line.

But it transpired that one more situation was found in objects – which reveals a new beauty to us.

Namely: intuitive feeling discovered in objects the energy of dissonance, a dissonance obtained from the confrontation of two contrasting forms.

Objects contain a mass of temporal moments. Their forms are diverse, and consequently, the ways in which they are painted are diverse.

All these temporal aspects of things and their anatomy (the rings of a tree) have become more important than their essence and meaning.

And these new situations were adopted by the Cubists as a means of constructing pictures.

Moreover, these means were constructed so that the unexpected confrontation of two forms would produce a dissonance of maximum force and tension.

And the scale of each form is arbitrary.

Which justifies the appearance of parts of real objects in places that do not correspond to nature.

In achieving this new beauty, or simply energy, we have freed ourselves from the impression of the object's wholeness.

The millstone around the neck of painting is beginning to crack.

An object painted according to the principle of Cubism can be considered finished when its dissonances are exhausted.

Nevertheless, repetitive forms should be omitted by the artist since they are mere reiterations.

But if the artist finds little tension in the picture, he is free to take them from another object.
Consequently, in Cubism the principle of transmitting objects does not arise.
A picture is made, but the object is not transmitted.

Hence this conclusion:
Over the past millennia, the artist has striven to approach the depiction of an object as closely as possible, to transmit its essence and meaning; then in our era of Cubism, the artist destroyed objects together with their meaning, essence and purpose.
A new picture has arisen from their fragments.
Objects have vanished like smoke, for the sake of the new culture of art.

Cubism, Futurism, and the [Russian] Wanderers [a realist group emphasizing the social and political as well as the purely aesthetic] differ in their aims, but are almost equal in a painterly sense.
Cubism builds its pictures from the forms of lines and from a variety of painterly textures, and in this case, words and letters are introduced as a confrontation of various forms in the picture.
Its graphic meaning is important. It is all for the sake of achieving dissonance.
And this proves that the aim of painting is the one least touched upon.
Because the construction of such forms is based more on actual superimposition than on colouring, which can be obtained simply by black and white paint or by drawing.
To sum up:
Any painted surface turned into a convex painterly relief is an artificial, coloured sculpture, and any relief turned into surface is painting.

The proof of intuitive creation in the art of painting was false, for distortion is the result of the inner struggle of intuition in the form of the real.
Intuition is a new reason, consciously creating forms.
But the artist, enslaved by utilitarian reason, wages an unconscious struggle, now submitting to an object, now distorting it.

Gauguin, fleeing from culture to the savages, and discovering more freedom in the primitives than in academism, found himself subject to intuitive reason.

He sought something simple, distorted, coarse.

This was the searching of his creative will.

At all costs not to paint as the eye of his common sense saw.

He found colours but did not find form, and he did not find it because common sense showed him the absurdity of painting anything except nature.

And so he hung his great creative force on the bony skeleton of man, where it shrivelled up.

Many warriors and bearers of great talent have hung it up like washing on a fence.

And all this was done out of love for nature's little nooks.

And let the authorities not hinder us from warning our generation against the clothes stands that they have become so fond of and that keep them so warm.

The efforts of the art authorities to direct art along the path of common sense annulled creation.

And with most talented people, real form is distortion.

Distortion was driven by the most talented to the point of disappearance, but it did not go outside the bounds of zero.

But I have transformed myself in the zero of form and through zero have reached creation, that is, Suprematism, the new painterly realism – non-objective creation.

Suprematism is the beginning of a new culture: the savage is conquered like the ape. There is no longer love of little nooks, there is no longer love for which the truth of art was betrayed.

The square is not a subconscious form. It is the creation of intuitive reason.

The face of the new art.

The square is a living, regal infant.

The first step of pure creation in art. Before it there were naïve distortions and copies of nature.

Our world of art has become new, non-objective, pure.

Everything has disappeared; a mass of material is left from which a new form will be built.

In the art of Suprematism, forms will live, like all living forms of nature. These forms announce that man has attained his equilibrium; he has left

the level of single reason and reached one of double reason.
(Utilitarian reason and intuitive reason.)
The new painterly realism is a painterly one precisely because it has no
realism of mountains, sky, water . . .

Hitherto there has been a realism of objects, but not of painterly, coloured
units, which are constructed so that they depend neither on form, nor
on colour, nor on their position vis-à-vis each other.

Each form is free and individual.
Each form is a world.
Any painterly surface is more alive than any face from which a pair of
eyes and a smile protrude.
A face painted in a picture gives a pitiful parody of life, and this allusion
is merely a reminder of the living.
But a surface lives; it has been born. A coffin reminds us of the dead; a
picture, of the living.
This is why it is strange to look at a red or black painted surface.
This is why people snigger and spit at the exhibitions of new trends.
Art and its new aim have always been a spittoon.
But cats get used to one place, and it is difficult to house-train them to a
new one.
For such people, art is quite unnecessary, as long as their grandmothers
and favourite little nooks of lilac groves are painted.

Everything runs from the past to the future, but everything should live
in the present, for in the future the apple trees will shed their blossoms.
Tomorrow will wipe away the vestige of the present, and you are too
late for the current of life.
The mire of the past, like a millstone, will drag you into the slough.
That is why I hate those who supply you with monuments to the dead.
The academy and the critics are this millstone around your neck. The
old realism is the movement that seeks to transmit living nature.
They carry on just as in the times of the Grand Inquisition.
Their aim is ridiculous because they want at all costs to force what they
take from nature to live on the canvas.
At the same time as everything is breathing and running, their frozen
poses are in pictures.

And this torture is worse than breaking on the wheel.

Sculptured statues, inspired, hence living, have stopped dead, posed as running.

Isn't this torture?

Enclosing the soul in marble and then mocking the living.

But you are proud of an artist who knows how to torture.

You put birds in a cage for pleasure as well.

And for the sake of knowledge, you keep animals in zoological gardens.

I am happy to have broken out of that inquisition torture chamber, academism.

I have arrived at the surface and can arrive at the dimension of the living body.

But I shall use the dimension from which I shall create the new.

I have released all the birds from the eternal cage and flung open the gates to the animals in the zoological gardens.

May they tear to bits and devour the leftovers of your art.

And may the freed bear bathe his body amid the flows of the frozen north and not languish in the aquarium of distilled water in the academic garden.

You go into raptures over a picture's composition, but in fact, composition is the death sentence for a figure condemned by the artist to an eternal pose.

Your rapture is the confirmation of this sentence.

The group of Suprematists – *[Kasimir] Malevich, [Ivan] Puni, [Mikhail] Menkov, [Ivan] Klyun, [Ksenia] Boguslavskaya, and [Olga] Rozanova – has waged the struggle for the liberation of objects from the obligations of art.*

And appeals to the academy to renounce the inquisition of nature.

Idealism and the demands of aesthetic sense are the instruments of torture.

The idealization of the human form is the mortification of the many lines of living muscle.

Aestheticism is the garbage of intuitive feeling.

You all wish to see pieces of living nature on the hooks of your walls.

Just as Nero admired the torn bodies of people and animals from the zoological garden.

I say to all: Abandon love, abandon aestheticism, abandon the baggage

of wisdom, for in the new culture, your wisdom is ridiculous and insignificant.

I have untied the knots of wisdom and liberated the consciousness of colour!

Hurry up and shed the hardened skin of centuries, so that you can catch up with us more easily.

I have overcome the impossible and made gulfs with my breath.

You are caught in the nets of the horizon, like fish!

We, Suprematists, throw open the way to you.

Hurry!

For tomorrow you will not recognize us.

M25 Hugo Ball

Dada Manifesto (1916)

Read at the first public Dada soirée, at the Waag Hall in Zürich, on 14
July 1916.

HUGO BALL (1886–1927) was the founder of the Cabaret Voltaire; the
catalyst of Zürich Dada and the polymorphous international manifest-
ation that ensued; and probably the person with the best claim to
suggesting or discovering its name. 'Dada' means something – some-
thing different – in French, German, Italian, Romanian and Russian, as
the Dada manifestos never cease to proclaim. It is a found word, like a
found object, found in a dictionary but free of any particular association
or prescriptive meaning. It is also a nonsense word. Its very utterance
makes the point: *dada* is almost infantile; it is essentially (one might say
syllabically) unserious. It is in fact the perfect appellation for the anarchic,
eclectic, transgressive performance that it became. Dada made an exhi-
bition of itself. That was its *raison d'être*.

Dada was nothing if not contrary. 'NO MORE WORDS. No more
manifestos,' runs a Dada manifesto. Dada had more than its share of
imps and jackanapes and professional provocateurs. It had schisms
aplenty. It had fun. It had effect. 'For my generation,' reflects Andrei
Codrescu (born 1946), the Romanian-American author of *The Post-Human
Dada Guide* (2009), 'Dada became a way of life, synonymous with life'
– the DADA-DNA of life. And for all it paraded its shameless gratuitous-
ness and monstrous childishness, it was not without artistic integrity or
intellectual appetite – even a certain ideological commitment. In the first
issue of the Dada review, *Cabaret Voltaire*, dated 15 May 1916, Hugo Ball
defined its activities as a reminder to the world 'that there are independ-
ent men – beyond war and nationalism – who live for their ideals'.

Cabaret Voltaire, Dada-central, was dedicated to 'artistic entertainment'

– 'our kind of *Candide* against the times', said Ball, in a reference to Voltaire's celebrated satire of 1759. ('If this is the best of all possible worlds, then what must the others be like?') In the shadow of Verdun, Dadaism dared to imagine all possible worlds, theatrically. This was at the same time a revolutionary and a variety act: in Dada, everything goes. 'Just as Dada is the cabaret of the world, so the world is the cabaret Dada.' The cabaret is the Dada donation to modernism, the fount and origin of its mischief-making overtaking of sense and sensibility.

The site of the original Cabaret Voltaire was (and still is) Spiegelgasse 1, Zürich. Across the road at number 6 lived a sequestered Russian émigré, intent on his writing. The book was *Imperialism, the Highest Stage of Capitalism* (1917), a kind of sequel to *The Communist Manifesto*. The regular scribbler was a little man by the name of Lenin. In a diary entry of 1917, Hugo Ball pondered the curious juxtaposition: 'He must have heard every evening our music and tirades, I wonder whether with pleasure and profit. And while we opened our gallery in the Bahnhofstrasse, the Russians travelled to St Petersburg to start the revolution. Is Dadaism in the end as sign and gesture the counterpart to Bolshevism? Does Dadaism confront destruction and absolute calculation with the completely quixotic, purposeless, and incomprehensible world? It will be interesting to see what happens there and here.'

The first to be invoked in the manifesto below are two fellow founder Dadaist manifestoists, Tristan Tzara (M28) and Richard Huelsenbeck (M29). At this same soirée, Huelsenbeck read a 'declaration' sending up *The Communist Manifesto*. It proposed to replace the famous slogan 'Workers of the World, Unite!' with 'Workers of the World, Go Dada!'

* * *

Dada is a new tendency in art. One can tell this from the fact that until now nobody knew anything about it, and tomorrow everyone in Zürich will be talking about it. Dada comes from the dictionary. It is terribly simple. In French it means 'hobby horse'. In German it means 'good-bye', 'Get off my back', 'Be seeing you sometime'. In Romanian: 'Yes, indeed, you are right, that's it. But of course, yes, definitely, right.' And so forth.

An international word. Just a word, and the word a movement. Very easy to understand. Quite terribly simple. To make of it an artistic

tendency must mean that one is anticipating complications. Dada psychology, dada Germany cum indigestion and fog paroxysm, dada literature, dada bourgeoisie, and yourselves, honoured poets, who are always writing with words but never writing the word itself, who are always writing around the actual point. Dada world war without end, dada revolution without beginning, dada, you friends and also poets, esteemed sirs, manufacturers, and evangelists. Dada Tzara, dada Huelsenbeck, dada m'dada, dada m'dada dada mhm, dada dera dada, dada Hue, dada Tza.

How does one achieve eternal bliss? By saying dada. How does one become famous? By saying dada. With a noble gesture and delicate propriety. Till one goes crazy. Till one loses consciousness. How can one get rid of everything that smacks of journalism, worms, everything nice and right, blinkered, moralistic, europeanized, enervated? By saying dada. Dada is the world soul, dada is the pawnshop. Dada is the world's best lily-milk soap. Dada Mr Rubiner, dada Mr Korrodi. Dada Mr Anastasius Lilienstein. In plain language: the hospitality of the Swiss is something to be profoundly appreciated. And in questions of aesthetics the key is quality.

I shall be reading poems that are meant to dispense with conventional language, no less, and to have done with it. Dada Johann Fuchsgang Goethe. Dada Stendhal. Dada Dalai Lama, Buddha, Bible and Nietzsche. Dada m'dada. Dada mhm dada da. It's a question of connections, and of loosening them up a bit to start with. I don't want words that other people have invented. All the words are other people's inventions. I want my own stuff, my own rhythm, and vowels and consonants too, matching the rhythm and all my own. If this pulsation is seven yards long, I want words for it that are seven yards long. Mr Schulz's words are only two and a half centimetres long.

It will serve to show how articulated language comes into being. I let the vowels fool around. I let the vowels quite simply occur, as a cat miaows . . . Words emerge, shoulders of words, legs, arms, hands of words. Au, oi, uh. One shouldn't let too many words out. A line of poetry is a chance to get rid of all the filth that clings to this accursed language, as if put there by stockbrokers' hands, hands worn smooth by coins. I want the word where it ends and begins. Dada is the heart of words.

Each thing has its word, but the word has become a thing by itself. Why shouldn't I find it? Why can't a tree be called Pluplusch, and Pluplubasch

when it has been raining? The word, the word, the word outside your domain, your stuffiness, this laughable impotence, your stupendous smugness, outside all the parrotry of your self-evident limitedness. The word, gentlemen, is a public concern of the first importance.

M26 Olga Rozanova

Cubism, Futurism, Suprematism (1917)

Written for the journal *Supremus*, but not published.

OLGA ROZANOVA (1886–1918) was once dubbed by Malevich himself 'the only true Suprematist'. In fact she had an eye and a mind of her own. She arrived at Suprematism via Neo-Primitivism, Cubism, Futurism and Cubo-Futurism; she knew the field. Here she enters into a dialogue with her senior. Whereas for Malevich '*paint* is the main thing', for Rozanova it is *colour*. 'It is the properties of colour that create dynamism, engender style, and justify the construction.' In his 'Posthumous Word' on Rozanova, Rodchenko wrote: 'Was it not you who wanted to light up the world in cascades of colour? Was it not you who proposed projecting colour compositions into the ether? . . . You [who] thought of creating colour through light.'

Suprematism was for Rozanova a laboratory whose experiments were carried on in radiant, rarefied abstract painting – 'painting of transfigured colour far from utilitarian goals' – and by attempting to transform the everyday into a 'living environment' for art, with Suprematist designs for women's fashions, handbags and embroideries. It might be said that she put the object back into non-objective art. If there was something a little inhuman in Malevich's uncompromising stance, Rozanova spoke of revealing a new beauty to the world.

See also Malevich, 'Suprematist Manifesto' (M24) and Popova, 'On Organizing Anew' (M38).

* * *

. . . We propose liberating painting from its subservience to the ready-

made form of reality and to make it first and foremost a creative, not a reproductive, art.

The savage happily drawing the outlines of a bull or a deer on a piece of stone, the primitive, the academician, the artists of antiquity and of the Renaissance, the Impressionists, the Cubists, and even to some degree the Futurists are all united by the same thing: the object. These artists are intrigued, delighted, amazed and gladdened by nature. They try to fathom her essence, they aspire to immortalize her . . .

Cubism killed the love of the everyday appearance of the object, but not the love of the object as a whole. Nature continued to be the guide of aesthetic ideas. The works of the Cubists lack a clearly defined idea of non-objective art.

Their art is characterized by efforts to complicate the task of depicting reality. Their complaint against the established prescriptions for copying nature turned into a formidable bomb that smashed the decayed metaphysics of figurative art into smithereens – an art that had lost all idea of aim and technique . . .

In its force and its clarity of perception, Futurism provided art with a unique expression – the fusion of two worlds, the subjective and the objective. Maybe this event is destined never to be repeated.

But the ideological gnosticism of Futurism had no effect on the damned consciousness of the majority who, to this day, continue to reiterate that Futurism marks a radical break in the course of world art, a crisis of art . . .

Our time is one of metal, its soul is initiative and technology: the Futurists brought technology to its full potential . . .

Until the Futurists came along, artists used to express movement in the following conventional manner: a maximum expression of movement resulted from placing forms on the surface of the canvas parallel to the perimeter of the canvas, and a maximum static expression resulted from the placing of the forms parallel to the surface of the canvas.

The spectator did not sense movement in the picture. All he saw was a rendering of movement . . .

For the Suprematists, the painting has ceased, once and for all, to be a function of the frame.

We do not regard the forms that we use as real objects. We do not

force them to depend on the up and down directions in the painting . . . We consider their painterly content.

Consequently, the emphasis on symmetry or asymmetry, on static or dynamic elements, is the result of creative thinking and not of the preconceived notions of common logic. The aesthetic value of the non-objective painting lies entirely in its painterly content.

We perceive the colour of an object as its hue made visible by the refraction of light (the rainbow, the spectrum). But we can also conceive of colour independently of our conception of the object, and beyond the colours of the spectrum.

We can see green, blue and white mentally . . .

The unreality of the Cubo-Futurists was a product of their self-destructive desire to convey the total reality of the object via the prism of pure subjectivity. This was so remarkable that 'non-existence', created by the artist's will, acquired the value of a new reality, of a kind of abstract absolute that killed any interest in what was actually being observed . . .

Suprematism rejects the use of real forms for painterly ends. Like leaky vessels, they cannot hold colour. Stifled by the chance simplicity or complexity of these forms, which may not always correspond to their respective colour content, colour just creeps about, faded and dim . . . We create quality of form in connection with quality of colour, and not each separately.

We have chosen the plane as the transmitter of colour, since its reflective surface will transmit the colour the most effectively and with the least mutability. As a result, reliefs, appliqués, textures that imitate material reality, and sculptural effects (for example, a brushstroke creates shadow), which were used in figurative painting (right up to, and including, Futurism), cannot be applied to two-dimensional painting on a plane: such factors influence and change the essence of colour . . .

Just as change in the atmosphere can create a strong or weak air current in nature, one can overturn and destroy things, so dynamism in the world of colours is created by the properties of their values, by their weight or lightness, by their intensity or duration. This dynamism is, essentially, very real. It commands attention. It engenders style and justifies [the] construction.

Dynamism liberates painting from the arbitrary laws of taste and

establishes the law of pragmatic inevitability. It also liberates painting from utilitarian considerations . . .

The works of pure painting have the right to exist independently and not in relation to banal interior furnishings. To many, our efforts and endeavours – as well as those of our Cubist and Futurist predecessors – to put painting on a course of self-determination may seem ridiculous, and this is because they are difficult to understand and do not come with glowing recommendations. Nevertheless, we do believe that a time will come when, for many people, our art will become an aesthetic necessity – an art justified by its selfless aspiration to reveal a new beauty.

M27 Vladimir Mayakovsky and others
Manifesto of the Flying Federation of Futurists (1918)

'Given in Moscow, March 1918.' Signed by David Burliuk, Vasily Kamensky and Mayakovsky.

'Judaic' here means biblical subjects and themes, rather than anything more specific or sinister.

For biographical details on Mayakovsky, see the headnote to 'A Drop of Tar' (M23).

* * *

The old regime rested on three foundations: political slavery, social slavery, spiritual slavery.

The February revolution destroyed political slavery. The road to Tobolsk is covered with the black feathers of the two-headed eagle.

October [1917] threw the bomb of social revolution under capital.

Far away on the horizon you can see the fat rear ends of fleeing factory owners.

And only the third foundation – Spiritual Slavery – stands unwavering.

It continues to spit out a fountain of stagnant water called old art.

The theatres still put on 'Judaic' and other 'tsarist [plays]' (the compositions of the Romanovs); we have monuments to generals; princes, tsars' mistresses, and *tsaritsas*' lovers still stand with a heavy, threatening paw on the throat of young streets.

In junk shops pompously referred to as exhibitions, they sell the pure dabblings of landowners' lordly daughters, and dachas in the style of 'rococo' and other Ludwigs.

And, finally, on our own shining holidays, it is not our own anthem we sing but a grey-haired '*Marseillaise*' borrowed from the French.

That's enough.

We, the proletariat of art – call on the proletariat of the factories and the land to a third, bloodless but cruel revolution – the Spiritual Revolution

We demand recognition:

1. The separation of art from the state, the destruction of patronage, privilege, and control in the area of art.

Down with the diploma, awards, official posts, and ranks.

2. That all the material means of art: the theatres, choir chapels, exhibition spaces, and buildings of the academy of arts and the art schools – be handed over to the masters of art themselves for the equal use of them by all the people of art.

3. Universal art education, for we believe that the foundation of the future free art can only come out of the depths of a democratic Russia, which until now has only craved the bread of art.

4. The immediate requisition, along with foodstuffs, of all hidden aesthetic stores for the fair and equal use by all of Russia.

Long live the third Revolution – the Revolution of the Spirit!

M28 Tristan Tzara

Dada Manifesto (1918)

Read at the Dadaist soirée at the Saal zur Meise in Zürich, on 23 July 1918; first published in *Dada 3* (December 1918); reprinted in *Sept Manifestes Dada* [*Seven Dada Manifestos*] (Paris, 1924).

TRISTAN TZARA (Samuel Rosenstock, 1896–1963) was the daddy of Dada – a combination of capo and impresario, splendiferous showmanship and vainglorious self-advancement. Tzara was a diminutive Romanian post-Symbolist poet who came to Zürich to study philosophy in 1915. In his autobiography, 'Faites vos jeux' ('Place your bets'), written at the age of twenty-seven, he dramatizes his own unreliable character, bad faith, depressive morbidity and 'melancholy thirst'. Tzara was by no means a negligible poet, but he was a virtuoso of the manifesto. In print, he was captivating. In person, he left a lot to be desired.

Tzara dreamt of fame. For that express purpose he took Marinetti as his model. One of his confederates describes him in this period as a kind of super-Futurist, 'who wanted to exceed Futurism by his own length and marinate Marinetti in his own sauce'. Tzara was impatient to supplant Futurism with Dadaism ('which sounds so much better'), and he succeeded, borrowing liberally in the process. The very idea of the cabaret drew on the Futurist *serate* or performance, not least in its provocation of the audience, just as Dada stand-up or free-form drew on the famous *parole in libertà* (words-in-freedom). When Tzara gave his first reading at a Dada matinée in Paris, in 1920, he made use of offstage electric bells, manned by André Breton and Louis Aragon, as Marinetti-style sound effects – but in Tzara's case it was to conceal the embarrassment of his accent (so excruciating that Breton would flee to an adjoining room whenever he started to recite, and Aragon claimed that he even had to be taught how to say 'Dada' in French). Marinetti himself was published in the *Cabaret Voltaire* review, and

carefully studied. Above all, the Dadaists moved into manifestos. The Dada manifesto was their signature and tribute. Small wonder that the Italians regarded Zürich Dada as 'Futurisme allemandisé' (Germanized).

* * *

The magic of a word – Dada – which has brought journalists to the gates of a world unforeseen, is of no importance to us.

To put out a manifesto you must want: ABC to fulminate against 1, 2, 3, to fly into a rage and sharpen your wings to conquer and disseminate little abcs and big abcs, to sign, shout, swear, to organize prose into a form of absolute and irrefutable evidence, to prove your non plus ultra and maintain that novelty resembles life just as the latest appearance of some whore proves the essence of God. His existence was previously proved by the accordion, the landscape, the wheedling word. To impose your ABC is a natural thing – hence deplorable. Everybody does it in the form of crystalbluffmadonna, monetary system, pharmaceutical product, or a bare leg advertising the ardent sterile spring. The love of novelty is the cross of sympathy, demonstrates a naive *je m'enfoutisme*, it is a transitory, positive sign without a cause.

But this need itself is obsolete. In documenting art on the basis of supreme simplicity: novelty, we are human and true for the sake of amusement, impulsive, vibrant to crucify boredom. At the crossroads of the lights, alert, attentively awaiting the years, in the forest. I write a manifesto and I want nothing, yet I say certain things, and in principle I am against manifestos, as I am also against principles (half-pints to measure the moral value of every phrase too too convenient; approximation was invented by the Impressionists). I write this manifesto to show that people can perform contrary actions together while taking one fresh gulp of air; I am against action; for continuous contradiction, for affirmation too, I am neither for nor against and I do not explain because I hate common sense.

Dada – there you have a word that leads ideas to the hunt: every bourgeois is a little dramatist; he invents all sorts of speeches instead of putting the characters suitable to the quality of his intelligence, chrysalises, on chairs, seeks causes or aims (according to the psychoanalytic method he practises) to cement his plot, a story that speaks and defines itself. Every spectator is a plotter if he tries to explain a word: (to know)! Safe in the

cottony refuge of serpentine complications, he manipulates his instincts. Hence the mishaps of conjugal life.

To explain: the amusement of redbellies in the mills of empty skulls.

DADA MEANS NOTHING

If you find it futile, and don't want to waste your time on a word that means nothing . . . The first thought that comes to these people is bacteriological in character: to find its etymological, or at least historical or psychological origin. We see by the papers that the Kru Negroes call the tail of a holy cow Dada. The cube and the mother in a certain district of Italy are called: Dada. A hobby horse, a nurse, both in Russian and Romanian: Dada. Some learned journalists regard it as an art for babies, other holy jesusescallingthelittlechildren of our day, as a relapse into a dry and noisy, noisy and monotonous primitivism. Sensibility is not constructed on the basis of a word; all constructions converge on perfection which is boring, the stagnant idea of a gilded swamp, a relative human product. A work of art should not be beauty in itself, for beauty is dead; it should be neither gay nor sad, neither light nor dark to rejoice or torture the individual by serving him the cakes of sacred aureoles or the sweets of a vaulted race through the atmospheres. A work of art is never beautiful by decree, objectively and for all. Hence criticism is useless, it exists only subjectively, for each man separately, without the slightest character of universality. Does anyone think he has found a psychic base common to all mankind? The attempt of Jesus and the Bible covers with their broad benevolent wings: shit, animals, days. How can one expect to put order into the chaos that constitutes that infinite and shapeless variation: man? The principle: 'love thy neighbour' is a hypocrisy. 'Know thyself' is utopian but more acceptable, for it embraces wickedness. No pity. After the carnage we still retain the hope of a purified mankind. I speak only of myself since I do not wish to convince, I have no right to drag others into my river, I oblige no one to follow me and everybody practises his art in his own way, if he knows the joy that rises like arrows to the astral layers, or that other joy that goes down into the mines of corpse-flowers and fertile spasms. Stalactites: seek them everywhere, in mangers magnified by pain, eyes white as the hares of the angels.

And so Dada was born of a need for independence, of a distrust towards unity. Those who are with us preserve their freedom. We recognize no theory. We have enough Cubist and Futurist academies:

laboratories for formal ideas. Is the aim of art to make money and cajole the nice, nice bourgeois? Rhymes ring with the assonance of the currencies and the inflection slips along the line of the belly in profile. All groups of artists have arrived at this trust company after riding their steeds on various comets. While the door remains open to the possibility of wallowing in cushions and good things to eat.

Here we cast anchor in rich ground. Here we have a right to do some proclaiming, for we have known cold shudders and awakenings. Ghosts drunk on energy, we dig the trident into unsuspecting flesh. We are a downpour of maledictions as tropically abundant as vertiginous vegetation, resin and rain are our sweat, we bleed and burn with thirst, our blood is vigour.

Cubism was born out of the simple way of looking at an object: Cézanne painted a cup twenty centimetres below his eyes, the Cubists look at it from above, others complicate appearance by making a perpendicular section, arranging it conscientiously on the side. (I do not forget the creative artists and the profound laws of matter which they established once and for all.)

The Futurist sees the same cup in movement, a succession of objects, one beside the other, and maliciously adds a few force lines. This does not prevent the canvas from being a good or a bad painting suitable for the investment of intellectual capital.

The new painter creates a world, the elements of which are also its implements, a sober, definitive work without argument. The new artist protests: he no longer paints (symbolic and illusionist reproduction) but creates – directly in stone, wood, iron, tin, boulders – locomotive organisms capable of being turned in all directions by the limpid wind of momentary sensation. All pictorial or plastic work is useless: let it then be a monstrosity that frightens servile minds, and not sweetening to decorate the refectories of animals in human costume, illustrating the sad fable of mankind.

Painting is the art of making two lines geometrically established as parallel meet on a canvas before our eyes in a reality which transposes other conditions and possibilities into a world. This world is not specified or defined in the work, it belongs in its innumerable variations to the spectator. For its creator it is without cause and without theory. *Order = disorder; ego = non-ego; affirmation = negation*: the supreme radiations of an absolute art. Absolute in the purity of a cosmic ordered chaos, eternal in the globule of a second without duration, without breath, without

control. I love an ancient work for its novelty. It is only contrast that connects us with the past. The writers who teach morality and discuss or improve psychological foundations have, aside from a hidden desire to make money, an absurd view of life, which they have classified, cut into sections, channelized: they insist on waving the baton as the categories dance. Their readers snigger and go on: for what?

There is a literature that does not reach the voracious mass. It is the work of creators, issued from a real necessity in the author, produced for himself. It expresses the knowledge of a supreme egoism, in which laws wither away. Every page must explode, either by profound heavy seriousness, the whirlwind, poetic frenzy, the new, the eternal, the crushing joke, enthusiasm for principles, or by the way in which it is printed. On the one hand a tottering world in flight, betrothed to the glockenspiel of hell; on the other hand: new men. Rough, bouncing, riding on hiccups. Behind them a crippled world and literary quacks with a mania for improvement.

I say unto you: there is no beginning and we do not tremble, we are not sentimental. We are a furious wind, tearing the dirty linen of clouds and prayers, preparing the great spectacle of disaster, fire, decomposition. We will put an end to mourning and replace tears by sirens screeching from one continent to another. Pavilions of intense joy and widowers with the sadness of poison. Dada is the signboard of abstraction; advertising and business are also elements of poetry.

I destroy the drawers of the brain and of social organization: spread demoralization wherever I go and cast my hand from heaven to hell, my eyes from hell to heaven, restore the fecund wheel of a universal circus to objective forces and the imagination of every individual.

Philosophy is the question: from which side shall we look at life, God, the idea or other phenomena. Everything one looks at is false. I do not consider the relative result more important than the choice between cake and cherries after dinner. The system of quickly looking at the other side of a thing in order to impose your opinion indirectly is called dialectics, in other words, haggling over the spirit of fried potatoes while dancing method around it.

If I cry out:

Ideal, ideal, ideal,

Knowledge, knowledge, knowledge,
Boomboom, boomboom, boomboom,

I have given a pretty faithful version of progress, law, morality and all other fine qualities that various highly intelligent men have discussed in so many books, only to conclude that after all everyone dances to his own personal boomboom, and that the writer is entitled to his boomboom: the satisfaction of pathological curiosity; a private bell for inexplicable needs; a bath; pecuniary difficulties; a stomach with repercussions in life; the authority of the mystic wand formulated as the bouquet of a phantom orchestra made up of silent fiddle bows greased with philtres made of chicken manure. With the blue eye-glasses of an angel they have excavated the inner life for a dime's worth of unanimous gratitude. If all of them are right and if all pills are Pink Pills, let us try for once not to be right. Some people think they can explain rationally, by thought, what they think. But that is extremely relative. Psychoanalysis is a dangerous disease, it puts to sleep the anti-objective impulses of men and systematizes the bourgeoisie. There is no ultimate Truth. The dialectic is an amusing mechanism which guides us / in a banal kind of way / to the opinions we had in the first place. Does anyone think that, by a minute refinement of logic, he has demonstrated the truth and established the correctness of these opinions? Logic imprisoned by the senses is an organic disease. To this element philosophers always like to add: the power of observation. But actually this magnificent quality of the mind is the proof of its impotence. We observe, we regard from one or more points of view, we choose them among the millions that exist. Experience is also a product of chance and individual faculties. Science disgusts me as soon as it becomes a speculative system, loses its character of utility – that is so useless but is at least individual. I detest greasy objectivity, and harmony, the science that finds everything in order. Carry on, my children, humanity . . . Science says we are the servants of nature: everything is in order, make love and bash your brains in. Carry on, my children, humanity, kind bourgeois and journalist virgins . . . I am against systems, the most acceptable system is on principle to have none. To complete oneself, to perfect oneself in one's own littleness, to fill the vessel with one's individuality, to have the courage to fight for and against thought, the mystery of bread, the sudden burst of an infernal propeller into economic lilies:

Dadaist Spontaneity

I call *je m'en foutisme* the kind of life in which everyone retains his own conditions, though respecting other individualisms, except when the need arises to defend oneself, in which the two-step becomes national anthem, curiosity shop, a radio transmitting Bach fugues, electric signs and posters for whorehouses, an organ broadcasting carnations for God, all this together physically replacing photography and the universal catechism.

Active Simplicity

Inability to distinguish between degrees of clarity: to lick the penumbra and float in the big mouth filled with honey and excrement. Measured by the scale of eternity, all activity is vain – (if we allow thought to engage in an adventure the result of which would be infinitely grotesque and add significantly to our knowledge of human impotence). But supposing life to be a poor farce, without aim or initial parturition, and because we think it our duty to extricate ourselves as fresh and clean as washed chrysanthemums, we have proclaimed as the sole basis for agreement: art. It is not as important as we, mercenaries of the spirit, have been proclaiming for centuries. Art afflicts no one and those who manage to take an interest in it will harvest caresses and a fine opportunity to populate the country with their conversation. Art is a private affair, the artist produces it for himself; an intelligible work is the product of a journalist, and because at this moment it strikes my fancy to combine this monstrosity with oil paints; a paper tube simulating the metal that is automatically pressed and poured hatred cowardice villainy. The artist, the poet, rejoices at the venom of the masses condensed into a section chief of this industry, he is happy to be insulted, it is proof of his immutability. When a writer or artist is praised by the newspapers, it is proof of the intelligibility of his work: wretched lining of a coat for public use; tatters covering brutality, piss contributing to the warmth of an animal brooding vile instincts. Flabby, insipid flesh reproducing with the help of typographical microbes.

We have thrown out the cry-baby in us. Any infiltration of this kind is candied diarrhoea. To encourage this art is to digest it. What we need

is works that are strong straight precise and forever beyond understanding. Logic is a complication. Logic is always wrong. It draws the threads of notions, words, in their formal exterior, towards illusory ends and centres. Its chains kill, it is an enormous centipede stifling independence. Married to logic, art would live in incest, swallowing, engulfing its own tail, still part of its own body, fornicating within itself, and passion would become a nightmare tarred with Protestantism, a monument, a heap of ponderous grey entrails. But the suppleness, enthusiasm, even the joy of injustice, this little truth which we practise innocently and which makes us beautiful: we are subtle, and our fingers are malleable and slippery as the branches of that sinuous, almost liquid plant; it defines our soul, say the cynics. That too is a point of view; but all flowers are not sacred, fortunately, and the divine thing in us is our call to anti-human action. I am speaking of a paper flower for the buttonholes of the gentlemen who frequent the ball of masked life, the kitchen of grace, white cousins lithe or fat. They traffic with whatever we have selected. The contradiction and unity of poles in a single toss can be the truth. If one absolutely insists on uttering this platitude, the appendix of libidinous, malodorous morality. Morality creates atrophy like every plague produced by intelligence. The control of morality and logic has inflicted us with impassivity in the presence of policemen – who are the cause of slavery, putrid rats infecting the bowels of the bourgeoisie which have infected the only luminous clean corridors of glass that remained open to artists.

Let each man proclaim: there is a great negative work of destruction to be accomplished. We must sweep and clean. Affirm the cleanliness of the individual after the state of madness, aggressive complete madness of a world abandoned to the hands of bandits, who rend one another and destroy the centuries. Without aim or design, without organization: indomitable madness, decomposition. Those who are strong in words or force will survive, for they are quick in defence, the agility of limbs and sentiments flames on their faceted flanks.

Morality has determined charity and pity, two balls of fat that have grown like elephants, like planets, and are called good. There is nothing good about them. Goodness is lucid, clear and decided, pitiless towards compromise and politics. Morality is an injection of chocolate into the veins of all men. This task is not ordered by a supernatural force but by the trust of idea brokers and grasping academicians.

Sentimentality: at the sight of a group of men quarrelling and bored, they invented the calendar and the medicament wisdom. With a sticking of labels the battle of philosophers was set off (mercantilism, scales, meticulous and petty measures) and for the second time it was understood that pity is a sentiment like diarrhoea in relation to the disgust that destroys health, a foul attempt by carrion corpses to compromise the sun. I proclaim the opposition of all cosmic faculties to this gonorrhoea of a putrid sun issued from the factories of philosophical thought, I proclaim bitter struggle with all the weapons of

Dadaist Disgust

Every product of disgust capable of becoming a negation of the family is *Dada*; a protest with the fists of its whole being engaged in destructive action:

Dada; knowledge of all the means rejected up until now by the shamefaced sex of comfortable compromise and good manners: Dada; abolition of logic, which is the dance of those impotent to create: Dada; of every social hierarchy and equation set up for the sake of values by our valets: Dada; every object, all objects, sentiments, obscurities, apparitions and the precise clash of parallel lines are weapons for the fight: Dada; abolition of memory: Dada; abolition of archaeology: Dada; abolition of prophets: Dada; abolition of the future: Dada; absolute and unquestionable faith in every god that is the immediate product of spontaneity:

Dada; elegant and unprejudiced leap from a harmony to the other sphere; trajectory of a word tossed like a screeching phonograph record; to respect all individuals in their folly of the moment: whether it be serious, fearful, timid, ardent, vigorous, determined, enthusiastic; to divest one's church of every useless cumbersome accessory; to spit out disagreeable or amorous ideas like a luminous waterfall, or coddle them – with the extreme satisfaction that it doesn't matter in the least – with the same intensity in the thicket of one's soul – pure of insects for blood well-born, and gilded with bodies of archangels. Freedom: DADA DADA DADA, a roaring of tense colours, and interlacing of opposites and of all contradictions, grotesques, inconsistencies: LIFE

M29 Richard Huelsenbeck

First German Dada Manifesto (1918)

Read as the 'First German Dada Manifesto' at the I. B. Neumann Gallery
in Berlin in February 1918; first published in *Der Zweemann* (Hanover,
1919); reprinted in the *Dada Almanach* (Berlin, 1920); reissued as the
'Collective Dada Manifesto' (1920), signed by Ball, Huelsenbeck, Tzara,
Pierre Albert-Birot, Hans Arp, George Grosz, Franz Jung, Raoul Haus-
mann (see M32) and Marcel Janco (1895–1984), Tzara's friend and ally,
who subsequently founded a Dada museum in the artists' village of Ein
Hod in Israel. Some ninety years later, in his 'Second Diasporist Mani-
festo' (M98), R. B. Kitaj paid homage to Tzara and Janco together as
'Jewish founders of Dada'.

This manifesto reveals and exemplifies certain Dada attitudes – 'Dada
is a state of mind' is in itself an apt reflection, appropriated by André
Breton – whilst its concluding thought is very Dada. Huelsenbeck could
turn a phrase. He called Kurt Schwitters 'the Caspar David Friedrich of
the Dadaist revolution'. The temptation to 'blast' this and 'blast' that is
reminiscent of Wyndham Lewis (see M17).

RICHARD HUELSENBECK (1892–1974) was a Dada drummer, famous
for loud, invented African chants ending in 'Umba! Umba!', and in later
life a New York psychoanalyst, trading under the name of Dr Charles R.
Hulbeck. In *The Post-Human Dada Guide* he is said to embody the essen-
tial qualities of the Dada life: prodigality, horniness, charming simplicity,
and contention over the birth of one's phonetic religion.

It was Huelsenbeck who spearheaded the move from Zürich Dada
to Berlin Dada. Zürich was a sheltered place, and Paris positively sybar-
itic. In Berlin there was revolution in the streets. The German
Communist Party (KPD), founded by Karl Liebknecht and Rosa Luxem-
burg, published its own 'Spartacus Manifesto' (1918). 'Germany is

pregnant with the social revolution, but socialism can be realized only by the proletariat of the world.' The social revolution failed: the Spartacist revolt was crushed; their leaders were shot like dogs. Huelsenbeck's confederate Raoul Hausmann wrote: 'On an unhappy day [in 1919], the news about the murder of Karl Liebknecht and Rosa Luxemburg spread. The proletariat was paralysed and did not awake from its paralysis . . . Therefore, we had to make the Dada-action stronger: against a world that did not react decently even when faced with unforgivable atrocities.' Dada takes the place of Sparta, continuing the revolutionary project. Revolution in one country was always problematic; revolution in one realm might yet carry the day. Action-art rarely had more meaning. That same year, in the first issue of the review *Der Dada*, Jefim Golyscheff, Hausmann and Huelsenbeck published a manifesto, 'What is Dadaism and what does it want in Germany?' (M32), explicitly aligning itself with the Communist cause – with a Dadaist twist. Many Dadaists were also Communists, though Dada never officially joined the Party or the Proletkult; the Soviet-style commissar for enlightenment may have sounded like a Dada invention, but the Dadas were averse to commissars of every kind.

In April 1919 Hausmann and Johannes Baader 'founded' a Dada republic by manifesto, in which they instructed the mayor of Berlin to hand over the treasury and commanded the city's employees to obey only the orders of the joint authors. Sadly, the Dada republic was stillborn.

* * *

Art in its execution and direction is dependent on the time in which it lives, and artists are creatures of their epoch. The highest art will be that which in its conscious content presents the thousandfold problems of the day, the art which has been visibly shattered by the explosions of last week, which is forever trying to collect its limbs after yesterday's crash. The best and most extraordinary artists will be those who every hour snatch the tatters of their bodies out of the frenzied cataract of life, who, with bleeding hands and hearts, hold fast to the intelligence of their time. Has Expressionism fulfilled our expectations of such an art, which should be a representation of our most vital concerns?

No! No! No!

Have the Expressionists fulfilled our expectations of an art that burns the essence of life into our flesh?

No! No! No!

Under the pretext of turning inward, the Expressionists in literature and painting have banded together into a generation which is already looking forward to honourable mention in the histories of literature and art and aspiring to the most respectable civic distinctions. On the pretext of carrying on propaganda for the soul, they have, in their struggle for naturalism, found their way back to the abstract, pathetic gestures which presuppose a comfortable life free from content or strife. The stages are filling up with kings, poets and Faustian characters of all sorts; the theory of a melioristic philosophy, the psychological *naïveté*, which is highly significant for a critical understanding of Expressionism, runs ghostlike through the minds of men who never act. Hatred of the press, hatred of advertising, hatred of sensations are typical of people who prefer their armchair to the noise of the street, and who even make it a point of pride to be swindled by every small-time profiteer. That sentimental resistance to the times, which are neither better nor worse, neither more reaction- ary nor more revolutionary than other times, that weak-kneed resistance, flirting with prayers and incense when it does not prefer to load its cardboard cannon with Attic iambics – is the quality of a youth which never knew how to be young. Expressionism, discovered abroad, and in Germany, true to style, transformed into an opulent idyll and the expectation of a good pension, has nothing in common with the efforts of active men. The signers of this manifesto have, under the battle cry:

Dada !!!!

gathered together to put forward a new art, from which they expect the realization of new ideals. What then is DADAISM?

The word Dada symbolizes the most primitive relation to the reality of the environment; with Dadaism a new reality comes into its own. Life appears as a simultaneous muddle of noises, colours and spiritual rhythms, which is taken unmodified into Dadaist art, with all the sensa- tional screams and fevers of its reckless everyday psyche and with all its brutal reality. This is the sharp dividing line separating Dadaism from all artistic directions up to now and particularly from FUTURISM, which not long ago some puddingheads took to be a new version of Impres- sionist realization. Dadaism for the first time has ceased to take an

aesthetic attitude towards life, and this it accomplishes by tearing all the slogans of ethics, culture and inwardness, which are merely cloaks for weak muscles, into their components.

The Bruitist poem

represents a streetcar as it is, the essence of the streetcar with the yawning of Schulze, the coupon clipper and the screeching of the brakes.

The Simultaneist poem

teaches a sense of the merrygoround of all things; while Herr Schulze reads his paper, the Balkan Express crosses the bridge at Nish, a pig squeals in Butcher Nuttke's cellar.

The Static poem

makes words into individuals, out of the letters spelling woods, steps the woods with its treetops, liveried foresters and wild sows, maybe a boarding house steps out too, and maybe it's called Bellevue or Bella Vista. Dadaism leads to amazing new possibilities and forms of expression in all the arts. It made Cubism a dance on the stage, it disseminated the BRUITIST music of the Futurists (whose purely Italian concerns it has no desire to generalize) in every country of Europe. The word Dada in itself indicates the internationalism of the movement which is bound to no frontiers, religions or professions. Dada is the international expression of our times, the great rebellion of artistic movements, the artistic reflex of all these offensives, peace congresses, riots in the vegetable market, midnight suppers at the Esplanade, etc., etc. Dada champions the use of the
new medium in painting.

Dada is a CLUB, founded in Berlin, which you can join without commitments. In this club every man is chairman and every man can have his say in artistic matters. Dada is not a pretext for the ambition of a few literary men (as our enemies would have you believe), Dada is a state of mind that can be revealed in any conversation whatever, so that you are compelled to say: this man is a DADAIST – that man is not; the Dada Club consequently has members all over the world, in Honolulu as well as New Orleans and Meseritz. Under certain circumstances to be a Dadaist may mean to be more a businessman, more a political partisan than an artist – to be an artist only by accident – to be a Dadaist means to let oneself be thrown by things, to oppose all sedimentation; to sit in a chair for a single moment is to risk one's life (Mr Wengs pulled his revolver out of his trouser pocket). A fabric tears under your hand, you

say yes to a life that strives upward by negation. Affirmation – negation: the gigantic hocus-pocus of existence fires the nerves of the true Dadaist – and there he is, reclining, hunting, cycling – half Pantagruel, half St Francis, laughing and laughing. Blast the aesthetic-ethical attitude! Blast the bloodless abstraction of Expressionism! Blast the literary hollowheads and their theories for improving the world! For Dadaism in word and image, for all the Dada things that go on in the world. To be against this manifesto is to be a Dadaist!

M30 Amédée Ozenfant and Charles-Édouard Jeanneret [Le Corbusier]
Purism (1918)

Dated 15 October 1918, but not published until after the Armistice, shortly before the opening of their joint exhibition at the Galerie Thomas in Paris (December 1918 – January 1919), in *Après le cubisme* (Paris, 1918). The two authors published a longer essay on 'Le Purisme' in *L'Esprit Nouveau* 4 (January 1921), the multi-media review founded by the painter Ozenfant, the architect Jeanneret, and the poet-publicist Paul Dermée.

Purism was a reaction to Cubism and the Great War – a bid to put both behind them – embracing painting and architecture, interior and industrial design, and urban planning. It championed traditionalism, even classicism, with a formal emphasis on clean lines, refinement, visual clarification and purification, whilst at the same time embracing new technologies, new materials and the machine aesthetic. Perhaps the Purists wanted to have it both ways. Purism peaked in 1920–25, based on the work made by Ozenfant and Jeanneret, its founders and leading proponents, and their closest colleague, Fernand Léger, formerly a leading Cubist (or Tubist, in recognition of his characteristic shapes). Its culmination was the L'Esprit Nouveau Pavilion at the 1925 International Exhibition in Paris. Its mouthpiece was the journal of the same name – taken from a lecture by the inspirational Apollinaire (see M6), 'L'Esprit Nouveau et les poètes' (1918) – which abruptly ceased publication when Ozenfant and Jeanneret fell out, among other things, over where to hang the paintings in the latter's newest architectural commission, the Villa La Roche.

AMÉDÉE OZENFANT (1886–1966) was an intellectual painter and patriot. Rejected for military service for health reasons, he decided to do his bit by founding a periodical, *L'Elan*, to express 'the true French spirit'. It was Ozenfant who first used the terms 'Purism' and 'Purist' in his 'Notes

on Cubism' in the tenth and last issue of *L'Elan*, dated 1 December 1916. 'CUBISM IS A MOVEMENT OF PURISM', he declared; it was following in the (French) footsteps of Ingres, Cézanne and Seurat. Soon enough, however, Purism was elevated to a higher plane, and Cubism relegated to the status of 'romantic ornamentalism'.

Ozenfant was a rover, who has not yet found his place. In 1938 he opened the Ozenfant School of Fine Arts in New York. His method was 'discipline, precision and care . . . painting to a fine edge . . . with three coats' – Purism of a kind, possibly. In 1944 he taught at Black Mountain College, the nursery of the American avant-garde, with an international cadre of practitioner-professors, including the graphic artist Josef Albers and the architect Walter Gropius, founder of the Bauhaus (see M33). Ozenfant was in the thick of things for a significant period; he was central to Purist Paris; and yet, at the modernist roll call, he is curiously absent.

CHARLES-ÉDOUARD JEANNERET [LE CORBUSIER] (1887–1965) was perhaps the most influential architect of the twentieth century. He was also a painter, a writer, a thinker, and a self-promoter of genius, or something close to it. His pen name – the name by which he lived and will live – was an altered form of a family name, Lecorbésier, known to some as 'the crow-like one' (from *le corbeau,* the crow). It was adopted at the beginning of the Purist period, in 1920, the period in which Le Corbusier became Le Corbusier, a story continued in his revolutionary manifesto 'Toward an Architecture' (M45).

* * *

PURISM DOES NOT AIM TO BE A SCIENTIFIC ART, WHICH WOULD HAVE NO MEANING.

■ ■ ■

It holds that Cubism, regardless of what is said about it, remains a decorative art, a romantic ornamentalism.

■ ■ ■

There is an artistic hierarchy: decorative art at the bottom, the human figure at the top.

■ ■ ■

The value of painting derives from the intrinsic qualities of plastic elements and not from their representational or narrative potential.

■ ■ ■

PURISM expresses not variations, but what is *invariable*. The work should not be accidental, exceptional, impressionistic, inorganic, contestatory, picturesque, but on the contrary general, static, expressive of what is constant.

■ ■ ■

PURISM aims to conceive clearly, to execute faithfully, precisely, without waste; it turns away from troubled conceptions, from summary, bristly execution. Serious art must banish all technique deceptive as to the real value of conception.

■ ■ ■

Art is above all a matter of conception.

■ ■ ■

Technique is only a tool that humbly serves the conception.

■ ■ ■

PURISM fears the bizarre and the 'original'. It seeks out pure elements with which to reconstruct organized paintings that seem to be made by nature itself.

■ ■ ■

The craftsmanship should be sufficiently secure not to hinder the conception.

■ ■ ■

PURISM does not believe that a return to nature means a return to copying nature.

■ ■ ■

It allows for any distortion that is justified by a search for what is constant.

■ ■ ■

All freedoms belong to art save that of not being clear.

M31 Aleksandr Rodchenko and others
Manifesto of Suprematists and Non-Objective Painters (1919)

Written in preparation for the 10th State Exhibition: 'Non-Objective Creation and Suprematism' in Moscow in 1919. Just before this, ASKRANOV, a new experimental association of non-objective artists was formed by Liubov Popova, Nadezhda Udaltsova, her husband Aleksandr Drevin, Aleksandr Vesnin, Varvara Stepanova (1894–1958) and her husband Aleksandr Rodchenko. It was designed as a counterweight to Malevich's group of Suprematists. Initially they wanted to exhibit on their own. Subsequently this idea was dropped, and the two groups joined forces, Malevich exhibiting *White on White* (1918), Rodchenko exhibiting *Black on Black* (1919).

ALEKSANDR RODCHENKO (1891–1956) was the iconic figure of Soviet Constructivism, understood as a project (almost an ideology) to fuse art and life, a symbiosis of progressive artists and new technology. In the years following the Revolution, however, it became clear that the Party was out of sympathy with the avant-garde. Osip Brik warned that 'the artistic culture of the future is being created in factories and plants, not in attic studios'. In 1920 Malevich announced the death of easel painting. 'There can be no question of painting in Suprematism,' he declared, 'painting was done for long ago.' Rodchenko's response to all this was to give up the attic studio, and indeed art itself. 'Art has no place in modern life . . . Every man must wage war against art, as against opium.' He turned to designing newspaper kiosks, workers' clubs and – with more success – film posters, including one for Eisenstein's *The Battleship Potemkin* (1925). He found his niche in photography, collaborating with Mayakovsky in advertising material for the Gum department store and the Red October biscuit factory. This work was accorded equal status with their other creative work. It was at the same time beautiful and

useful – utilitarian even, as prescribed. Defending photography, he once argued that no single image of someone could match the truth of a dossier of photographs taken throughout his life. Constructivist, portraitist or archivist, Rodchenko's photography endures.

See also his 'Manifesto of the Constructivist Group' (M44).

★ ★ ★

Achievements in creative work of the world's explorers.

The only innovators of the earth, the Suprematists and non-objective painters, play with inventiveness like jugglers with balls.

We are already outstripping one another.

People, look, this is my latest venture: concentration of colour. The light of colour.

Flying ahead of others, I greet the rest of the 'Suprenons' [a compound of Suprematists and non-objectivists].

You there!

Don't look back, always move ahead.

The world will be enriched by the innovators of painting.

Objects died yesterday. We live in an abstract spiritual creativity.

We are creators of non-objectivity.

Of colour as such,

Of tone as such.

We glorify the revolution aloud as the only engine of life.

We glorify the vibrations of the inventors.

Young and strong, we march with the flaming torches of the revolution.

Henceforth, always be revolutionary, new and audacious.

This is the place – for the rebellious spirit.

The petty and materialistic – be off with you!

Greetings to all of you, comrades, who are fighting for new ideas in art.

Innovators of all times, and countries, inventors, builders of the new, eternally new, we are rushing into the eternity of achievements.

We, who enter the fray with art speculators who have got the knack of stencilling one manner or another.

We are proud, we are starving in attics, but we have not yielded one iota to the bourgeoisie.

We painted our furious canvases under the hisses and sniggers of overfed bureaucrats and petty bourgeois.

Today we reiterate that even now we will not yield to the so-called proletariat of the former monarchist lackeys, to the intelligentsia, which has taken the place of the previous bureaucrats.

Twenty years from now, the Soviet Republic will be proud of these canvases . . .

M32 Richard Huelsenbeck and Raoul Hausmann
What is Dadaism and what does it want in Germany? (1919)

First published in *Der Dada* 1 (1919) by the German group of the 'Dadaist Revolutionary Central Council'; reprinted in Huelsenbeck's history of the movement, *En Avant Dada: Eine Geschichte des Dadaismus* (Hanover, 1920). A Communist-Dadaist Manifesto.

RAOUL HAUSMANN (1886–1971) was known as the 'Dadasoph', the Dada philosopher or sage. In addition to his other activities, he had the distinction of making a kind of manifesto-object, or Dada portrait in 3-D (3-Dada?), *Mechanical Head: Spirit of Our Time* (1919), a wigmaker's wooden dummy, complete with wallet, ruler, pocket-watch mechanism and case, bronze device for raising a camera, typewriter cylinder, segment of measuring tape, collapsible cup, nails and bolt. There is a plausible suggestion that it may be regarded as a portrait of Tristan Tzara (M28). Appropriately enough, it appeared in the Dadaist review *Mécano*, edited by Theo van Doesburg (see M42).

See also the 'First German Dada Manifesto' (M29).

* * *

1. Dadaism demands:
1) The international revolutionary union of all creative and intellectual men and women on the basis of radical Communism;
2) The introduction of progressive unemployment through comprehensive mechanization of every field of activity. Only by unemployment does it become possible for the individual to achieve certainly as to the truth of life and finally become accustomed to experience;

3) The immediate expropriation of property (socialization) and the communal feeding of all; further, the erection of cities of light, and gardens which will belong to society as a whole and prepare man for a state of freedom.

2. The Central Council demands:

a. Daily meals at public expense for all creative and intellectual men and women on the Potsdamer Platz (Berlin);

b. Compulsory adherence of all clergymen and teachers to the Dadaist articles of faith;

c. The most brutal struggle against all directions of so-called 'workers of the spirit' (Hiller, Adler), against their concealed bourgeoisism, against expressionism and post-classical education as advocated by the Sturm group;

d. The immediate erection of a state art centre, elimination of concepts of property in the new art (expressionism); the concept of property is entirely excluded from the super-individual movement Dadaism which liberates all mankind;

e. Introduction of the simultaneist poem as a Communist state prayer;

f. Requisition of churches for the performance of bruitism, simultaneist and Dadaist poems;

g. Establishment of a Dadaist advisory council for the remodelling of life in every city of over 50,000 inhabitants;

h. Immediate organization of a large-scale Dadaist propaganda campaign with 150 circuses for the enlightenment of the proletariat;

i. Submission of all laws and decrees to the Dadaist central council for approval;

j. Immediate regulation of all sexual relations according to the views of international Dadaism through establishment of a Dadaist sexual centre.

M33 Walter Gropius

What is Architecture? (1919)

A statement for the Exhibition for Unknown Architects (April 1919), organized by the Arbeitsrat für Künst (AFK), a kind of artists' trade union, arising out of the revolutionary ferment of the period. The theme of the exhibition was simple enough – utopia. Among the exhibitors were two prominent Dadaists, Jefim Golyscheff and Raoul Hausmann (see M32). This statement bears a close resemblance to a shorter statement, its rhetoric a little more restrained, prefacing the programme of the Staatliches Bauhaus in Weimar, founded that same month. It was clearly intended as something in the nature of a founding manifesto.

The Bauhaus was founded on the principle of unifying art, craft and technology. Institutionally, it emerged from a merger of the Weimar Academy of Fine Art and the Grand Ducal School of Arts and Crafts. Officially, its life was coterminus with the brief life of the Weimar Republic (1919–33) – both closed by the Nazis – but its example spread far and wide, exerting a profound influence on every kind of creative practice, not least through the forced exile of its leading figures, among them its first and last directors, Walter Gropius (1883–1969) and Ludwig Mies van der Rohe (1886–1969), who both became American citizens. The Bauhaus was a formative institution for the teachers and practitioners of the international avant-garde; the 'Bauhaus style' is a byword for intellectual rigour, radical innovation, minimal ornamentation, and a fingerprint at once adventurous and scrupulous. It is mischievously said to be the forerunner of IKEA.

GROPIUS was the founder of the Bauhaus, and in every sense one of the principal architects of modernism. Remarkably, he once worked in the same practice as two of the others, Le Corbusier and Mies van der Rohe. The Bauhaus according to Gropius was a total institution. After it moved from Weimar to Dessau, in 1925, the professors lived in new

houses built by the director himself. Kandinsky shared one with Paul Klee (1879–1940) – a daunting pairing. The demands made on teachers and students alike were considerable. Klee was an inspiring painter and pedagogue. He acted as 'form master' (artistic adviser) in the bookbinding and stained glass workshops; he offered basic instruction; he gave courses on textile composition and the theory of form, and classes in painting and sculpture. Gropius was not only a master builder. He was also a great talent-spotter.

The mode of expression in this manifesto is very striking. The condition of that abject creature the architect is remorselessly exposed; it is shriving-time for the profession. Revolution was in the air. Gropius himself was deliberately calling for a new form of relations among artists, in their common calling as craftsmen. Did he have recourse to *The Communist Manifesto*? 'All that is solid melts into air, all that is holy is profaned, and man is at last compelled to face with sober senses, his real conditions of life, and his relations with his kind.' He would not be the last architect to do so (see M90).

See also Robert Venturi, 'Non-Straightforward Architecture' (M79), Coop Himmelb(l)au, 'Architecture Must Blaze' (M87), Lebbeus Woods, 'Manifesto' (M90), and Charles Jencks, '13 Propositions of Post-Modern Architecture' (M93).

<p style="text-align:center">★ ★ ★</p>

What is architecture? The crystalline expression of man's noblest thoughts, his ardour, his humanity, his faith, his religion! That is what it once *was*! But who of those living in our age that is cursed with practicality still comprehends its all-embracing, soul-giving nature? We walk through our streets and cities and do not howl with shame at such deserts of ugliness! Let us be quite clear: these grey, hollow, spiritless mock-ups, in which we live and work, will be shameful evidence for posterity of the spiritual descent into hell of our generation, which forgot that great, *unique* art: *architecture*. Let us not deceive ourselves, in our European arrogance, that the wretched buildings of *our* era could alter the overall picture. All our works are nothing but splinters. Structures created by practical requirements and necessity do not satisfy the longing for a world of beauty built anew from the bottom up, for the rebirth of that spiritual

unity which ascended to the miracle of the Gothic cathedrals. We shall not live to see it. But there is one consolation for us: the *idea*, the building-up of an ardent, bold, forward-looking architectural idea to be fulfilled by a happier age that must come. Artists, let us at last break down the walls erected by our deforming academic training between the 'arts' *and all of us become builders again!* Let us together will, think out, create the new idea of architecture. Painters and sculptors, break through the barriers to architecture and become fellow builders, fellow strugglers for the final goal of art: the creative conception of the cathedral of the future, which will once again be all in *one* shape, architecture and sculpture and painting.

But ideas die as soon as they become compromises. Hence there must be clear watersheds between dream and reality, between longing for the stars and everyday labour. Architects, sculptors, painters, we must all return to the crafts! For there is no 'professional art'. Artists are craftsmen in the original sense of the word, and only in rare, blessed moments of revelation that lie outside the power of their will can blossom unconsciously from the work of their hands. Painters and sculptors, become craftsmen again, smash the frame of salon art that is around your pictures, go into the buildings, bless them with fairy tales of colour, chisel ideas into the bare walls – and *build in imagination*, unconcerned about technical difficulties. The boon of imagination is always more important than all technique, which always adapts itself to man's creative will. There *are* no architects today, we are all of us merely preparing the way for him who will once again deserve the name of architect, for that means: *lord of art*, who will build gardens out of deserts and pile up wonders to the sky.

M34 Francis Picabia

Dada Manifesto (1920)

First published on the front cover of the review *391*, 12 (March 1920), in Paris, below *Dada Painting* by Marcel Duchamp (1887–1968): the iconoclastic and now iconic portrait of a moustachioed Mona Lisa – a Dada gesture – bearing the legend *L.H.O.O.Q.*, a play on words, or rather letters, in two languages. If the letters are pronounced in rapid, idiomatic French, it sounds like *elle a chaud au cul* ('she has a hot arse', or, for the rhymically inclined, 'she is hot to trot'). If pronounced in English, without aspirating the H, it sounds like 'Look'.

391 (1917–24), patterned on Alfred Steiglitz's *291* in New York, was a peripatetic review published, edited and often written by Picabia – it is tempting to add 'dedicated to Picabia', who was not lacking in competitive self-regard. The issues that appeared in the period 1919–21, first in Zürich and then in Paris, had a deep imprint of Dada.

FRANCIS PICABIA (1879–1953) was a clever man and a versatile artist who delighted in giving gratuitous offence, verbal and visual, as his manifesto makes clear. His Dada *Portrait of Cézanne* (1920) is a stuffed monkey, tacked to a board, with a phallus-like appendage. Spiteful, sceptical, ironic, nihilistic, irreverent and malevolent, he romped through most artistic styles from Impressionism to Surrealism, with remarkable facility and singular lack of feeling. In the final issue of *391*, in 1924, he announced a new movement, Instantaneism, an anti-movement which lived and died in that instant.

See also his 'Dada Cannibalistic Manifesto' (M35).

<p style="text-align:center">* * *</p>

The Cubists want to cover Dada with snow; that may surprise you but it is so, they want to empty the snow from their pipe and cover Dada like a blanket.

Are you sure about that?

Absolutely, the facts spill out from their grotesque mouths.

They think that Dada might put a stop to their odious trade: selling art for vast sums of money.

Art is worth more than sausages, more than women, more than everything.

Art can be seen as clearly as God! (see Saint-Sulpice).

Art is a drug for imbeciles.

The tables are turning thanks to the spirits: pictures and other works of art are like strong box-tables: the mind is locked inside and becomes more and more fantastic as sale-room prices rise.

Comedy, comedy, comedy, comedy, comedy, my dear friends.

Dealers don't like art, they know the mystery of the spirit . . .

Buy reproductions of signed works.

Don't be a snob, you are no less intelligent because your neighbour has the same as you.

No more fly shit on the walls.

There will be some in any case, obviously, but not quite so much.

Dada will certainly be increasingly vilified, its wire-cutters enabling it to cut through the procession singing 'Come on Darling' [a nineteenth-century popular song]. What sacrilege!!!

Cubism represents the dearth of ideas.

They have cubed primitive art, cubed Negro sculpture, cubed violins, cubed guitars, cubed comics, cubed shit and cubed the profiles of young women. Now they want to cube money!!!

As for Dada, it means nothing, nothing, nothing. It makes the public say 'We understand nothing, nothing, nothing.'

The Dadaists are nothing, nothing, nothing and they will certainly succeed in nothing, nothing, nothing.

Francis *PICABIA*

who knows nothing, nothing, nothing.

M35 Francis Picabia

Dada Cannibalistic Manifesto (1920)

First published in *Dadaphone* 7 (March 1920), in Paris.

The figure of the cannibalist (perhaps an art-movement manqué) seems to have exercised the avant-garde imagination. Compare Oswald de Andrade's 'Cannibalist Manifesto' (M53).

On Picabia, see also his 'Dada Manifesto' (M34).

* * *

You are all accused; stand up. The orator will speak to you only if you are standing.
Standing as for the Marseillaise,
standing as for the Russian hymn,
standing as for God save the king,
standing as before the flag.
Finally standing before DADA, which represents life and accuses you of loving
everything out of snobbism from the moment that it becomes expensive.
Are you completely settled? So much the better, that way you are going to listen to
me with greater attention.
What are you doing here, parked like serious oysters – for you are serious, right?
Serious serious, serious to death.
Death is a serious thing, huh?
One dies as a hero, or as an idiot, which is the same thing. The only word which is not
ephemeral is the word death. You love death for others.

To death, death, death.

Only money which doesn't die, it just leaves on trips.

It is God, one respects it, the serious person – money respect of families.

Honour, honour to money; the man who has money is an honourable man.

Honour is bought and sold like ass. Ass, ass represents life like fried potatoes,

and all of you who are serious, you will smell worse than cow shit.

DADA doesn't smell anything, it is nothing, nothing, nothing.

It is like your hopes: nothing

like your paradise: nothing

like your idols: nothing

like your political men: nothing

like your heroes: nothing

like your artists: nothing

like your religions: nothing

Whistle, cry, smash my mouth and then, and then? I will tell you again that

you are all pears. In three months we, my friends and I, are going to sell you

our paintings for several francs.

M36 Tristan Tzara and others
Twenty-Three Manifestos of the Dada Movement (1920)

First published in *Littérature* 13 (1920), in Paris. *Littérature* (1919–24) was an important journal, edited by a powerful triumvirate: André Breton, Louis Aragon and Philippe Soupault – 'the three musketeers'. Its name was suggested by Paul Valéry, after the last line of Verlaine's 'L'art poétique': 'and all the rest is literature'. It retained a certain ambiguity. Avant-garde artists and others were prone to speak slightingly of 'litera-ture' ('de la littérature') as little more than fancy (or empty) words; and a fellow musketeer assured Proust, of all people, that *Littérature* was intended to signify the very opposite. However that may be, it was at the forefront of Dadaist experimentation and Surrealist gestation.

It was perhaps inevitable that the pope of Surrealism would fall out with the capo of Dadaism. Breton first courted Tzara ('I think about you as I've never before thought about anyone') and then dumped him, finding him insupportable and ungovernable. Tzara, it has been said, was a disappointing mail-order bride. He was certainly a handful, and rivalrous to boot. Given the output of both men, there is a certain irony in the attempt of one to diminish the other by characterizing him as a mere writer of manifestos, and not a poet: 'Dada is amazed to see that it now has only a few poor devils on its side, who, huddled up in their poetry, emote like good bourgeois over the memory of its already ancient misdeeds,' wrote Breton acidly in 1922, as Surrealism was coming on stream. 'And what does it matter if, going his sorry little way, Mr Tzara must one day share his glory with Marinetti or Baju [a Decadent pamphleteer]!' Breton had a fine line in disdain (see M50 and M54). 'It has been said that I change men the way most people change socks,' he continued. 'Kindly allow me this luxury, as I can't keep wear-ing the same pair for ever: when one stops fitting, I hand it down to my servants.'

There are shades of Marinetti in some of these manifestos, whatever André Breton may say. In Dada circles, the authors are a roll call of the great and good. See also the Dada Manifestos of Hugo Ball (M25) and Tristan Tzara (M28).

* * *

These manifestos were read:

At the Salon des Indépendents (Grand Palais des Champs Elysées), 5 February 1920.

At the Club du Faubourg, 6, rue de Puteaux, 7 February 1920.

At the Université Populaire of Faubourg Saint-Antoine, 19 February 1920.

The order in which they are published was drawn by lot.

Dada Manifesto

No more painters, no more writers, no more musicians, no more sculptors, no more religions, no more republicans, no more royalists, no more imperialists, no more anarchists, no more socialists, no more Bolsheviks, no more politicians, no more proletarians, no more democrats, no more bourgeois, no more aristocrats, no more armies, no more police, no more fatherlands, enough of all these imbecilities, no more anything, no more anything, nothing, *nothing, nothing, nothing.*

We hope something new will come from this, being exactly what we no longer want, determinedly less putrid, less selfish, less materialistic, less obtuse, less immensely *grotesque.*

Long live concubines and the con-cubists. All members of the DADA movement are presidents.

ME*

Everything that is not me is incomprehensible.

Whether sought on Pacific sands or gathered in the hinterland of my own existence, the shell that I press to my ear will ring with the same

* Deep wells and springs.

voice and I'll think it the voice of the sea and it will be but the sound of myself.

If I suddenly find it's no longer enough to hold every word in my hand like pretty pearly objects, every word will enable me to listen to the sea, and in the mirror of their sound will I find no image but my own.

However it may seem, language boils down to just this I and whenever I utter a word it divests itself of everything that isn't me until it becomes an organic noise through which my life unfolds.

There is only me in this world and if I sometimes lapse into believing that a woman exists I have but to lean my head on her breast to hear the sound of *my* heart and recognize myself.

Feelings are only languages, enabling certain functions to be performed.

In my left pocket I carry a remarkably accurate self-portrait: a watch in burnished steel. It speaks, marks time and understands none of it.

Everything that is me is incomprehensible.

<div style="text-align: right">LOUIS ARAGON</div>

Tristan Tzara

Take a good look at me!
 I'm stupid, I'm a joker, I'm a clown.
 Take a good look at me!
 I'm ugly, my face is expressionless, I'm short.
 I'm just like all of you![1]
But before you look, ask yourselves this: are you shooting those arrows of liquid sentiment through the iris or fly shit? Are the eyes of your belly maybe slices of tumours whose starings will one day seep out in the form of gonorrhoeal discharge from some part of your body? You view things with your navel – why are you trying to protect it from the ridiculous spectacle we're putting on especially for it? A little bit lower, cunts with teeth, gulping everything down – the poetry of eternity, love, pure love, of course – bleeding beefsteaks and oil painting.

All who see and understand readily fall into line between poetry and

1. Wanted to publicize myself a bit

love, between beefsteak and painting. They'll be swallowed up, they'll be swallowed up.

I was recently accused of nicking some furs. Probably people thought I was still hanging out with poets. With poets who satisfy their legitimate need for a chilly wank in warm furs: H a h u I know some other equally purposeless pleasures. Give your family a ring and piss in the hole reserved for musical, gastronomic and sacred nonsenses.

DADA proposes 2 solutions:
NO MORE LOOKING
NO MORE SPEAKING[2]
Don't look anymore.
Don't speak anymore.

Because I, chameleon changing infiltration of convenient attitudes – multicoloured opinions to suit all occasions, size and price – I always do the opposite of what I suggest to others.[3]

I've forgotten something:
Where? Why? How?
What I mean is:

ventilator of cold examples will serve the cavalcade's fragile snake and I have never had the pleasure of seeing you 'my dear' rigid the ear will come out of itself from the envelope like all marine equipment and products from the firm of Aa and Co chewing gum for example and dogs have blue eyes, I drink chamomile, they drink the wind, DADA introduces new perspectives, nowadays people sit at the corners of tables adopting positions which slip a little to the right and to the left, this is why I am angry with Dada, people everywhere should demand the suppression of Ds, eat some Aa, polish yourselves with Aa toothpaste, dress yourselves in Aa designs. Aa is the handkerchief and sexual organ blowing its nose, rapid collapse – in rubber – without noise, has no need for manifestos or address book, gives a 25% discount dress yourselves in Aa designs it has blue eyes.

TRTZ

20–2–1920

2. No more manifestos
3. Sometimes

Dada Mugs

What's your name? (*He shrugs.*)

Where are you? – The Grand Palais on the Champs Elysées.

What day is it? – Thursday . . . February 1920.

What do you do for a living? – I used to plough the fields, I dressed the vines.

And your parents? – My father's a simpleton, without intelligence; my mother too, they're as bad as each other; I had to do everything.

A dozen eggs costs six francs; how much is one egg? – Six francs.

Why are you laughing? – The others are making me laugh.

Do you believe in God and the Holy Virgin? – They always get the job done.

How do you know? – I just know.

Did you sleep well? – My dreams take after taubes [German aeroplanes], after wild boars, about falling down wells, about people chasing me, trying to attack me.

How do you rate yourself? – You're far too good for me. I'm just pining away; I'd like to have some X-rays. I was really intelligent until last month.

What do you yearn for? – I don't know.

ANDRÉ BRETON

Philosophical Dada

To André Breton

CHAPTER I

DADA has blue eyes, a pale face and curly hair; has the English look of young men who are keen on sport.

DADA has melancholy fingers – the Spanish look.

DADA has a small nose – the Russian look.

DADA has a porcelain arse – the French look.

DADA dreams of Byron and Greece.

DADA dreams of Shakespeare and Charlie Chaplin.

DADA dreams of Nietzsche and Jesus Christ.

DADA dreams of Barrès and sunsets.

DADA has a brain like a water lily.

DADA has a brain like a brain.

DADA is an artichoke doorknob.

DADA's face is broad and slender and its voice is arched like the sirens' tone.

DADA is a magic lantern.

DADA's tail has been twisted into an eagle's beak.

DADA's philosophy is sad and merry, indulgent and wide.

Venetian crystals, jewels, valves, bibliophiles, voyages, poetic novels, restaurants, mental illnesses, Louis XIII, dilettantism, the last operetta, sparkling star, peasant, a glass of beer downed a little at a time, a new specimen of dew, that's one aspect of DADA!

Uncomplications and uncertainties.

Changeable and highly strung, DADA is a hammock rocking a soothing sway.

CHAPTER II

A star falls upon a river, leaving a trail of replicas. Happiness and misery with a silent voice whisper in our ears.

Black or shining sun.

Here in the bottom of the boat we're oblivious to the course we should choose.

A tunnel and return.

Ecstasy becomes anguish in the idyll of domesticity.

Beds are paler than the dead, despite man's despairing cries.

DADA embraces in spring water and its kisses must be water meeting fire.

DADA is Tristan Tzara.

DADA is Francis Picabia.

DADA is everything as it equally loves the pure at heart, nightfall, sighing foliage and the entwined lovers drinking with abandon from the divine double wellsprings of Love and Beauty!

CHAPTER III

DADA has always been twenty-two, it's slimmed down a bit in the last twenty-two years. DADA is married to a peasant girl who loves birds.

CHAPTER IV

DADA lives on a peplum-cushion surrounded by chrysanthemums wearing Parisian masks.

CHAPTER V

Human emotions appear to it on the banks of optimism, torn to shreds by Baudelaire's antique poetry.

CHAPTER VI

'Oh God I'm turning into an imbecile!' cries DADA.
The wish to fall asleep.
To have a manservant.
An imbecile manservant at the other end of the chamber.

CHAPTER VII

The same manservant opened the door and, as usual, wouldn't let us in. Far off we could make out the voice of Dada.

FRANCIS PICABIA
Martigues, 12 February 1920

Dada Development

Man has great respect for language and the cult of thought; whenever

he opens his mouth you see his tongue kept under glass and the reeking mothballs of his brain stink out the air.

For us *everything* is an opportunity to have fun. Every time we laugh we empty ourselves and the wind possesses us, rattling the doors and windows, driving the night of wind into us.

Wind. The ones who came before us are the artists. The others are devils. Let's take advantage of the devils, let's put ourselves – and the idiot too – where the head and hand should be.

We need entertaining. We're determined to stay exactly as we are or will be. We need a free and empty body, we need a laugh and we need nothing.

PAUL ÉLUARD

Literature and the Rest

I've been told repeatedly, more than two hundred times (maybe three hundred), that two and two make four. Oh, that's good, or too bad. But that open hand there in front of you, those five fingers exist . . . or don't exist. I couldn't care less. Beautiful words trimmed with feathers or little perfumed rockets, sentences constructed with transparent pebbles – none of them worth the two sous I throw in your face.

So who's going to dare sow that absurd plant they call rye-grass or wheat in your brains, brains that are thinner and smaller themselves than willow leaves. They can have a good laugh if they want by gouging out my eyes to see what grows in the manure that serves me for a brain. You'll see nothing there because there is nothing there. You're all as blown up as fattened geese with ideas and principles and as like me as brothers, just go for a walk in the fields and bear it in mind that the burgeoning wheat is a novel by Monsieur René Bazin [a French novelist of provincial life].

All alone here, in front of these plasterboard walls, I've come to realize that all my friends, be they murderers or men of letters, are every bit as stupid as me. The worst offenders are those who enjoy taking themselves seriously.

Why have you written a manifesto? They shout at me.

I am writing a manifesto because I have nothing to say.

Literature does exist, but in the heart of imbeciles.

It's absurd to divide writers into good and bad ones. On one side there are my friends and on the other, the rest.

When all my contemporaries have understood all these things, it might just become possible to breathe more easily and open your eyes and mouth without risking asphyxiation. I also hope that the people I was just talking about, who hold me in the most delicious disdain, will never understand a thing. That's the blessing I wish on them.

Whether they're howling in the name of morality, tradition or litera-ture, it's always the same howling, the same whingeing. Their contemptuous smile is as sweet to me as the fury of their majestic spouses. They can despise me; they'll never work out what I think of myself because my life is running clockwise.

None of this lot here has the guts to express their disgust with as much as a whistle. Well I've got the guts, I could whistle and shout out loud that this manifesto is absolutely stupid and stuffed full of contradictions, but I'd console myself later with the thought that so-called 'literature', that dandelion born in the cretin's diaphragm, is even more stupid.

PHILIPPE SOUPAULT

Dada Patisserie

The table is round, the sky is bright, the spider is tiny, the glass is trans-parent, eyes come in ten different colours, Louis Aragon has the Military Cross, Tzara hasn't got syphilis, elephants are silent, the rain falls, a car travels more easily than a star, I am thirsty, draughts are pointless, poets are pin cushions – or pigs, writing paper is convenient, the stove is draw-ing well, daggers kill well, revolvers kill better, the air is still too deep.

We swallow all of this and if we digest it we most certainly don't give a shit.

PAUL ÉLUARD

Dada Skating

We read the papers like other mortals. Without wishing to make anyone unhappy, it is perfectly acceptable to say that the word DADA lends itself readily to puns. That's even part of the reason we adopted it in the first place. We haven't the faintest idea how to treat any subject

seriously – least of all this subject: us. So everything that's written about DADA is doing its best to please us. We'd swap the whole of art criticism for any news item whatsoever. Certainly the wartime press never stopped us taking Marshal Foch for a phoney and President Wilson for a fool.

We ask for nothing better than to be judged on appearances. It's reported all over the place that I wear glasses. If I told you why you'd never believe me. It's in remembrance of this grammatical model: 'Noses were made to wear glasses: also I wear glasses.' What is it they say? Oh yes, this brings home the fact that we're not getting any younger.

Pierre is a man. But there is no DADA truth. You've only got to say a thing for the opposite to become DADA. I once saw Tristan Tzara in a tobacconist's unable to muster up the voice to ask for a packet of cigarettes. I don't know what was the matter with him. I can still hear Philippe Soupault asking an ironmonger most insistently for some live birds. As for me, it's perfectly possible that I am dreaming at this very moment.

A white eucharistic host is equal to a red one after all. DADA makes no promises about getting you to heaven. It would be ludicrous, in principle, to anticipate a DADA masterpiece in the fields of literature and painting. Naturally we have absolutely no belief in the possibility of social improvement either, even if we do hate conservatism more than anything and pledge our full support for any revolution whatsoever. 'Peace at any price' was DADA's slogan during the war just as 'War at any price' is DADA's slogan in times of peace.

Contrariness remains nothing more than the most flattering form of posturing. I'm not aware of a hint of ambition in myself: yet it seems to you that I'm getting all worked up: why doesn't the idea that my right side is the shadow of my left and vice versa render me utterly incapable of movement?

We pass for poets in the most general sense of the word because we target the worst conventions in language. You can be terribly familiar with the word 'hello' and still say 'goodbye' to the woman you've just met up with again after being away for a year.

DADA attacks you through your own powers of reasoning. If we reduce you to a point where you maintain you are better off believing than not believing what all the religions of beauty, love, truth and justice

teach, then we'll know you're not afraid of putting yourselves at the mercy of DADA, by agreeing to meet us on our chosen territory . . . which is doubt.

ANDRÉ BRETON

The Pleasures of Dada

Dada has pleasures just like everyone else. Dada's principle pleasure is to see itself in others. Dada provokes laughter, curiosity or fury. Since these are three most agreeable things, Dada is very happy.

What makes Dada all the happier is if people laugh at it spontaneously. Since Art and Artists are extremely serious inventions, especially when their roots are in comedy, people go to comedies at the theatre when they wish to laugh. Not us. We don't take anything seriously. People do laugh but only to mock us. Dada is very happy. Curiosity is awoken too. Serious-minded men, who know, deep down, how miracles are arranged – miracles such as Père La Colique [diarrhoea] or the Virgin's tears – realize that it would be much more fun to have fun with us. They have no wish to bring about the collapse of the great cathedral of Art, but look how they rub up against us trying to get our recipe. Dada doesn't have any recipes but is always hungry. Dada is very happy.

And now for fury, adorable fury. This is the way great love affairs start. Concerns for the future? Only about being loved too much. Certainly there would always be the option of swapping roles, taking it in turns to laugh, yearn or fly into a fury. But expecting some sort of benefit to arise. The gorgeous gob of somebody vomiting insults is wide open and Dada is very good at *basse-boule* [baseball?]. Dada is very happy.

Dada also likes tossing stones into the water, not to see what happens but to stupidly contemplate the ripples. Anglers don't like Dada.

Dada likes ringing on doorbells, striking matches and setting light to hair and beards. It puts mustard in chalices, urine in fonts and margarine in artists' tubes of paint. It knows you and knows the ones who lead you. It likes you and doesn't like them. You can be fun. You probably enjoy life. But you've got some bad habits. You're too fond of what you've been taught to be fond of. Cemeteries, melancholy, the tragic lover, Venetian gondolas. You shout at the moon. You believe in art and respect Artists.

You could easily become friends of Dada – it would be enough to

demolish all your little card castles and redeem every iota of your freedom. Mistrust your leaders. They exploit your ill-considered affection for the fake and the famous to lead you by the nose and make things even better for themselves.

You cling to your chains as if you want to be used with impunity like bears in a sideshow – do you? They flatter you and call you Wild Bears. Carpathian bears. They talk of freedom and magnificent mountains. But that's just to rake in the bourgeois spectators' wads of cash. You dance for an old carrot and a whiff of honey. If you weren't so cowardly, sinking under the weight of all those lofty thoughts and non-existent abstractions you've been forced into, all that nonsense dressed up as dogma, you'd stand up straight and play the massacre game, just like we do. But you're too scared of no longer believing and of bobbing about like corks on the surface of a two-gallon barrel with nothing but the memory of fizzy lemonade. You don't understand that one can be attached to nothing and be happy.

If you ever manage to pull yourself together Dada will clack its jaws as a sign of friendship. But if you rid yourselves of lice only to keep your fleas Dada will bring its little insecticide spray into play.

Dada is very happy.

<div align="right">GEORGES RIBEMONT-DESSAIGNES</div>

Manifesto of the Crocrodarium Dada [Hans Arp]

Statue lamps come up from the bottom of the sea and shout long live DADA to greet the passing liners and dada presidents feminine dada masculine dada plural dada definite dada indefinite dada and three rabbits in Chinese ink by arp the dadaist in ridged bicycle porcelain we leave for London in the royal aquarium ask in every pharmacy for rasputin's and the tzar's and the pope's dadaists which are only valid for two and a half hours.

<div align="right">ARP</div>

Art

Essentially what's behind the word BEAUTY is unthinking, visual convention. Life bears no relation to what grammarians call *beauty*. Virtue

like patriotism only exists for those mediocre intellects with a lifelong devotion to the sarcophagus. This tide of men and women who believe in *Art* as if it were a religion with *God* at its heart must be stemmed. We don't believe in *God* any more than we do in *Art* – nor his priests, bishops and cardinals.

Art is, and can only ever be, the expression of our contemporary life. *Beauty*, the institution, is exactly like the *Musée Grevin* [a waxworks museum] and bounces easily off the *soul* of shopkeepers and *Art* experts, caretakers of the museum church of the past's crystallizations.

Tralala Tralala

Count us out.

We're not feeding ourselves at a mass for memories and magic tricks by Robert Houdin.

Let's face it, you don't understand what we're doing. And to tell the truth, my friends, we understand it even less – delightful, huh? You're quite right. But do you really believe that *God* knew English and French??? ???

You explain *Life* to him in those two beautiful languages Tralala Tralala Tralala Tralala Tralala Tralala.

So have a good look with your sense of smell, forget the fireworks of Beauty at 100,000, 200,000 or 199,000,000 dollars.

Anyway I've had enough, those who don't understand will never understand and those who understand when they have to understand certainly don't need me.

<div style="text-align:right">FRANCIS PICABIA</div>

Dada God-swatter

The most ancient and formidable enemy of Dada is called GOD!

He intervenes between us and all things and gets in the way.

His cheating eyes show up when we're staring into our glass.

He screws our mistresses and sticks himself in between their skin and ours.

He roosts on the shoulders of victorious generals, old folks crowned with the downfalls of bestselling artists. From way on high he draws adoring gazes to himself.

He's the forger, the speculator, the deceiver, the great bully and the supreme stuffer of brains.

He poisons life for a bunch of imbeciles. God's a fool, God's got goitre, God struts about like a dandy, God dresses to the left. How many poets, painters, musicians – the most ignorant of all people – pull on a God every morning like a condom, and thus disguised extend a great green belly for the worship of the masses!

Well we're going to shout about it: ENOUGH of all these annoying stinking gods festering like a disgusting verminous pea pod.

Let's QUICKLY carry out some corrosive fumigations to purify the atmosphere and scour the house with lashings of alcohol.

Cover EVERYTHING in Dada bug powder! No nonsense hygiene!

Dada God-swatter

Dada omni-swatter

Dada anti-taboo!

<div align="right">PAUL DERMÉE</div>

The Corridor

1st: Just as the first name Apollonie, from which the Pantheon appears exactly as it does from the rue Soufflot, is less attractive than a dogcart it's completely pointless to imagine that the most stupid amongst us is really less stupid than he appears, and therefore even more stupid. When we've finished praising certain particularly seedy gentlemen to the skies on the pretext that they always behave exactly as they should – that is to say, idiotically – maybe it'll be time for a little fun, if we join the ranks of those who dismiss '*Aloïse ou l'Amour perverti*' (published by Albin Michel) as tedious without even bothering to open the thing. Who has ever really taken on board the fact that whatever precautions you take they will never be enough? Not daring to sit back down, due to the flatulence caused by reading until utterly worn out by hystero-mania and for fear of producing a ridiculous effect, is no reason to regret ever having stood up. It seems that by the end of the third year some trainers themselves become wild. The inhabitants of central Europe have no idea how lucky they are to find simple conversations a uniquely dangerous experience. Furthermore, is it really so consoling to tell yourself, as you stroke your highly polished shoes, that this earth is home to some truly useless men? No, in spite of everything. For sometimes their eyes are quite moist with pleasure. They live, like the others, between a butter-soft eroticism and mental chaos that

compels even the brightest demon to sometimes confess her embarrass-
ment. (And that is their greatest crime!) A misfortune makes you so
cheerful that you submit to any influence that comes your way only to
reject it again shortly afterwards until you get to the last one and that one
is living in the hope of not being one and is to be rejected no more. None-
theless Napoleon, on being given his Egyptian proclamation to read over
again, came out with the words: 'This is a bit boastful!' and perhaps we
shouldn't assume that he was trying to be witty. (These are the words of
an excellent man.) You will only ever gain a clearer perspective when you
manage to enter into a dialogue with your own prostate. Probably. By
then the only truly dignified position a man can adopt is to remain lying
down like an effigy, but always on the most hilarious part of the body,
thus producing an outrageous effect on the sky.

2nd: People are still not sufficiently resigned to *everything*. That's what
they should teach you at primary school and it's just what you want to
hear endlessly repeated behind your back when you're ill.

3rd: But everybody abandons their principles for as little as somebody
else's apparently foolish behaviour, and it's just as true that the good Lord
is nothing more than an unremarkable doctor and that people hardly
love anything anymore, for they have ceased to love themselves. The
final joy is no less for it. That joy has to be seen clasped between belly
folds when you've managed to retrieve all the falsities that objectively
escape from your brain in daytime. Obviously this is not what one would
use to extract the gasses from a corpse if one manages to extract them
from Maurice Barrès who still passes for being alive.

<div align="right">Dr VAL [WALTER] SERNER</div>

Dada is american

Cubism was born in Spain; France appropriated the patent for it with no
government guarantee. Unfortunately, just like French matches, Cubism
didn't catch on; not enough phosphorus on the surfaces of the box. Mr
Rosenberg [a dealer] is in the process of making an enormous box but
the matches he's got hidden in there are soaking wet, floating about on
mouldy liquid.

Cubism was Spanish, it became Alsatian, it dances on the official red
carpets of a few Parisian and commercial galleries.

Unthinkable that Cubism would burst out with a 'Long live Dada'; it's a consumptive on a chaise longue; all youth has fled from its malicious eyes; it's like that old lady Roch Grey, who hates children and speaks with enormous contempt of the kindergarten.

I felt I should talk a little about Cubism, being one of those who expected a great deal from this geometric word; I am compelled to confess my disappointment and, at the same time, my joy in observing DADA, the global expression of all that is young, lively and athletic; no religion leaking from a cathedral appendicitis for Dada. DADA is american, DADA is russian, DADA is spanish, DADA is swiss, DADA is german, DADA is french, belgian, norwegian, swedish, monégasque. Anyone who lives without a system, who finds nothing to like about museums but the parquet floors, is DADA; museum walls are Père Lachaise [a cemetery] or Père la Colique, they will never be Père Dada. The life expectancy of real Dada works should be just 6 hours.

I, Walter Conrad Arensberg, american poet, hereby declare that I am against Dada, seeing that this is the only way I'm going to get involved in dada, in dada, in dada, in dada, in dada.

Hurrah, hurrah, hurrah. Long live Dada.

WALTER CONRAD ARENSBERG
New York 33 West 67th Street

The Manifesto of Mr Antipyrine

DADA is our intensity: it holds up inconsequential bayonets to the German baby's Sumatral head; Dada is life without slippers or apparel; it is for and against unity and decidedly against the future; we wisely recognize that our brains will become cosy cushions, that our anti-dogmatism is as exclusivist as a civil servant and that we are not free and cry freedom harsh necessity without discipline or morality and spit on humanity.

DADA remains in the European framework of weaknesses, it's still shit, but from now on we want to shit in different colours to decorate the art zoo of all consular flags.

We direct circuses and whistle amongst the winds of fairs, among convents, prostitutes, theatres, realities, feelings, restaurants. Hohi, hoho, bang, bang.

We declare the car to be a feeling that quite pampered us in the slowness of its abstractions and transatlantic liners and noises and ideas. We exteriorize the faculty, however, we are looking for the central essence and we are happy being able to hide it; we don't want to count the marvellous elite's many windows because DADA exists for nobody and we want the whole world to understand this, because it is the balcony of Dada, I assure you. From where you can hear military marches and descend slicing the air like a seraphim to the public baths to have a piss and understand the parable.

DADA is neither madness, nor wisdom, nor irony, take a look, dear bourgeois.

Art was a game of conkers, children strung together words with chimes at the end, then they started crying and shouted out the stanza, and put dolly's booties on it and the stanza became queen to do a little expiration, and the queen became a whale without an explanation, the children ran and ran with restricted respiration.

Then the great ambassadors of feeling came along and shouted historically in chorus:

> Psychology psychology hihi
> Science Science Science
> Long live France
> We are not naïve
> We are consecutive
> We are exclusive
> We are not simple
> and we are perfectly capable of debating intelligence.

Be we, DADA, we are not of their opinion, as art isn't serious, I assure you, and if we exhibit crime in order to say vegetation learnedly, it is in order to give you pleasure, dear listeners, I love you so, I love you so, I assure you, and adore you.

TRISTAN TZARA

Dada Geography

Historical anecdotes are not enormously important. It's impossible to determine when and where DADA came into being. The name itself,

all the better for being perfectly ambiguous, was just something one of us came up with.

Cubism was a school of painting. Futurism a political movement: DADA is a state of mind. To compare them is patently either ignorant or pretentious.

Free thinking in religious matters is nothing like a church. DADA is free thinking in artistic terms.

As long as prayers are forcibly recited in schools under the guise of museum visits and textual analysis, we will rail against despotism and seek to disrupt the ceremony.

DADA devotes itself to nothing, neither love nor work. It is unthinkable that a man should leave any trace of his existence on this earth.

DADA, acknowledging only instinct, condemns explanation in principle. According to Dada we should exercise no control over ourselves. Have done with those dogmas, morality and taste: have done with them for ever.

ANDRÉ BRETON

To the Public

Before I came down there among you to tear out your rotten teeth, your scab-filled ears, your canker-covered tongue.

Before shattering your putrid bones –

Slitting open your diarrhoea-filled abdomen and removing from it your over-fattened liver, your ignoble spleen and your diabetic kidneys to be used as fertilizer on the fields –

Before I rip off your ugly, incontinent and cheesy little dick –

Before I thus extinguish your appetite for beauty, orgasms, sugar, philosophy, pepper and metaphysical mathematical and poetical cucumbers –

Before disinfecting you with vitriol and thus making you clean and passionately buffing you up –

Before all of that –

We're going to have a great big bath in antiseptic –

And we're warning you –

It's us who are the murderers –

Of all your little newborn babies –

And to end here's a song

Ki Ki Ki Ki Ki Ki Ki
And here's God with a nightingale for a horse
He's handsome, he's ugly –
Madam, your gob stinks of pimp's come.
In the morning –
'Cos in the evening it's more like the arse of an angel in love with a lily.
Nice, huh?
Cheerio, mate.

<div align="right">GEORGE RIBEMONT-DESSAIGNES</div>

Dada Parasol

So you don't like my manifesto?

You've come here bursting with hostility and you're going to start whistling at me before you've even heard me out?

Great! Carry on, the wheel turns as it's turned since Adam, nothing changes, except now we've only got two legs instead of four.

But you're really making me laugh and I wish to repay you for your lovely welcome by talking to you about Aart, poetry, etc. etc. hippicack-uanna.

Have you ever seen a telegraph pole having a tough time trying to grow beside roads between nettles and blown tyres?

But as soon as it's grown a bit taller than its neighbours it grows so fast that you could never stop it . . . never!

Then it opens out right up there in the sky, lights up, swells out, is a parasol, a taxi, an encyclopaedia or a toothpick.

So are you happy now? OK . . . that's it . . . that's all I wanted to say to you. That's poetreee for you . . . honest!

Poetry = toothpick, encyclopaedia, taxi or parasol-shade, and if you're not satisfied . . . TO THE TOWER WITH YOU

<div align="right">CÉLINE ARNAULD</div>

Dada Typewriter

Ever since we were born some lazy gits have been trying to convince us that there's such a thing as art. Well we're even lazier and today we're going to say it loud and clear: 'Art is nothing.'

There is nothing. Once our contemporaries get around to accepting what we say they'll quickly forget that huge farce called art.

Why be stubborn?

There is nothing:

There never was anything.

You can shout and chuck whatever you can lay your hands on at us, you know perfectly well that we're right.

Who's going to tell me what Art is?

Who dares claim they know what Beauty's about?

For my listeners' convenience I offer you this definition of Art, Beauty and the rest:

Art and Beauty = NOTHING.

And now, of course, you're going to start yelling or laughing again.

Listen to me.

Once upon a time, some years ago, there was a bloke called Jesus Christ who cured blind and deaf people. Nobody took any notice of him. The doctors got worried and had a meeting. Then some of them went to see the Minister of Health and the bloke called Jesus Christ got awarded a big prize for services to education.

It's the same thing with me . . . I want to open your eyes and all you do is laugh.

You'll never be serious.

<div style="text-align: right">PHILIPPE SOUPAULT</div>

Five ways to Dada shortage or two words of explanation

Tear up a bit of paper, preferably pages 35–6 of poetry RON RON, set light to it, all DADA books are well printed, this must be done according to DADA methods, which once existed.

The road paved with gas jets, sliding corridors providing DADA

DADA, at the last minute, a long time ago for others, has neither providers nor methods

but a heck of a lot of noise is made about it since grammars, dictionaries and manifestos are still necessary.

MORAL:

We see everything, we love nothing,

We are indifferent

In-di-ffe-rent

We're dead but we're not rotting because we never have the same heart in our breast, nor the same brain in our head.

And we suck in everything around us, around us, we do

NOTHING, Dada satisfaction.

<div align="right">PAUL ÉLUARD</div>

Sensational revelations

As slowly I open their lids, my eyes can only bear one single light more gentle on them than your anger is to my heart: doubts feebly fizzle out when they come up against friendship. Friendship leads me to the edge of the world, it abandons me and I wait.

Today you find me abominably sad. All that my heart can produce is a damp squib. You won't like that image. I'm already beginning to bore you. I'm not even going to swear at you. Who knows where weariness starts, who knows where it ends? I'm looking at you and you're looking at me. What insignificant misdemeanour are you going to find to throw at me pretending it's a blessed olive branch? I'm not trying to force you to be silent, nor make you start shouting. All I am aware of nowadays is this great emptiness inside caused by those who are my friends as drops of water in a river are friends of the drop they sweep with them to the sea. If you want to vouch for someone you say: I'm as sure of him as I am of myself. And yet if there's one man on this earth I cannot be psychologically sure of, it's me. I don't take any notice of the rules I set for myself; and this perpetual inconsistency enables others to recognize me and call me by my name; I can't see myself in profile. I'm always betraying myself, letting myself down, contradicting myself. I'm not someone I'd ever put my trust in. No need to despair on that score. But as you know just one look from my friends is enough to wreck all my plans – that's why we are friends. I give everything up just to waste my time with them, I even drop myself. I suppose you think I bestow on them the trust I refuse myself? Wake up! I know all about their shortcomings, thousands of things about them shock me. They do things I'd never do for all the gold in the world.

I know they have great affection for me. It's a long time since we

stopped carrying those little scales around with us that weigh up a person's worth. I don't believe in my friends just as I don't believe in myself.

I have put myself at the mercy of these people I call friends for the most idiotic – yet strongly heartfelt – reasons. It's a torrent sweeping me along and I acknowledge it as my master and flatter it with my voice.

You lot, immobilized in this room like a stagnant pool of mud, don't ask me what route I'm going to take out of this world, nor what makes me bow to a foreign power. The man whose body is caught up in a spiral from here on in is speaking to you serenely: don't listen to the words he is forming, just hear the monotonous song of his lips.

Today you find me abominably sad.

LOUIS ARAGON

Manifesto of Monsieur Aa the antiphilosopher

Without looking for I adore you
who's a French boxer
irregular maritime values like Dada's depression in the blood
of the two-headed one
I slide undecided between death and phosphates which scratch the
communal brain of
dadaist poets for a bit
happily
for
now
aspect
tariffs and high living costs made me decide to give up Ds it's not true
that Dada
falsehoods tore them off me since repayment will start from
here's a reason to cry the nothing that's called nothing
and I swept the illness through customs
me the armour and umbrella of the brain from midday to two
hours of subscription
superstitious releasing wheels
of the spermatozoid ballet that you will find at dress rehearsal in
the hearts of all suspect individuals
I'm going to nibble your fingers for a bit

I'll pay for your resubscription to love on film that screeches like
metal doors
and you are all idiots
I'll come back some time as your urine
reborn into life's delights the midwife wind
and I'm setting up a boarding school for poets' pimps
and I'll come back again some time just to start all over again
and you are all complete idiots
and the self cleptomanic's key only turns with the aid of dim
revolutionary oil
on the node of every machine is the nose of a newborn
and we are all complete idiots
and very suspicious of a new form of intelligence and a new logic in our
usual way
which is certainly not Dada
and you allow yourselves to be swept along by A-ism
and you are all complete idiots
poultices
made with the alcohol of purified sleep
bandages
and virgin
idiots

<div align="right">TRISTAN TZARA</div>

M37 Naum Gabo and Anton Pevzner

The Realistic Manifesto (1920)

First issued as a poster, on 5 August 1920, to accompany the artists' open-air exhibition with Gustav Klucis on Tverskoie Boulevard, Moscow. Gabo himself testified later that he alone wrote and subsequently translated the manifesto. It was intended as an affirmation of the value of avant-garde art, as distinct from the more utilitarian tendency. 'Realistic' here does not mean realistic in common usage; nor does it imply support for 'realist', representational art. Rather, it indicates a focus on what might be called the essential reality ('the innermost essence of a thing', 'the essential life and constant structure of the body') – real life.

NAUM GABO (Naum Pevzner, 1890–1977) and ANTON (NOTON) PEVZNER (1886–1962) were brothers. Gabo was the communicator, a noted Constructivist sculptor who later settled in the United States.

* * *

Above the tempests of our weekdays,

Across the ashes and cindered homes of the past,

Before the gates of the vacant future,

We proclaim today to you artists, painters, sculptors, musicians, actors, poets . . . to you people to whom Art is no mere ground for conversation but the source of real exaltation, our word and deed.

The impasse into which Art has come to in the last twenty years must be broken.

The growth of human knowledge with its powerful penetration into the mysterious laws of the world which started at the dawn of this century,

The blossoming of a new culture and a new civilization with their unprecedented-in-history surge of the masses towards the possession of

the riches of Nature, a surge which binds the people into one union, and last, not least, the war and the revolution (those purifying torrents of the coming epoch), have made us face the fact of new forms of life, already born and active.

What does Art carry into this unfolding epoch of human history?

Does it possess the means necessary for the construction of the new Great Style?

Or does it suppose that the new epoch may not have a new style?

Or does it suppose that the new life can accept a new creation which is constructed on the foundations of the old?

In spite of the demand of the renascent spirit of our time, Art is still nourished by impression, external appearance, and wanders helplessly back and forth from Naturalism to Symbolism, from Romanticism to Mysticism.

The attempts of the Cubists and the Futurists to lift the visual arts from the bogs of the past have led only to new delusions.

Cubism, having started with simplification of the representative technique ended with its analysis and stuck there.

The distracted world of the Cubists, broken in shreds by their logical anarchy, cannot satisfy us who have already accomplished the Revolution or who are already constructing and building up anew.

One could heed with interest the experiments of the Cubists, but one cannot follow them, being convinced that their experiments are being made on the surface of Art and do not touch on the bases of it seeing plainly that the end result amounts to the same old graphic, to the same old volume and to the same decorative surface as of old.

One could have hailed Futurism in its time for the refreshing sweep of its announced Revolution in Art, for its devastating criticism of the past, as in no other way could have assailed those artistic barricades of 'good taste' . . . powder was needed for that and a lot of it . . . but one cannot construct a system of art on one revolutionary phrase alone.

One had to examine Futurism beneath its appearance to realize that one faced a very ordinary chatterer, a very agile and prevaricating guy, clad in the tatters of worn-out words like 'patriotism', 'militarism', 'contempt for the female', and all the rest of such provincial tags.

In the domain of purely pictorial problems, Futurism has not gone further than the renovated effort to fix on canvas a purely optical reflex

which has already shown its bankruptcy with the Impressionists. It is obvious now to every one of us that by the simple graphic registration of a row of momentarily arrested movements, one cannot re-create movement itself. It makes one think of the pulse of a dead body.

The pompous slogan of 'Speed' was played from the hands of the Futurists as a great trump. We concede the sonority of that slogan and we quite see how it can sweep the strongest of the provincials off their feet. But ask any Futurist how does he imagine 'speed' and there will emerge a whole arsenal of frenzied automobiles, rattling railway depots, snarled wires, the clank and the noise and the clang of carouselling streets . . . does one really need to convince them that all that is not necessary for speed and for its rhythms?

Look at a ray of sun . . . the stillest of the still forces, it speeds more than 300 kilometres in a second . . . behold our starry firmament . . . who hears it . . . and yet what are our depots to those depots of the Universe? What are our earthly trains to those hurrying trains of the galaxies?

Indeed, the whole Futurist noise about speed is too obvious an anecdote, and from the moment that Futurism proclaimed that 'Space and Time are yesterday's dead', it sunk into the obscurity of abstractions.

Besides those two artistic schools our recent past has had nothing of importance or deserving attention.

But Life does not wait and the growth of generations does not stop and we go to relieve those who have passed into history, having in our hands the results of their experiments, with their mistakes and their achievements, after years of experience equal to centuries . . . we say . . .

No new artistic system will withstand the pressure of a growing new culture until the very foundation of Art will be erected on the real laws of Life.

Until all artists will say with us . . .

All is a fiction . . . only life and its laws are authentic and in life only the active is beautiful and wise and strong and right, for life does not know beauty as an aesthetic measure . . . efficacious existence is the highest beauty.

Life knows neither good nor bad nor justice as a measure of morals . . . need is the highest and most just of all morals.

Life does not know rationally abstracted truths as a measure of cognizance, deed is the highest, and surest of truths.

Those are the laws of life. Can art withstand these laws if it is built on abstraction, on mirage and fiction?

We say . . .

Space and time are reborn to us today.

Space and time are the only forms on which life is built and hence art must be constructed.

States, political and economic systems perish, ideas crumble, under the strain of ages . . . but life is strong and grows and time goes on in its real continuity.

Who will show us forms more efficacious than this . . . who is the great one who will give us foundations stronger than this?

Who is the genius who will tell us a legend more ravishing than this prosaic tale which is called life?

The realization of our perceptions of the world in the forms of space and time is the only aim of our pictorial and plastic art.

In them we do not measure our works with the yardstick of beauty, we do not weigh them with pounds of tenderness and sentiments.

The plumb-line in our hands, eyes as precise as a ruler, in a spirit as taut as a compass . . . we construct our work as the universe constructs its own, as the engineer constructs his bridges, as the mathematician his formula of the orbits. We know that everything has its own essential image; chair, table, lamp, telephone, book, house, man . . . they are all entire worlds with their own rhythms, their own orbits.

That is why we in creating things take away from them the labels of their owners – all accidental and local, leaving only the reality of the constant rhythm of the forces in them.

1. *Thence in painting we renounce colour as a pictorial element, colour is the idealized optical surface of objects; an exterior and superficial impression of them; colour is accidental and has nothing in common with the innermost essence of a thing.*

We affirm that the tone of a substance, i.e. its light-absorbing material body is its only pictorial reality.

2. *We renounce in a line, its descriptive value; in real life there are no descriptive lines, description is an accidental trace of a man on things, it is not bound up with the essential life and constant structure of the body. Descriptiveness is an element of graphic illustration and decoration.*

We affirm *the line only as a direction of the static forces and their rhythm in objects.*

3. We renounce *volume as a pictorial and plastic form of space; one cannot measure space in volumes as one cannot measure liquid in yards: look at our space . . . what is it if not one continuous depth?*

We affirm *depth as the only pictorial and plastic form of space.*

4. We renounce *in sculpture, the mass as a sculptural element.*

It is known to every engineer that the static forces of a solid body and its material strength do not depend on the quantity of the mass . . . example a rail, a T-beam etc. But you sculptors of all shades and directions, you still adhere to the age-old prejudice that you cannot free the volume of mass. Here (in this exhibition) we take four planes and we construct with them the same volume as of four tons of mass. Thus we bring back to sculpture the line as a direction and in it we affirm depth as the one form of space.

5. We renounce *the thousand-year-old delusion in art that held the static rhythms as the only elements of the plastic and pictorial arts.*

We affirm *in these arts a new element of the kinetic rhythms as the basic forms of our perception of real time.*

These are the five fundamental principles of our work and our constructive technique. Today we proclaim our words to you people. In the squares and on the streets we are placing our work convinced that art must not remain a sanctuary for the idle, a consolation for the weary, and a justification for the lazy.

Art should attend us everywhere that life flows and acts . . . at the bench, at the table, at work, at rest, at play; on working days and holidays . . . at home and on the road . . . in order that the flame to live should not extinguish in mankind.

We do not look for justification, neither in the past nor in the future.

Nobody can tell us what the future is and what utensils does one eat it with.

Not to lie about the future is impossible and one can lie about it at will.

We assert that the shouts about the future are for us the same as the tears about the past: a renovated day-dream of the romantics.

A monkish delirium of the heavenly kingdom of the old attired in contemporary clothes.

He who is busy today with the morrow is busy doing nothing.

And he who tomorrow will bring us nothing of what he has done today is of no use for the future.

Today is the deed.

We will account for it tomorrow.

The past we are leaving behind as carrion.

The future we leave to the fortune-tellers.

We take the present day.

M38 Liubov Popova

On Organizing Anew (c.1921)

An untitled text from an undated, unfinished manuscript in a private collection in Moscow.

LIUBOV POPOVA (1889–1924) was a privileged participant in the European avant-garde. In more senses than one, she travelled even further than her comrade and friend Rozanova, studying in Paris with Henri Le Fauconnier and Jean Metzinger in 1912–13, travelling in Italy in 1914, and moving rapidly from apprentice realism and decorative Impressionism through Cubo-Futurism and Suprematism to Constructivism and even 'Productionism' – making the transition from studio painting to production art of various kinds. Popova became an expert in textile design, and a pioneer of new genres such as stage, poster and book design.

See also Rozanova, 'Cubism, Futurism, Suprematism' (M26).

* * *

We have no need to conceal our pride that we are living in this new Great Epoch of Great Organizations.

Not a single historical moment will be repeated.

The past is for history. The present and the future are for organizing life, for organizing what is both creative will and creative exigency.

We are breaking with the past, because we cannot accept its hypotheses. We ourselves are creating our own hypotheses anew and only upon them, as in our inventions, can we build our new life and new world-view.

More than anyone else, the artist knows this intuitively and believes in it absolutely. That is exactly why artists, above all, undertook a revolution and have created – are still creating – a new world-view. Revolution

in art has always predicted the breaking of the old public consciousness and the appearance of a new order in life.

A real revolution, unprecedented in all the enormity of its significance for the future, is sweeping away all the old conceptions, customs, concepts, qualities and attachments and is replacing them with new and very different ones, as if borrowed from another planet or from alien creatures. But wasn't art the forerunner of this revolution – art that replaced the old world-view with the need to organize – and to such an extent that even the end of 'art' was declared? In fact, this [new] form has declared the end not only of the old art, but perhaps of art in general or, if not the end, then an artistic transformation so great that it cannot be accommodated within the old conception of art.

An analysis of the conception of the subject as distinguished from its representational significance lies at the basis of our approach toward reality: at first there was the deformation of the subject, and this was followed by the exposition of its essence, which is the concretization of a given consciousness within given forms. It also marks the beginning of the organization of the artistic media.

As a purpose, this is not new, for there has been no significant era in art when the subject was not deformed in accordance with the external energy of expression or reconstructed from a need to concretize a particular world-view.

To the extent that a given confluence of historical conditions for the formation of a certain consciousness is unique, that condition of consciousness in relation to its own past, present and future will also be singular and unique.

That's the first point.

The second point is still more important – above all, the moment of creation: a new organization of elements is created out of the constant, traditional ones, which are so only because, ultimately, we know only one and the same concrete material.

Through a transformed, [more] abstract reality, the artist will be liberated from all the conventional world-views that existed hitherto.

In the absolute freedom of non-objectivity and under the precise dictation of its consciousness (which helps the expediency and necessity of the new artistic organization to manifest themselves), [the artist] is now constructing [his] own art, with total conviction.

Our fanaticism is conscious and assured, for the scope of our experiences has taught us to assume our positive place in history.

The more organized, the more essential the new forms in art, the more apparent it will become that our era is a great one and indispensable to humanity.

(Form + colour + texture + rhythm + material + etc.) × ideology (the need to organize) = our art.

M39 Tristan Tzara and others

Dada Excites Everything (1921)

Dated 12 January but actually distributed on 15 January 1921, this poster was prepared for a lecture being given that afternoon by Marinetti at the Théatre de l'Oeuvre in Paris. Marinetti had made statements to the press suggesting that Dada was an offshoot of Futurism. The Dadaists turned out in force. Marinetti was presenting a new variant he called 'Tactilism'. This was deflated by Picabia, who traced it to New York Dada; Marinetti was then shouted down by the rest of the group (Aragon, Breton, Tzara and others). Hence: 'The Futurist is dead. Of what? Of Dada.'

<p style="text-align:center">* * *</p>

<p style="text-align:right">(The signatories of this manifesto
live in France, America, Spain,
Germany, Italy, Switzerland,
Belgium, etc. but have
no nationality.)</p>

DADA EXCITES EVERYTHING

DADA knows everything. DADA spits everything out.

BUT • • • • • • • • •

HAS DADA EVER SPOKEN TO YOU:

> *about Italy*
> *about accordions*
> *about women's pants*

about the fatherland
about sardines
about Fiume
about Art (you exaggerate my friend)
about gentleness
about D'Annunzio
what a horror
about heroism
about moustaches
about lewdness
about sleeping with Verlaine
about the ideal (it's nice)
about Massachusetts
about the past
about odours
about salads
about genius, about genius, about genius
about the eight-hour day
about the Parma violets

NEVER NEVER NEVER

DADA doesn't speak. DADA has no fixed idea. DADA doesn't catch flies.

THE MINISTRY IS OVERTURNED. BY WHOM?

BY DADA

The Futurist is dead. Of What? Of DADA

A Young girl commits suicide. Because of What? DADA
The spirits are telephoned. Who invented it? DADA
Someone walks on your feet. It's DADA
If you have serious ideas about life,

If you make artistic discoveries
and if all of a sudden your head begins to crackle with
 laughter,
If you find all your ideas useless and ridiculous, know that

IT IS DADA BEGINNING TO SPEAK TO YOU

cubism constructs a cathedral of *artistic* liver paste

WHAT DOES DADA DO?

expressionism poisons *artistic* sardines

WHAT DOES DADA DO?

simultaneism is still at its first *artistic* communion

WHAT DOES DADA DO?

futurism wants to mount in an *artistic* lyricism-elevator

WHAT DOES DADA DO?

unanism embraces allism and fishes with an *artistic* line

WHAT DOES DADA DO?

neo-classicism discovers the good deeds of *artistic* art

WHAT DOES DADA DO?

paroxysm makes a trust of all *artistic* cheeses

WHAT DOES DADA DO?

ultraism recommends the mixture of these seven *artistic* things

WHAT DOES DADA DO?

creationism vorticism imagism also propose some *artistic* recipes

WHAT DOES DADA DO?

WHAT DOES DADA DO?

50 francs reward to the person who finds the best way to explain DADA to us

Dada passes everything through a new net.
Dada is the bitterness which opens its laugh on all that which has been
 made consecrated forgotten in our language in our brain in our habits.
It says to you: There is Humanity and the lovely idiocies which have made
 it happy to this advanced age

DADA HAS ALWAYS EXISTED
THE HOLY VIRGIN WAS ALREADY A DADAIST

DADA IS NEVER RIGHT

Citizens, comrades, ladies, gentlemen
Beware of forgeries!

Imitators of DADA want to present DADA in an artistic form which it has never had

CITIZENS,

You are presented today in a pornographic form, a vulgar and baroque spirit which is not the PURE IDIOCY claimed by DADA
BUT DOGMATISM AND PRETENTIOUS IMBECILITY

M40 Manuel Maples Arce

A Strident Prescription (1921)

Distributed as a poster: first published in *Revista Actual* 1 (December 1921) in Mexico City.

MANUEL MAPLES ARCE (1898–1981) was the founding figure and chief proponent of Stridentism, a Mexican avant-garde artistic movement with something of everythingism about it – all isms and none, a dash of utopianism and a sprinkling of social revolution – well captured in an exchange in Roberto Bolaño's great novel, *The Savage Detectives* (2007): 'You're a stridentist, body and soul. You'll help us build Stridentopolis, Cesárea, I said. And then she smiled, as if I was telling her a good joke but one she already knew, and she said that she had quit her job a week ago and that anyway she'd always been a visceral realist, not a stridentist. And so am I, I said or shouted, all of us Mexicans are more visceral realists than stridentists, but what does it matter? Stridentism and visceral realism are just two masks to get us to where we really want to go. And where is that? she said. To modernity, Cesárea, I said, to godamned modernity.'

The movement attracted some interesting supporters and hangers-on, including a poet of the revolution, Germán List Arzubide, who rode with Zapata and exalted him in a biography; Tina Modotti, the photographer of choice for the important Mexican mural movement, whose 1929 retrospective was described as 'The First Revolutionary Photography Exhibition in Mexico'; and Edward Weston, revolutionary photographer of exquisite nudes (*Nude, Tina Modotti*) and equally exquisite vegetables (*Toadstools, Point Lobos*).

* * *

Subversive illuminations by Renée Dunan, F. T. Marinetti, Guillermo de
Torre, Lasso de la Vega, Salvat Papasseit, etc., together with a few more
peripheral crystallizations.

S

 Death to Father Hidalgo [one of the heroes of Mexican independence]

U

 Down with San Rafael

C

 And San Lázaro — [districts of Mexico City]

C

 Corner —

E

 No bill-sticking

S

S

In the name of the contemporary Mexican avant-garde, and in genuine
horror at the notices and signs plastered on the doors of chemists and
dispensaries subsidized by law at the behest of a cartulary system for the
last twenty gushing centuries, I affirm my position at the explosive apex
of my unique modernity, as definite as it is eminently revolutionary. The
whole off-centre world contemplates its navel with spherical surprise and
wringing of hands while I categorically demand (with no further excep-
tions for 'players' diametrically exploded in phonographic fires with
strangulated cries) with rebellious and emphatic 'Stridentism' in self-
defence against the textual blows of the latest intellective plebiscites,
'Death to Father Hidalgo, Down with San Rafael and San Lázaro, Corner,
No bill-sticking'.

I. My madness has not been reckoned with. Truth never occurs outside
our own selves. Life is but a system open to the rains that fall at intervals.
From this standpoint our superlative literature insists upon honouring
telephones whose perfumed conversations are articulated along elec-
tronic wires. Aesthetic truth is merely an uncoercible emotional state
unravelling on a baseless plane of integrating equivalences. Things have
no conceivable intrinsic value and their poetic parallels only flourish in
an inner dimension, their relationships and coordinations are more

defined and emotionally evocative than a disestablished reality, as you can see from the fragments of one of my forthcoming new latitudinal poematics: 'Those Electric Roses . . .' (*Cosmópolis*, 34). As Albert Birot says, to produce a work of art it is essential to create and not to copy. 'We seek truth not in the reality of appearances but in the reality of thought.' At this particular moment, we are attending the performance of ourselves. In our illuminated panoramas circumscribed by spherical modernist skies, all must be in transcendental harmony. I believe, with Epstein, that we should not imitate nature but study its laws and do as nature does.

II. Every artistic technique fulfils a spiritual function at a given moment. When expressionist formats are awkward or inadequate ways of transmitting our personal emotions – their sole and elementary aesthetic function – we need to turn off the electricity and pull out the plug, even against all the reactionary forces and upstart opinions of official critics. A rheumatic chest protector has burnt out, but this is no reason for me to stop the game. Whose turn is it next? Now the dice are thrown by Cipriano Max Jacob, a sensationalist act when one considers such a circumspect journalist.

While Blaise Cendrars, always keeping his balance transcendentally, intentionally mistaken, does not know whether what he sees is a starry sky or a drop of water under the microscope.

III. 'A racing car is more beautiful than the Victory of Samothrace.' I add my positive passion for the typewriter and superabundant love of the literature of the classified ads to this enthusiastic statement by the Italian Futurist Marinetti, hailed by Lucini, Buzzi, Cavacchioli and the rest. I have found deeper and greater emotion in an arbitrary but thought-provoking newspaper clipping than in all the pseudo-lyrical barrel-organs or melodic sweetmeats freely peddled to young ladies, and insultingly recited to audiences of spasmodic fox-trotting debutantes and members of the bourgeoisie preoccupied with their mistresses and safe-deposit boxes. As indeed my spiritual brother Guillermo de Torre so courageously proclaimed in his Egoist Manifesto, read at the first Ultraist explosion in Paris, without puncturing all those poematizations so enthusiastically applauded in literary circles where only the pasteboard imitations of literapods are admitted.

IV. All Stridentist propaganda must praise the modern beauty of the machine. It is there in the gymnastic bridges tautly stretched over ravines on muscles of steel, in the smoke from factory chimneys, the Cubist emotions evoked by great transatlantic liners with their smoking red and black funnels horoscopically anchored – according to Ruiz Huidobro – at their teeming congested quaysides, the reign of great throbbing industrial cities, the blue shirts of the workers exploding at such an emotional and moving moment, all the beauty of this century so forcefully prophesied by Émile Verhaeren, so sincerely loved by Nicholas Beauduin, and so completely understood and dignified by every avant-garde artist. Finally, trams have been ransomed from the taunts of the prosaic (prestigiously valued by a pot-bellied bourgeoisie and their marriageable daughters throughout years of successive backwardness and intransigent melancholy), and from among chronological archives.

V. To the electric chair with Chopin! This is my hygienically cleansing vow. Anti-selenegraphic Futurists have already demanded the assassination of moonlight in block capitals, and the Spanish Ultraists, via their spokesman Rafael Cansinos Assens, have transcribed the end of the dry leaves shaken about in subversive newspapers and leaflets. Similarly, it is a matter of the utmost telegraphic urgency to harness radical and effective methods. To the electric chair with Chopin! MMA (trademark) is a magic product: it does away with all the germs of a putrified literature in twenty-four hours and is harmless, even pleasant, to use. Shake well before using. I insist. Let us perpetrate our crime on the night-long melancholy of the 'Nocturnes', and simultaneously proclaim the aristocracy of petrol. The blue discharge of car exhausts, scented with a dynamic modernity, has exactly the same emotional value as the beloved talents of our 'exquisite' modernists.

VI. Provincials iron-tram tickets of former times into their wallets. Where is the Hotel Iturbide? Every dyspeptic newspaper is gorged with photographs of Maria Consea [wife of the former dictator Porfirio Díaz] beaming off the front page, and there is always someone who dares be totally taken aback by the architectural shock of the National Theatre. Yet no one so far has shown any susceptibility at all to the subliminal emotions of the roadside, patchworked with wonderful billboards and geometric posters. Planes of pure colour: blue, yellow, red. With 80

horsepower and a half a cup of petrol we literally gobbled up the whole length of the Avenida Juarez. I mentally do an unforeseen elliptical turn to avoid the statue of Carlos IV. Car accessories, Haynes spare parts, wheels, batteries and generators, chassis, spare tyres, horns, spark plugs, oil, petrol. I've made a mistake: Moctezuma de Orizaba is the best beer in Mexico, Buen Tono cigars are of course smoked, etc. A perpendicular brick has crashed through the schematic scaffolding. Everything shudders. My sensations are magnified. The penultimate façade collapses on top of me.

VII. As of now, no more Creationism, Dadaism, paroxysm, Expressionism, Synthesism, Imaginism, Suprematism, Cubism, Orphism, etc. No more -isms, however theoretical or practical. Let us formulate a quintessential synthesis to strip away all tendencies that flourished on the highest planes of luminescent and modern exaltation. Not through syncretism – a false desire for reconciliation – but through a rigorous aesthetic conviction and sense of spiritual urgency. It is not a question of prismal techniques, fundamentally anti-seismic, being mistakenly distilled in the glasses of fraternal etiquette, but of inherently organic tendencies, easily adapted with reciprocity, that illuminate our marvellous desire to maximize internal emotions and sensory perceptions in multi-spirited and multi-faceted forms, resolving the equations posed by modern technical problems in all their sinuous complexity.

VIII. Man is not a systematically balanced clockwork mechanism. Genuine emotion is a form of supreme arbitrariness and specific chaos. The whole world is conducted like an amateur band. Ideas are killed off while a single aspect of the emotions, rather than their original three dimensions, is presented, with mock excuses on grounds of clarity and simplicity, overlooking the fact that at any panoramic moment emotions will surface, not only for elemental and conscious reasons but also because of a strong binary impulse of internal propulsion, clumsily susceptible to external worlds yet, in contrast, prodigiously responsive to the roto-translatory projections emanating from the ideal plane of aesthetic truth that Apollinaire called 'the golden section'. From this, one can derive a fuller interpretation of electrically charged personal emotions due to the positive elements of recent technological developments, since these crystallize a unanimous and unifying aspect of life.

Ideas often run off the rails. They never follow on continuously, one after another, but are simultaneous and intermittent. (ii. *Profond aujourd 'hui*. Cendrars. *Cosmópolis*, 33). They dioramically fill the canvas, super-imposing themselves in a disciplined convergence at the apex of introspective instant.

IX. And who raised the question of sincerity? Just a moment, ladies and gentlemen, while we shovel on more coal. Every eye is blinded by aluminium flashes, and this absent-minded young lady strolls superfi-cially across the lateral advertisements. Here we have a demonstrative graph. Intermittent conversations surface in the domestic drawing room and a friend begins to play the piano. The electric chrysanthe-mum sheds its petals in mercurial snows. And that isn't all. Neighbours burn petrol instead of incense. Ministerial idiocies are promulgated through the gutter press. My abstracted fingers dissolve in smoke. Now, I ask, who of us is the most sincere? Those of us who refuse to admit strange influences, but who purify and crystallize ourselves through the kinaesthetic filter of personal emotions, or all those ideochlorotic and diernefist 'artists' whose only concern is to ingratiate themselves with the amorphous crowd of a scanty audience, an audience of dicta-torial and retrograde officious idiots, photophobic academics, and blacklegging art dealers?

X. Let us become more cosmopolitan. We can no longer stick to the traditional chapters of national art. News is sent by telegraph to the top of skyscrapers, those wonderful skyscrapers everyone detests, dromed-ary clouds floating above them, and electric lifts moving within their muscular webbing. The forty-eighth floor. One, two, three, four, etc. Here we are. And trains devour the kilometres along the parallel bars of the open-air gymnasium. Steam evaporating into absence. Everything approaches and recedes with the motion of the moment. The environ-ment is transformed and its influence modifies everything around it. Racial traits and characteristics begin to be erased from cultural and genetic profiles, through rigorous processes of selection, whilst the psychological unity of the century flowers under the sun of today's meridian. The only possible boundaries in art are the uncrossable ones of our own alienated emotions.

XI. Impose aesthetic limits. Create art from one's own innate abilities nurtured within one's own environment. Not reincorporate old values but create anew. Destroy all those erroneous modern theories rendered false by dint of being interpretations, such as those derived from Impressionist (Post-Impressionism) and luminist dead-ends (Divisionism, Vibrationism, Pointillism, etc.). In painting, suppress all the mental suggestion and false literariness so lauded by our critical buffoons. Establish limits, not according to Lessing's interpretive parallels, but on the level of transcendence and equivalence. As Reverdy says, a new art demands a new syntaxis. In this context, Braque's saying is apposite: 'A painter thinks in colours, hence the need for a new syntax of colours.'

XII. No more retrospection. No more Futurism. Everyone silent, open-mouthed, miraculously illuminated by the vertiginous light of the present; like a sentinel witness to the prodigiousness of unmistakable emotion, unique and electronically sensitized to the upwardly moving 'I', vertical on the point of the meridional moment, forever renewed yet forever the same. Let us honour the avant-garde. Walter Conrad Arensberg has already praised positive 'Stridentism' by announcing that his poems have a life span of only six hours. Let us love our unparalleled century. Does the public really not have the intellectual capacity to penetrate the phenomenon of our formidable aesthetic movement? All right then. They can stand in the doorway or take themselves off to a music hall. Our egotism is now supreme, our confidence unswerving.

XIII. My gramophone-listening clientele of the infinitely foolish, and the bilious critics eaten away by the lacerating wounds of a pestilential and tortured old-fashioned literature, are of particular delight to me. These retrograde academics, specialists in obfuscation and every variety of esoteric anadroids, are highly praised by our stinking authoritarian intellectual environment. Naturally they purport to circumscribe my heavenly horizons with their useless delimitations, petty rages and ridiculous vainglorious operettas. Yet such an audience merely encounters the electrifying hermeticism of my negative subversive laughter, in my radically extreme inner conviction, uncircumscribed isolation and glorious intransigence. What possible spiritual relationship or ideological affinity could there be between a gentleman who puts on evening dress to wash dishes and the music of Erik Satie? With one golden Stridentist word, I

can convey the maxims of Dada, created from nothing to counteract the 'official nothings of books, exhibitions and plays'. This synthesis is a radical force set against the solid conservatism of an agglomeration of bookworn bookworms.

XIV. Success to the new generation of Mexican poets, painters and sculptors which has not been corrupted by the easy money of government sinecures, which still stands aloof from the pathetic praise of official critics and the applause of a brutish and concupiscent public! Success to all those who have not resorted to licking the plates at Enrique Gonzáles Martinez' culinary banquets, to fabricating art out of the stylicide of their intellectual menstruations. Success to those who are magnificently sincere, who have not vanished into the lamentable efflorescences of our nationalistic environment alongside the stench made by the pulque-brewers and the leftovers of fried food. To each and every one we wish success in the name of the contemporary Mexican modernist avant-garde. That they may come and do battle alongside us in the devilish ranks of the '*découvert*' where, I believe with Lasso de la Vega, 'we have come a long way from the spirituality of the beast. Like Zarathustra, we have shed our burdens and shaken off prejudice. Our great laughter is great laughter. We are engraving, here and now, new tablets of stone.' And finally, I demand the head of the scholastic nightingales responsible for turning poetry into a reposian cancan, mounted on the bars of a chair, plucked bare after the downpour in the idyllic pigpens of a bourgeoise Sunday. Logic is a mistake and the right to wholeness a monstrous joke.

The intelcesteticide Renée Dunan interrupts me. But Salvat-Papasseit, tumbling from his swing, reads this announcement on the screen: spit on the cretins' bald heads, and while the rest of the world spins off its axis, contemplating itself with spherical astonishment, wringing its hands, I, in my glorious isolation, am illuminated by the marvellous incandescence of my electrically charged nerves.

M41 Dziga Vertov

WE: Variant of a Manifesto (1922)

Published in the journal *Kinofot* [*Cinema-photo*] 1 (1922) in Moscow – the
first appearance in print of the manifesto of the *kinok* group of docu-
mentary film-makers formed by Vertov in 1919. *Kinok* ('cinema-eye-man')
was his coinage, following the pattern of his other coinages. *Kinoglaz*,
universally known as kino-eye, was the name of the movement he led
and a kind of shorthand for their principles and their practice; it was
also the title of his feature-length film of 1925, which initiates his mature
work. *Kinopravda* (*Cinema-truth*) was the name of a film journal he
started in 1922, taking its cue from the newspaper started by Lenin
(*Pravda*). *Kinopravda* ran for three years and twenty-three issues; it served
as a laboratory for his thinking and a shop window for the furious
theorizing that emerged. *Kinochestvo* was something like the quality of
the Kino-Eye; it was employed in contradistinction to the usual 'cine-
matography', which tends to be used pejoratively in *kinok* parlance, as
redolent of traditionalism, commercialism and, no doubt, bourgeois
parasitism.

 The original conception of this manifesto went back to 1919. Vertov
recorded, as if in a scenario for a film, 'Moscow. The end of 1919. An
unheated room. A small vent-window with a broken pane. Next to the
window a table. On the table, a glass of yesterday's undrunk tea that has
turned to ice. Near the glass is a manuscript. We read: "Manifesto on the
Disarmament of Theatrical Cinematography". One of the variants of
this manifesto, entitled "WE", was later published in the magazine *Kino-
fot*.' WE was a family affair: Vertov's brother and principal cameraman
Mikhail Kaufman (his other brother Boris became the cameraman of
choice for Jean Vigo, Elia Kazan and Sidney Lumet), and his life partner
and collaborator Elizaveta Svilova (1900–76), an important figure in her
own right, the chief editor for Goskino, the state film production agency

(1922–24), and later director of the Central State Studio of Documentary Film.

DZIGA VERTOV (Denis Arkadievitch Kaufman, 1896–1954) was a pioneer Russian documentary film-maker and film theoretician, and also a poet, journalist and Constructivist (see M31 and M44) – a disciple of Mayakovsky (M23) – in short, an artist, blending education, propaganda and thrills in the service of the revolution, not to mention the realization of high art and kino-eye. That was a tall order, and ultimately an impossible one to fulfil, but for a few charged years in the 1920s he took the film, and the form, by the scruff of the neck and showed the world what it might be. His masterpiece, *The Man with a Movie Camera* (1929), is the emblem of that project. Vertov was a transformative presence: a true revolutionary.

His very name was a manifesto. It has Constructivist associations, and translates roughly as 'spinning top'. Vertov trained originally as a musician and neurologist, experimenting with 'sound collages' in his spare time. All of this fed into his film work. Typically, he was expounding his ideas on the use of sound years before it became technically feasible. His own first sound film, *Enthusiasm* (1931), on the Soviet miners of the Donbass, may be the first use of direct sound (recorded on location and woven into something very like a symphony); the nomadic film-maker Chris Marker, a keen student of Vertov, has called it 'the greatest documentary ever made'. Charlie Chaplin, who was searching for a similarly anti-naturalistic way of using sound, wrote a rare testimonial: 'I regard *Enthusiasm* as one of the most moving symphonies I have ever heard. Dziga Vertov is a musician. Professors should learn from him instead of arguing with him.'

Nevertheless, Vertov suffered a vertiginous decline. The conditions for his work disappeared. By 1930, Constructivism, Lenin and Bolshevik idealism were gone, to be replaced by sclerosis, Stalin and socialist realism. Kino-eye and its creator fell out of favour. *Three Songs of Lenin* (1934) was delayed, allegedly because it neglected Stalin. *The Man with a Movie Camera* disappeared from view. Bourgeois as it might be, the fiction film triumphed over the cinema of fact. Vertov was effectively denied the opportunity to make anything he could call his own. Only his life was spared. By the time of his death, in 1954, his name was

reviled in the Soviet Union and very largely forgotten (or unknown) in the West.

Very soon, however, he was brought back to life, by the French. In the late 1960s, the phenomenon that was Jean-Luc Godard named his Marxist film cooperative 'The Dziga Vertov Group'. More significantly, a decade earlier Jean Rouch and Edgar Morin saw and admired Vertov's films and called their new documentary style *cinéma-vérité* in homage to *kinopravda*. The Situationist Guy Debord (M70) was also a film-maker, making his own film version of *The Society of the Spectacle* (1973), complete with a concluding scene from Orson Welles's *Mr Arkadin* (1955) in which Arkadin (Welles) tells his guests the parable of the scorpion who asks a frog to carry him across a river, with fatal consequences for both, accompanied by found footage of a doomed cavalry charge. Debord, too, drew inspiration from Vertov, and from the *kinok* credo that the documentary film-maker's job is to record slices of reality – 'life as it is' or 'life caught unawares' – and then to splice these slices in such a way as to create works of art, without sacrificing the essential truthfulness of the material. 'The goal is to make things on the screen look like "life facts",' as Vertov put it, 'and at the same time to mean more than that.'

That conception of documentary film-making is now all-pervasive. The spinning top has spun his magic the world over. His manifesto sings like Marinetti's.

See also Dogme 95's 'Manifesto' (M91) and Werner Herzog's 'Minnesota Declaration' (M94).

* * *

We call ourselves *kinoks* – as opposed to 'cinematographers', a herd of junkmen doing rather well peddling their rags.

We see no connection between true *kinchestvo* and the cunning and calculation of the profiteers.

We consider the psychological Russo-German film-drama – weighed down with apparitions and childhood memories – an absurdity.

To the American adventure film with its showy dynamism and to the dramatizations of the American Pinkertons the *kinoks* say thanks for the rapid shot changes and the close-ups. Good . . . but disorderly,

not based on a precise study of movement. A cut above the psycho-
logical drama, but still lacking in foundation. A cliché. A copy of
a copy.

WE proclaim the old films, based on the romance, theatrical films
and the like, to be leprous.
 – Keep away from them!
 – Keep your eyes off them!
 – They're mortally dangerous!
 – Contagious!

WE affirm the future of cinema art by denying its present.

'Cinematography' must die so that the art of the cinema may live.
WE *call for its death to be hastened.*

WE protest against that mixing of the arts which many call synthesis.
The mixture of bad colours, even those ideally selected from the spec-
trum, produces not white, but mud.

Synthesis should come at the summit of each art's achievement and
not before.

WE are cleansing *kinochestvo* of foreign matter – of music, literature
and theatre; we seek our own rhythm, one lifted from nowhere else, and
we find it in the movements of things.

WE invite you:
 – to flee –
the sweet embraces of the romance,
the poison of the psychological novel,
the clutches of the theatre of adultery;
to turn your back on music,
 – to flee –
out into the open, into four dimensions (three + time), in search of
our own material, our metre and rhythm.

The 'psychological' prevents man from being as precise as a stopwatch;
it interferes with his desire for kinship with the machine.

In an art of movement we have no reason to devote our particular
attention to contemporary man.

The machine makes us ashamed of man's inability to control himself,
but what are we to do if electricity's unerring ways are more exciting to
us than the disorderly haste of active men and the corrupting inertia of
passive ones?

Saws dancing at a sawmill convey to us a joy more intimate and intelligible than that on human dance floors.

For his inability to control his movements, WE temporarily exclude man as a subject for film.

Our path leads through the poetry of machines, from the bungling citizen to the perfect electric man.

In revealing the machine's soul, in causing the worker to love his workbench, the peasant his tractor, the engineer his engine –

we introduce creative joy into all mechanical labour,

we bring people into closer kinship with machines,

we foster new people.

The new man, free of unwieldiness and clumsiness, will have the light, precise movements of machines and he will be the gratifying subject of our films.

Openly recognizing the rhythm of machines, the delight of mechanical labour, the perception of the beauty of chemical processes, WE sing of earthquakes, we compose film epics of electric power plants and flame, we delight in the movements of comets and meteors and the gestures of searchlights that dazzle the stars.

[. . .]

Cinema is, as well, the *art of inventing movements* of things in space in response to the demands of science; it embodies the inventor's dream – be he scholar, artist, engineer, or carpenter; it is the realization by *kinchestvo* of that which cannot be realized in life.

Drawings in motion. Blueprints in motion. Plans for the future. The theory of relativity on the screen.

WE greet the ordered fantasy of movement.

Our eyes spinning, like propellers, take off into the future on the wings of hypothesis. WE believe that the time is at hand when we shall be able to hurl into space the hurricanes of movement, reined in by our tactical lassoes.

Hurrah for *dynamic geometry*, the race of points, lines, planes, volumes.

Hurrah for the poetry of machines, propelled and driving; the poetry of levers, wheels and wings of steel; the iron cry of movements; the blinding grimaces of red-hot streams.

M42 Theo van Doesburg and others

Manifesto I of De Stijl (1922)

Composed in 1918; first published in *De Stijl* 5 (1922) in Amsterdam.

The De Stijl group was founded in Holland in 1917, dedicated to a synthesis of art, design and architecture. Van Doesburg was its leader and ambassador-at-large. Its members included Gerrit Rietveld, designer of the Red and Blue Chair; J. J. P. Oud, the Municipal Architect for Rotterdam; Piet Mondrian, the great painter of the grid, issuing in a cool *Broadway Boogie Woogie* (1942–3); Georges Vantongerloo, Bart van der Leck and Vilmos Huszár. Van Doesburg's relationship with Mondrian, his inspiration, proved easier at one remove; their temperaments clashed, and possibly their geometrical principles. Legend has it that Mondrian never accepted the diagonal, whereas van Doesburg insisted on its dynamic properties – and so they parted, to be reconciled several years later, after a chance meeting in a Paris café.

THEO VAN DOESBURG (Christian Emil Marie Küpper, 1883–1931) was a man of multiple aliases and manifold accomplishments. He took the name of his stepfather, Theo(dorus) Doesburg, and added the 'van'. He painted, promoted De Stijl, and designed all manner of things: homes for artists, decoration for the Café Aubette in Strasbourg, and a geometrically constructed alphabet, revived in digital form as Architype Van Doesburg. He was simultaneously a Constructivist and a Dadaist, publishing *Mécano* (in Leiden), an 'ultra-individualistic, irregular international review for the diffusion of neo-Dada ideas and mental hygiene', under the heteronym I. K. Bonset (possibly an anagram of *Ik ben zot*, 'I am foolish'). *Mécano* advertised Bonset as its literary editor and Van Doesburg as its 'visual arts technician' (*mécanicien plastique*). The latter was already well known as the editor of *De Stijl*; the fact that they were one and the same surprised even the unsurprisable avant-garde.

I. K. Bonset was also an essayist and a derivative Dada manifestoist.

('Dada is the complete astringent cleansing to cure you of your art-and-logic diarrhoea. Dada is the cork in the bottle of your stupidity.') Aldo Camini, on the other hand, was a writer of severe anti-philosophical screeds, inspired by the Futurist Carlo Carrà in Metaphysical mode. In this guise, Van Doesburg (for it was he) opposed individualism and argued for a collective experience of a new reality, evoked (by sounds, noises and smells, perhaps) rather than described.

His second wife, Nelly van Moorsel (1899–1975), was an accomplished pianist, whose recitals were a regular feature of the Dada Tour of Holland (1923) led by Van Doesburg and Kurt Schwitters (1887–1948).

See also 'Manifesto Prole Art' (M46).

* * *

1. There is an old and a new consciousness of time.
 The old is connected with the individual.
 The new is connected with the universal.
 The struggle of the individual against the universal is revealing itself in the world war as well as in the art of the present day.
2. The war is destroying the old world and its contents: individual domination in every state.
3. The new art has brought forward what the new consciousness of time contains: a balance between the universal and the individual.
4. The new consciousness is prepared to realize the internal life as well as the external life.
5. Traditions, dogmas and the domination of the individual are opposed to this realization.
6. The founders of the new plastic art, therefore, call upon all who believe in the reformation of art and culture to eradicate these obstacles to development, as in the new plastic art (by excluding natural form) they have eradicated that which blocks pure artistic expression, the ultimate consequence of all concepts of art.
7. The artists of today have been driven the whole world over by the same consciousness, and therefore have taken part from an intellectual point of view in this war against the domination of individual despotism. They therefore sympathize with all who work to establish international unity in life, art, culture, either intellectually or materially.

M43 Vicente Huidobro

We Must Create (1922)

First published in French in his collection *Manifestes* (1925).

VICENTE HUIDOBRO (1893–1948) was a cosmopolitan Chilean poet, exponent of the artistic movement of Creacionismo (Creationism), which held that artists of any stripe should 'create' rather than 'imitate', that is to say invent or 'add to the facts of the world', as he writes in the manifesto, and not simply describe it – an echo, perhaps, of the celebrated formulation in Marx's *Theses on Feuerbach* (1888): 'The philosophers have only interpreted the world in various ways; the point is to change it.'

Huidobro himself was not an artist – but he knew them, he consorted with them (he was a special friend of Juan Gris) and he collaborated with them. Like Breton, he was in his fashion a purveyor of the avant-garde to the avant-garde, and beyond. He founded and edited a peripatetic international journal *Creación*, later *Création*, à la Picabia (see M34). He was also a waspish commentator, specializing in the suitable dismissal. 'I find that Surrealism is, in fact, nothing but the violin of psychoanalysis.' As for Futurism, 'a new art for the eleven thousand virgins, but not for those who know anything about anything.'

* * *

We must create.

Man no longer imitates. He invents, he adds to the facts of the world, born in Nature's breast, new facts born in his head: a poem, a painting, a statue, a steamer, a car, a plane . . .

We must create.

That's the sign of our times.

Today's man has shattered the bark of appearances and surprised what there was underneath.

Poetry must not imitate the aspects of things but rather follow the constructive laws that are their essence, guaranteeing the real independence of everything.

Inventing is making things that are parallel in space, meet in time or vice versa, so that they present a new fact in their conjunction.

The totality of the diverse new facts united by a single spirit constitutes the created work.

If they are not united by a single spirit, the result will be an impure work with an amorphous look, resulting from a fantasy with no laws.

The study of art throughout history shows us very clearly this tendency of imitation to move towards creation in all human productions. We can establish a law of Scientific and Mechanical Selection equivalent to the law of Natural Selection.

In art the power of the creator interests us more than that of the observer, and besides the former contains in itself the second, to a higher degree.

M44 Aleksandr Rodchenko

Manifesto of the Constructivist Group (c. 1922)

From a typewritten copy in the Rodchenko and Stepanova archive, Moscow.

The Constructivist Group emerged in December 1920. It included Aleksei Gan, Rodchenko and Stepanova. The following year, Gan became a member of INKhUK (the Institute of Artistic Culture), and the group became known as 'the first working group of INKhUK Constructivists'. Gan was an influential theoretician. His book *Konstructivism* (1922) defined its subject as 'the Communist expression of real structures'. His ideas touched the revolutionary film-maker Dziga Vertov, inventor of 'kino-eye' (see M41).

The manifesto contains an interesting account of how innovations in avant-garde painting facilitated the expansion of artists' concepts of the elements and objects of art, as each element of each object ('a mug, a floor brush, boots') is separated out – constructed and deconstructed – and revealed anew.

On Rodchenko, see the headnote to his 'Manifesto of Suprematists and Non-Objective Painters' (M31).

* * *

We don't feel obliged to build Pennsylvania Stations, skyscrapers, Handley Page Tract houses, turbo-compressors, and so on.

We didn't create technology.

We didn't create man.

BUT WE,

Artists yesterday

CONSTRUCTORS today,

1. WE PROCESSED

the human being

2. WE ORGANIZE

technology

1. WE DISCOVERED
2. PROPAGATE
3. CLEAN OUT
4. MERGE

PREVIOUSLY – Engineers relaxed with art

NOW – Artists relax with technology

WHAT'S NEEDED – IS NO REST

Who saw A WALL . . .

Who saw JUST A PLANE –

EVERYONE . . . AND NO ONE

Someone who had actually seen came and simply SHOWED:
the *square*

This means opening the eyes TO THE PLANE.

Who saw an ANGLE

Who saw an ARMATURE, SKETCH

EVERYONE . . . AND NO ONE

Someone who had actually seen came and simply SHOWED:

A line

Who saw: an iron bridge

a dreadnought

a zeppelin

a helicopter

EVERYONE . . . AND NO ONE.

We Came – the first working group of CONSTRUCTIVISTS –

ALEKSEI GAN, RODCHENKO, STEPANOVA

. . . AND WE SIMPLY SAID: This is – *today*

Technology is – the mortal enemy of art.

TECHNOLOGY . . .

We – are your first fighting and punitive force.

We are also your last slave-workers.

We are not dreamers from art who build in the imagination:

Aeroradiostations

Elevators and

Flaming cities

WE – ARE THE BEGINNING

OUR WORK IS TODAY:

A mug

A floor brush

Boots

A catalogue

And when a person in his laboratory set up

A square,

His radio carried it to all and sundry, to those who needed it and those who didn't need it, and soon on all the 'ships of left art', sailing under red, black and white flags . . . everything all over, throughout, everything was covered in *squares*.

And yesterday, when one person in his laboratory set up

A line, grid, and point

His radio carried it to all and sundry, to those who needed it and those who didn't need it, and soon, and especially on all the 'ships of left art' with the new title 'constructive', sailing under different flags . . . everything all over . . . everything throughout is being constructed of *lines and grids*.

OF COURSE, the square existed previously, the line and the grid existed previously.

What's the deal.

Well it's simply – THEY WERE POINTED OUT.

THEY WERE ANNOUNCED.

The square – 1915, the laboratory of MALEVICH

The line, grid, point – 1919, the laboratory of RODCHENKO

BUT – after this

The first working group of CONSTRUCTIVISTS (ALEKSEI GAN, RODCHENKO, STEPANOVA)

announced:

THE COMMUNIST EXPRESSION OF MATERIAL CONSTRUCTIONS and

IRRECONCILABLE WAR AGAINST ART:

Everything came to a point,

and 'new' constructivists jumped on the bandwagon, wrote 'constructive' poems, novels, paintings, and other such junk. Others, taken with our slogans, imagining themselves to be geniuses, designed elevators and radio posters, but they have forgotten that all attention should be concentrated on the experimental laboratories, which shows us

Aleksandr Rodchenko

NEW
elements
routes
things
experiments.

– THE DEMONSTRATION EXPERIMENTAL
LABORATORY AND MATERIAL CONSTRUCTIONS'
STATION OF THE FIRST WORKING GROUP OF
CONSTRUCTIVISTS OF THE RSFSR

M45 *Le Corbusier*

Toward an Architecture (1923)

The 'Argument' of *Vers une Architecture* (Paris, 1923); first translated or mutilated into English by the architect Frederick Etchells in 1927.

Toward an Architecture was an emancipatory work. It was originally entitled *Architecture and Revolution*. It began as a series of articles in the Purist journal *L'Esprit Nouveau* (see M30). Le Corbusier designed the book as carefully as he designed everything else. If the prophetic-aphoristic style owed something to the Futurist Sant'Elia (M19), the profound interpenetration of text and illustration owed something to the *Blaue Reiter Almanac* (M8). When it was reissued in 1958, Le Corbusier dismissed the idea of introducing any 'modern photographs'. 'The book has no reason to exist,' he would say, without its original photographic 'documentation'. It was the exhilarating range and the shocking juxtapositions of these illustrations that riveted the attention: in Le Corbusier's world, the Pisa basilica faces a sleek grain silo; the Parthenon surmounts a racy Delage Grand-Sport 1921. Nothing was better calculated to 'open one's eyes' – his perennial injunction.

Paul Valéry called the book 'a perfect machine for reading', a play on the author's notorious aphorism, 'the house is a machine for living in' – an improvement on Sant' Elia ('the Futurist house must be like a gigantic machine') and an influential formulation. Cubist paintings were cleverly called 'machines for seeing' by the writer Jean Paulhan. Le Corbusier was an engineer of houses *and* human souls.

Among architects and designers, the response was more equivocal. There was a certain amount of professional jealousy. From De Stijl (see M42), Van Doesburg rushed out a manifesto entitled 'Toward a Collective Construction', ostensibly written the same year. His colleague Oud called Le Corbusier's work propaganda, not architecture, though he

admitted to enjoying it. The American colossus Frank Lloyd Wright (1867–1959) approved, up to a point. 'I should be content were France – our fashion-monger in this school of "surface and mass" – to again set a fashion among us for a generation or two – as seems likely. Lean, hard plainness, mistaken for simplicity, has the quality of simplicity to a refreshing extent, where all is fat or false. It is aristocratic, by contrast. I say this fashion would be good for what ails the United States in architecture, this cowardly, superficial artificiality. Any transient influence in the right direction is welcome.'

The underlying message here was a rival claim to precedence: the claim of Americans over Europeans, the New World over the Old. In 'Towards a New Architecture' (1928) Wright continued the argument on behalf of the Americans: 'We are, by nature of our opportunity, time and place, the logical people to give highest expression to the "new" . . . We fail to see it in ourselves because we have been imitating an old world that now sees in us, neglected, a higher estate than it has even known in its own sense of itself.' This theme, a kind of manifest destiny in modernity, would be taken up again and again in the years to come, nowhere more powerfully than in Barnett Newman's clarion call, 'The Sublime is Now' (M64).

See also Robert Venturi, 'Non-Straightforward Architecture' (M79), Coop Himmelb(l)au, 'Architecture Must Blaze' (M87), and Charles Jencks, '13 Propositions of Post-Modern Architecture' (M93).

* * *

Argument

Aesthetic of the Engineer
Architecture

Aesthetic of the Engineer, Architecture: two things firmly allied, sequential, the one in full flower, the other in painful regression.

The engineer, inspired by the law of Economy and guided by calculations, puts us in accord with universal laws. He attains harmony.

The architect, through the ordonnance of forms, realizes an order that is a pure creation of his mind; through forms, he affects our senses intensely, provoking plastic emotions; through the relationships that he creates, he stirs in us deep

resonances, he gives us the measure of an order that we sense to be in accord with that of the world, he determines the diverse movements of our minds and our hearts; it is then that we experience beauty.

Three Reminders to Architects

Volume

Our eyes are made for seeing forms in light.
Primary forms are beautiful forms because they are clearly legible.
The architects of today no longer make simple forms.
Relying on calculations, engineers use geometric forms, satisfying our eyes through geometry and our minds through mathematics; their works are on the way to great art.

Surface

A volume is enveloped by a surface, that is divided according to the generators and the directing vectors of the volume, accentuating the individuality of this volume.
Architects today are afraid of the geometric constituents of surfaces.
The great problems of modern construction will be solved through geometry.
Under strict obligation to an imperative programme, engineers use the directing vectors and accentuators of forms. They create limpid and impressive plastic facts.

Plan

The plan is the generator.
Without a plan, there is disorder, arbitrariness.
The plan carries within it the essence of the sensation.
The great problems of tomorrow, dictated by collective needs, pose the question of the plan anew.
Modern life demands, awaits a new plan for the house and for the city.

Regulating Lines

Of the fateful birth of architecture
 The obligation to order. The regulating line is a guarantee against arbitrariness. It brings satisfaction to the mind.
 The regulating line is the means; it is not a formula. Its choices and its expressive modalities are integral parts of architectural creation.

Eyes that do not see

Liners

A great era has just begun.
 There exists a new spirit.
 There exists a host of works in this new spirit, they are encountered above all in industrial production.
 Architecture suffocates in routine.
 The 'styles' are a lie. Style is a unity of principle that animates all the works of an era and results from a distinctive state of mind.
 Our era fixes its style every day.
 Our eyes, unfortunately, are not yet able to discern it.

Airplanes

The airplane is a product of high selection.
 The lesson of the airplane is in the logic that governed the statement of the problem and its realization.
 The problem of the house has not been posed.
 Current architectural things do not answer our needs.
 Yet there are standards for the dwelling.
 The mechanical carries within it the economic factor that selects.
 The house is a machine for living in.

Automobiles

We must see to the establishment of standards so we can face up to the problem of perfection.

The Parthenon is a problem of selection applied to a standard.

Architecture works on standards.

Standards are a matter of logic, of analysis, of scrupulous study; they are based on a problem well posed. Experimentation fixes the standard definitively.

Architecture

The Lessons of Rome

Architecture is the use of raw materials to establish stirring relationships.

Architecture goes beyond utilitarian things.

Architecture is a plastic thing.

Spirit of order, unity of intention.

The sense of relationships; architecture organizes quantities.

Passion can make drama out of inert stone.

The Illusion of the Plan

The plan proceeds from the inside out; the exterior is the result of an interior.

The elements of architecture are light and shadow, walls and space.

Ordonnance is the hierarchy of goals, the classification of intentions.

Man sees architectural things with eyes that are 1 metre 70 from the ground.

We can reckon only with goals accessible to the eye, with intentions that take the elements of architecture into account. If we reckon with intentions that do not belong to the language of architecture, we end up with an illusory plan; we break the rules of the plan through faulty conception or a penchant for vain things.

Pure Creation of the Mind

Contour modulation is the touchstone of the architect.

The latter reveals himself as artist or mere engineer

Contour modulation is free of all constraint.

It is no longer a question of routine, nor of traditions, nor of construction methods, nor of adaptation to utilitarian needs.

Contour modulation is a pure creation of the mind; it calls for the plastic artist.

Mass-Production Housing

A great era has just begun.

There exists a new spirit.

Industry, invading like a river that rolls to its destiny, brings us new tools adapted to this new era animated by a new spirit.

The law of Economy necessarily governs our actions and our conceptions.

The problem of the house is a problem of the era. Social equilibrium depends on it today. The first obligation of architecture, in an era of renewal, is to bring about a revision of values, a revision of the constitutive elements of the house.

Mass production is based on analysis and experimentation.

Heavy industry should turn its attention to building and standardize the elements of the house.

We must create a mass-production state of mind.

A state of mind for building mass-production housing.

A state of mind for living in mass-production housing.

A state of mind for conceiving mass-production housing.

If we wrest from our hearts and minds static conceptions of the house and envision the question from a critical and objective point of view, we will come to the house-tool, the mass-production house that is healthy (morally, too) and beautiful from the aesthetic of the work tools that go with our existence.

Beautiful too from all the life that the artistic sense can bring to strict and pure organs.

Architecture or Revolution

In every domain of industry, new problems have been posed and tools capable of solving them have been created. If we set this fact against the past, there is resolution. In building, the factory production of standardized parts has begun; on the basis of new economic necessities, part elements and ensemble elements have been created; conclusive realizations have been achieved in parts and in ensembles. If we set ourselves against the past, there is revolution in the methods and the magnitude of enterprises.

Whereas the history of architecture evolves slowly over the centuries in terms of structure and décor, in the last fifty years iron and cement have brought gains that are the index of a great power to build and the index of an architecture whose code is in upheaval. If we set ourselves against the past, we determine that the 'styles' no longer exist for us, that the style of an era has been elaborated; there has been a revolution.

Consciously or unconsciously, minds have become aware of these events; consciously or unconsciously, needs are born.

The social mechanism, deeply disturbed, oscillates between improvements of historical importance and catastrophe.

It is the primal instinct of every living thing to secure a shelter. The various working classes of society no longer have suitable shelter, neither labourers nor intellectuals. It is a question of building that is key to the equilibrium upset today: architecture or revolution.

M46 Theo van Doesburg and others

Manifesto Prole Art (1923)

First published in *Merz* 2 (April 1923), in Hanover. Signed by Arp, Schwitters, Tzara, Van Doesburg and Christof Spengemann, a Dada writer and publisher.

Merz (1923–32) was produced and edited by the uncontainable Kurt Schwitters. Distributed in more than sixteen countries, it was truly international and genuinely conversational, promoting a dialogue between temperaments, currents and movements – Constructivists and Dadaists and his own one-man movement, 'Merz'. In Schwitters' eclectic practice, *Merz* was a collage form taking its name from a fragment of found text bearing the legend *Commerz and Privatbank*. This generated the first *Merzbild* or *Merzpicture* in 1918–19 and went on to christen every conceivable artwork or activity, including even an advertising agency (*Merzwerbe*) and the sculptural transformation of his own home, the *Merzbau*.

* * *

There is no such thing as an art that refers to a particular class of people, and if it did exist, it would not be important for life.

We ask those who want to create a proletarian art: 'What is proletarian art?' Is it art made by proletarians themselves? Or art that only serves the proletariat? Or art intended to awaken proletarian (revolutionary) instincts? There is no such thing as art made by proletarians, because a proletarian who makes art is no longer a proletarian, but becomes an artist. The artist is neither a proletarian nor a bourgeois, and what he creates belongs neither to the proletariat nor to the bourgeoisie, but to all. Art is a spiritual function of man, with the purpose of delivering him from the chaos of life (tragedy). Art is free in the use of its means, but

bound to its own laws, and only to its own laws, and as soon as the work is a work of art, it is sublimely raised above the class differences of proletariat and bourgeoisie. If art were intended exclusively to serve the proletariat (apart from the fact that the proletariat is infected by bourgeois taste) then this art would be limited, and indeed would be just as limited as specifically bourgeois art. Such art would not be universal, would not grow out of the world nationality feeling, but out of an individual and social perspective restricted to a particular time and place. If art is now supposed to awaken proletarian instincts in a tendentious manner, it then essentially uses the same means as church art or national socialist art. As banal as it may sound, whether somebody paints a red army led by Trotsky or an imperial army led by Napoleon is essentially the same. Whether it is intended to arouse proletarian instincts or patriotic feelings is of no significance for the value of the picture as a work of art. From an artistic point of view both are fraudulent.

Art should only arouse with its own means the creative power of man, its aim is the mature person, not the proletarian nor the bourgeois. With a limited perspective, lacking in culture, only those of little talent can make something such as proletarian art (i.e. politics in painted form), as they have no appreciation of greatness. But the artist refrains from [treating] the special area of social organization.

Art as we want it to be is neither proletarian nor bourgeois, for it develops powers that are strong enough to influence the whole culture rather than letting itself be influenced by social affairs.

The proletariat is a condition that must be overcome, the bourgeoisie is a condition that must be overcome. However, by imitating the bourgeois cult, the proletarians with their proletarian cult are themselves supporting this depraved culture of the bourgeois without realizing it; to the detriment of art and to the detriment of culture.

With their conservative love for old, outmoded forms of expression and their utterly incomprehensible distaste for the new art, they are keeping alive the very thing they claim to want to fight: bourgeois culture. Thus it is that bourgeois sentimentalism and bourgeois romanticism, despite all the intensive efforts of the radical artists to annihilate them, continue to exist and are even cultivated anew. Communism is already just as much a bourgeois affair as majority socialism, namely capitalism in a new form. The bourgeoisie is using the apparatus of Communism,

which was invented not by the proletariat, but by bourgeois men, only as a means of renewing their own degenerate culture (Russia). As a result, the proletarian artist is fighting for neither art nor for the future new life, but for the bourgeoisie. Every proletarian work of art is nothing more than a poster for the bourgeoisie.

That which we, on the other hand, are preparing is *Gesamtkunstwerk* [a synthesis of the arts] that is sublimely superior to all posters, whether they are made for sparkling wine, Dada or a Communist dictatorship.

M47 Tomoshoi Murayama and others

Mavo Manifesto (1923)

First published in the pamphlet for the opening exhibition of the Mavo
Group, at the Buddhist temple Denpōin in Asakusa, Japan, 28 July–
3 August 1923. Composed by Murayama and co-signed by Kadowaki
Shinrō, Ōura Shūzō, Ogata Kamenosuke and Yanase Masamu.

The Mavo Group were a negative entity, as they said; more an inclin-
ation than an organization. Apocryphally, the name or acronym Mavo
was arrived at by cutting up pieces of paper with the names of the five
founders spelled out in Romanized letters, scattering them around the
room, and choosing the four remaining letters (or perhaps the ones
furthest away) to make up a random word. This sounds too good to
be true, if only because there is no letter V in the Japanese syllabary.
Alternatively, and no less improbably, it represents M for *masse* (mass)
and V for *vitesse* (speed), with A for *alpha* and O for *omega*.

The Mavoists regarded themselves as distinctly avant-garde. They
were in revolt against traditional artistic practices and societies, and they
did not care who knew it. An advertising flyer for their first exhibition
was also published in their eponymous journal: 'How disgraceful it is
for anyone who does not see this astonishing exhibition! Futurism Expres-
sionism Dadaism There is nothing newer than this, there is nothing as
frightening as this, there is nothing truer than this.' Futurism, Expres-
sionism and Dadaism were crossed out, or cancelled, in a confrontational
gesture of public erasure, as Mavo's historian has said. Murayama was
not in the same rhetorical league as Marinetti, but the art of public eras-
ure is a gesture with a good modernist pedigree.

TOMOSHOI MURAYAMA (1901–77) was an artist and playwright, a
perennial vangardist and congenital oppositionist. Philosophically eager,

he was steeped in the work of Schopenhauer and Nietszche. In the early 1920s he studied art and drama at Humboldt University in Berlin. This may be the explanation for the emphasis on Expressionism and Constructivism in Mavo's earliest statements. Murayama took to combining Constructivist painting with a collage of real objects. He called this 'conscious constructivism'. Mavo artists and *Mavo* magazine adopted the same formulation.

* * *

I

We are forming a group which is (mainly) concerned with Constructivist art.

We call our group Mavo. We are Mavoists. The principles or inclinations expressed in our works and this manifesto is Mavoism. Therefore, we have chosen the mark MV. We have gathered together because we share the same inclination as Constructivist artists.

However, we definitely did not gather because we have identical principles and beliefs about art.

Thus, we do not aggressively try to regulate our artistic convictions.

We recognize, however, that when looking out over the general world of Constructivist art, we are bound to each other by a very concrete inclination.

Because our group is formed thus, it is a matter of timing, a thing of the moment.

We, each one of us, of course, possess assertions, convictions and passions that we feel we must elevate to the level of objectivity and appropriateness. However, as long as we are going to form a group, we respect one another. Furthermore, while recognizing what we inherently possess may be exclusive at times, we acknowledge the fact that we could not form a group without it.

In short, in terms of organization our group is a negative entity.

2

Next we would like to look at the nature of our Mavoist inclination. We do not subscribe to the convictions or 'outward signs' of any existing groups. (It is not necessary to interpret this strictly. You can think of this as the 'colour of a group'.)

We stand at the vanguard, and will eternally stand there. We are not bound. We are radical. We revolutionize / make revolution. We advance. We create. We ceaselessly affirm and negate. We live in all the meanings of words. Nothing can be compared to us.

We cannot help but acknowledge that what ties us together is the approximation of the forms of Constructivist art. However, we do not think it is necessary to explain the 'what' or 'how' of this. That is something you will understand by looking at our work.

3

We have exhibitions from one to four times a year. We also call for works from the general public.

Works from the general public must be judged by a variety of conditions.

Ideally speaking, there is no restriction on our judging method. However, we must be forgiven for accepting our own work at the present time.

As for judging standards, we are concerned with the two points of scope and merit.

To restrict the scope of works to those with the character and power of the formation of our group. However, this should be understood as being extremely broad.

In regard to the matter of merit, there is nothing left to do but trust the value judgement represented in our work.

We also experiment with lectures, theatre, musical concerts, magazine publishing, etc. We also accept posters, window displays, book designs, stage designs, various kinds of ornaments, architectural plans, and so forth. [. . .]

M48 David Alfaro Siqueiros and others
Manifesto of the Union of Mexican Workers, Technicians, Painters and Sculptors (1923)

First published in *El Machete* (Mexico City), the Union newspaper. Signed, 'for the proletariat of the world', by Siqueiros as Secretary-General, and by the following Committee members: Diego Rivera, Xavier Guerrero, Fermín Revueltas, José Clemente Orozco, Ramón Alva Guardarrama, Germán Cueto and Carlos Mérida.

Together with the colourful Diego Rivera and the strict socialist realist José Clemente Orozco, David Alfaro Siqueiros (1896–1974) was one of the 'Big Three' Mexican muralists, all of whom put their names to this manifesto. Siqueiros was a dedicated political activist, a self-proclaimed Marxist, and an unreconstructed Stalinist: the darling and despair of the Mexican Communist Party. He was twice sent into exile, in 1932 and again in 1940, after leading a (failed) assassination attempt on the exiled Leon Trotsky.

See also 'Manifesto: Towards a Free Revolutionary Art' (M59).

★ ★ ★

To the Indian race humiliated for centuries; to soldiers made executioners by the praetorians; to workers and peasants scourged by the greed of the rich; to intellectuals uncorrupted by the bourgeoisie.

COMRADES
The military coup of Enrique Estrada and Guadalupe Sánchez (the Mexican peasants' and workers' greatest enemies) has been of transcendental importance in precipitating and clarifying the situation in our country. This, aside from minor details of a purely political nature, is as follows:

On the one hand the social revolution, ideologically more coherent than ever, and on the other the armed bourgeoisie. Soldiers of the people, peasants and

armed workers defending their rights, against soldiers of the people, press-ganged by deceit or force by the politico-military leaders in the pay of the bourgeoisie.

On their side, the exploiters of the people in concubinage with traitors who sell the blood of soldiers who fought in the Revolution.

On our side, those who cry out for an end to an old cruel order – an order in which you, the peasants on the land, fertilize the soil so that the fruit it bears be swallowed by greedy profiteers and politicians while you starve; in which you, the workers in the city, man the factories, weave the cloth, and produce with your own hands modern comforts to serve prostitutes and drones while your bones shiver with cold; in which you, the Indian soldier, in an heroic selfless act, leave the land you till and give your life to fight the poverty your race has endured for centuries only for a Sánchez or an Estrada to waste the generous gift of your blood by favouring the bourgeois leeches who strip your children of their happiness and rob you of your land.

Not *only* are our people (especially our Indians) the source of all that is noble toil, all that is virtue, but also, every manifestation of the physical and spiritual existence of our race as an ethnic force springs from them. So does the extraordinary and marvellous ability to *create beauty. The art of the Mexican people is the most important and vital spiritual manifestation in the world today, and its Indian traditions lie at its very heart.* It is great precisely because it is of the people and therefore collective. That is why our primary aesthetic aim is to propagate works of art which will help destroy all traces of bourgeois individualism. We reject so-called Salon painting and all the ultra-intellectual salon art of the aristocracy and exalt the manifestation of monumental art because they are useful. We believe that any work of art which is alien or contrary to popular taste is bourgeois and should disappear because it perverts the aesthetic of our race. This perversion is already almost complete in our cities.

We believe that while our society is in a transitional stage between the destruction of an old order and the introduction of a new order, the creators of beauty must turn their work into clear ideological propaganda for the people, and make art, which at present is mere individualist masturbation, something of beauty, education and purpose for everyone.

We are all too aware that the advent of a bourgeois government in Mexico will mean the natural decline of our race's popular indigenous

aesthetic, at present found only in the lower classes but which was, however, beginning to penetrate and purify intellectual circles. *We will fight to prevent this happening.* Because we are sure that victory for the working classes will bring a harmonious flowering of ethnic art, of cosmogonical and historical significance to our race, comparable to that of our wonderful ancient autochthonous civilizations. *We will fight tirelessly to bring this about.*

Victory for La Heurta, Estrada and Sánchez will be, aesthetically and socially, a victory for typists' taste; criollo and bourgeois approval (which is all-corrupting) of popular music, painting and literature, the reign of the 'picturesque', the American 'kewpie doll', and the introduction of 'l'amore e come zucchero'. Love is like sugar. The counter-revolution in Mexico will, as a result, prolong the pain of the people and crush their admirable spirit.

The members of the Painters' and Sculptors' Union have in the past supported the candidacy of General Plutarco Elias Calles because we believed that his revolutionary fervour, more than any other, would guarantee a government which would improve the conditions of the productive classes in Mexico. We reiterate this support in the light of the latest politico-military events and put ourselves at the service of his cause, *the cause of the people,* to use as it sees fit.

We now appeal to revolutionary intellectuals in Mexico to forget their proverbial centuries-old sentimentality and languor and join us in the social, aesthetic and educational struggle we are waging.

In the name of the blood shed by our people during ten years of revolution, with the threat of a reactionary barracks revolt hanging over us, we urgently appeal to all revolutionary peasants, workers and soldiers in Mexico to understand the vital importance of the impending battle and, laying aside tactical differences, form a united front to combat the common enemy.

We appeal to ordinary soldiers who, unaware of what is happening or deceived by their traitorous officers, are about to shed the blood of their brothers of race and class. Remember that the bourgeoisie will use the self-same weapons with which the Revolution guaranteed your brother's land and livelihood to now seize them.

M49 The Red Group

Manifesto (1924)

Dated 13 June 1924; first published in *Der Rote Fahne* [*The Red Flag*] 57 (1924) in Berlin. The principal officers of the Union of Communist Artists were listed at the foot of the document, as follows. Chairman: George Grosz. Deputy Chairman: Karl Witte, writer. Secretary: John Heartfield.

The Red Group emerged from the Novembergruppe, formed in November 1918 to organize and mobilize radical artists in the service of the revolution in Germany. Most of its members had been involved in Berlin Dada (see M29 and M32).

<p align="center">★ ★ ★</p>

Communist Artists' Group

Artists organized and active in the Communist Party have combined to form a Communist Artists' Group. The members of this group, known as 'The Red Group of the Union of Communist Artists', share the conviction that a good Communist is first of all a Communist, and only secondarily a technician, artist and so on. They believe that all knowledge and skills are tools placed in the service of the class struggle.

In close conjunction with the local central organs of the Communist Party they have undertaken to realize the following programme, briefly outlined below, in order to increase the effectiveness of communist propaganda in the fields of literature, drama and the visual arts. The mode of production of communist artists, hitherto much too anarchistic, must now be replaced by a planned form of cooperation:

1. Organization of ideologically unified propaganda evenings.
2. Practical support in all revolutionary meetings.
3. Opposition to the Free German ideological survivals in proletarian meetings (patriotic romanticism).
4. Artistic training organized within each district; sample copies of wall newspapers; guidance in preparing posters and placards for demonstrations, etc; support of the efforts (far too dilettantish at present) of party members to proclaim the revolution by word and image.
5. Organization of travelling exhibitions.
6. Ideological and practical education among the revolutionary artists themselves.
7. Public opposition to counter-revolutionary cultural manifestations.
8. Disruption and neutralization of work by bourgeois artists.
9. Exploitation of bourgeois art exhibitions for propaganda purposes.
10. Contact with pupils in art establishments and institutions, in order to revolutionize them.

We regard the 'Red Group' as the core of an ever-expanding organization of all proletarian revolutionary artists in Germany.

Already several writers, along with our drama comrade Erwin Piscator, have joined the Communist Artists' Group. We now appeal to further artists and writers to join our ranks and work in practical terms with us on the basis of our working plan.

M50 André Breton

Manifesto of Surrealism (1924)

Published in Paris in 1924, two or three months before the first issue of *La Révolution Surréaliste* (December 1924), the Surrealist house journal and hymn sheet, and André Breton's rule book.

The 'Manifesto of Surrealism' announced a new movement – a new vice, as its author cunningly said – the most controversial and consequential movement of the decade, and perhaps beyond. Surrealism was more than an artistic tendency: it was a way of life. (At least, it had that ambition.) Unlike the founding Manifesto of Futurism (M1), the founding 'Manifesto of Surrealism' made few waves on first publication; but the after-shock was tremendous. Not least, it confirmed André Breton (1896–1966) to himself and to others as the undisputed leader and intellectual motivator of this extraordinary creation.

Breton was first smitten by Paul Valéry and his fascinating little meditation on art and life, *La Soirée avec Monsieur Teste* (1896), and then by Apollinaire and *Les Soirées de Paris* (see M6). He could have said with Monsieur Teste, 'stupidity is not my forte'; and after Apollinaire he became the other great impresario of twentieth-century French art. His writing is dense, haunting, penetrating, unsparing; the judgements delivered as if incontrovertible; the cumulative effect a kind of intellectual and moral pummelling. Breton was a moralist at heart. For him, as for his model Baudelaire ('Baudelaire is Surrealist in morality'), painting was a moral calling. Art and morality marched arm-in-arm together.

His idea of Surrealism (defined 'once and for all' in the manifesto as 'psychic automatism') was epitomized in his favourite quotation from a work that seized the pre-Surrealist imagination a few years before, *Les Chants de Maldoror* (1869), by the Comte de Lautréamont, the pseudonym of Isidore Ducasse, who is mentioned cryptically in the manifesto. A line in his work describes a young boy 'as beautiful as the chance meeting of

an umbrella and a sewing machine upon a dissecting table'. It is scarcely an exaggeration to say that Surrealism took its cue from this. Max Ernst defined Surrealist collage as 'the systematic exploitation of the fortuitous or engineered encounter of two or more intrinsically incompatible realities on a surface which is manifestly inappropriate for the purpose'.

In 1928 Breton published two essential works: the treatise on *Surrealism and Painting* (serialized in the journal) and the mysterious semi-documentary love story *Nadja* ('Beauty will be CONVULSIVE or it will not be'). They caused a sensation. Among painters, he championed Picasso and Giorgio de Chirico – already recognized by Apollinaire – and created a sort of Surrealist galaxy by introducing and espousing (and frequently chastising) André Masson, Max Ernst, Joan Miró, and a little later Salvador Dalí, Yves Tanguy and René Magritte. These men could be said to have performed acts of ABSOLUTE SURREALISM, in Breton's parlance, by analogy with Messrs Aragon, Éluard, Soupault and company in the literary realm.

Many of these men had dabbled or devilled in Dadaism. Breton himself was one. Just as Dadaism borrowed from Futurism, Surrealism borrowed from both. The Futurists' 'words-in-freedom' and 'unconscious inspiration' were not all that far removed from the Surrealists' automatic writing and psychic automatism. Breton echoed Marinetti and Tzara. Surrealism as he elaborated it was a mélange of new insight and discoveries made elsewhere – part poaching, part paralleling, part passing – sur-passing, as one might say.

Breton was prepared to put Surrealism at the service of the revolution – *Le Surréalisme au Service de la Révolution* was in fact the title of the periodical that succeeded *La Révolution Surréaliste*, the last issue of which contained the Second Manifesto of Surrealism (M54) in December 1929 – but his emancipatory sympathy did not extend to the brotherhood of the avant-garde. As Tristan Tzara discovered (see M36), André Breton was an authoritarian, if not a disciplinarian. It is no accident that he was dubbed the Pope of Surrealism.

* * *

Beloved imagination, what I most like in you is your unsparing quality.
The mere word 'freedom' is the only one that still excites me. I deem

it capable of indefinitely sustaining the old human fanaticism. It doubt-less satisfies my only legitimate aspiration. Among all the many misfortunes to which we are heir, it is only fair to admit that we are allowed the greatest degree of freedom of thought. It is up to us not to misuse it. To reduce the imagination to a state of slavery – even though it would mean the elimination of what is commonly called happiness – is to betray all sense of absolute justice within oneself, Imagination alone offers me some intimation of what *can be*, and this is enough to remove to some slight degree the terrible injunction; enough, too, to allow me to devote myself to it without fear of making a mistake (as though it were possible to make a bigger mistake). Where does it begin to turn bad, and where does the mind's stability cease? For the mind, is the possibility of erring not rather the contingency of good?

There remains madness, 'the madness that one locks up', as it has aptly been described. That madness or another . . . We all know, in fact, that the insane owe their incarceration to a tiny number of legally reprehensible acts and that, were it not for these acts their freedom (or what we see as their freedom) would not be threatened. I am willing to admit that they are, to some degree, victims of their imagination, in that it induces them not to pay attention to certain rules – outside of which the species feels itself threatened – which we are all supposed to know and respect. But their profound indifference to the way in which we judge them, and even to the various punishments meted out to them, allows us to suppose that they derive a great deal of comfort and consolation from their imagination, that they enjoy their madness sufficiently to endure the thought that its validity does not extend beyond themselves. And, indeed, hallucinations, illusions, etc., are not a source of trifling pleasure. The best controlled sensuality partakes of it, and I know that there are many evenings when I would gladly tame that pretty hand which, during the last pages of Taine's *L'Intelligence*, indulges in some curious misdeeds. I could spend my whole life prying loose the secrets of the insane. These people are honest to a fault, and their *naïveté* has no peer but my own. Christopher Columbus should have set out to discover America with a boatload of madmen. And note how this madness has taken shape, and endured.

[. . .]

We are still living under the reign of logic: this, of course, is what I have been driving at. But in this day and age logical methods are applicable only

to solving problems of secondary interest. The absolute rationalism that is still in vogue allows us to consider only facts relating directly to our experience. Logical ends, on the contrary, escape us. It is pointless to add that experience itself has found itself increasingly circumscribed. It paces back and forth in a cage from which it is more and more difficult to make it emerge. It too leans for support on what is most immediately expedient, and it is protected by the sentinels of common sense. Under the pretence of civilization and progress, we have managed to banish from the mind everything that may rightly or wrongly be termed superstition, or fancy; forbidden is any kind of search for truth which is not in conformance with accepted practices. It was, apparently, by pure chance that a part of our mental world which we pretended not to be concerned with any longer – and, in my opinion by far the most important part – has been brought back to light. For this we must give thanks to the discoveries of Sigmund Freud. On the basis of these discoveries a current of opinion is finally forming by means of which the human explorer will be able to carry his investigations much further, authorized as he will henceforth be not to confine himself solely to the most summary realities. The imagination is perhaps on the point of reasserting itself, of reclaiming its rights. If the depths of our mind contain within it strange forces capable of augmenting those on the surface, or of waging a victorious battle against them, there is every reason to seize them – first to seize them, then, if need be, to submit them to the control of our reason. The analysts themselves have everything to gain by it. But it is worth noting that no means has been designated a priori for carrying out this undertaking, that until further notice it can be construed to be the province of poets as well as scholars, and that its success is not dependent upon the more or less capricious paths that will be followed.

Freud very rightly brought his critical faculties to bear upon the dream. It is, in fact, inadmissible that this considerable portion of psychic activity (since, at least from man's birth until his death, thought offers no solution of continuity, the sum of the moments of dream, from the point of view of time, and taking into consideration only the time of pure dreaming, that is the dreams of sleep, is not inferior to the sum of the moments of reality, or, to be more precisely limiting, the moments of waking) has still today been so grossly neglected. I have always been amazed at the way an ordinary observer lends so much more credence and attaches so much more importance to waking events than to those

occurring in dreams. It is because man, when he ceases to sleep, is above all the plaything of his memory, and in its normal state memory takes pleasure in weakly retracing for him the circumstances of the dream, in stripping it of any real importance, and in dismissing the only *determinant* from the point where he thinks he has left it a few hours before: this firm hope, this concern. He is under the impression of continuing something that is worthwhile. Thus the dream finds itself reduced to a mere parenthesis, as is the night. And, like the night, dreams generally contribute little to furthering our understanding. This curious state of affairs seems to me to call for certain reflections:

1) Within the limits where they operate (or are thought to operate) dreams give every evidence of being continuous and show signs of organization. Memory alone arrogates to itself the right to excerpt from dreams, to ignore the transitions, and to depict for us rather a series of dreams than the *dream itself*. By the same token, at any given moment we have only a distinct notion of realities, the coordination of which is a question of will . . . What is worth noting is that nothing allows us to presuppose a greater dissipation of the elements of which the dream is constituted. I am sorry to have to speak about it according to a formula which in principle excludes the dream. When will we have sleeping logicians, sleeping philosophers? I would like to sleep, in order to surrender myself to the dreamers, the way I surrender myself to those who read me with eyes wide open; in order to stop imposing, in this realm, the conscious rhythm of my thought. Perhaps my dream last night follows that of the night before, and will be continued the next night, with an exemplary strictness. *It's quite possible*, as the saying goes. And since it has not been proved in the slightest that, in doing so, the 'reality' with which I am kept busy continues to exist in the state of dream, that it does not sink back down into the immemorial, why should I not grant to dreams what I occasionally refuse reality, that is, this value of certainty in itself which, in its own time, is not open to my repudiation? Why should I not expect from the sign of the dream more than I expect from a degree of consciousness which is daily more acute? Can't the dream also be used in solving the fundamental questions of life? Are these questions the same in one case as in the other and, in the dream, do these questions already exist? Is the dream any less restrictive or punitive than the rest? I

am growing old and, more than that reality to which I believe I subject myself, it is perhaps the dream, the difference with which I treat the dream, which makes me grow old.

2) Let me come back again to the waking state. I have no choice but to consider it a phenomenon of interference. Not only does the mind display, in this state, a strange tendency to lose its bearings (as evidenced by the slips and mistakes the secrets of which are just beginning to be revealed to us), but, what is more, it does not appear that, when the mind is functioning normally, it really responds to anything but the suggestions which come to it from the depths of that dark night to which I commend it. However conditioned it may be, its balance is relative. It scarcely dares express itself and, if it does, it confines itself to verifying that such and such an idea, or such and such a woman, has made an impression on it. What impression it would be hard pressed to say, by which it reveals the degree of its subjectivity, and nothing more. This idea, this woman, disturb it, they tend to make it less severe. What they do is isolate the mind for a second from its solvent and spirit it to heaven, as the beautiful precipitate it can be, that it is. When all else fails, it then calls upon chance, a divinity even more obscure than the others to whom it ascribes all its aberrations. Who can say to me that the angle by which that idea which affects it is offered, that what it likes in the eye of that woman is not precisely what links it to its dream, binds it to those fundamental facts which, through its own fault, it has lost? And if things were different, what might it be capable of? I would like to provide it with the key to this corridor.

3) The mind of the man who dreams is fully satisfied by what happens to him. The agonizing question of possibility is no longer pertinent. Kill, fly faster, love to your heart's content. And if you should die, are you not certain of reawaking among the dead? Let yourself be carried along, events will not tolerate your interference. You are nameless. The ease of everything is priceless.

What reason, I ask, a reason so much vaster than the other, makes dreams seem so natural and allows me to welcome unreservedly a welter of episodes so strange that they could confound me now as I write? And yet I can believe my eyes, my ears; this great day has arrived, this beast has spoken.

If man's awaking is harder, if it breaks the spell too abruptly, it is

because he has been led to make for himself too impoverished a notion of atonement.

4) From the moment when it is subjected to a methodical examination, when, by means yet to be determined, we succeed in recording the contents of dreams in their entirety (and that presupposes a discipline of memory spanning generations; but let us nonetheless begin by noting the most salient facts), when its graph will expand with unparalleled volume and regularity, we may hope that the mysteries which really are not will give way to the great Mystery. I believe in the future resolution of these two states, dream and reality, which are seemingly so contradictory, into a kind of absolute reality, a *surreality*, if one may so speak. It is in quest of this surreality that I am going, certain not to find it but too unmindful of my death not to calculate to some slight degree the joys of its possession.

A story is told according to which Saint-Pol-Roux, in times gone by, used to have a notice posted on the door of his manor house in Camaret, every evening before he went to sleep, which read: THE POET IS WORKING.

A great deal more could be said, but in passing I merely wanted to touch upon a subject which in itself would require a very long and much more detailed discussion; I shall come back to it. At this juncture, my intention was merely to mark a point by noting the *hate of the marvellous* which rages in certain men, this absurdity beneath which they try to bury it. Let us not mince words: the marvellous is always beautiful, anything marvellous is beautiful, in fact only the marvellous is beautiful.

[. . .]

Those who might dispute our right to employ the term SURREALISM in the very special sense that we understand it are being extremely dishonest, for there can be no doubt that this word had no currency before we came along. Therefore, I am defining it once and for all:

SURREALISM, *n*. Psychic automatism in its pure state, by which one proposes to express – verbally, by means of the written word, or in any other manner – the actual functioning of thought. Dictated by thought, in the absence of any control exercised by reason, exempt from any aesthetic or moral concern.

ENCYCLOPEDIA. *Philosophy.* Surrealism is based on the belief in

the superior reality of certain forms of previously neglected associations, in the omnipotence of dream, in the disinterested play of thought. It tends to ruin once and for all other psychic mechanisms and to substitute itself for them in solving all the principal problems of life. The following have performed acts of ABSOLUTE SURREALISM: Messrs. Aragon, Baron, Boiffard, Breton, Carrive, Crevel, Delteil, Desnos, Éluard, Gérard, Limbour, Malkine, Morise, Naville, Noll, Péret, Picon, Soupault, Vitrac.

They seem to be, up to the present time, the only ones, and there would be no ambiguity about it were it not for the case of Isidore Ducasse, about whom I lack information. And, of course, if one is to judge them only superficially by their results, a good number of poets could pass for Surrealists, beginning with Dante and, in his finer moments, Shakespeare. *In the course of the various attempts I have made to reduce what is, by breach of trust, called genius, I have found nothing which in the final analysis can be attributed to any other method than that.*

Young's *Nights* are Surrealist from one end to the other; unfortunately it is a priest who is speaking, a bad priest no doubt, but a priest nonetheless.

> Swift is Surrealist in malice,
> Sade is Surrealist in sadism.
> Chateaubriand is Surrealist in exoticism.
> Constant is Surrealist in politics.
> Hugo is Surrealist when he isn't stupid.
> Desbordes-Valmore is Surrealist in love.
> Bertrand is Surrealist in the past.
> Rabbe is Surrealist in death.
> Poe is Surrealist in adventure.
> Baudelaire is Surrealist in morality.
> Rimbaud is Surrealist in the way he lived, and elsewhere.
> Mallarmé is Surrealist when he is confiding.
> Jarry is Surrealist in absinthe.
> Nouveau is Surrealist in the kiss.
> Saint-Pol-Roux is Surrealist in his use of symbols.
> Fargue is Surrealist in the atmosphere.
> Vaché is Surrealist in me.
> Reverdy is Surrealist at home.

Saint-Jean-Perse is Surrealist at a distance.

Roussel is Surrealist as a storyteller.

Etc.

I would like to stress this point: they are not always Surrealists, in that I discern in each of them a certain number of preconceived ideas to which – very naïvely! – they hold. They hold to them because they had not *heard the Surrealist voice*, the one that continues to preach on the eve of death and above the storms, because they did not want to serve simply to orchestrate the marvellous score. They were instruments too full of pride, and this is why they have not always produced a harmonious sound.*

Surrealism does not allow those who devote themselves to it to forsake it whenever they like. There is every reason to believe that it acts on the mind very much as drugs do; like drugs, it creates a certain state of need and can push man to frightful revolts. It also is, if you like, an artificial paradise, and the taste one has for it derives from Baudelaire's criticism for the same reason as the others. Thus the analysis of the mysterious effects and special pleasures it can produce – in many respects Surrealism occurs as a *new vice* which does not necessarily seem to be restricted to the happy few; like hashish, it has the ability to satisfy all manner of tastes – such an analysis has to be included in the present study.

[. . .]

Surrealism, such as I conceive of it, asserts our complete *non-conformism* clearly enough so that there can be no question of translating it, at the trial of the real world, as evidence for the defence. It could, on the contrary, only serve to justify the complete state of distraction which we hope to achieve here below. Kant's absentmindedness regarding women, Pasteur's absentmindedness about 'grapes', Curie's absentmindedness with respect to vehicles, are in this regard profoundly symptomatic. This world is only very relatively in tune with thought, and incidents of this kind are only the most obvious episodes of a war in which I am proud to be participating. Surrealism is the 'invisible ray' which will one day

*I could say the same of a number of philosophers and painters, including, among the latter, Uccello, from painters of the past, and, in the modern era, Seurat, Gustave Moreau, Matisse (in 'La Musique', for example), Derain, Picasso (by far the most pure), Braque, Duchamp, Picabia, Chirico (so admirable for so long), Klee, Man Ray, Max Ernst and, one so close to us, André Masson.

enable us to win out over our opponents. 'You are no longer trembling, carcass.' This summer the roses are blue; the wood is of glass. The earth, draped in its verdant cloak, makes as little impression upon me as a ghost. It is living and ceasing to live that are imaginary solutions. Existence is elsewhere.

M51 José Carlos Mariátegui

Art, Revolution and Decadence (1926)

Dated 3 November 1926, Lima, Peru.

JOSÉ CARLOS MARIÁTEGUI (1894–1930) was a Peruvian journalist, activist, theorist and influential socialist. His most famous work, *Seven Interpretative Essays on Peruvian Reality* (1928), is still widely read as a pioneer materialist analysis of Latin American society. At the time he wrote this manifesto he also founded the journal *Amauta* to serve as a forum for discussion of socialism, art and culture in Peru, and in all of Latin America. Two years later, in 1928, he was instrumental in establishing the Socialist Party of Peru (subsequently the Communist Party); he became its Secretary-General. Mariátegui was also responsible for coining the phrase *sendero luminoso al futuro* ('the shining path to the future'), in reference to Marxism, later adopted by the Shining Path guerrillas in Peru (a Maoist group).

For Vicente Huidobro, a significant figure taken to task below, see M43.

* * *

It is important to dispel with the utmost speed a misleading idea which is confusing some young artists. We must correct certain hasty definitions, and establish that not all new art is revolutionary, nor is it really new. Two spirits coexist in the world at present, that of revolution and that of decadence. Only the former confers on a poem or painting the title new art.

We cannot accept as new, art which merely contributes a new technique. That would be flirting with the most fallacious of current illusions. No aesthetic can reduce art to a question of technique. New technique

must also correspond to a new spirit. If not, the only things to change are the trappings, the setting. And a revolution in art is not satisfied with formal achievements.

Distinguishing between the two contemporary categories of artists is not easy. Decadence and revolution; just as the two coexist in the same world, so they exist within the same individual. The artist's conscience is the arena for the struggle between the two spirits. This struggle is sometimes, almost always, beyond the comprehension of the artist himself. But one of the two spirits ultimately prevails. The other remains strangled in the arena.

The decadence of capitalist civilization is reflected in the atomization and dissolute nature of its art. In this crisis, art has above all lost its essential unity. Each of its principles, each of its elements, has asserted its autonomy. Secession is the most natural conclusion. Schools proliferate *ad infinitum* because no centrifugal forces exist.

But this anarchy, in which the spirit of bourgeois art dies, irreparably fragmented and broken, heralds a new order. It is the transition from dusk to dawn. In this crisis, the elements of a future art emerge separately. Cubism, Dadaism, Expressionism, etc., signal a crisis and herald a reconstruction at the same time. No single movement provides a formula, but all contribute (an element, a value, a principle) to its development.

The revolutionary nature of contemporary schools or trends does not lie in the creation of a new technique. Nor does it lie in the destruction of the old. It lies in the rejection, dismissal and ridicule of the bourgeois absolute. Art is always nourished, consciously or unconsciously – it's not important – by the absolute of its age. The contemporary artist's soul is, in the majority of cases, empty. The literature of decadence is literature with no absolute. But man can take no more than a few steps like that. He cannot march forward without a faith, because having no faith means having no goal. And marching without a goal is standing still. The artist who declares himself most exasperatedly sceptical and nihilistic is, generally, the one who most desperately needs a myth.

The Russian Futurists have embraced Communism, the Italian Futurists have embraced Fascism. Is there any better historical proof that artists cannot avoid political polarization? Massimo Bontempelli says that in 1920 he felt almost Communist and in 1923 [1922], the year of the march

to Rome, he felt almost Fascist. Now he feels totally Fascist. Many people have made fun of Bontempelli for that confession. I defend him; I think he is sincere. The empty soul of poor Bontempelli has to accept the Myth which Mussolini lays on his altar. (The Italian avant-garde is convinced that Fascism is the Revolution.)

César Vallejo writes that, while Haya de La Torre thinks the *Divine Comedy* and *Don Quixote* have political undercurrents, Vicente Huidobro maintains that art is independent of politics. The causes and motives behind this assertion are so old-fashioned and invalid that I wouldn't ascribe it to an Ultraist poet, assuming Ultraist poets are capable of discussing politics, economics and religion. If, for Huidobro, politics is exclusively what goes on in the Palais Bourbon, we can clearly endow his art with all the autonomy he wishes. But the fact is that politics, for those of us who, as Unamuno says, see it as a religion, is the very fabric of history. In classical periods, or periods of supreme order, politics may be merely administration and trappings; in romantic periods and regimes in crisis, however, politics occupies the foreground.

This is evident in the conduct of Louis Aragon, André Breton and their fellow artists of the Surrealist Revolution – the best minds of the French avant-garde – as they march towards Communism. Drieu La Rochelle, so close to this state of mind when he wrote 'Mésure de la France', and 'Plainte contre l'Inconnu', could not follow them. But since he could not escape politics either, he declared himself vaguely Fascist and clearly reactionary.

In the Hispanic world, Ortega y Gasset is responsible for part of this misleading idea about new art. Since he could not distinguish between schools or trends, he could not distinguish, at least in modern art, between revolutionary elements and decadent elements. The author of *The Dehumanisation of Art* [1925] did not define new art. Instead, he took as features of a revolution those which are typical of decadence. This led him to state, among other things, that 'new inspiration is always, unfailingly, cosmic'. His symptomological framework is, in general, correct; but his diagnosis is incomplete and mistaken.

Method is not enough. Technique is not enough. Despite his images and his modernity, Paul Morand is a product of decadence. A sense of dissoluteness pervades his literature. After flirting with Dadaism for a while, Jean Cocteau now gives us 'Rappel à l'ordre' ['Call to Order'].

It is important to clarify this matter, to dispel the very last misconceptions. The task is not easy. Many points are difficult to reconcile. Glimpses of decadence are frequently seen in the avant-garde even when, overcoming the subjectivism which sometimes infects it, they want to achieve truly revolutionary goals. Hidalgo, thinking of Lenin, says in a multidimensional poem, that the 'Salome breasts' and 'tomboy hairstyle' are the first steps towards the socialization of women. This should not surprise us. There are poets who think that the jazz band is a herald of the revolution.

Fortunately there are artists in the world, like Bernard Shaw, who are capable of understanding that 'art cannot be great unless it provides an iconography for a living religion, but it cannot be completely objectionable either except when it imitates the iconography of a religion which has become superstition'. This path seems to be the one taken by various new artists in French and other literature. The future will mock the naïve stupidity with which some critics of their time called them 'new' and even 'revolutionary'.

M52 Salvador Dalí and others

Yellow Manifesto (1928)

First published in March 1928 and widely distributed throughout Cata-
lonia and beyond.

The 'Yellow Manifesto' or 'Catalan Anti-Art Manifesto' was signed by
the art critic Sebastiàn Gasch, the literary critic Luís Montanyà, and Dalí.
It became the most important manifesto of the avant-garde in that region,
and perhaps in that country. Addressed to young Catalans, it denounced
the putrescent state of official culture and mounted a fierce defence of
modernism, embracing as brothers the exponents of Futurism, Cubism,
Dadaism and Surrealism.

SALVADOR DALÍ (1904–89) arrived on the Paris scene with his first
one-man show in 1929, with a preface contributed by none other than
André Breton (see the headnote to M54). He was already a Surrealist.
He wrote later: 'It was in 1929 that Salvador Dalí brought his attention
to bear upon the internal mechanisms of paranoiac phenomena and
envisaged the possibility of an experimental method based on the
sudden power of the systematic associations proper to paranoia; this
method afterwards became the delirio-critical synthesis which bears
the name of paranoiac-critical activity.' It is sometimes difficult to
know whether Dalí was made for Surrealism or Surrealism for Dalí.
As he himself observed, 'The only difference between me and a
madman is that I am not mad.'

His article on 'Surrealist Objects' in *Le Surréalisme au Service de la
Révolution* (1931) gave a vital stimulus to that important area of Surrealist
art – 'created wholly for the purpose of materializing in a fetishistic way,
with the maximum of tangible reality, ideas and fantasies having a deli-
rious character' – the fur cup, the lobster telephone, the four-legged doll.

Dalí was mad enough to become obsessed by Hitler, and to accept a

medal from Franco. In 1934 he was formally expelled from the Surrealist movement, after a short trial. Dalí was unapologetic. He was Surrealism, and he would take it with him. He rejected any suggestion of Hitler-idolatry, but refused explicitly to denounce Fascism. He became more egotistic, more erratic in his behaviour (more delirio-critical, perhaps), and more avaricious – in a brilliant stroke, Breton dubbed him 'Avida Dollars' (an anagram of Salvador Dalí, meaning eager for dollars).

* * *

We have eliminated from this MANIFESTO all courtesy in our attitude. It is useless to attempt any discussion with the representatives of present-day Catalan culture, which is artistically negative although efficient in other respects. Compromise and correctness lead to deliquescent and lamentable states of confusion of all values, to the most unbreathable spiritual atmospheres, to the most pernicious of influences. An example: *La Nova Revista*. Violent hostility, in contrast, clearly locates values and positions and creates a hygienic state of mind.

WE HAVE ELIMINATED all reasoning There exists an enor-
WE HAVE ELIMINATED all literature mous bibliography
WE HAVE ELIMINATED all poetry and all the effort
WE HAVE ELIMINATED all philosophy of artists of today
 in favour of to replace all this.
 our ideas

WE CONFINE OURSELVES to the most objective listing of facts.

WE CONFINE OURSELVES to pointing out the grotesque and extremely sad spectacle of the Catalan intelligentsia of today, shut in a blocked and putrefied atmosphere.

WE WARN those still uncontaminated of the risk of infection. A matter of strict spiritual asepsis.

WE KNOW that we are not going to say anything new. We are certain, however, that it is the basis of everything new that now exists and everything new that could possibly be created.

WE LIVE in a new era, of unforeseen poetic intensity.

MECHANIZATION has revolutionized the world.
MECHANIZATION – the antithesis of circumstantially indispensable futurism – has established the most profound change humanity has known.

A MULTITUDE anonymous – and anti-artistic – is collaborating with its daily endeavours towards the affirmation of the new era, while still living in accordance with its own period.

A POST-MACHINIST STATE OF MIND HAS BEEN FORMED

ARTISTS of today have created a new art in accordance with this state of mind. In accordance with their era.

HERE, HOWEVER, PEOPLE GO ON
VEGETATING IDYLLICALLY

THE CULTURE of present-day Catalonia is useless for the joy of our era. Nothing is more dangerous, more false or more adulterating.

WE ASK CATALAN INTELLECTUALS:

'What use has the Bernat Metge Foundation [for the study of the classics] been to you, if you end up confusing Ancient Greece with pseudo-classical ballerinas?'

WE DECLARE that sportsmen are nearer the spirit of Greece than our intellectuals.

WE GO ON TO ADD that a sportsman, free from artistic notions and all erudition is nearer and more suited to experience the art of today and the poetry of today than myopic intellectuals, burdened by negative training.

FOR US Greece continues in the numerical precision of an aeroplane engine, in the anti-artistic, anonymously manufactured English fabric meant for golf, in the naked performer of the American music-hall.

WE NOTE that the theatre has ceased to exist for some people and almost for everybody.

WE NOTE that everyday concerts, lectures and shows taking place among us now, tend to be synonymous with unbreathable, crushingly boring places.

IN CONTRAST new events, of intense joy and cheerfulness, demand the attention of the youth of today.

THERE IS the cinema

THERE ARE stadia, boxing, rugby, tennis and a thousand other sports

THERE IS	the popular music of today: jazz and modern dance
THERE ARE	motor and aeronautics shows
THERE ARE	beach games
THERE ARE	beauty competitions in the open air
THERE IS	the fashion show
THERE IS	the naked performer under the electric lights of the music-hall
THERE IS	modern music
THERE IS	the motor-racing track
THERE ARE	art exhibitions of modern artists
THERE ARE	moreover, great engineering and some magnificent ocean liners
THERE IS	an architecture of today
THERE ARE	implements, objects and furniture of the present era
THERE IS	modern literature
THERE ARE	modern poets
THERE IS	modern theatre
THERE IS	the gramophone, which is a little machine the camera, which is another little machine

THERE ARE	newspapers with extremely quick and vast information
THERE ARE	encyclopaedias of extraordinary erudition
THERE IS	science in great action
THERE IS	well-documented, guiding criticism
THERE ARE	etc., etc., etc.
THERE IS	finally, an immobile ear over a small puff of smoke.
WE DENOUNCE	the sentimental influence of [the poet] Guimerà's racial clichés
WE DENOUNCE	the sickly sentimentality served up by Orféo Català, with its shabby repertoire of popular songs adapted and adulterated by people with no capacity whatsoever for music, and even, of original compositions. (We think optimistically of the choir of American Revellers.)
WE DENOUNCE	the total lack of youth in our youth
WE DENOUNCE	the total lack of decision and audacity
WE DENOUNCE	the fear of new events, of words, of the risk of the ridiculous
WE DENOUNCE	the torpor of the putrid atmosphere of clubs and egos mingled with art

WE DENOUNCE	the total unawareness of critics with regard to the art of the present and the past
WE DENOUNCE	young people who seek to repeat painting of the past
WE DENOUNCE	young people who seek to imitate literature of the past
WE DENOUNCE	old, authentic architecture
WE DENOUNCE	decorative art, unless it is standardized
WE DENOUNCE	painters of crooked trees
WE DENOUNCE	present-day Catalan poetry, made with stale Maragallian clichés
WE DENOUNCE	artistic poisons for the use of children like: *Jordi*. (For the joy and understanding of children, nothing is more suitable than Rousseau, Picasso, Chagall . . .)
WE DENOUNCE	the psychology of little girls who sing: 'Rosó, Rosó . . .'
WE DENOUNCE	the psychology of little boys who sing: 'Rosó, Rosó . . .'

FINALLY WE DEDICATE OURSELVES TO THE GREAT ARTISTS OF TODAY, within the most diverse tendencies and categories:

PICASSO, GRIS, OZENFANT, CHIRICO, JOAN MIRÓ, LIPCHITZ, BRANCUSI, ARP, LE CORBUSIER, REVERDY, TRIS- TAN TZARA, PAUL ÉLUARD, LOUIS ARAGON, ROBERT DESNOS, JEAN COCTEAU, GARCÍA LORCA, STRAVINSKY, MARITAIN, RAYNAL, ZERVOS, ANDRÉ BRETON, ETC., ETC.

M53 Oswald de Andrade

Cannibalist Manifesto (1928)

First published in *Revista de Antropofagia* 1 (May 1928), in São Paulo, Brazil.

This is a manifesto of some renown: for its modernist traffic in references and cultures, for its wit, and for its negotiation between nationalism and cosmopolitanism. Its best-known line (in English in the original), 'Tupi or not to Tupi, that is the question', is at once a pun, a political point, and a performance of the theme. *Tupi* is the generic name for the Native Americans (or Native Indians) of Brazil – who have in the past been accused of cannibalism. Here they are celebrated, but also put in question, by means of a borrowing from *Hamlet* ("To be or not to be . . .'). Andrade cannibalized Shakespeare himself, one might say, to make his point.

'It does not sadden me that we should note the horrible barbarity in a practice such as theirs,' wrote Montaigne in a celebrated essay, 'On the Cannibals' (1580): 'What does sadden me is that, while judging correctly of their wrong-doings, we should be so blind to our own.' Andrade was deeply interested in the troublesome issue of civilization and barbarism. He knew that essay well enough to cite it in the manifesto, and he surely knew that Montaigne was one of Shakespeare's principal sources in his own exploration of that issue in *The Tempest*. He cannibalized European culture too.

OSWALD DE ANDRADE (1890–1954) was a poet and polemicist, and one of the founders of Brazilian modernism. He wrote an earlier 'Manifesto of Brazilwood Poetry' (1924), linked to a book of poems, emphasizing that Brazilian culture was a product of imported European culture, and calling on artists to create Brazilian works in order to export it, like the Brazil tree. His long-standing companion was the leading Brazilian modernist painter Tarsila do Amaral (1886–1973), a partner who

seems to have had a greater impact on his life and work than is commonly realized – whose painting *Abaporu* ('Man eats'), as Andrade called it, was given to him for his birthday in 1928, shortly before the writing of the manifesto.

See also an earlier 'Cannibalist Manifesto' by Picabia (M35).

* * *

Only cannibalism unites us. Socially. Economically. Philosophically.

The world's only law. The disguised expression of all individualisms, of all collectivisms. Of all religions. Of all peace treaties.

Tupi, or not tupi, that is the question.

Down with all catechisms. And down with the mother of the Gracchi. The only things that interest me are those that are not mine. The laws of men. The laws of the cannibalists.

We are tired of all the dramatic suspicious Catholic husbands. Freud put an end to the enigma of woman and to other frights of printed psychology.

Truth was reviled by clothing, that waterproofing separating the interior from the exterior world. The reaction against the dressed man. The American cinema will inform you.

Children of the sun, the mother of mortals. Found and loved ferociously, with all the hypocrisy of nostalgia, by the immigrants, slaves and tourists. In the country of the giant snake [a water spirit in Amazonian mythology].

It was because we never had grammar books, nor collections of old vegetables. And we never knew what urban, suburban, frontiers and continents were. We were a lazy spot on the map of Brazil.

A participating consciousness, a religious rhythm.

Down with all the importers of the canned conscience. The palpable existence of life. The pre-logical mentality for M. Lévy-Bruhl to study.

We want the Carahiba revolution. Bigger than the French Revolution. The unification of all successful rebellions led by man. Without us, Europe would not even have its meagre Declaration of the Rights of Man. The golden age proclaimed by America. The golden age and all the girls.

Descent. Contact with Carahiban Brazil. Où Villeganhon print terre [sic] [the French mission in Brazil in Montaigne's essay]. Montaigne.

Natural man. Rousseau. From the French Revolution to Romanticism, to the Bolshevik Revolution, to the Surrealist revolution and the technical barbarity of Keyserling. We continue on our path.

We were never catechized. We sustained ourselves by way of sleepy laws. We made Christ be born in Bahia. Or in Belém in Pará [the Brazilian city of Belém (Bethlehem) in the state of Pará].

But we never let the concept of logic invade our midst.

Down with Father Vieira [the Portuguese Jesuit instrumental in the colonization of Brazil]. He contracted our first debt, so as to get his commission. The illiterate king told him: write it down on paper but without too many fine words. And so the loan was made. An assessment on Brazilian sugar. Vieira left the money in Portugal and left us with the fine words.

The spirit refused to conceive of the idea of spirit without body. Cannibalism. The need for a cannibalist vaccine. We are for balance. Down with the religions of the meridian. And foreign inquisitions.

We can only pay heed to an oracular world.

Justice became a code of vengeance and Science was transformed into magic. Cannibalism. The permanent transformation of taboo into totem.

Down with the reversible world and objective ideas. Transformed into corpses. The curtailment of dynamic thought. The individual as victim of the system. The source of classic injustices. Of romantic injustices. And the forgetting of interior conquests.

Routes. Routes. Routes. Routes. Routes. Routes. Routes.

The Carahiban instinct.

The life and death of hypotheses. From the equation – me as part of the Cosmos – to the axiom – the Cosmos as part of me. Subsistence. Knowledge. Cannibalism.

Down with the vegetable élites. In communication with the earth.

We were never catechized. Instead we invented the Carnival. The Indian dressed as a Senator of the Empire. Pretending to be Pitt. Or appearing in Alencar's operas full of good Portuguese feelings.

We already had Communism. We already had Surrealist language. The golden age. Catiti Catiti Imara Natiá Notiá Imara Ipejú. [A Tupi text: 'New moon, oh new moon, blow memories of me into (the man I want).']

Magic and life. We had the relation and the distribution of physical

goods, moral goods and the goods of dignity. And we knew how to transpose mystery and death with the help of grammatical forms.

I asked a man what Law was. He told me it was the guarantee to exercise the possible. That man was called Gibberish. I swallowed him.

Determinism does not exist only where there is mystery. But what has this got to do with us?

Down with the stories of men, that begin at Cape Finistère. The undated uncountersigned world. No Napoleon. No Caesar.

The determining of progress by catalogues and television sets. They are only machines. And the blood transfusors.

Down with the antagonical sublimations. Brought in caravels.

Down with the truth of missionary peoples, defined by the sagacity of a cannibal, the Viscount of Cairú:- A lie repeated many times.

But they who came were not crusaders. They were fugitives from a civilization that we are devouring, because we are strong and vengeful just like Jaboty [the Brazilian tortoise, a trickster figure].

If God is the conscience of the Universe Uncreated, Guaracy [Tupi sun goddess] is the mother of living beings. Jacy [Tupi moon goddess] is the mother of all plants.

We did not speculate. But we had the power to guess. We had Politics which is the science of distribution. And a planetary social system.

The migrations. The flight from tedious states. Down with urban sclerosis. Down with Conservatoires and tedious speculation.

From William James to Voronoff. The transfiguration of taboo in totem. Cannibalism.

The *paterfamilias* and the creation of the Moral of the Stork: real ignorance of things + lack of imagination + sentiment of authority towards the curious progeny.

It is necessary to start with a profound atheism in order to arrive at the idea of God. But the Carahiba did not need one. Because they had Guaracy.

The created objective reacts like the Fallen Angel. After, Moses wanders. What has this got to do with us?

Before the Portuguese discovered Brazil, Brazil had discovered happiness.

Down with the Indian candleholder. The Indian son of Mary, godson of Catherine de Medici and son-in-law of Dom Antonio de Mariz.

Happiness is the proof of the pudding.

In the matriarchy of Pindorama [Tupi name for Brazil].

Down with the Memory, source of custom. Personal experience renewed.

We are concretists. Ideas take hold, react, burn people in public squares. We must suppress ideas and other paralyses. Along the routes. Believe in signs, believe in the instruments and the stars.

Down with Goethe, the mother of the Gracchi, and the court of João VI [King of Portugal, Brazil's last colonial monarch before independence (1822)].

Happiness is the proof of the pudding.

The *lucta* [struggle] between what one would call the Uncreated and the Creature illustrated by the permanent contradiction between man and his taboo. The daily love and the capitalist *modus vivendi*. Cannibalism. Absorption of the sacred enemy. In order to transform him into totem. The human adventure. The mundane finality. However, only the purest of élites managed to become cannibalist in the flesh and thus ascended to the highest sense of life, avoiding all the evils identified by Freud, catechist evils. What happens is not a sublimation of sexual instincts. It's the thermometric scale of the cannibalist instinct. Moving from carnal to wilful and creating friendship. Affective, love. Speculative, science. Deviation and transference. And then vilification. The low cannibalism in the sins of the catechism – envy, usury, calumny, murder. Plague of the so-called cultured Christianized peoples, it is against it that we are acting. Cannibalists.

Down with Anchieta [sixteenth-century Jesuit missionary] singing the eleven thousand virgins of the sky in the land of Iracema – the patriarch João Ramalho founder of São Paulo.

Our independence has not yet been proclaimed. A typical phrase of João VI: – My son, put this crown on your head, before some adventurer puts it on his! We must expel the spirit of Bragança [the Portuguese kings of the period], the laws and the snuff of Maria da Fonte [emblem of allegiance to Portuguese tradition].

Down with social reality, dressed and oppressive, registered by Freud – reality without complexes, without madness, without prostitution and without the prisons of the matriarchy of Pindorama.

M54 André Breton

Second Manifesto of Surrealism (1929)

First published in the twelfth and final edition of *La Révolution Surréaliste*, 15 December 1929.

This second manifesto is more austere and more theoretical than the first. It is concerned with Surrealism's relationship with Communism – more precisely, the Surrealist movement's relationship with the Communist Party – and with itself. It marks Breton's newly declared position: allied to Trotsky against orthodox, Stalinist Communism. It also gives evidence of something very like a purge. The tone is glacial; the talk is of last things. Breton had recently discovered Dalí. 'The art of Dalí, the most hallucinatory to date ever known, constitutes a veritable menace. Absolutely new beings, visibly evil in intent, have been put on the march. And it is a sombre pleasure to see how nothing can stop their passage except they themselves, and to recognize in the way in which they multiply and blend, that they are predatory beings.' As in art, so in politics.

As for the movement, Breton wrote later with characteristic fatalism, 'Surrealism at that time reminds me of a demasted ship, which could from one moment to the next either have gone to the bottom or have triumphantly reached the land of which Rimbaud spoke, where he would at last have known the true life.' Salvador Dalí's hallucinatory horror-show notwithstanding, the Surrealists were caught in a bind. Twenty years on, it found expression in Barnett Newman's poignant insight: 'instead of creating a magical world, the Surrealists succeeded only in illustrating it'.

Strange to relate, Breton and Trotsky were to collaborate over a manifesto of revolutionary art, some ten years later, in Mexico (M59).

* * *

Surrealism, although a special part of its function is to examine with a critical eye the notions of reality and unreality, reason and irrationality, reflection and impulse, knowledge and 'fatal' ignorance, usefulness and uselessness, is analogous at least in one respect with historical material- ism in that it too tends to take as its point of departure the 'colossal abortion' of the Hegelian system. It seems impossible to me to assign any limitations – economic limitations, for instance – to the exercise of a thought finally made tractable to negation, and to the negation of negation. How can one accept the fact that the dialectical method can only be validly applied to the solution of social problems? The entire aim of Surrealism is to supply it with practical possibilities in no way competi- tive in the most immediate realm of consciousness. I really fail to see – some narrow-minded revolutionaries notwithstanding – why we should refrain from supporting the Revolution, provided we view the problems of love, dreams, madness, art and religion from the same angle they do. [...]
Whatever the evolution of Surrealism may have been in the realm of politics, however urgently the order may have been passed on to us to count only upon the proletarian Revolution for the liberation of mankind – *the primary condition of the mind* – I can say in all honesty that we did not find any valid reason to change our minds about the means of expres- sion which are characteristically ours and which, we have been able to verify through usage, served us well. Let anyone who cares to condemn this or that specifically Surrealist image that I may have used at random in the course of a preface, it will not release him from further obligations as far as images are concerned. 'This family is a litter of dogs.' [Rimbaud] When, by quoting such a sentence out of context, anyone provokes a good deal of gloating, all he will actually have done is assemble a great many ignoramuses. One will not have succeeded in sanctioning neo- naturalistic procedures at the expense of ours, that is, in deprecating everything which, since naturalism, has contributed to the most import- ant conquests the mind has made. I am here reminded of the answers I gave, in September 1928, to these two questions that were asked me:

1) Do you believe that literary and artistic output is a purely individual phenomenon? Don't you think that it can or must be the reflection of the main currents which determine the economic and social evolution of humanity?

2) Do you believe in a literature and an art which express the aspirations of the working class? Who, in your opinion, are the principal representatives of this literature and this art?

My answers were as follows:

1) Most certainly, the same goes for literary or artistic output as for any intellectual phenomenon, in that the only question one can rightly raise concerning it is that of the *sovereignty of thought*. That is, it is impossible to answer your question affirmatively or negatively, and all one can say is that the only observable philosophical attitude in such a case consists in playing up the 'contradiction (which does exist) between the nature of human thought which we take to be absolute and the reality of that thought in a crowd of individuals of limited thought'. [Engels] This thought, in the area where you ask me to consider such and such a specific expression in relation to it, can only oscillate between the awareness of its inviolate autonomy and that of its utter dependence. In our own time, artistic and literary production appears to me to be wholly sacrificed to the needs that this drama after a century of truly harrowing poetry and philosophy (Hegel, Feuerbach, Marx, Lautréamont, Rimbaud, Jarry, Freud, Chaplin, Trotsky) has to work itself out. Under these circumstances, to say that this output can or must reflect the main currents which determine the social and economic evolution of humanity would be offering a rather unrefined judgement, implying the purely circumstantial awareness of thought and giving little credit to its fundamental nature: both unconditioned and conditioned, utopian and realistic, finding its end in itself and aspiring only to serve, etc.

2) I do not believe in the present possibility of an art or literature which expresses the aspirations of the working class. If I refuse to believe in such a possibility, it is because, in any pre-revolutionary period the writer or artist, who of necessity is a product of the bourgeoisie, is by definition incapable of translating these aspirations. I do not deny that he can get some idea of these aspirations and that, in rather exceptional moral circumstances, he may be capable of conceiving of the relativity of any cause in terms of the proletarian cause. I consider it to be a matter of sensitivity and integrity for him. This does not mean, however, that he will elude the remarkable doubt, inherent in the means of expression which are his, which forces him to consider from a very special angle,

within himself and for himself alone, the work he intends to do. In order
to be viable, this work demands to be *situated* in relationship to certain
other already existing works and must, in its turn, open up new paths.
Making all due allowances, it would, for example, be just as pointless to
protest against the assertion of a poetic determinism. whose laws cannot
be promulgated, as against that of dialectical materialism. Speaking
personally, I am convinced that the two kinds of evolution are strictly
similar and, moreover, that they have at least this much in common: *they
are both unsparing.*

[. . .]

It is incumbent on us . . . to try to see more and more clearly what is
transpiring unbeknownst to man in the depths of his mind, even if he
should begin to hold his own vortex against us. We are, in all this, a far
cry from wanting to reduce the portion of what can be untangled, and
nothing could be further from our minds than being sent back to the
scientific study of 'complexes'. To be sure, Surrealism, which as we have
seen deliberately opted for the Marxist doctrine in the realm of social
problems, has no intention of minimizing Freudian doctrine as it applies
to the evaluation of ideas: on the contrary, Surrealism believes Freudian
criticism to be the first and only one with a really solid basis. While it is
impossible for Surrealism to remain indifferent to the debate which, in
its presence, pits qualified practitioners of various psychoanalytical
tendencies against one another – just as it is obliged to consider daily and
with impassioned interest the struggle taking place within the leadership
of the International – it need not interfere in a controversy which, it
would seem, cannot long pursue a useful course except among practi-
tioners. This is not the area in which Surrealism intends to point up the
result of its personal experiments. But since by their very nature those
individuals who are drawn to Surrealism are especially interested in the
Freudian concept which affects the greater part of their deep concerns
as men – the concern to create, to destroy artistically – I mean the defin-
ition of the phenomenon known as 'sublimation'. Surrealism basically
asks these people to bring to the accomplishment of their mission a new
awareness, to perform an act of self-observation, which in their case is of
very exceptional value, to compensate for what is insufficient about the
penetration of so-called 'artistic' states of mind by men who for the most
part are not artists but doctors. Moreover, Surrealism demands that, by

taking a path opposite from the one we have just seen them follow, those who possess, in the Freudian sense, the 'precious faculty' we are referring to, bend their efforts toward studying in this light the most complex mechanism of all, 'inspiration', and, from the moment they cease thinking of it as something sacred, Surrealism demands that, however confident they are of its extraordinary virtue, they dream only of making it shed its final ties, or even – something no one had ever dared conceive of – of making it submit to them. There is no point in resorting to subtleties on this point; we all know well enough what inspiration is. There is no way of mistaking it; it is what has provided for the supreme needs of expression in every time and clime. It is commonly said that it is either present or it is not, and if it is absent, nothing of what, by way of comparison, is suggested by the human cleverness that interest, discursive intelligence and the talent acquired by the dint of hard work obliterate, can make up for it. We can easily recognize it by the total possession of our mind which, at rare intervals, prevents our being, for every problem posed, the plaything of one rational solution rather than some other equally rational solution, by that sort of short circuit it creates between a given idea and a respondent idea (written, for example). Just as in the physical world, a short circuit occurs when the two 'poles' of a machine are joined by a conductor of little or no resistance. In poetry and in painting, Surrealism has done everything it can and more to increase these short circuits. It believes, and it will never believe in anything more wholeheartedly, in reproducing artificially this ideal moment when man, in the grips of a particular emotion, is suddenly seized by this something 'stronger than himself' which projects him, in self-defence, into immortality. If he were lucid, awake, he would be terrified as he wriggled out of this tight situation. The whole point for him is not to be free of it, for him to go on talking the entire time this mysterious ringing lasts: it is in fact the point at which he ceases to belong to himself that he belongs to us. These products of psychic activity, as far removed as possible from the desire to make sense, as free as possible of any ideas of responsibility which are always prone to act as brakes, as independent as possible of everything which is not 'the passive life of the intelligence' – these products which automatic writing and the description of dreams represent offer at one and the same time the advantage of being unique in providing elements of appreciation of great style to a body of criticism which, in the realm

of art, reveals itself to be strangely helpless, of permitting a general reclassification of lyrical values, and of proposing a key capable of opening indefinitely that box of many bottoms called man, a key that dissuades him from turning back, for reasons of self-preservation, when in the darkness he bumps into doors, locked from outside, of the 'beyond' of reality, of reason, of genius, and of love. A day will come when we will no longer allow ourselves to use it in such cavalier fashion, as we have done, with its palpable proofs of an existence other than the one we think we are living. We will then be surprised to realize that, having come so close to seizing *the truth*, most of us have been careful to provide ourselves with an alibi, be it literary or any other, rather than throwing ourselves, without knowing how to swim, into the water, and without believing in the phoenix, plunging into the fire to reach this truth.

[. . .]

Every day brings us new indications of disappointments which we must have the courage to admit, if for no other reason than as a measure of mental hygiene, and inscribe in the horribly debit side of the ledger of life. With all too few exceptions, they concern people in whom, far too generously, we placed our trust and hope.

This said, we would by way of compensation like to give due credit to a man from whom we have been separated for many long years, the expression of whose thought still interests us, a man whose concerns, to judge by what we have still been able to read by him, are not all that far from our own, and under these circumstances, there is perhaps good reason to think that our misunderstanding with him was not based on anything quite so serious as we may have been led to think. It is entirely possible that Tzara, who early in 1922, at the time of the liquidation of 'Dada' as a movement, no longer saw eye to eye with us insofar as the practical methods we should use in the pursuit of a common goal were concerned, was the victim of excessive charges which we, because of this lack of agreement, levelled against him – as he levelled equally outrageous charges against us – and that, during the notorious performance of the *Coeur à barbe*, in order for our rupture to take the turn we know it did, all that was required was for him to make some untoward gesture, the meaning of which, he claims – *and I only recently learned this* – we misinterpreted. (It must be admitted that the main object of 'Dada' spectacles was always to create as much confusion as possible, and that in the

mind of the organizer the whole idea was to bring the misunderstanding between participants and public to its highest pitch. It should be borne in mind that not all of us, that evening, were on the same side.) Personally, I am perfectly willing to accept this version, and I see no other reason, therefore, not to insist, insofar as all those who were involved are concerned, that these incidents be forgotten. Since they took place, I am of the opinion that, as Tzara's intellectual attitude has never ceased to be unequivocal, we would be acting with undue narrow-mindedness not to tell him so publicly. As far as we are concerned – my friends and I – we would like to show by this reconciliation that what governs our conduct in every circumstance is in no wise the sectarian desire to impose at any cost a viewpoint which we do not even ask Tzara to share completely, but rather the concern to recognize value – what we think of as *value* – wherever it exists. We believe in the *efficacity* of Tzara's poetry, which is the same as saying we consider it, apart from Surrealism, as the only really 'situated' poetry. When I speak of its efficacity, I mean to imply that it is operative in the broadest possible area and that it represents a notable step forward today in the direction of human liberation. When I say that it is 'situated', the reader will understand that I am comparing it with all those works which might just as well have been written yesterday or the day before: in the front rank of the things that Lautréamont has not rendered absolutely impossible there is Tzara's poetry. *De nos oiseaux* having just appeared, it is fortunately not the press's silence which will succeed in stopping the damage it can do.

Therefore, without having to ask Tzara to get hold of himself, we would simply like to suggest that he make what he is doing more obvious than it was possible for him to do over these past few years. Knowing that he himself is desirous of joining forces with us, as in the past, let us remind him that, by his own admission, he once wrote 'to look for men, and nothing more'. In this connection, let him not forget, we were like him. Let no one think that we found ourselves, and then lost ourselves. [...]

Man, who would wrongly allow himself to be intimidated by a few monstrous historical failures, is still free to *believe* in his freedom. He is his own master, in spite of the old clouds which pass and his blind forces which encounter obstacles. Doesn't he have any inkling of the brief beauty concealed and of the long and accessible beauty that can be

André Breton

revealed? Let him also look carefully for the key to love, which the poet claimed to have found: he has it. It is up to him and him alone to rise above the fleeting sentiment of living dangerously and of dying. Let him, in spite of any restrictions, use the avenging arm of the idea against the bestiality of all beings and of all things, and let him one day, vanquished – *but vanquished only if the world is the world* – welcome the discharge of his sad rifles like a salvo fired in salute.

M55 F. T. Marinetti and Fillìa

Manifesto of Futurist Cuisine (1930)

First published in the *Gazzetta del popolo*, 28 December 1930, in Turin, and in a French version in *Comœdia*, 20 January 1931. It also appeared in the advertising brochure of the first Futurist restaurant, the Taverna del Santopalato, which opened on 8 March 1931 in Turin, and in the Futurist cookbook, *La cucina futurista* (*The Futurist Cookbook*) (1932), compiled by Marinetti and Fillìa.

On the centenary of the founding Manifesto of Futurism, 20 February 2009, the New York arts organization Performa invited 100 people to a Futurist banquet at Inside Park, a refurbished church next to the Waldorf Astoria. The menu was drawn from *The Futurist Cookbook*. It began with Futurist cocktails: 'Inventina', inspired by Marinetti, consisting of one third Asti Spumante, one third pineapple liqueur and one third orange juice; and 'Alcoholic Joust', a tribute to Prampolini, made from red wine, citronade and Campari bitters, topped with chocolate and cream cheese.

The food was conceptual, if not theatrical. Each guest was greeted with tiny initials cut out of salami or cheese. Next came 'aerofood', according to the manifesto – perfume sprayed into the air by the waiters. Then 'milk in green light': a plate of sour milk with radishes, under green floodlights. A performance artist began energetically to recite Futurist poetry, complete with complicated sound effects. After about twenty minutes of this, one of the guests threw a glass of water over him – a dangerously Dada gesture – to no effect.

Futurist pheasant arrived – not quite the original Chicken Fiat with ball bearings – and Futurist risotto, followed by alcoholic jellies called 'Marinettian Bombes'. These proved too great a temptation, and the evening ended in bombe-throwing and jelly-soaking: a thoroughly Futurist conclusion.

For biographical details about Marinetti ('the caffeine of Europe'), see the founding Manifesto (M1).

Fillia ('a saucepan always on the boil') was the pseudonym of Luigi Colombo (1904–36), painter, poet, dramatist and leader of the Turin Futurists.

* * *

Italian Futurism, which has sired numerous Futurisms and avant-garde movements abroad, is by no means the prisoner of worldwide victories it has won 'over twenty years of great artistic and political battles that have often been consecrated by the spilling of blood,' as Benito Mussolini has suggested. Yet again, Futurism risks unpopularity with its scheme for a complete rethinking of what we eat.

Of all artistic-literary movements, it is the only one that is essentially reckless and without fear. The Novecento movement in painting and literature is, in reality, two very moderate, practical Futurisms of the political Right. Bound by tradition, they feel their way carefully towards the new by taking full advantage of what each has to offer.

Against Pasta

Futurism has been defined by philosophers as 'mysticism in action', by Benedetto Croce as 'antihistoricism', by Graça Aranha as 'liberation from aesthetic terror', and by us as 'innovative Italian pride', being the formula for 'original life and art', 'the religion of speed', 'humanity's maximum drive towards synthesis', 'health of the spirit', 'a method for continuous creativity', 'fast-moving geometrical splendour', and 'aesthetics of the machine'.

Contrary to established practice therefore, we Futurists disregard the example and cautiousness of tradition so that, at all costs, we can invent something *new*, even though it may be judged by all as madness.

Though we recognize that great things have been achieved in the past by men who were poorly fed or who survived on coarse victuals, we assert this truth: What we think or dream or do is determined by what we eat and what we drink.

On this subject, let us consult our lips, our tongue, our palate, our taste buds, our gastric juices, and let us enter – in a spirit of originality – the world of gastric chemistry.

We Futurists sense that for the male, the pleasure of love is found in plumbing the depths from top to bottom, whereas for the female it is fanned out horizontally. Gastronomic pleasure, on the other hand, for both the male and female is always upwards, from the bottom to the top of the human body. And furthermore, we think it necessary to prevent Italian men from becoming stolid, leaden hunks, dull and insensitive. They need to be more in tune with the Italian female, who is a slender, spiralling transparency of passion, tenderness, light, strong will, impulsiveness and heroic tenacity. We must make the Italian body agile, in keeping with the super-lightweight aluminium trains that will take the place of the heavy iron, wood and steel trains currently in use.

We Futurists are convinced that in the likely event of future wars, it will be the most lithe, agile peoples who will be victorious. To this end we have greatly enlivened the literatures of the world with Words-in-Freedom and the technique of simultaneity. We have turned boredom out of the theatres, with our concentrated, a-logical *Theatre of Surprises* and dramas of inanimate objects, and have greatly extended the range of the plastic arts through our anti-realism. We have also created an architecture of geometrical splendour, devoid of ornamentation, as well as abstract cinema and photography. And now, after all of this, we are establishing a diet in keeping with an increasingly airborne, faster pace of life.

Above all, we believe it is necessary:

a) to be rid of pasta, that idiotic gastronomic fetish of the Italians.

It may well be that cod, roast beef and puddings are good for the English, and that the same goes for the Dutch with their meat cooked with cheese, or the Germans with their *Sauerkraut*, smoked *Speck* and *Kotelett*; but pasta is not good for the Italians. It contradicts, for example, the lively spirit and passionate, generous, intuitive nature of the Neapolitans. They have been heroic fighters, inspired artists, powerful orators, sharp-witted lawyers, and industrious farmers in spite of their mountains of pasta every day. By eating it, they develop their characteristic ironical, emotional scepticism, which often crushes their exuberance.

A very intelligent Neapolitan professor, Dr Signorelli, has written

'Unlike bread and rice, pasta is a food that is swallowed and not chewed. This starchy food, for the most part, is digested by the saliva in the mouth and the task of conversion is carried out by the pancreas and the liver. This leads to an imbalance and, consequently, has negative effects on these organs. It induces sluggishness, depression, inertia brought on by nostalgia, and neutralism.'

An Invitation to Chemists

Pasta, which is 40 per cent less nutritious than meat, fish and vegetables, binds the Italians of today, with its knotty strands, to the languid looms of Penelope and to somnolent sails waiting for a wind. What is the point of continuing to let its heavy bulk stand against that immense network of long and short waves that Italian genius has flung over the oceans and continents, against those landscapes of colour, form and sound with which radio-television circumnavigates the Earth? The apologists for pasta carry its leaden ball, its ruins, in their stomachs, like prisoners serving a life sentence, or archaeologists. Bear in mind too that the abolition of pasta will liberate Italy from the costly burden of foreign grain and will work in favour of the Italian rice industry.

b) The abolition of volume and weight in the way we understand and evaluate nutrition.

c) Abolition of all the traditional recipes in order to try out all the new, seemingly ridiculous combinations recommended by Jarro Maincave and other Futurist chefs.

d) Abolition of the routine daily insipidities from the pleasures of the palate.

We invite the chemical industry to do its duty and, very soon, provide the body with all the calories it needs by means of nutritional equivalents, supplied free of charge by the State, in the form of pills or powders, albuminous compounds, synthetic fats and vitamins. We shall thus arrive at a real reduction in the cost of living and of wages, with a corresponding reduction in the number of working hours. Today the production of 2,000 kilowatts requires only one workman. Machines will soon constitute an obedient workforce of iron, steel and aluminium at the service of mankind, which will be relieved, almost entirely, of manual labour.

This being reduced to two or three hours, will allow the refinement and the exultation of the other hours through thought, the arts, and the anticipation of perfect meals.

For all social classes, meals will be a thing of the past, yet the daily round of nourishing equivalents will nevertheless be perfect.

The perfect meal requires:

1. An inventive harmony between the table setting (glasswear, crockery and decoration) and the tastes and colours of the food.

2. Absolute originality in the choice of foods.

'Sculpted Meat'

Example: to prepare *Alaska salmon baked in the rays of the sun, with a Martian sauce*, you take an Alaska salmon, you slice it, season it with pepper, salt and fine oil, and place it under the grill until it is a golden brown. Add tomatoes (sliced in two and grilled beforehand), parsley and garlic.

When ready to serve, place several anchovy fillets on the slices to form a chessboard pattern. Top each slice with capers and a thin slice of lemon. The sauce will be made from anchovies, the yolk of hard-boiled eggs, basil, olive oil, a small glass of Italian Aurum liqueur, all passed through a sieve. (Recipe by Bulgheroni, head chef of the Goose Quill restaurant.)

Example: to prepare *Woodcock Mount Rosa with Venus sauce*, you take a fine woodcock, clean it, cover the breast with slices of ham and fatty bacon, place it in a casserole with some butter, salt, pepper and juniper berries, and cook it in a very hot oven for fifteen minutes, basting it with cognac. Take it out of the casserole and place it immediately on a large square of toasted bread, soaked in rum and cognac, then cover it with puff pastry. Return it to the oven until the pastry is well cooked. Serve it with the following sauce: half a glass of Marsala and white wine, four spoonfuls of huckleberries and some finely chopped orange peel, the mixture having been boiled for ten minutes. Pour the sauce into a sauce-boat and serve it very hot. (Recipe by Bulgheroni, head chef of the Goose Quill restaurant.)

3. Invention of appetizing food sculptures, whose novel harmony of

shape and colour feeds the eyes and titillates the imagination before tempting the lips.

Example: *Sculpted meat*, created by the futurist painter Fillìa as a snapshot interpretation of Italian landscapes, is made from a large cylindrical rissole of minced veal, stuffed and roasted with eleven different kinds of cooked vegetables. This cylinder, placed vertically in the centre of the plate, is crowned with thick honey and supported at its base with a ring of sausage set on three spherical pieces of golden brown chicken.

Equator + North Pole

Example: The edible plastic composition *Equator + North Pole*, created by the Futurist painter Enrico Prampolini, is made from an equatorial sea of egg yolks with oysters and salt, pepper and lemon juice. From the centre, a cone of solid egg white emerges, decorated with orange segments that resemble succulent pieces of the sun. The top of the cone is strewn with pieces of black truffle, shaped like black aeroplanes soaring triumphantly to their zenith.

These appetizing, sculpted, coloured, scented and tactile compositions will provide perfect simultaneous meals.

4. Banishment of the knife and fork when eating these sculptures, so that they give tactile pleasure before ever reaching the lips.

5. Use of the art of scents to enhance the taste of food. Each dish should be heralded by a perfume that will be expunged from the table by means of ventilators.

6. The use of music must be limited to the intervals between one course and the next, so as not to distract the sensibilities of the tongue and palate, yet having the effect of nullifying the tastes already enjoyed and returning the taste buds to a virginal state.

7. Banishment of speeches and political discussion from the table.

8. Measure use of poetry and music as impromptu ingredients, to kindle up the flavours of a particular dish through their sensual intensity.

9. Between courses, a rapid presentation to the nostrils and eyes of the diners of some dishes they will be eating and of others they will not, to generate curiosity, surprise and fantasy.

10. The creation of simultaneously eaten, continually changing appetizers that contain ten or twenty flavours, to be sampled in just a few moments. These canapés will have the same magnifying, analogical function in Futurist cuisine as images have in literature. A particular appetizer will have the power to sum up a whole area of life, the development of a passionate affair, or an entire voyage to the Far East.

11. The kitchen to be equipped with scientific instruments: *ozonizers*, to lend the scent of ozone to liquids and foodstuffs; *ultraviolet lamps*, since many foodstuffs, when irradiated with ultraviolet light, acquire active properties, become more digestible, prevent rickets in young children, etc.; *electrolyzers*, to alter the composition of extracted juices, etc., so as to obtain a new product, with new properties, from a known product; *colloid blenders*, to facilitate the milling of flour, the pulverization of nuts and spices, etc.; *distillers, and vacuum stills, sterilizers, dialyzers*, the use of which must be well informed, avoiding error, for example, of cooking foodstuffs in steam pressure cookers, which destroys active ingredients (vitamins etc.) owing to the high temperatures. *Chemical indicators* will register the acid and alkaline content of sauces and will have the effect of correcting errors such as lack of salt, too much vinegar, too much pepper, and too much sweetness.

M56 John Reed Club of New York

Draft Manifesto (1932)

Drafted for the national organization of John Reed Clubs, to be submitted to its conference in May 1932. First published in *New Masses*, June 1932.

JOHN REED (1887–1920) was a journalist and Communist activist who wrote a celebrated eye-witness account of the Russian Revolution, *Ten Days that Shook the World* (1919). Clubs named after him were formed all over the United States in the late 1920s and early 1930s: the time of the Great Depression and the Wall Street Crash. They were aligned to the Communist Party of the USA, with its eye on a new crisis of capitalism, and intended primarily to foster young leftist talent. They attracted plenty. The young African-American novelist Richard Wright, author of *Native Son* (1940), was elected secretary of the Chicago club in 1933. Wright was keen enough; his complaint (widely shared) had to do with the demands made on their time by the Party for activities that seemed irrelevant to their artistic goal. He couldn't be a writer, as he put it, if he was constantly preparing reports on the price of pork chops.

* * *

Mankind is passing through the most profound crisis in its history. An old world is dying; a new one is being born. Capitalist civilization, which has dominated the economic, political and cultural life of continents, is in the process of decay. It received a deadly blow during the imperialist war which it engendered. It is now breeding new and more devastating wars. At this very moment the Far East seethes with military conflicts and preparations which will have far-reaching consequences for the whole of humanity.

Meantime, the prevailing economic crisis is placing greater and greater

burdens upon the mass of the world's population, upon those who work with hand or brain. In the cities of five-sixths of the globe, millions of workers are tramping the streets looking for jobs in vain. In the rural districts, millions of farmers are bankrupt. The colonial countries reverberate with revolutionary struggles of oppressed peoples against imperialist exploitation; in the capitalist countries the class struggle grows sharper from day to day.

The present crisis has stripped capitalism naked. It stands more revealed than ever as a system of robbery and fraud, unemployment and terror, starvation and war.

The general crisis of capitalism is reflected in its culture. The economic and political machinery of the bourgeoisie is in decay, its philosophy, its literature and its art are bankrupt. Sections of the bourgeoisie are beginning to lose faith in its early progressive ideas. The bourgeoisie is no longer a progressive class, and its ideas are no longer progressive ideas. On the contrary: as the bourgeois world moves towards the abyss, it reverts to the mysticism of the Middle Ages. Fascism in politics is accompanied by neo-catholicism in thinking. Capitalism cannot give the mass of mankind bread. It is equally unable to evolve creative ideas.

This crisis in every aspect of life holds America, like other capitalist countries, in its iron grip. Here there is unemployment, starvation, terror and preparation for war. Here the government, national, state and local, is dropping the hypocritical mask of democracy, and openly flaunts a fascist face. The demand of the unemployed for work or bread is answered with machine-gun bullets. Strike areas are closed to investigators; strike leaders are murdered in cold blood. And as the pretence of constitutionalism is dropped, as brute force is used against workers fighting for better living conditions, investigations reveal the utmost corruption and graft in government, and the closest cooperation of the capitalist political parties and organized crime.

In America, too, bourgeois culture writhes in a blind alley. Since the imperialist war, the best talents in bourgeois literature and art, philosophy and science, those who have the finest imaginations and the richest craftsmanship, have revealed from year to year the sterility, the utter impotence of bourgeois culture to advance mankind to higher levels. They have made it clear that although the bourgeoisie has a monopoly of the instruments of culture, its culture is in decay. Most of the American writers who have

developed in the past fifteen years betray the cynicism and despair of capitalist values. The movies are a vast corrupt commercial enterprise, turning out infantile entertainment or crude propaganda for the profit of stockholders. Philosophy has become mystical and idealist. Science goes in for godseeking. Painting loses itself in abstractions or trivialities.

In the past two years, however, a marked change has come over the American intelligentsia. The class struggle in culture has assumed sharp forms. Recently we have witnessed two major movements among American intellectuals: the Humanist movement, frankly reactionary in its ideas; and a movement to the left among certain types of liberal intellectuals.

The reasons for the swing to the left are not hard to find. The best of the younger American writers have come, by and large, from the middle classes. During the boom which followed the war these classes increased their income. They played the stock market with profit. They were beneficiaries of the New Era. The crash in the autumn of 1929 fell on their heads like a thunderbolt. They found themselves the victims of the greatest expropriation in the history of the country. The articulate members of the middle classes – the writers and artists, the members of the learned professions – lost that faith in capitalism which during the twenties trapped them into dreaming on the decadent shores of post-war European culture. These intellectuals suddenly awoke to the fact that we live in the era of imperialism and revolution; that two civilizations are in mortal combat and that they must take sides.

A number of factors intensified their consciousness of the true state of affairs. The crisis has affected the intellectual's mind because it has affected his income. Thousands of school-teachers, engineers, chemists, newspapermen and members of other professions are unemployed. The publishing business has suffered acutely from the economic crisis. Middle-class patrons are no longer able to buy paintings as they did formerly. The movies and theatres are discharging writers, actors and artists. And in the midst of this economic crisis, the middle-class intelligentsia, nauseated by the last war, sees another one, more barbarous still, on the horizon. They see the civilization in whose tenets they were nurtured going to pieces.

In contrast, they see a new civilization rising in the Soviet Union. They see a land of 160,000,000 people, occupying one-sixth of the globe, where

workers rule in alliance with farmers. In this vast country there is no unemployment. Amidst the decay of capitalist economy, Soviet industry and agriculture rise to higher and higher levels of production every year. In contrast to capitalist anarchy, they see planned Socialist economy. They see a system with private profit and the parasitic classes which it nourishes abolished; they see a world in which the land, the factories, the mines, the rivers, and the hands and brains of the people produce wealth not for a handful of capitalists but for the nation as a whole. In contrast to the imperialist oppression of the colonies, to the lynching of Negroes, to Scottsboro cases, they see 132 races and nationalities in full social and political equality cooperating in the building of a Socialist society. Above all, they see a cultural revolution unprecedented in history, unparalleled in the contemporary world. They see the destruction of the monopoly of culture. They see knowledge, art and science made more accessible to the mass of workers and peasants. They see workers and peasants themselves creating literature and art, themselves participating in science and invention. And seeing this, they realize that the Soviet Union is the vanguard of the new Communist society which is to replace the old.

Some of the intellectuals who have thought seriously about the world crisis, the coming war and the achievements of the Soviet Union, have taken the next logical step. They have begun to realize that in every capitalist country the revolutionary working class struggles for the abolition of the outworn and barbarous system of capitalism. Some of them, aligning themselves with the American workers, have gone to strike areas in Kentucky and Pennsylvania and have given their talents to the cause of the working class.

Such allies from the disillusioned middle-class intelligentsia are to be welcomed. But of primary importance at this stage is the development of the revolutionary culture of the working class itself. The proletarian revolution has its own philosophy developed by Marx, Engels and Lenin. It has developed its own revolutionary schools, newspapers and magazines; it has its worker-correspondents, its own literature and art. In the past two decades there have developed writers, artists and critics who have approached the American scene from the viewpoint of the revolutionary workers.

To give this movement in arts and letters greater scope and force, to bring it closer to the daily struggle of the workers, the John Reed Club

was formed in the fall of 1929. In the past two and a half years, the influence of this organization has spread to many cities. Today there are thirteen John Reed Clubs throughout the country. These organizations are open to writers and artists, whatever their social origin, who subscribe to the fundamental programme adopted by the international conference of revolutionary writers and artists which met at Kharkov, in November 1930. The programme contains six points upon which all honest intellectuals, regardless of their background may unite in the common struggle against capitalism. They are:

1. Fight against imperialist war, defend the Soviet Union against capitalist aggression;
2. Fight against fascism, whether open or concealed, like social-fascism;
3. Fight for the development and strengthening of the revolutionary labour movement;
4. Fight against white chauvinism (against all forms of Negro discrimination or persecution) and against the persecution of the foreign-born;
5. Fight against the influence of middle-class ideas in the work of revolutionary writers and artists;
6. Fight against the imprisonment of revolutionary writers and artists, as well as other class-war prisoners throughout the world.

On the basis of this minimum programme, we call upon all honest intellectuals, all honest writers and artists, to abandon decisively the treacherous illusion that art can exist for art's sake, or that the artist can remain remote from the historic conflicts in which all men must take sides. We call upon them to break with bourgeois ideas which seek to conceal violence and fraud, the corruption and decay of capitalist society. We call upon them to align themselves with the working class in its struggle against capitalist oppression and exploitation, against unemployment and terror, against fascism and war. We urge them to join with the literary and artistic movement of the working class in forging a new art that shall be a weapon in the battle for a new and superior world.

M57 Mario Sironi

Manifesto of Mural Painting (1933)

First published in *Colonna* 1 (December 1933) in Milan. Composed by Sironi; co-signed by Achille Funi, Massimo Campigli and Carlo Carrà.

MARIO SIRONI (1885–1961) was at one time regarded as one of the most gifted artists of his generation, but then he found Fascism. The manifestos he signed in the inter-war years identify him as a fervent nationalist who dreamed that the Fascist movement would restore the confidence of the Italian race (whatever that might mean). Immediately after Mussolini formed his first cabinet in 1922, Sironi joined a number of writers and artists in publishing a statement in *Il Principe*: 'We are confident that in Mussolini we have the Man who knows how to value correctly the strength of our world-dominating Art' – a triumph of hope over experience.

Sironi continued to receive official commissions throughout the 1930s, but his work was the subject of venomous controversy. He was disliked by supporters of the modern movement for what they saw as a stale revival of ancient styles (Byzantine, Pompeian, Etruscan . . .), and he was condemned by bulldog Fascist commentators for being too avant-garde and individualistic. A former secretary of the party accused him of a 'Jewish' intellectualism that was fundamentally anti-Fascist and anti-Italian. Such was the level of debate; but that sally cost Sironi his job as art critic for Mussolini's newspaper *Il Popolo d'Italia*, and led to a galling exclusion from the 1934 Venice Biennale. In post-Mussolini Italy, Sironi was left out in the cold. He died bitter.

Mural painting appealed to Fascists and Communists alike (as Sironi seems to acknowledge). 'Mural painting is social painting,' he says here.

* * *

Fascism is a style of life: it is life itself for Italians. No formula will ever succeed in completely expressing it, let alone defining it. Similarly, no formula will ever succeed in expressing, let alone defining, what is understood as Fascist art, that is to say, an art which is the plastic expression of the Fascist spirit.

Fascist art will be created little by little and will be the result of the slow labour of the best people. That which can and must be done straight away is to free artists from the numerous doubts which linger on.

In the Fascist state art acquires a social function: an educative function. It must translate the ethic of our times. It must give a unity of style and grandeur of contour to common life. Thus art will once again become what it was in the greatest of times and at the heart of the greatest of civilizations: a perfect instrument of spiritual direction.

The individualist conception of 'art for art's sake' is dead. As a result of this there is a deep incompatibility between the goals that Fascist art assigns itself and all the forms of art born of the arbitrary, of individualization, of the particular aesthetic of a group, of a coterie, an academy. The great disquiet which troubles all European art is the product of a time of spiritual decomposition. Modern painting, for years and years technical exercises and minute analyses of natural phenomena of Nordic origin, today feels the need for a superior spiritual synthesis.

Fascist art rejects experiments or investigations, the endeavours which the current century has indulged in. It rejects above all the 'consequences' of these investigations, which have unfortunately been prolonged into the present. Although seeming varied and often diverse, these investigations all derive from the vulgar materialist view of life which was characteristic of the past century and which is not only alien to us, but eventually became intolerable.

Mural painting is social painting par excellence. It acts on the popular imagination more directly than any other form of painting, and inspires lesser arts more directly.

The renaissance of mural painting, above all of the fresco, allows the formulation of the problem of Fascist art. The answer is the practical purpose of mural painting (public buildings, public places with a civic function). They are governed by laws; it is the supremacy of the stylistic element over the emotional, it is its intimate association with architecture which forbids the artist from giving way to improvisation and simple

virtuosity. On the contrary, they oblige the artist to control himself by a decisive and virile technical execution of his task. The technique of mural painting obliges the artist to develop his own imagination and to organize it completely. There is no form of painting in which order and rigour of composition predominate, no form of 'genre' painting, which stands up to these tests set by the technical demands and large dimensions of the mural painting technique.

From mural painting will arise the 'Fascist style' with which the new civilization will be able to identify. The educative function of painting is above all a question of style. The artist will succeed in making an impression on popular consciousness by the style, by the suggestion of climate, rather than by the subject-matter (as the Communists think).

Questions of subject are too simplistic to be essential to the solution. Mere political orthodoxy of 'subject' does not suffice: it is a convenient expedient, erroneously used by the 'advocates of content'. To be in harmony with the spirit of revolution, the style of Fascist painting will have to be antique as well as very new: it will have to resolutely dispense with the hitherto predominant trend of a narrow and monotonous art, based on an alleged, fundamentally false, 'good sense' which reflects neither a 'modern' nor a 'traditional' attitude. It will have to combat all the false returns which bolster an elementary aestheticism and constitute an obvious outrage to any true sense of tradition.

A moral question arises for every artist. The artist must renounce this egocentricity which from now on can only sterilize his spirit, and become a 'militant' artist who serves a moral ideal, subordinating his own individuality to collective work.

We do not intend to advocate practical anonymity, which is repugnant to the Italian temperament, but rather an intimate sense of devotion to collective work. We firmly believe that the artist will become a *man amongst men* as was the case in the most prestigious eras of our civilization.

We do not want to advocate hypothetical agreement on a single artistic formula – which would be practically impossible – but a precise and express artistic will to free art from subjective and arbitrary elements, such as that specious originality, which is desired and sustained only by our vanity.

We believe that the voluntary establishment of a work-discipline is necessary

to create true and authentic talent. Our great traditions, principally decorative in character, mural and stylistic, strongly favour the birth of a Fascist style. No elective affinities with the great epochs of our past can be understood without a profound understanding of our time. The spirituality of the beginnings of the Renaissance is closer to us than the splendour of the great Venetians. The art of pagan and Christian Rome is closer to us than Greek art. We have recently come to mural painting by virtue of aesthetic principles which have developed in the Italian spirit since the war. It is not by chance, but by insight into our times that the most audacious experiments of Italian painters have already focused, for years, on mural techniques and stylistic problems. The way forward is indicated by these endeavours, until the necessary unity can be achieved.

M58 Károly (Charles) Sirató and others

Dimensionist Manifesto (1936)

First published in French as 'Manifeste Dimensioniste' in the form of an insert in the *Revue N+1* in Paris. Drafted by the Hungarian poet Károly (Charles) Sirató (1905–80). According to the original text, 'the following artists signed the Dimensionist Manifesto in Paris in 1936': Hans Arp, Francis Picabia, Wassily Kandinsky, Frederick Kann, Marcel Duchamp, Mario Nissim, Nina Negri, Pierre Albert-Biro, Anton Prinner, Robert Delaunay, Sonia Delaunay-Terk, Ervand Kotchar, Camille Bryen, César Domela, Enrico Prampolini, Siri Rathsman, Sophie Taeuber-Arp. And 'the following foreign endorsements appeared in the first (movemental) edition of the manifesto': Ben Nicholson (London), Alexander Calder (New York), Vicente Huidobro (Santiago), David Kakabadze (Tbilisi), Katarzyna Kobro (Warsaw), Joan Miró (Barcelona), László Moholy-Nagy (London), Antonio Pedro (Lisbon).

Of this roster of the great and the good and the movementally misled, Sirató's versatile fellow countryman Moholy-Nagy (1895–1946), another master at the Bauhaus (see M33), had anticipated much of Dimensionism in his book, *The New Vision: From Material to Architecture* (1928 and still in print), a work that had an impact on several generations of the avant-garde, notably the composer John Cage. In fact, Dimensionist discourse had been in the air since the turn of the century. The Cubists revolutionized thinking about the two-dimensional representation of the third dimension (depth); they also introduced the first collages and *papiers collés* (pasted papers) – true 3-D. But Braque and Picasso always scoffed at talk of the 'fourth dimension' and the mediumistic baggage it carried with it. They were immensely proud of the move into 3-D. 4-D was one D too far. That is where the Dimensionists came in.

Dimensionism, it seems, is alive and well. At the Institute of Contemporary Arts in London in 2009, the artist Mark Leckey began his

performance of a 'Long Tail World' with a reading of the Dimensionist Manifesto, as if to indicate the fulfilment of Sirató's vision in the digital age. However, the triumph of cosmic art and the abolition of rigid matter may have to wait a little longer. The climax of the show at the ICA demonstrated a touching reliance on traditional objects: a huge inflatable head of Felix the Cat looming over the blackboard on which Mark Leckey did his calculations, in a mist of dry ice.

★ ★ ★

Dimensionism is a general movement in the arts, begun unconsciously by Cubism and Futurism – continuously elaborated and developed afterwards by every people in Western civilization.

Today the essence and the theory of this great movement explode in an absolute conviction.

At the origin of Dimensionism are the new ideas of Space-Time present in the European way of thinking, promulgated in particular by Einstein's theories as well as the recent techniques of our age.

The absolute need to evolve – an irreducible instinct – leaves dead forms and exhausted contents as the prey for dilettantes, forcing the avant-gardes to move towards the unknown.

We are obliged to admit – contrary to the classical thesis – that Space and Time are no longer different categories but according to the non-Euclidean conception are coherent dimensions, putting an end to all the old limits and boundaries of the arts.

This new ideology has provoked a real earthquake and a subsequent slippage in the conventional systems of the arts. We designate all of these phenomena taken as a whole by the term 'DIMENSIONISM'.

Tendency or Principle of Dimensionism, Formula 'N+1'.

(Formula found in the theory of Planism and then generalized, reducing to a common law the most chaotic and inexplicable manifestations of the art of our time.)

ANIMATED BY A CONCEPTION OF THE WORLD, THE ARTS, IN A COLLECTIVE FERMENTATION (Interpenetration of the Arts)

HAVE STARTED MOVING

AND EACH OF THEM HAS EVOLVED WITH A NEW
DIMENSION
EACH OF THEM HAS FOUND A FORM OF EXPRESSION
INHERENT TO
THE SUPPLEMENTARY DIMENSION OBJECTIFYING THE
GRAVE MENTAL
CONSEQUENCES OF THIS FUNDAMENTAL CHANGE

So the Dimensionist tendency has constrained:

I . . . Literature to come forth from the line and

Pass	into	the	plane
Calligrams	Typograms	Planism	
(preplanism)		Electric poems	

II . . . Painting to leave the plane and occupy space.

Painting in space 'Konstructivism'
 Spatial Constructions
 Ploy-Material Constructions

III . . . Sculpture to abandon closed space unmoving and dead, that is Euclidean space in three dimensions, in order to use Minkovsky's four-dimensional space for artistic expression.

First, 'full' sculpture (Classical Sculpture), will disembowel itself, and by introducing in its own body the sculpted and calculated 'lack' of interior space – then movement – is transformed into:

Hollow Sculpture.
Open Sculpture.
Mobile Sculpture.
Motorized Objects.

Then must come the creation of an absolutely new art: Cosmic Art Vaporization of Sculpture.

Synos-Sense theatre, provisional denominations. Total conquest by art of four-dimensional space.

until now a 'Vacuum Artis'.

Rigid matter is abolished and replaced by gazefied materials. Instead of looking at objects of art, the person becomes the centre and the subject

of creation; creation consists of sensorial effects taking place in a closed cosmic space.

That is the most concise statement of the principle of Dimensionism. Deductive towards the past. Inductive towards the future. Living for the present.

M59 André Breton, Diego Rivera and Leon Trotsky
Manifesto: Towards a Free Revolutionary Art (1938)

Written on 25 July 1938 by Breton and Trotsky; first published in English in *Partisan Review* IV (Fall 1938) and immediately afterwards in the *London Bulletin* (December 1938–January 1939).

In 1938 André Breton went to Mexico on a lecture tour. Leon Trotsky (1879–1940), second only to Lenin as the principal architect of the Russian Revolution, had been given asylum there in 1936, after he was expelled from the Communist Party and deported from the Soviet Union, at Stalin's behest, in 1929. He lived latterly in a villa-fortress on the outskirts of Mexico City, memorializing, anathematizing, looking after his beloved rabbits, and fearing for his life. With reason: in May 1940 the muralist and manifestoist David Alfaro Siqueiros (M48) was involved in an assassination attempt. Three months later an agent of the NKVD (the Soviet secret police) entered the compound and drove an ice pick into Trotsky's skull.

Breton and Trotsky were introduced by Diego Rivera. Trotsky had lived at Rivera's house and had had an affair with Rivera's wife, Frida Kahlo. The manifesto was the product of a shared perception of the repressive nature of both Fascism and Stalinism. Whatever his failings as a human being, Trotsky was a formidable intellectual. His writing could be devastating. *Literature and Revolution* (1925), for example, offers an array of brilliant reflections on Futurism: 'The original Futurism of Russia . . . was the revolt of Bohemia, that is, the semi-pauperized left wing of the intelligentsia, against the closed-in and caste-like aesthetics of the bourgeois intelligentsia. Through the outer layer of this poetic revolt was felt the pressure of deep social forces, which Futurism itself did not quite understand. The struggle against the old vocabulary and

syntax of poetry, regardless of all its Bohemian extravagances, was a progressive revolt against a vocabulary that cramped and selected artificially with the view of being undisturbed by anything extraneous; a revolt against Impressionism, which was sipping life through a straw; a revolt against Symbolism, which had become false in its heavenly vacuity . . . and against all the other squeezed lemons and picked chicken bones of the little world of the liberal-mystic intelligentsia.' So much for the liberal-mystic intelligentsia.

Trotsky apparently considered it expedient in the circumstances for Rivera's name to be substituted for his own on the manifesto. The call for an International Federation of Independent Revolutionary Art (IFIRA) came to nothing. The fervour of the moment echoes still – but not for the distinguished Argentinian writer Borges, who reviewed the manifesto when it first came out. 'I believe,' he wrote, 'and only believe that Marxism (like Lutheranism, like the moon, like a horse, like a line from Shakespeare) may be a stimulus for art, but it is absurd to decree that it is the only one. It is absurd for art to be a department of politics. That, however, is precisely what this incredible manifesto claims . . . A poor independent art they are imagining, subordinate to the pedantries of committees and five capital letters!'

On Breton, see the headnote to the 'Manifesto of Surrealism' (M 50).

* * *

We can say without exaggeration that never has civilization been menaced so seriously as today. The Vandals, with instruments which were barbarous, and so comparatively ineffective, blotted out the culture of antiquity in one corner of Europe. But today we see world civilization, united in its historic destiny, reeling under the blows of reactionary forces armed with the entire arsenal of modern technology. We are by no means thinking only of the world war that draws near. Even in times of 'peace' the position of art and science has become absolutely intolerable.

In so far as it originates with an individual, in so far as it brings into play subjective talents to create something which brings about an object-ive enriching of culture, any philosophical, sociological, scientific or artistic discovery seems to be the fruit of a precious *chance*, that is to say,

the manifestation, more or less spontaneous, of *necessity*. Such creations cannot be slighted, whether from the standpoint of general knowledge (which interprets the existing world), or of revolutionary knowledge (which, the better to change the world, requires an exact analysis of the laws which govern its movement). Specifically, we cannot remain indifferent to the intellectual conditions under which creative activity takes place, nor should we fail to pay all respect to those particular laws which govern intellectual creation.

In the contemporary world we must recognize the ever more widespread destruction of those conditions under which intellectual creation is possible. From this follows of necessity an increasingly manifest degradation not only of the work of art but also of the specifically 'artistic' personality. The regime of Hitler, now that it has rid Germany of all those artists whose work expressed the slightest sympathy for liberty, however superficial, has reduced those who still consent to take up pen or brush to the status of domestic servants of the regime, whose task it is to glorify it on order, according to the worst possible aesthetic conventions. If reports may be believed, it is the same in the Soviet Union, where Thermidorian reaction is now reaching its climax.

It goes without saying that we do not identify ourselves with the currently fashionable catchword: 'Neither fascism nor communism!', a shibboleth which suits the temperament of the philistine, conservative and frightened, clinging to the tattered remnants of the 'democratic' past. True art, which is not content to play variations on ready-made models but rather insists on expressing the inner needs of man and of mankind in its time – true art is unable *not* to be revolutionary, *not* to aspire to a complete and radical reconstruction of society. This it must do, were it only to deliver intellectual creation from the chains which bind it, and to allow all mankind to raise itself to those heights which only isolated geniuses have achieved in the past. We recognize that only the social revolution can sweep clean the path for a new culture. If, however, we reject all solidarity with the bureaucracy now in control of the Soviet Union, it is precisely because, in our eyes, it represents not communism but its most treacherous and dangerous enemy.

The totalitarian regime of the USSR, working through the so-called cultural organizations it controls in other countries, has spread over the entire world a deep twilight hostile to every sort of spiritual value. A

twilight of filth and blood in which, disguised as intellectuals and artists, those men steep themselves who have made of servility a career, of lying for pay a custom, and of the palliation of crime a source of pleasure. The official art of Stalinism mirrors with a blatancy unexampled in history their efforts to put a good face on their mercenary profession.

The repugnance which this shameful negation of principles of art inspires in the artistic world – a negation which even slave states have never dared to carry so far – should give rise to an active, uncompromising condemnation. The *opposition* of writers and artists is one of the forces which can usefully contribute to the discrediting and overthrow of regimes which are destroying, along with the right of the proletariat to aspire to a better world, every sentiment of nobility and even of human dignity.

The communist revolution is not afraid of art. It realizes that the role of the artist in a decadent capitalist society is determined by the conflict between the individual and various social forms which are hostile to him. This fact alone, in so far as he is conscious of it, makes the artist the natural ally of revolution. The process of *sublimation*, which here comes into play and which psychoanalysis has analysed, tries to restore the broken equilibrium between the integral 'ego' and the outside elements it rejects. This restoration works to the advantage of the 'idea of self', which marshals against the unbearable present reality all those powers of the interior world, of the 'self', which are *common to all men* and which are constantly flowering and developing. The need for emancipation felt by the individual spirit has only to follow its natural course to be led to mingle its stream with this primeval necessity – the need for the emancipation of man.

The conception of the writer's function which the young Marx worked out is worth recalling. 'The writer,' he declared, 'naturally must make money in order to live and write, but he should not under any circumstances live and write in order to make money . . . The writer by no means looks on his work as a *means*. It is an *end in itself* and so little a means in the eyes of himself and of others that if necessary he sacrifices his existence to the existence of his work . . . *The first condition of freedom of the press is that it is not a business activity.*' It is more than ever fitting to use this statement against those who would regiment intellectual activity in the direction of ends foreign to itself, and prescribe, in the guise of so-called

reasons of state, the themes of art. The free choice of these themes and the absence of all restrictions on the range of his exploitations – these are possessions which the artist has a right to claim as inalienable. In the realm of artistic creation, the imagination must escape from all constraint and must under no pretext allow itself to be placed under bonds. To those who urge us, whether for today or for tomorrow, to consent that art should submit to a discipline which we hold to be radically incompatible with its nature, we give a flat refusal and we repeat our deliberate intention of standing by the formula *complete freedom for art*.

We recognize, of course, that the revolutionary state has the right to defend itself against the counter-attack of the bourgeoisie, even when this drapes itself in the flag of science or art. But there is an abyss between these enforced and temporary measures of revolutionary self-defence and the pretension to lay commands on intellectual creation. If, for the better development of the forces of material production, the revolution must build a *socialist* regime with centralized control, to develop intellectual creation an *anarchist* regime of individual liberty should from the first be established. No authority, no dictation, not the least trace of orders from above! Only on a base of friendly cooperation, without constraint from outside, will it be possible for scholars and artists to carry out their tasks, which will be more far-reaching than ever before in history.

It should be clear by now that in defending freedom of thought we have no intention of justifying political indifference, and that it is far from our wish to revive a so-called pure art which generally serves the extremely impure ends of reaction. No, our conception of the role of art is too high to refuse it an influence on the fate of society. We believe that the supreme task of art in our epoch is to take part actively and consciously in the preparation of the revolution. But the artist cannot serve the struggle for freedom unless he subjectively assimilates its social content, unless he feels in his very nerves its meaning and drama and freely seeks to give his own inner world incarnation in his art.

In the present period of the death agony of capitalism, democratic as well as fascist, the artist sees himself threatened with the loss of his right to live and continue working. He sees all avenues of communication choked with the debris of capitalist collapse. Only naturally, he turns to the Stalinist organizations which hold out the possibility of escaping from his isolation. But if he is to avoid complete demoralization he cannot

remain there, because of the impossibility of delivering his own message and the degrading servility which these organizations exact from him in exchange for certain material advantages. He must understand that his place is elsewhere, not among those who betray the cause of the revolution and mankind, but among those who with unshaken fidelity bear witness to the revolution, among those who, for this reason, are alone able to bring it to fruition, and along with it the ultimate free expression of all forms of human genius.

The aim of this appeal is to find a common ground on which may be reunited all revolutionary writers and artists, the better to serve the revolution by their art and to defend the liberty of that art itself against the usurpers of the revolution. We believe that aesthetic, philosophical and political tendencies of the most varied sort can find here a common ground. Marxists can march here hand in hand with anarchists, provided both parties uncompromisingly reject the reactionary police patrol spirit represented by Joseph Stalin and by his henchman García Oliver [a Spanish anarcho-syndicalist revolutionary, regarded as a traitor to the cause, for his willingness to compromise with Franco in the Spanish Civil War].

We know very well that thousands on thousands of isolated thinkers and artists are today scattered throughout the world, their voices drowned out by the loud choruses of well-disciplined liars. Hundreds of small local magazines are trying to gather youthful forces about them, seeking new paths and not subsidies. Every progressive tendency in art is destroyed by Fascism as 'degenerate'. Every free creation is called 'Fascist' by the Stalinists. Independent revolutionary art must now gather its forces for the struggle against reactionary persecution. It must proclaim aloud the right to exist. Such a union of forces is the aim of the *International Federation of Independent Revolutionary Art* which we believe it is now necessary to form.

We by no means insist on every idea put forth in this manifesto, which we ourselves consider only a first step in the new direction. We urge every friend and defender of art, who cannot but realize the necessity for this appeal, to make himself heard at once. We address the same appeal to all those publications of the left wing which are ready to participate in the creation of the International Federation and to consider its task and its methods of action.

When a preliminary international contact has been established through the press and by correspondence, we will proceed to the organ-

ization of local and national congresses on a modest scale. The final step will be the assembly of a world congress which will officially mark the foundation of the International Federation.

Our aims:

The independence of art – for the revolution.
The revolution – for the complete liberation of art!

M60 Jean (Hans) Arp

Concrete Art (1942)

First published as 'Art concret' in a catalogue for the first international exhibition of concrete art, at the Basle Kunsthalle, in 1944; extracted from an article written in French but published in English as 'Abstract art, concrete art' in Peggy Guggenheim's *Art of This Century* (New York, 1942).

The term 'Concrete art' seems to have been introduced by the prolific Theo van Doesburg (see M42) in a 'Manifesto of Concrete Art', published in the first and only issue of *Art Concret* (1930). Paradoxically, Concrete art is abstract art. More intuitively, perhaps, Concretism has affinities with Constructivism. Van Doesburg called for an abstract art entirely free of any underpinning in observed reality or symbolic implication. He argued that there was nothing more concrete or more real than a line, a colour, or a plane (a flat area of colour) – hence 'Planism' in Dimensionist parlance (M58), another manifesto signed by Arp.

JEAN (HANS) ARP (1886–1966) was a sculptor, painter, poet, essayist and all-purpose abstract artist. He came from Alsace-Lorraine, which was passed back and forth between France and Germany like a parcel. When he spoke in French, he referred to himself as Jean; when he spoke in German, as Hans. Arp was a Franco-German citizen of the world. He liked to tell the story of how he avoided (German) military service in the First World War, by entering the date in every blank space on the forms he was given, drawing a line underneath, and carefully adding them all up. He then took off all his clothes and presented himself and his paperwork to the officials. He was sent home.

Arp was present at the creation of most of the significant initiatives of the inter-war avant-garde. He was a founding member of the Dada movement in Zürich (see M25). Together with Max Ernst, an important figure, he established the Cologne Dada group in the 1920s. Like Ernst,

he ran with the Surrealists in Paris in the late 1920s (see M50); and then with Abstraction-Création, a kind of counter-Breton tendency, in the early 1930s. For Arp, Surrealist art could also be Concrete art, as he underlines in the manifesto. For Arp, the Concrete was not pre-set.

The 'Inventionist Manifesto' (M62) also espouses Concrete art.

* * *

We don't want to copy nature. We don't want to reproduce, we want to produce. We want to produce like a plant that produces a fruit, and not reproduce. We want to produce directly and not by way of any intermediary.

Since this art doesn't have the slightest trace of abstraction, we name it: concrete art.

Works of Concrete art should not be signed by the artists. These paintings, sculptures – these objects – should remain anonymous in the huge studio of nature, like clouds, mountains, seas, animals, men. Yes! Men should go back to nature! Artists should work in communities as they did in the Middle Ages. In 1915, [Otto] van Rees, [Adya] van Rees, [Otto] Freundlich, [Sophie] Taeuber [Arp's wife], and myself made an attempt of that sort.

That year I wrote: 'These works are constructed with lines, surfaces, forms and colours that try to go beyond the human and attain the infinite and the eternal. They reject our egotism . . . The hands of our brothers, instead of being interchangeable with our own hands, have become enemy hands. Instead of anonymity, we have renown and masterpieces; wisdom is dead . . . Reproduction is imitation, play acting, tightrope walking.'

The Renaissance bumptiously exalted human reason. Modern times with their science and technology have turned man into a megalomaniac. The atrocious chaos of our era is the consequence of that overrating of reason.

The evolution of traditional painting towards Concrete art, from Cézanne by way of the Cubists, has been frequently explained, and these historical explanations have merely confused the issue. All at once, 'according to the laws of chance', around 1914, the human mind underwent a transformation: it was confronted with an ethical problem.

Concrete art wants to transform the world. It wants to make life more bearable. It wants to save man from the most dangerous of follies: vanity. It wants to simplify the life of man. It wants to identify him with nature. Reason uproots man and makes him lead a tragic life. Concrete art is a basic art, a sane and natural art that grows the stars of peace, love and poetry in the head and in the heart. Wherever Concrete art appears, melancholy leaves, dragging along its grey suitcases full of black sighs.

Kandinsky, Sonia Delaunay, Robert Delaunay, [Alberto] Magnelli and [Fernand] Léger were among the first masters of Concrete art. Without having met, we were all working towards the same goal. Most of these works were not exhibited until 1920. This marked a blossoming of all the colours and all the shapes in the world. These paintings, these sculptures – these objects were stripped of any conventional element whatsoever. Partisans of this new art cropped up in all countries. Concrete art influenced architecture, furniture, film-making and typography.

Aside from their exhibited works, certain works by [Marcel] Duchamp, Man Ray, [André] Masson, [Joan] Miró and Ernst, and a number of 'Surrealist objects, are also Concrete art. Devoid of any descriptive, dreamlike, literary or polemical content, the works of these artists are, it seems to me, highly important in the evolution of Concrete art, for, by allusion, they manage to introduce into that art the psychic emotion that makes it live.

M61 Lucio Fontana

White Manifesto (1946)

'Manifesto blanco' was published in Buenos Aires in 1946; although it was not actually signed by Fontana, it was produced under his direction by his students Bernado Arias, Horacio Cazeneuve, Marcos Fridman, Pablo Arias, Rodolfo Burgos, Enrique Benito, César Bernal, Luis Coll, Alfredo Hansen and Jorge Rocamonte.

LUCIO FONTANA (1899–1968) was Argentinian, but educated in Italy in the classical-academic tradition. He was a born boundary-crosser, moving easily between movements and ideas and eluding definition. In the 1930s he was briefly a member of Abstraction-Création in Paris, with Arp and others (see headnote to M60), but his ideas moved on and so did he. The 'White Manifesto' formed the basis for his subsequent concept of 'Spazialismo' (Spatialism) and for a practice founded on the idea of an art 'unsullied by our ideas'. He won the first prize for paint-ing at the 1966 Venice Biennale for a series of white canvases, each with a single, vertical slash. The slash became his signature.

The 'Inventionist Manifesto' (M62) espouses the 'White function', but does not elaborate.

* * *

We are continuing the evolution of art.

Art is currently in a dormant phase. There is an energy which man cannot convey. In this manifesto we shall express it verbally.

For this reason we call on all those in the world of science who know that art is a fundamental requirement for our species, that they may direct part of their research towards discovering that malleable substance full

of light, and instruments that will produce sounds which will enable the development of four-dimensional art.

We will provide the researchers with the necessary information. The ideas are irrefutable. They exist as seeds within the social fabric, awaiting expression by artists and thinkers.

All things arise from necessity and are of value in their own time.

The transformations of the material base of existence have determined man's psychological states throughout history.

The system which has directed civilization from the beginning is undergoing transformation.

Gradually, it is being replaced by another system, which is its opposite in both essence and form. The fabric and character of both society and the individual will be transformed. Each man will live in an organization integral to his work.

The great scientific discoveries are directed towards this new organization of our lives.

The discovery of new physical forces, the mastery of matter and space, have gradually imposed unprecedented conditions on mankind.

The application of these discoveries to all aspects of our lives brings about a change in human nature. Man's psychological make-up is transformed. We are living in a mechanical age, in which plaster and paint are no longer meaningful.

Since the discovery of the known art-forms at various junctures throughout history, an analytical process has taken place within each one. Each has its own ordering principles independent of the others.

Everything that could be expressed had been done – all possibilities have come to light and have been developed.

Identical spiritual states have been expressed through music, architecture and poetry.

Man divided his energy in various ways, in response to the need for knowledge.

Wherever the limits of concrete explanation were reached, idealism came to predominate. The workings of nature were neglected. Man became aware of the process of intelligence. Everything lay in the possibilities of intelligence. Knowledge consisted in confused speculations which rarely attained truth.

Art (i.e. plastic or representational art) consisted of ideal portrayals

of familiar forms through images which were idealistically seen as lifelike. The observer imagined that one object was, in fact, behind another; he imagined in the portrayal the actual difference between the muscles and the clothing.

Today, knowledge acquired from experience has replaced creative, imaginative knowledge. We are aware of a world that exists and which is self-explanatory; a world which cannot be modified in any way by our ideas.

We need an art which is, of itself, valid; an art unsullied by our ideas.

This materialism anchored in every consciousness demands that art have its own values, free from the style of representation which is today stripped of all credibility. Twentieth-century man, shaped by materialism, has become inured to conventional forms of representation and to the constant retelling of already familiar experiences. Abstraction has been developed as the culmination of successive transformations.

However, this new stage no longer corresponds to the demands of contemporary man.

What is required is a change in both essence and form. It is necessary to transcend painting, sculpture, poetry and music. We require a greater art, which will be consistent with the demands of the new spirit.

The fundamental conditions of modern art have been clear since the thirteenth century, when space and depth were first represented. The great artists who followed gave renewed momentum to this tendency.

Baroque artists made great progress in this respect – their style of representation had a grandeur which has remained unsurpassed, imbuing the plastic arts with a sense of time. The figures appeared to leap out of the flat surface and to continue their represented movements in actual space.

This conception developed as a result of man's growing concept of existence. Then, for the first time, physics managed to explain nature through dynamics. As a means of explaining the universe, it was determined that movement was an inherent property of matter.

Having arrived at this evolutionary juncture, the need to represent movement was so great that it could not be met through the plastic arts. Therefore, the evolution continued through music. Painting and sculpture entered the neo-classical period, a stagnant point in the history of art and the connection between art and time was ignored. Having

conquered time, the need for movement grew increasingly clear. Progressive freedom from the restrictions of the church gave music greater and greater dynamism (Bach, Mozart, Beethoven). Art continued to develop around the notion of movement.

Music retained its dominant position for the next two hundred years, and since Impressionism it has developed parallel to the plastic arts. Since then man's evolution has been a march towards movement which has developed in time and space. In painting, the elements which obscured the impression of dynamism have been progressively suppressed.

The Impressionists sacrificed drawing and composition. The Futurists eliminated some elements and reduced the importance of others as they were subordinated to sensation. Futurism adopted motion as its solitary goal and objective. The Cubists denied that their painting was dynamic; yet the real essence of Cubism was the vision of nature in movement. [...]

Man has exhausted pictorial and sculptural forms of art. His own experiences, overwhelmingly repeated time and time again, bear witness to the fact that these art forms are stagnating in values which are alien to our civilization, devoid of the possibility of any future development.

The peaceful gentle life has come to an end. Speed has become a constant in the life of mankind.

The artistic eras of colour and static forms are coming to an end. Man is becoming less and less responsive to fixed, motionless images. The old static images no longer satisfy the modern man who has been shaped by the need for action, and a mechanized lifestyle of constant movement. The aesthetics of organic motion have replaced the outmoded aesthetics of fixed forms.

Calling on this change in man's nature, the moral and psychological changes of all human relations and activities, we leave behind all known art-forms, and commence the development of an art based on the union of time and space.

The new art takes its elements from nature.

Existence, nature and matter come together in a perfect unity.

They develop in time and space.

Change is an essential property of existence.

Movement, the capacity to evolve and to develop, is a basic property of matter. The latter exists solely in movement, not in any other manner.

Its development is eternal. Colour and sound, bound together in matter, come together in nature.

Matter, colour and sound in motion are the phenomena whose simultaneous development makes up the new art.

Colour in matter, developing in space assuming different forms. Sound produced by artefacts as yet unknown. Existing musical instruments are inadequate to meet the challenge of the required fullness and greatness of sound.

The construction of voluminous, changing shapes from a moving, malleable substance. Arranged in space, they integrate moving images in a synchronized form.

Thus, we are celebrating nature in all its plenitude.

[...]

We demand an art which is free of all aesthetic artifice.

We use what is true and natural in man. We reject the false aesthetics invented by speculative art.

We will draw closer to nature than ever before in the history of art.

Our love of nature does not compel us to copy it. The sense of beauty which we get from the shape of a plant, or a bird, or the sexual feelings aroused by a woman's body, are developed and elevated in man according to his sensitivity. We reject the particular emotions which can be derived from certain shapes. We aim to draw together in synthesis all of man's experiences which, along with his natural temperament, constitute a true manifestation of existence.

As our point of departure we shall take the earliest artistic experiences. Prehistoric man, who first heard the sound made by striking a hollow object, found himself captivated by the rhythm. Driven by the power of the rhythm he must have danced into a state of euphoria. For primitive man, sensation was everything – the sensation of nature, wild and unknown, the sensation of music and rhythm. We intend to develop that original characteristic of man.

The subconscious, that magnificent well of images perceived by the mind, takes on the essence and form of those images and harbours the notions that make up man's nature. Thus, as the objective world is transformed, what the subconscious identifies with is also transformed, and this produces changes in man's mode of conception.

The subconscious determines the historical legacy of pre-civilized

states and the manner of our adaptation to new lifestyles. The subconscious shapes, composes and transforms the individual. It gives him a sense of order, which comes from the world and is adopted by the individual. All artistic concepts are due to the workings of the subconscious.

Plastic art developed from its original base of natural shapes. The manifestations of the subconscious adapted easily to natural forms as a consequence of the idealized conception of existence.

Our material consciousness, that is, our need for things which are easily verifiable, demands that art-forms should flow directly from the individual and that they should assume natural form. An art based on forms created by the subconscious and balanced by reason, constitutes a true expression of existence and is the synthesis of a moment in time.

The position of the rational artists is false. In their effort to privilege reason and to deny the workings of the subconscious, they succeed only in rendering them less visible. We can see this process at work in their every endeavour.

Reason does not create. In creating shapes, it is subordinate to the subconscious. In all of his activities, man uses all of his faculties. Their free development is fundamental for creating and interpreting a new kind of art. Analysis and synthesis, meditation and spontaneity, construction and sensation, are all values which come together to work in union; and their development in experience is the only way to achieve a complete demonstration of being.

Society suppresses disparate energies and integrates them into a greater unified force. Modern science is based on the progressive unification of all its elements.

Humanity weaves together its knowledge and its values, in an historic process which has developed over hundreds of years.

A new, integrated art flows from this new state of consciousness, in which existence is shown in its totality.

After several millennia of analytical artistic development, the moment of synthesis has arrived. Prior to this moment, specialization was necessary. Now, however, this specialization amounts to a disintegration of the unity we envisage.

We imagine synthesis as the sum total of the physical elements: colour, sound, movement, time, space, integrated in physical and mental union. Colour, the element of space; sound, the element of time and

movement, which develops in time and space. These are fundamental to the new art which encompasses the four dimensions of existence. Time and space.

The new art requires that all of man's energies be used productively in creation and interpretation. Existence is shown in an integrated manner, with all its vitality. *Colour Sound Movement*

M62 Edgar Bayley and others

Inventionist Manifesto (1946)

Published in *Revista Arte Concreto – Invención* 1 (1 August 1946); issued to
mark the Inventionists' first exhibition, at the Salon Peuser, Buenos Aires,
Argentina, in March 1946. Co-signed by Antonio Caraduje, Simón Contre-
ras, Manuel O. Espinosa, Alfredo Hlito, Enio Iommi, Obdulio Landi, Raúl
Lozza, R. V. D. Lozza, Tomás Maldonado, Alberto Molemberg, Primaldo
Mónaco, Oscar Nuñez, Lidy Prati, Jorge Souza, Matilde Werbin.

EDGAR BAYLEY (1919–90) was an avant-garde Argentinian poet. A
little earlier, in 1944, he had collaborated with the Czech-Argentinian
sculptor Gyula Kosice and the Uruguayan Constructivist Joaquín Torres
García to launch *Arturo*, a magazine championing pure invention,
geometric abstraction, and the confluence of all the arts. *Arturo* survived
for one issue only, but it made itself heard.

Concrete art, espoused here, was much in vogue in the 1940s. See also
'Concrete Art' (M60) and 'Neo-Concrete Manifesto' (M68).

* * *

The artistic age of representational fiction is coming to an end. Man is
becoming less and less sensitive to illusory images. That is, he is becom-
ing progressively more integrated in the world. The old phantasmagoria
no longer meets the aesthetic needs of the new man, brought up in a
society that demands his total, unreserved commitment.

The prehistory of the human spirit is thus closed.

Scientific aesthetics will replace the age-old speculative, idealistic
aesthetics.

Deliberations on the nature of 'the beautiful' are now meaningless.

The metaphysics of 'the beautiful' have died of exhaustion. The physics of beauty is relevant now.

There is nothing esoteric in art: those who claim to be 'experts' are frauds. Representational art shows static, abstractly restrained 'realities'. And all representational art has in fact been abstract. Non-representational aesthetic experiences were called 'abstract' only because of an idealistic misunderstanding. In fact, through these experiences, consciously or not, we have moved in the opposite direction from abstraction. The results, which have exalted the concrete values of painting, are irrefutable evidence of this. The battle waged for so-called abstract art is actually the battle for concrete invention.

Representational art tends to muffle man's cognitive energy, distract him from his own power.

The raw material of representational art has always been illusion.

Illusion of space.

Illusion of expression.

Illusion of reality.

Illusion of movement.

A formidable mirage from which man has always returned disappointed and weakened.

Concrete art, on the other hand, exalts Being, because it practises it.

Art of action, it generates the will to act.

A poem or a painting must not justify inaction but, on the contrary, must help man act within his society. We Concrete artists do not avoid conflict. We are in every conflict. In the front line.

Art must no longer reinforce differences. Art must serve the world's new sense of communion. We practise the technique of joy.

Only outmoded techniques feed off gloom, resentment and secrecy.

Up with inventive jubilation. Down with the ill-omened moths of Existentialism or Romanticism.

Down with the second-rate poets and their tiny wounds or insignificant intimate dramas. Down with all élite art. Up with collective art.

'Kill the Optical,' say the Surrealists, the last Mohicans of representation. 'Exalt the Optical,' we say.

The key to everything: surround people with real things not with ghosts.

Concrete art makes people relate directly to real things not to fabrications.

For a specific aesthetics, a specific technique. Aesthetic function versus 'good taste'. White function.

Don't Search or Find: Invent.

M63 Constant Nieuwenhuys

Manifesto (1948)

First published in *Reflex* 1 (September – October 1948) in Amsterdam.

CONSTANT NIEUWENHUYS (1920–2005), known as Constant, was a Dutch painter and innovator, a co-founder of the influential Cobra Group in the late 1940s, with his countrymen Karel Appel and Corneille (Cornelis van Beverloo) and the Danish artist Asger Jorn; the International Movement for a Bauhaus of the Imagination (1956), with Jorn; and the Situationist International (1957), with Guy Debord (see M70).

Constant was haunted by the war and its desolating aftermath. Cobra (an acronym of their points of origin, Copenhagen, Brussels and Amsterdam) saw their role as artist insurgents: they would inject some heretical vitality into that bleak outlook, and shake the post-war complacency. In 1949 they were given an exhibition by the progressive director of the Stedelijk Museum in Amsterdam. The exhibition was a deliberate affront to bourgeois society. It succeeded, and was duly dismissed as nothing more than 'scribbles, claptrap and daubs'. Cobra decamped to Paris, but the impetus had gone. 'Die in beauty' was their last slogan, one of their number recalled.

Constant began to work towards a vision of utopia. The International Movement for a Bauhaus of the Imagination drew on the original Bauhaus (see M33) and on André Malraux's idea of 'a museum without walls'. For the Situationist International (SI), he made a series of scale models of 'a different city for a different life'. This was his *New Babylon*, a vision of a Situationist city in a post-capitalist world, a city of automation as a stage for nomadic movement and mass play, with high-tech elements refitted by residents, like giant toys. The New Babylon would be constructed above ground, with most of the traffic below. Moving walls, changeable spaces, climate-controlled communities, neighbourhoods

designed for different emotions – all of this, it has been noted, is nothing less than the experimental realization of Marx's dictum that consciousness is shaped by environment.

After that, as if exhausted by utopian optimism, he resigned from the SI and went back to Cézanne, and painting.

* * *

The dissolution of Western classical culture is a phenomenon that can be understood only against the background of a social evolution which can end only in the total collapse of a principle of society thousands of years old and its replacement by a system whose laws are based on the immediate demands of human vitality. The influence the ruling classes have wielded over the creative consciousness in history has reduced art to an increasingly dependent position, until finally the real psychic function of that art was attainable only for a few spirits of genius who in their frustration and after a long struggle were able to break out of the conventions of form and rediscover the basic principles of all creative activity.

Together with the class society from which it emerged, this culture of the individual is faced by destruction too, as the former's institutions, kept alive artificially, offer no further opportunities for the creative imagination and only impede the free expression of human vitality. All the isms so typical of the last fifty years of art history represent so many attempts to bring new life to this culture and to adapt its aesthetic to the barren ground of its social environment. Modern art, suffering from a permanent tendency to the constructive, an obsession with objectivity (brought on by the disease that has destroyed our speculative-idealizing culture), stands isolated and powerless in a society which seems bent on its own destruction. As the extension of a style created for a social élite, with the disappearance of that élite modern art has lost its social justification and is confronted only by the criticism formulated by a clique of its connoisseurs and amateurs.

Western art, once the celebrator of emperors and popes, turned to serve the newly powerful bourgeoisie, becoming an instrument of the glorification of bourgeois ideals. Now that these ideals have become a fiction with the disappearance of their economic base, a new era is upon us, in which the whole matrix of cultural conventions loses its significance

and a new freedom can be won from the most primary source of life. But, just as with a social revolution, this spiritual revolution cannot be enacted without conflict. Stubbornly the bourgeois mind clutches onto its aesthetic ideal and in a last, desperate effort employs all its wiles to convert the indifferent masses to the same belief. Taking advantage of the general lack of interest, suggestions are made of a special social need for what is referred to as 'an ideal of beauty', all designed to prevent the flowering of a new, conflicting sense of beauty which emerges from the vital emotions.

As early as the end of the First World War the DADA movement tried by violent means to break away from the old ideal of beauty. Although this movement concentrated increasingly on the political arena, as the artists involved perceived that their struggle for freedom brought them into conflict with the laws that formed the very foundations of society, the vital power released by this confrontation also stimulated the birth of a new artistic vision.

In 1924 the Surrealist Manifesto appeared, revealing a hitherto hidden creative impulse – it seemed that a new source of inspiration had been discovered. But BRETON's movement suffocated in its own intellectualism, without ever converting its basic principle into a tangible value. For Surrealism was an art of ideas and as such also infected by the disease of past class culture, while the movement failed to destroy the values this culture proclaimed in its own justification.

It is precisely this act of destruction that forms the key to the liberation of the human spirit from passivity. It is the basic pre-condition for the flowering of a people's art that encompasses everyone. The general social impotence, the passivity of the masses, are an indication of the brakes that cultural norms apply to the natural expression of the forces of life. For the satisfaction of this primitive need for vital expression is the driving force of life, the cure for every form of vital weakness. It transforms art into a power for spiritual health. As such it is the property of all and for this reason every limitation that reduces art to the preserve of a small group of specialists, connoisseurs and virtuosi must be removed.

But this people's art is not an art that necessarily conforms to the norms set by the people, for they expect what they were brought up with, unless they have had the opportunity to experience something different. In other words, unless the people themselves are actively

involved in the making of art. A people's art is a form of expression nourished only by a natural and therefore general urge to expression. Instead of solving problems posed by some preconceived aesthetic ideal, this art recognizes only the norms of expressivity, spontaneously directed by its own intuition. The great value of a people's art is that, precisely because it is the form of expression of the untrained, the greatest possible latitude is given to the unconscious, thereby opening up ever wider perspectives for the comprehension of the secret of life. In the art of genius, too, Western classical culture has recognized the value of the unconscious, for it was the unconscious which made possible a partial liberation from the conventions which bound art. But this could be achieved only after a long, personal process of development, and was always seen as revolutionary. The cycle of revolutionary deeds which we call the evolution of art has now entered its last phase: the loosening of stylistic conventions. Already weakened by Impressionism, laid bare by Cubism (and later by Constructivism and Neo-Plasticism), it signifies the end of art as a force of aesthetic idealism on a higher plane than life. What we call 'genius' is nothing else but the power of the individual to free himself from the ruling aesthetic and place himself above it. As this aesthetic loses its stranglehold, and with the disappearance of the exceptional personal performance, 'genius' will become public property and the word 'art' will acquire a completely new meaning. That is not to say that the expression of all people will take on a similar, generalized value, but that everyone will be able to express himself because the genius of the people, a fountain in which everyone can bathe, replaces the individual performance.

In this period of change, the role of the creative artist can only be that of the revolutionary: it is his duty to destroy the last remnants of an empty, irksome aesthetic, arousing the creative instincts still slumbering unconscious in the human mind. The masses, brought up with aesthetic conventions imposed from without, are as yet unaware of their creative potential. This will be stimulated by an art which does not define but suggests, by the arousal of associations and the speculations which come forth from them, creating a new and fantastic way of seeing. The onlooker's creative ability (inherent to human nature) will bring this new way of seeing within everyone's reach once aesthetic conventions cease to hinder the working of the unconscious.

Hitherto condemned to a purely passive role in our culture, the onlooker will himself become involved in the creative process. The interaction between creator and observer makes art of this kind a powerful stimulator in the birth of the creativity of the people. The ever greater dissolution and ever more overt impotence of our culture makes the struggle of today's creative artists easier than their predecessors – time is on their side. The phenomenon of 'kitsch' has spread so quickly that today it overshadows more cultivated forms of expression, or else is so intimately interwoven with them that a demarcation line is difficult to draw. Thanks to these developments, the power of the old ideals of beauty is doomed to decay and eventually disappear and a new artistic principle, now coming into being, will automatically replace them. This new principle is based on the total influence of matter on the creative spirit. This creative concept is not one of theories or forms, which could be described as solidified matter, but arises from the confrontation between the human spirit and raw materials that suggest forms and ideas.

Every definition of form restricts the material effect and with it the suggestion it projects. Suggestive art is materialistic art because only matter stimulates creative activity, while the more perfectly defined the form, the less active is the onlooker. Because we see the activation of the urge to create as art's most important task, in the coming period we will strive for the greatest possible materialistic and therefore greatest possible suggestive effect. Viewed in this light, the creative act is more important than that which it creates, while the latter will gain in significance the more it reveals the work which brought it into being and the less it appears as a polished end-product. The illusion has been shattered that a work of art has a fixed value: its value is dependent on the creative ability of the onlooker, which in turn is stimulated by the suggestions the work of art arouses. Only living art can activate the creative spirit, and only living art is of general significance. For only living art gives expression to the emotions, yearnings, reactions and ambitions which as a result of society's shortcomings we all share.

A living art makes no distinctions between beautiful and ugly because it sets no aesthetic norms. The ugly which in the art of past centuries has come to supplement the beautiful is a permanent complaint against the unnatural class society and its aesthetic of virtuosity; it is a demonstration of the retarding and limiting influence of this aesthetic on the

natural urge to create. If we observe forms of expression that include every stage of human life, for example that of a child (who has yet to be socially integrated), then we no longer find this distinction. The child knows of no law other than its spontaneous sensation of life and feels no need to express anything else. The same is true of primitive cultures, which is why they are so attractive to today's human beings, forced to live in a morbid atmosphere of unreality, lies and infertility. A new freedom is coming into being which will enable human beings to express themselves in accordance with their instincts. This change will deprive the artist of his special position and meet with stubborn resistance. For, as his individually won freedom becomes the possession of all, the artist's entire individual and social status will be undermined.

Our art is the art of a revolutionary period, simultaneously the reaction of a world going under and the herald of a new era. For this reason it does not conform to the ideals of the first, while those of the second have yet to be formulated. But it is the expression of a life force that is all the stronger for being resisted, and of considerable psychological significance in the struggle to establish a new society. The spirit of the bourgeoisie still permeates all areas of life, and now and then it even pretends to bring art to the people (a special people, that is, set to its hand).

But this art is too stale to serve as a drug any longer. The chalkings on pavements and walls clearly show that human beings were born to manifest themselves; now the struggle is in full swing against the power that would force them into the straitjacket of clerk or commoner and deprive them of this first vital need. A painting is not a composition of colour and line but an animal, a night, a scream, a human being, or all of these things together. The objective, abstract spirit of the bourgeois world has reduced the painting to the means which brought it into being; the creative imagination, however, seeks to recognize every form and even in the sterile environment of the abstract it has created a new relationship with reality, turning on the suggestive power which every natural or artificial form possesses for the active onlooker. This suggestive power knows no limits and so one can say that after a period in which it meant NOTHING, art has now entered an era in which it means EVERYTHING.

The cultural vacuum has never been so strong or so widespread as

after the last war, when the continuity of centuries of cultural evolution was broken by a single jerk of the string. The Surrealists, who in their rejection of the cultural order threw artistic expression overboard, experienced the disillusionment and bitterness of talent become useless in a destructive campaign against art, against a society which, though they recognized its responsibility, was still strong enough to be considered as theirs. However, painters after the Second World War see themselves confronted by a world of stage decors and false façades in which all lines of communication have been cut and all belief has vanished. The total lack of a future as a continuation of this world makes constructive thought impossible. Their only salvation is to turn their backs on the entire culture (including modern negativism, Surrealism and Existentialism). In this process of liberation it becomes increasingly apparent that this culture, unable to make artistic expression *possible*, can only make it *impossible*. The materialism of these painters did not lead, as bourgeois idealists had warned, to a spiritual void (like their own?), nor to creative impotence. On the contrary, for the first time every faculty of the human spirit was activated in a fertile relationship with matter. At the same time a process was started in which ties and specific cultural forms, which in this phase still played a role, were naturally thrown off, just as they were in other areas of life.

The problematic phase in the evolution of modern art has come to an end and is being followed by an experimental period. In other words, from the experience gained in this state of unlimited freedom, the rules are being formulated which will govern the new form of creativity. Come into being more or less unawares, in line with the laws of dialectics a new consciousness will follow.

M64 Barnett Newman

The Sublime is Now (1948)

First published in *Tiger's Eye* (December 1948). Compare Malevich's 'Suprematist Manifesto' (M24).

BARNETT NEWMAN (1905–70) was forty-two when he had a revelation. On a relatively small canvas stained with Indian red, he placed an upright strip of masking tape, in order to isolate the left from the right and then proceed with the painting. Instead, on an instinct, he coloured the masking tape orangey-scarlet. 'Suddenly I realized that I had been emptying space instead of filling it and that now my line came to life.' Thus was born *Onement 1* (1948), a breakthrough work, and the line or 'zip', a Newman trademark.

Onement 1 was a truly revolutionary work. Its volcanic impact matched that of Manet's *Déjeuner sur l'herbe* (1863) or Malevich's *Black Square* (1915). Newman had found himself – 'the self, terrible and constant, is for me the subject matter of painting' – and he had found a cause, a totally new and quintessentially American abstract art, often bundled together under the rubric of Abstract Expressionism. He believed that his own work was fundamental to that project; and he was right. Newman's work was an imperative to be seized. It has had a profound effect on painters and painting ever since.

One mark of its greatness is its capacity to elicit surprising responses. Forty years later, in an interview with his friend Benjamin Buchloh, the contemporary master Gerhard Richter reflected: 'If I'm thinking of political painting in our time, I'd rather have Barnett Newman. He painted some magnificent pictures.' 'So it is said,' retorted Buchloh. 'But magnificent in what way?' 'I can't describe it now,' replied Richter, 'what gets to me in them – I believe they're among the most important paintings of all.'

Newman was an artist, and a personality, of uncommon power. He was also an anarchist – a real one – who contributed a foreword to Kropotkin's *Memoirs of a Revolutionist* in the semi-revolutionary year of 1968. He had a high concept of his calling. The artist's role is that of creator. The idea that he is merely a performer with a paintbrush was not one that Newman was prepared to entertain. 'During the last few years,' he admonished in 1951, '[that idea] has become popular among social theoreticians, particularly ex-Marxists, pseudo-existentialists, psychiatrists, historians and literary men in general (Malraux is typical), when they refer to painting. The artist is approached not as an original thinker in his own medium but, rather, as an instinctive, intuitive executant who, largely unaware of what he is doing, breaks through the mystery by the magic of his performance to "express" truths the professionals think they can read better than he can himself.'

Barnett Newman was an original thinker-painter. He could also write a little. 'They say that I have advanced abstract painting to its extreme,' he wrote in a preface for an exhibition of 'The New American Painting' (1959), 'when it is obvious to me that I have made only a new beginning. In short, they find me too abstract for the abstract expressionists and too expressionist for the abstract purists.' He was not about to take lessons from *them*.

* * *

The invention of beauty by the Greeks, that is, their postulate of beauty as an ideal, has been the bugbear of European art and European aesthetic philosophies. Man's natural desire in the arts to express his relation to the Absolute became identified and confused with the absolutisms of perfect creations – with the fetish of quality – so that the European artist has been continually involved in the moral struggle between notions of beauty and the desire for sublimity.

The confusion can be seen sharply in Longinus, who, despite his knowledge of non-Grecian art, could not extricate himself from his platonic attitudes concerning beauty, from the problem of value, so that to him the feeling of exaltation became synonymous with the perfect statement – an objective rhetoric. But the confusion continued on in Kant, with his theory of transcendent perception, that the phenomenon

is *more* than phenomenon; and in Hegel, who built a theory of beauty, in which the sublime is at the bottom of a structure of *kinds of beauty*, thus creating a range of hierarchies in a set of relationships to reality that is completely formal. (Only Edmund Burke insisted on a separation. Even though it is an unsophisticated and primitive one, it is a clear one and it would be interesting to know how closely the Surrealists were influenced by it. To me Burke reads like a Surrealist manual.)

The confusion in philosophy is but the reflection of the struggle that makes up the history of the plastic arts. To us today there is no doubt that Greek art is an insistence that the sense of exaltation is to be found in perfect form, that exaltation is the same as ideal sensibility – in contrast, for example, with the Gothic or Baroque, in which the sublime consists of a desire to destroy form, where form can be formless.

The climax in this struggle between beauty and the sublime can best be examined inside the Renaissance and the reaction later against the Renaissance that is known as modern art. In the Renaissance, the revival of the ideals of Greek beauty set the artists the task of rephrasing an accepted Christ legend in terms of absolute beauty as against the original Gothic ecstasy over the legend's evocation of the Absolute. And the Renaissance artists dressed up the traditional ecstasy in an even older tradition – that of eloquent nudity or rich velvet. It was no idle quip that moved Michelangelo to call himself a sculptor rather than a painter, for he knew that only in his sculpture could the desire for the grand statement of Christian sublimity be reached. He could despise with good reason the beauty cults who felt the Christ drama on a stage of rich velvets and brocades and beautifully textured flesh tints. Michelangelo knew that the meaning of the Greek humanities for his time involved making Christ the man into Christ who is God; that his plastic problem was neither the medieval one, to make a cathedral, nor the Greek one, to make a man like a god, but to make a cathedral out of man. In doing so he set a standard for sublimity that the painting of his time could not reach. Instead, painting continued on its merry quest for a voluptuous art until in modern times the Impressionists, disgusted with its inadequacy, began the movement to destroy the established rhetoric of beauty by the Impressionist insistence on a surface of ugly strokes.

The impulse of modern art was this desire to destroy beauty. However, in discarding Renaissance notions of beauty, and without an adequate

substitute for a sublime message, the Impressionists were compelled to preoccupy themselves, in their struggle, with the culture values of their plastic history, so that instead of evoking a new way of experiencing life they were able only to make a transfer of values. By glorifying their own way of living, they were caught up in the problem of what is really beautiful and could only make a restatement of their position on the general question of beauty; just as later the Cubists, by their Dada gestures of substituting a sheet of newspaper and sandpaper for both the velvet surfaces of the Renaissance and the Impressionists, made a similar transfer of values instead of creating a new vision, and succeeded only in elevating the sheet of paper. So strong is the grip of the *rhetoric* of exaltation as an attitude in the larger context of the European culture pattern that the elements of sublimity in the revolution we know as modern art exist in its effort and energy to escape the pattern rather than in the realization of a new experience. Picasso's effort may be sublime but there is no doubt that his work is a preoccupation with the question of what is the nature of beauty. Even Mondrian, in his attempt to destroy the Renaissance picture by his insistence on pure subject matter, succeeded only in raising the white plane and the right angle into a realm of sublimity, where the sublime paradoxically becomes an absolute of perfect sensations. The geometry (perfection) swallowed up his metaphysics (exaltation).

The failure of European art to achieve the sublime is due to this blind desire to exist inside the reality of sensation (the objective world, whether distorted or pure) and to build an art within a framework of pure plasticity (the Greek ideal of beauty, whether plasticity be a romantic active surface or a classical stable one). In other words, modern art, caught without a sublime content, was incapable of creating a new sublime image and, unable to move away from the Renaissance imagery of figures and objects except by distortion or by denying it completely for an empty world of geometric formalisms – a *pure* rhetoric of abstract mathematical relationships – became enmeshed in a struggle over the nature of beauty: whether beauty was in nature or could be found without nature.

I believe that here in America, some of us, free from the weight of European culture, are finding the answer, by completely denying that art has any concern with the problem of beauty and where to find it. The question that now arises is how, if we are living in a time without a

legend or mythos that can be called sublime, if we refuse to admit any exaltation in pure relations, if we refuse to live in the abstract, how can we be creating a sublime art?

We are reasserting man's natural desire for the exalted, for a concern with our relationship to the absolute emotions. We do not need the obsolete props of an outmoded and antiquated legend. We are creating images whose reality is self-evident and which are devoid of the props and crutches that evoke associations with outmoded images, both sublime and beautiful. We are freeing ourselves of the impediments of memory, association, nostalgia, legend, myth, or what have you, that have been the devices of Western European painting. Instead of making *cathedrals* out of Christ, man or 'life', we are making [them] out of ourselves, out of our own feelings. The image we produce is the self-evident one of revelation, real and concrete, that can be understood by anyone who will look at it without the nostalgic glasses of history.

M65 Victor Vasarely

Notes for a Manifesto (1955)

First published in *Mouvement II* (Paris: Galerie Denise René, 1955).

VICTOR VASARELY (1906–97) was a Hungarian-French abstract-kinetic painter touted as the father of Op-Art (short for Optical, that is, making use of optical illusions). His son Jean-Pierre, known as Yvaral, was a prominent member of GRAV (the Paris-based Groupe de Recherche d'Art Visuel), who issued their own manifesto a few years later, 'Transforming the Current Situation of Plastic Art' (1962). The very existence of that group testified to the ideals of the elder Vasarely: his commitment to collective activity and critique of the idea of individual artistic genius.

* * *

Here are the determining facts of the past which tie us together and which, among others, interest us: 'plastic' triumphs over anecdote (Manet) – the first geometrization of the exterior world (Cézanne) – the conquest of pure colour (Matisse) – the explosion of representation (Picasso) – exterior vision changes into interior vision (Kandinsky) – a branch of painting dissolves into architecture, becoming polychromatic (Mondrian) – departure from the large plastic synthetics (Le Corbusier) – new plastic alphabets (Arp, Taeuber, Magnelli, Herbin) – abandoning volume for *SPACE* (Calder) . . . The desire for a new conception was affirmed in the recent past by the invention of *PURE COMPOSITION* and by the choice of *UNITY*, which we will discuss later. Parallel to the decline of painting's ancestral technique, followed experimentation with *new materials* (chemical applications) and adoption of *new tools* (discovery of physics) . . . *Presently we are heading towards the complete abandonment*

of routine, towards the integration of sculpture and the conquest of the plane's
SUPERIOR DIMENSIONS.

From the beginning, abstraction examined and enlarged its compositional elements. Soon, *form-colour* invaded the entire two-dimensional surface, this metamorphosis led the painting-object, by way of architecture, to a spatial universe of polychromy. However, an extra-architectural solution was already proposed and we deliberately broke with the neoplastic law. *PURE COMPOSITION* is still a plastic plane where rigorous abstract elements, hardly numerous and expressed in few colours (matte or glossy), possess, on the whole surface, the same complete plastic quality: *POSITIVE-NEGATIVE*. But, by the effect of opposed perspectives, these elements give birth to and make vanish in turn a 'spatial feeling' and thus, the illusion of *motion* and *duration*. *FORM AND COLOUR ARE ONE*. Form can only exist when indicated by a coloured quality. Colour is only quality when unlimited in form. The line (drawing, contour) is a fiction which belongs not to one, but to two form-colours at the same time. It does not engender form-colours, it results from their meeting. *Two necessarily contrasted form-colours constitute PLASTIC UNITY, thus the UNITY of creation: eternal duality of all things, recognized finally as inseparable.* It is the coupling of affirmation and negation. Measurable and immeasurable, unity is both physical and metaphysical. It is the conception of the material, the mathematical structure of the Universe, as its spiritual superstructure. *Unity* is the absence of *BEAUTY*, the first form of sensitivity. Conceived with art, it constitutes *the work*, poetic equivalent of the World that it signifies. The simplest example of plastic unity is the square (or rectangle) with its complement *'contrast' or the two-dimensional plane with its complement 'surrounding space'.*

After these succinct explanations, we propose the following definition: *upon the straight line – horizontal and vertical – depends all creative speculation.* Two parallels forming the frame define the plane, or cut out part of the space. *FRAMING IS CREATING FROM NEW AND RECREATING ALL ART FROM THE PAST.* In the considerably expanded technique of the plastic artist, the plane remains the place of first conception. The *small format* in pure composition constitutes the departure from a re-creation of multiple two-dimensional functions (large format, fresco, tapestry, engraving). But we are already discovering a new orientation. The *SLIDE* will be to painting what the record is to music: manageable, faithful,

complex, in other words a document, a work tool, a work. It will constitute a new transitional function between the fixed image and the future moving image. *THE SCREEN IS PLANE BUT, ALLOWING MOTION, IT IS ALSO SPACE. It does not have two, but four dimensions.* Thanks to unity, the illusive 'motion-duration' of pure composition, in the new dimension offered by the screen, becomes real motion. The *Lozenge* is another expression of 'square-plane unity', square + space + motion = duration. Other innumerable multiform and multicoloured unities result in the infinite range of formal expression. 'Depth' gives us the relative scale. The 'distant' condenses, the 'near' dilates, reacting thus on the *COLOUR-LIGHT* quality. *We possess therefore, both the tool and the technique, and finally the science for attempting the plastic-cinétique adventure.* Geometry (square, circle, triangle, etc.), chemistry (cadmium, chrome, cobalt, etc.) and physics (coordinates, spectrum, colorimeter, etc.), represent some *constants*. We consider them as quantities; our measure, our sensitivity, our art, will make qualities from them. (It is not a question here of 'Euclidian' or 'Einsteinium', but the artist's own geometry which functions marvellously without precise calculations.) The animation of the plastic develops nowadays in three distinct manners: 1) Motion in an architectural synthesis, where a spatial and monumental plastic work is conceived such that metamorphoses operate there through the displacement of the spectator's point of view. 2) Automatic plastic objects which – while possessing an intrinsic quality – serve primarily as a means of animation at the moment of filming. Finally, 3) *The methodological investment of the CINEMATOGRAPHIC DOMAIN by abstract discipline. We are at the dawn of a great age. THE ERA OF PLASTIC PROJECTS ON FLAT AND DEEP SCREENS IN DAYLIGHT OR IN DARKNESS, BEGINS.*

The art product extends from the 'pleasant, useful object' to 'Art for Art's sake', from 'good taste' to the 'transcendent'. The entirety of plastic activities is inscribed in a vast perspective in gradations: decorative arts – fashion – advertising and propaganda by the image – decorations from big demonstrations of Industry, Festivals, Sports – sets from shows – polychromatic factory models – road signs and urbanization – documentary art film – recreative museum – art edition – synthesis of plastic Arts – finally, the search for the authentic avant-garde. In these diverse disciplines, the personal accent does not necessarily signify authenticity. And besides, we are not qualified in our time to decide about the major or minor

character of these different manifestations of the plastic arts. There are some arrière-garde talents, just as there are insufficiencies in the avant-garde. But neither the valuable work – if it is immutable or retrograde – nor the advanced work – if it is mediocre – counts for posterity. *The effect of the art product on us ranges (with some differences of intensity and quality) from small pleasure to the shock of Beauty. These diverse sensations are produced first of all in our emotive being by engendering the feeling of well-being or of tragedy. In this way, the goal of Art is almost attained.* Analysis, comprehension of a message depend on our knowledge and our degree of culture. Since only entities of art from the past are intelligible, since not everyone is permitted to study contemporary art in depth, *in place of its 'comprehension' we advocate its 'presence'. With sensitivity being a faculty proper to humans, our messages will certainly reach the average person naturally through his/her emotive receptivity.* Indeed, we cannot indefinitely leave the work of art's enjoyment to the elite of connoisseurs. The art of today is heading towards generous forms, hopefully recreatable; the art of tomorrow will be common treasure or it will not be. Traditions degenerate, ordinary forms of painting perish on condemned paths. Time judges and eliminates, renovation proceeds from a rupture and the demonstration of *authenticity* is discontinuous and unforeseen. It is painful, but mandatory, to abandon old values in order to assure the possession of new ones. Our position changed; our ethics, our aesthetic must in turn change. If the idea of plastic work resided before in an artisanal process and in the myth of the 'unique piece', *it is rediscovered today in the conception of possible RE-CREATION, MULTIPLICATION and EXPANSION.* Is the immense diffusion of literary or musical works carried out to the detriment of their unicity and quality? The majestic chain of fixed images on two dimensions extends from Lascaux to the abstracts . . . the future holds happiness for us in the new, moving and touching, plastic beauty.

M66 Jirō Yoshihara

The Gutai Manifesto (1956)

Proclaimed in October 1956; first published in *Genijutsu Shincho* (December 1956) in Osaka.

Yoshihara established the Gutai Art Association in 1954, with eighteen younger artists. For Gutai (concreteness or embodiment), making art that addressed the post-war world meant experimenting with new techniques and new materials – not the materials of high art, but the stuff of everyday life – old newspapers, sheet metal, masking tape, synthetic fabrics, inner tubing, light bulbs, plastic sheeting, water, mud, sand. When they used paint, they applied it with their feet, with automatic toy cars, or with glass bottles that shattered colour onto the canvas.

Their work was not confined to the canvas, the studio or the gallery. On the contrary, it was unconfined, broaching what has since become known as the site-specific, the interactive and the installation, not to mention the happening. Beginning in 1955, Gutai mounted an annual 'Experimental Outdoor Exhibition of Modern Art to Challenge the Mid-Summer Sun', and in 1957 the first 'Gutai Art on the Stage' presented Shiraga Kazuo's *Ultra-Modern Sanbasō*, at once art and theatre. A series of painted poles topples over on an otherwise empty stage; the artist himself appears, and dances, costumed extravagantly in red; an army of Gutai rush the stage, with bows and arrows, and complete the 'painting' by shooting the arrows into the backdrop. 'I ardently look forward to debating whether it is the act of shooting an arrow, or the surface that it pierces, that is art,' wrote Shiraga. Gutai pushed the envelope.

Gutai's experiments continued into the 1960s, exercising a formative influence on the Fluxus movement (see M74). The group disbanded in 1972, following the death of Yoshihara, its animating spirit. Its work was shocking all over again when exhibited at the 2009 Venice Biennale – a tribute its founder would have relished.

JIRŌ YOSHIHARA (1905–72) was obsessed with originality. His maxim was 'Create what has never been done before!' He wanted to engage with Art, as one of his collaborators put it, not just Japanese art. The Gutai Manifesto is a recapitulation – a manifestation – of how he went about it.

* * *

With our present-day awareness, the arts as we have known them up to now appear to us in general to be fakes fitted out with a tremendous affectation. Let us take leave of these piles of counterfeit objects on the altars, in the palaces, in the salons and the antique shops.

They are an illusion with which, by human hand and by way of fraud, materials such as paint, pieces of cloth, metals, clay or marble are loaded with false significance, so that, instead of just presenting their own material self, they take on the appearance of something else. Under the cloak of an intellectual aim, the materials have been completely murdered and can no longer speak to us.

Lock these corpses into their tombs. Gutai art does not change the material: it brings it to life. Gutai art does not falsify the material. In Gutai art the human spirit and the material reach out their hands to each other, even though they are otherwise opposed to each other. The material is not absorbed by the spirit. The spirit does not force the material into submission. If one leaves the material as it is, presenting it just as material, then it starts to tell us something and speaks with a mighty voice. Keeping the life of the material alive also means bringing its spirit to life. And lifting up the spirit means leading the material up to the height of the spirit.

Art is the home of the creative spirit, but never until now has the spirit created matter. The spirit has only ever created the spiritual. Certainly the spirit has always filled art with life, but this life will finally die as the times change. For all the magnificent life which existed in the art of the Renaissance, little more than its archaeological existence can be seen today.

What is still left of that vitality, even if passive, may in fact be found in Primitive Art and in art since Impressionism. These are either such things in which, due to skilful application of the paint, the deception of the material had not quite succeeded, or else those like Pointillist or

Fauvist pictures in which the materials, although used to reproduce nature, could not be murdered after all. Today, however, they are no longer able to call up deep emotion in us. They already belong to a world of the past.

Yet what is interesting in this respect is that novel beauty which is to be found in the works of art and architecture of the past, even if, in the course of the centuries, they have changed their appearance due to the damage of time or destruction by disasters. This is described as the beauty of decay, but is it not perhaps that beauty which material assumes when it is freed of artificial make-up and reveals its original characteristics? The fact that the ruins receive us warmly and kindly after all, and that they attract us with their cracks and flaking surfaces, could this not really be a sign of the material taking revenge, having recaptured its original life? In this sense I pay respect to [Jackson] Pollock's and [Georges] Mathieu's works in contemporary art. These works are the loud outcry of the material, of the very oil or enamel paints themselves. The two artists grapple with the material in a way which is completely appropriate to it and which they have discovered due to their talents. This even gives the impression that they serve the material. Differentiation and integration create mysterious effects.

Recently, Tomonaga So'ichi and Domoto Hisao presented the activities of Mathieu and [Michel] Tapié in informal art, which I found most interesting. I do not know all the details, but in the content presented, there were many points I could agree with. To my surprise, I also discovered that they demanded the immediate revelation of anything arising spontaneously and that they are not bound by the previously predominant forms. Despite the differences in expression as compared to our own, we still find a peculiar agreement with our claim to produce something living. If one follows this possibility, I am not sure as to the relationship in which the conceptually defined pictorial units like colours, lines, shapes, in abstract art are seen with regard to the true properties of the material. As far as the denial of abstraction is concerned, the essence of their declaration was not clear to me. In any case, it is obvious to us that purely formalistic abstract art has lost its charm and it is a fact that the foundation of the Gutai Art Society three years ago was accompanied by the slogan that they would go beyond the borders of Abstract Art and that the name Gutaiism (Concretism) was chosen. Above all we were

not able to avoid the idea that, in contrast to the centripetal origin of abstraction, we of necessity had to search for a centrifugal approach.

In those days we thought, and indeed still do think today, that the most important merits of Abstract Art lie in the fact that it has opened up the possibility to create a new, subjective shape of space, one which really deserves the name 'creation'.

We have decided to pursue the possibilities of pure and creative activity with great energy. We thought at that time, with regard to the actual application of the abstract spatial arts, of combining human creative ability with the characteristics of the material. When in the melting-pot of psychic automatism, the abilities of the individual united with the chosen material, we were overwhelmed by the shape of space still unknown to us, never before seen or experienced. Automatism, of necessity, reaches beyond the artist's self. We have struggled to find our own method of creating a space rather than relying on our own self. The work of one of our members will serve as an example. Yoshiko Kinoshita is actually a teacher of chemistry at a girls' school. She created a peculiar space by allowing chemicals to react on filter paper. Although it is possible to imagine the results beforehand to a certain extent, the final results of handling the chemicals cannot be established until the following day. The particular results and the shape of the material are in any case her own work. After Pollock, many Pollock-imitators appeared, but Pollock's splendour will never be extinguished. The talent of invention deserves respect.

Kazuo Shiraga placed a lump of paint on a huge piece of paper, and started to spread it around violently with his feet. For about the last two years art journalists have called this unprecedented method 'the Art of committing the whole self with the body'. Kazuo Shiraga had no intention at all of making this strange method of creating a work of art public. He had merely found a method which enabled him to confront and unite the material he had chosen with his own spiritual dynamics. In doing so he achieved an extremely convincing level.

In contrast to Shiraga, who works with an organic method, Shōzō Shimamoto has been working with mechanical manipulations for the past few years. The pictures of flying spray created by smashing a bottle full of paint, or the large surface he creates in a single moment by firing a small, hand-made cannon filled with paint by means of an acetylene gas explosion, etc., display a breathtaking freshness.

Other works which deserve mention are those of Yasuo Sumi, produced with a concrete mixer, or of Toshio Yoshida, who uses only one single lump of paint. All their actions are full of a new intellectual energy which demands our respect and recognition.

The search for an original, undiscovered world also resulted in numerous works in the so-called object form. In my opinion, conditions at the annual open-air exhibitions in the city of Ashiya have contributed to this. The way in which these works, in which the artists are confronted with many different materials, differ from the objects of Surrealism can be seen simply from the fact that the artists tend not to give them titles or to provide interpretations. The objects in Gutai art were, for example, a painted, bent iron plate (Atsuko Tanaka) or a work in hard red vinyl in the form of a mosquito net (Tsuruko Yamazaki), etc. With their characteristics, colours and forms, they were constant messages about the materials.

Our group does not impose restrictions on the art of its members, providing they remain in the field of free artistic creativity. For instance, many different experiments were carried out with extraordinary activity. This ranged from an art to be felt with the entire body to an art which could only be touched, right through to Gutai music (in which Shōzō Shimamoto has been doing interesting experiments for several years). There is also a work by Shōzō Shimamoto like a horizontal ladder with bars which you can feel as you walk over them. Then a work by Saburo Murakami which is like a telescope you can walk into and look up at the heavens, or an installation made of plastic bags with organic elasticity, etc. Atsuko Tanaka started with a work of flashing light bulbs which she called 'Clothing'. Sadamasa Motonaga worked with water, smoke, etc. Gutai art attaches the greatest importance to all daring steps which lead to an as yet undiscovered world. Sometimes, at first glance, we are compared with and mistaken for Dadaism, and we ourselves fully recognize the achievements of Dadaism, but we do believe that, in contrast to Dadaism, our work is the result of investigating the possibilities of calling the material to life.

We shall hope that a fresh spirit will always blow at our Gutai exhibitions and that the discovery of new life will call forth a tremendous scream in the material itself.

M67 Jean Tinguely

For Static (1959)

Written for the 'Concert for Seven Pictures', 1,500 copies of 'Für Statik' were scattered from an aeroplane over Düsseldorf on 14 March 1959.

JEAN TINGUELY (1925–91) was a Swiss painter and sculptor. He specialized in sculptural machines or kinetic art, in the Dada tradition, known officially as *Métamatics* – a branch of knowledge called 'metamechanics' (by analogy with metaphysics). Tinguely cunningly conceived of an artwork as a machine that could produce its own artwork. In this way performance art became high performance art. At the *Cyclo-Matic* evening he arranged at the ICA in London in 1959, two recordings were superimposed on top of one another at different speeds, while a woman walked through the audience handing out drawings from a manual Métamatic and two cyclists raced each other on a Super-cyclo-Métamatic. Metamechanics was all about movement – it was not static. But Tinguely was no simple-minded worshipper of machine technology. He did not fall for the Futurists. He made fools of machines (and occasionally of human beings, including himself) but embraced the contradictions of contraptions.

When Tinguely went to New York, in 1960, he was invited to stay by Dr Charles R. Hulbeck, the former Dada pioneer Richard Huelsenbeck (see M29), now a practising psychiatrist. Hulbeck called Tinguely 'a Meta-Dada, who fulfilled certain ideas of ours, notably the idea of motion'. Knowing no English, Tinguely talked his way into a commission for the sculpture garden of the Museum of Modern Art (MoMA). He made a commotion. *Homage to New York*, billed as a machine that destroys itself (or commits suicide), incorporated a meteorological trial balloon, many breakable bottles, an upright piano, a go-kart, a bathtub, hammers and saws, eighty bicycle wheels, and sundry other found items from New

Jersey dumps. Invited guests came to witness the last rites. Sadly, things did not go as planned. Despite its creator's well-aimed kicks, the machine stubbornly refused its appointed fate and had to be finished off with an axe. 'It wasn't the idea of a machine committing suicide that fascinated me primarily,' said Tinguely, 'it was the freedom that belonged to its ephemeral aspect – ephemeral like life, you understand. It was the opposite of the cathedrals, the opposite of the skyscrapers around us, the opposite of the museum idea, the opposite of the petrification in a fixed work of art.'

Had it succeeded, *Homage to New York* would have qualified as auto-destructive art, in Gustav Metzger's terms (see M69). Tinguely's destructive tendencies retain their lure. For his celebrated *Break Down* (2001), Michael Landy catalogued and destroyed all his possessions, 5.75 tonnes of them, in a kind of homage to Jean Tinguely.

* * *

Everything moves continuously. Immobility does not exist. Don't be subject to the influence of out-of-date concepts. Forget hours, seconds and minutes. Accept instability. Live in Time. Be static – with movement. For a static of the present movement. Resist the anxious wish to fix the instantaneous, to kill that which is living.

Stop insisting on 'values' which can only break down. Be free, live. Stop painting time. Stop evoking movements and gestures. You are movement and gesture. Stop building cathedrals and pyramids which are doomed to fall into ruin. Live in the present, live once more in Time and by Time – for a wonderful and absolute reality.

M68 Ferreira Gullar

Neo-Concrete Manifesto (1959)

First published in *Jornal do Brasil*, 22 March 1959, in Rio de Janeiro, on the occasion of the first Neo-Concrete Exhibition.

FERREIRA GULLAR (José Ribamar Ferreira, born 1930) is a Brazilian poet, playwright and TV critic, and author of the original mix of Neo-Concrete art, defined and differentiated below.

* * *

We use the term 'Neo-Concrete' to differentiate ourselves from those committed to non-figurative 'geometric' art (Neo-Plasticism, Constructivism, Suprematism, the [design] school of Ulm) and particularly the kind of Concrete art that is influenced by a dangerously acute rationalism. In the light of their artistic experience, the painters, sculptors, engravers and writers participating in this first Neo-Concrete Exhibition came to the conclusion that it was necessary to evaluate the theoretical principles on which Concrete art has been founded, none of which offers a rationale for the expressive potential they feel their art contains.

Born as Cubism, in a reaction to the pictorial language of the Impressionists, it was natural that geometric art should adopt theoretical positions diametrically opposed to the technical and allusive features of the painting of the time. Advances in physics and mechanics widened the horizons of objective thought and led those responsible for deepening this artistic revolution to an ever-increasing rationalization of the processes and purposes of painting. Mechanical notions of constructing works of art invaded the language of painters and sculptors, generating, in turn, equally extremist reactions of a reactionary nature such as the magical, irrational realism of Dada and Surrealism.

However, there is no doubt that, despite the consecration of the objectivity of science and the precision of mechanics, true artists – like, for example, Mondrian and [Anton] Pevzner [the early Realist (M37), later a Constructivist sculptor] – overcame the limits imposed by theory in the daily struggle to express themselves artistically. But the work of these artists has always been interpreted with reference to theoretic principles which their work, in fact, denied. We propose that neo-plasticism, Constructivism and the other similar movements should be re-evaluated with reference to their power of expression rather than to the theories on which they based their art.

If we want to understand Mondrian's art by examining his theories, we would have to conclude one of two things. Either we believe that it is possible for art to be part and parcel of everyday life – and Mondrian's work takes the first steps in this direction – or we conclude that such a thing is impossible, in which case his work fails in its aims. Either the vertical and the horizontal planes really are the fundamental rhythms of the universe and the work of Mondrian is the application of that universal principle, or the principle is flawed and his work is founded on an illusion. Nevertheless, the work of Mondrian exists, alive and fertile, in spite of such theoretical contradictions. There would be no point in seeing Mondrian as the destroyer of surface, the plane and line, if we do not perceive the new space which his art creates.

The same can be said of [Georges] Vantongerloo [a founder member of De Stijl (M42)] and Pevzner. It does not matter what mathematical equations are at the root of a piece of sculpture or of a painting by Vantongerloo. It is only when someone sees the work of art, that its rhythms and colours have meaning. The fact that Pevzner used figures of descriptive geometry as his starting-points is without interest alongside the new space that his sculptures gave birth to and the cosmic-organic expression which his works reveal. To establish the relationships between artistic objects and scientific instruments and between the intuition of the artist and the objective thought of the physicist and the engineer might have a specific cultural interest. But, from the aesthetic point of view, the interesting thing about art is that it transcends such considerations and creates and reveals a universe of existential significance.

Malevich, because he recognized the primacy of 'pure sensibility in art', spared his theoretical definitions the limitations of rationalism and

mechanicism, and gave his painting a transcendental dimension that makes him very relevant today. But Malevich paid dearly for the courage he showed in simultaneously opposing figurativism and mechanicist abstraction. To this day, certain rationalist theoreticians have considered him to be an ingenuous person who never understood properly the true meaning of the new plasticism . . .

In fact, Malevich's 'geometric' painting already expresses a lack of satisfaction, a will to transcend the rational and the sensory, that today manifests itself irrepressibly.

Neo-Concrete art, born out of the need to express the complex reality of modern humanity inside the structural language of a new plasticity, denies the validity of scientific and positivist attitudes in art and raises the question of expression, incorporating the new 'verbal' dimensions created by Constructivist neo-figurative art. Rationalism robs art of its autonomy and substitutes the unique qualities of art for notions of scientific objectivity: thus the concepts of form, space, time and structure – which in the language of the arts have an existential, emotional and affective significance – are confused with the theoretical approach of those who want to make a science of art.

In the name of prejudices that philosophers today denounce ([Maurice] Merleau-Ponty, [Ernst] Cassirer, [Susanne] Langer) – and that are no longer upheld in any intellectual field beginning with modern biology, which now has gone beyond Pavlovian mechanicism – the Concrete rationalists still think of human beings as machines and seek to limit art to the expression of this theoretical reality.

We do not conceive of a work of art as a 'machine' or as an 'object', but as a 'quasicorpus' (quasi-body), that is to say, something which amounts to more than the sum of its constituent elements; something which analysis may break down into various elements but which can only be understood phenomenologically. We believe that a work of art represents more than the material from which it is made and not because of any extra-terrestrial quality it might have: it represents more because it transcends mechanical relationships (sought for by the Gestalt) to become something tacitly significant (Merleau-Ponty), something new and unique. If we needed a simile for a work of art, we would not find one, therefore, either in the machine or in any objectively perceived object, but in living beings, as Langer and [Vladimir] Weidlé have said.

However, such a comparison would still not be able adequately to express the specific reality of the aesthetic organism.

That is because a work of art does not just occupy a particular place in objective space, but transcends it to become something new that the objective notions of time, space, form, structure, colour, etc. are not sufficient in themselves to explain. The difficulty of using precise terminology to express a world that is not so easily described by such notions did not stop art critics from indiscriminately using words which betray the complexity of works of art. Science and technology had a big influence here, to the extent that today, roles are inverted and certain artists, confused by this terminology, try to use objective notions as a creative method in their art.

Inevitably, artists such as these only get as far as illustrating ideas *a priori*, because their starting-point already closely prescribes the result. The Concrete rationalist artist denies the creativity of intuition and thinks of himself as an objective body in objective space. Artist and spectator are only required to be stimulated or to react: the artist speaks to the eye as an instrument and not to the eye as a human organ capable of interaction with the world; the artist speaks to the eye-machine and not to the eye-body.

It is because a work of art transcends mechanical space that, in it, the notions of cause and effect lose any validity. The notions of time, space, form, colour are so integrated – by the very fact that they did not exist beforehand, as notions, as art – that it is impossible to say art could be broken down into its constituent parts. Neo-Concrete art affirms the absolute integration of those elements, believes that the 'geometric' vocabulary that it uses can express complex human realities as proved by many of the works of Mondrian, Malevich, Pevzner, Gabo, Sofie Taeuber-Arp, et al. Even though these artists at times confused the concept of form-mechanics with that of form-expression, we must make clear that, in the language of art, the so-called geometric forms lose the objective character of geometry and turn into vehicles for the imagination. The Gestalt, given that it is a causal psychology, is also insufficient to allow us to understand a phenomenon which dissolves space and form as causally determined realities and creates a new time and *spatialization of the artistic creation*. By spatialization, we mean that the work of art *continuously makes itself present*, in a dynamic reaction with the impulse

that generated it and of which *it is already the origin*. And if such a reaction leads us back to the starting-point, it is because *Neo-Concrete* art aims to rekindle the creativity of that beginning. *Neo-Concrete* art lays the foundations for a new expressive space.

[. . .]

The participants in the first Neo-Concrete Exhibition are not part of a 'group'. They are not linked to each other by dogmatic principles. The evident affinity of the research they have been involved in in various fields brought them together and to this exhibition. Their commitment is firstly to their own particular experience and they will be together for as long as the deep affinity that brought them together exists.

M69 Gustav Metzger

Auto-Destructive Art (1959, 1960, 1961)

The first Manifesto of Auto-Destructive Art, published in 1959, was given as a lecture to the Architecture Association in 1964, which was taken over by students as a 'happening'. The first Public Demonstration of Auto-Destructive Art was made in 1960, and recreated by the artist at Tate Britain in 2004. An integral part of the installation at Tate Britain, a bag of rubbish, was removed by a cleaner, in error, soon afterwards. It was retrieved from the crusher, but the artist declared it ruined and created a new bag, with new rubbish, as a replacement. He published 'Machine, Auto-Creative and Auto-Destructive Art' in *Ark* (Summer 1962).

GUSTAV METZGER (born 1926) is the creator and presiding spirit of Auto-Destructive art. Metzger was active in the Committee of 100, and in the early Campaign for Nuclear Disarmament (CND). Auto-Destructive Art is, in part, a protest – 'an attack on capitalist values and the drive to nuclear annihilation' – as his manifestos make clear. His *Acid Action Painting* (1961), for example, consisted of three nylon canvases, coloured white, black and red, and arranged one behind the other, in that order; acid was then painted, flung and sprayed on to the nylon, which corrodes at the point of contact, producing rapidly changing shapes before its complete annihilation. It is thus simultaneously auto-creative and auto-destructive.

In 1966 Metzger and others, including the conceptual artist John Latham, the performance artist Yoko Ono and the Destructivist Ralph Ortiz (see M73), organized the first Destruction in Art Symposium in London, followed by another in New York two years later. The London symposium was accompanied by a number of public events or demonstrations (a favoured mode). One such was the burning of Skoob Towers, by Latham. These were towers of books (skoob backwards), dubbed

'the laws of England'. The intention was to demonstrate directly the artist's view that Western culture was burned out. The police and the fire brigade begged to differ. Latham moved on, undeterred, to Clement Greenberg's treatise, *Art and Culture* (1961). Greenberg was the guru of that era; his book was required reading. Latham invited his students at the Central St Martin's School of Art to join him in a feast at which the main course was *Art and Culture*, chewed up and spat out, page by page, for Latham to dissolve, distil and decant into several glass vials, displayed in a leather case as a work entitled *Spit and Chew: Art and Culture* (1966–9) – a work purchased by the Museum of Modern Art in New York, but rarely exhibited.

Metzger was taught by David Bomberg (1890–1957). Bomberg was an inspiring figure, and at one time a Vorticist; there is perhaps something about the art of auto-destruction, and Metzger's unwavering pursuit of his principles, that might have appealed to the corrosive intelligence of Wyndham Lewis (see M17). Metzger in his turn taught Pete Townshend, of The Who, who spoke later of these ideas in the context of his famous stage routine of guitar-smashing.

See also 'Destructivism' (M73).

* * *

Auto-Destructive Art (1959)

Auto-destructive art is primarily a form of public art for industrial societies.

Self-destructive painting, sculpture and construction is a total unity of idea, site, form, colour, method and timing of the disintegrative process.

Auto-destructive art can be created with natural forces, traditional art techniques and technological techniques.

The amplified sound of the auto-destructive process can be an element of the total conception.

The artist may collaborate with scientists, engineers.

Self-destructive art can be machine produced and factory assembled.

Auto-destructive paintings, sculptures and constructions have a

lifetime varying from a few moments to twenty years. When the disintegrative process is complete the work is to be removed from the site and scrapped.

Auto-Destructive Art (1960)

Man in Regent Street is auto-destructive.
>Rockets, nuclear weapons, are auto-destructive.
>Auto-destructive art.
>The drop drop dropping of HH bombs.
>Not interested in ruins, (the picturesque).
>Auto-destructive art re-enacts the obsession with destruction, the pummelling to which individuals and masses are subjected.
>Auto-destructive art mirrors the compulsive perfectionism of arms manufacture – polishing to destruction point.
>Auto-destructive art is the transformation of technology into public art. The immense productive capacity, the chaos of capitalism and of Soviet communism, the coexistence of surplus and starvation; the increasing stock-piling of nuclear weapons – more than enough to destroy technological societies; the disintegrative effect of machinery and of life in vast built-up areas on the person . . .
>Auto-destructive art is art which contains within itself an agent which automatically leads to its destruction within a period of time not to exceed twenty years. Other forms of auto-destructive art involve manual manipulation. There are forms of auto-destructive art where the artist has a tight control over the nature and timing of the disintegrative process, and there are other forms where the artist's control is slight.
>Materials and techniques used in creating auto-destructive art include: Acid, Adhesives, Ballistics, Canvas, Clay, Combustion, Compression, Concrete, Corrosion, Cybernetics, Drop, Elasticity, Electricity, Electrolysis, Feed-Back, Glass, Heat, Human Energy, Ice, Jet, Light, Load, Mass-Production, Metal, Motion Picture, Natural Forces, Nuclear Energy, Paint, Paper, Photography, Plaster, Plastics, Pressure, Radiation, Sand, Solar Energy, Sound, Steam, Stress, Terra-Cotta, Vibration, Water, Welding, Wire, Wood.

Gustav Metzger

Auto-Destructive Art Machine Art
Auto-Creative Art (1961)

Each visible fact absolutely expresses its reality.

Certain machine-produced forms are the most perfect forms of our period.

In the evenings some of the finest works of art produced now are dumped on the streets of Soho.

Auto-creative art is art of change, growth, movement.

Auto-destructive art and auto-creative art aim at the integration of art with the advances of science and technology. The immediate objective is the creation, with the aid of computers, of works of art whose movements are programmed and include 'self-regulation'. The spectator, by means of electronic devices, can have a direct bearing on the action of these works.

Auto-destructive art is an attack on capitalist values and the drive to nuclear annihilation.

M70 Guy Debord

Situationist Manifesto (1960)

Dated 17 May 1960; first published in the bulletin *Internationale Situationniste* 4 (June 1960) in Paris.

The Situationists formed in 1957, found their *métier* as inspired provocateurs during the insurrectionary 'events' of May 1968 in Paris, and disbanded in 1972. In its fifteen years of life the Situationist International (SI) had a grand total of seventy-two members. Yet its intellectual fascination has always exceeded its paid-up subscription; and that fascination continues undiminished to this day. It has been justly remarked that the Situationists were one of those rare avant-gardes whose radical art and radical politics were forged in unison. They are now the stuff of legend.

GUY DEBORD (1931–94) was the secretary and strategist of the SI, its philosopher and disciplinarian, and its central, indispensable figure – its Lenin with a grin, or at least a sense of humour. It would be an exaggeration to say that Debord *was* the SI – Constant Nieuwenhuys for one was a key figure from the outset (see M63), until his resignation in 1960 – but it would hardly have been the same without him. It was Debord who had a quasi-Marinetti-like sense of 'the necessary transcendence' of the past; a subtle appreciation of how handy it would be to retain a certain doctrinal ambiguity ('Of course, never any *doctrine*, only perspectives'); a command of rhetoric (the 'irreducible scorn' of the Situationist Manifesto is reminiscent of its Futurist predecessor); and above all, an almost instinctive feel for self-assertion through differentiation. As he put it in *The Society of the Spectacle* (1967): 'Dadism sought to *abolish art without realizing it*; Surrealism sought to *realize art without abolishing it*. The critical position since developed by the Situationists demonstrates that the abolition and the realization of art are inseparable aspects of a single *transcendence of art*.'

Life in the SI was not all jam and kippers. 'Neither Paradise, nor the

end of history,' wrote Debord in 1958. 'We will have *other misfortunes* (and other pleasures), that's all.' A *roman à clef* written by Michèle Bernstein, one of the founders (and Debord's first wife), captures straight-faced the air of fatality and absurdity that swirled around Situ HQ. The mistress Carole enters the lair of Gilles, the Debord figure:

> 'What are you working on, exactly? I have no idea.'
>
> 'Reification,' he answered.
>
> 'It's an important job,' I added.
>
> 'Yes, it is,' he said.
>
> 'I see,' Carole observed with admiration. 'Serious work, at a huge desk cluttered with thick books and papers.'
>
> 'No,' said Gilles. 'I walk. Mainly I walk.'

This was among other things a joke (perhaps an in-joke) about two ideas or practices dear to the heart of the Situationists: the *dérive* (drift), defined in the SI bulletin as 'a transient passage through varied ambiences'; and 'psycho-geography', defined as 'the study of the specific effects of the geographical environment'. How did the derided *dériviste* make sense of his transient passage? What did the self-respecting psycho-geographer do? He walked. Mainly he walked.

* * *

THE EXISTING FRAMEWORK cannot subdue the new human force that is increasing day by day alongside the irresistible development of technology and the dissatisfaction of its possible uses in our senseless social life.

Alienation and oppression in this society cannot be distributed amongst a range of variants, but only rejected en bloc with this very society. All real progress has clearly been suspended until the revolutionary solution of the present multiform crisis.

What are the organizational perspectives of life in a society which authentically 'reorganizes production on the basis of the free and equal association of the producers'? Work would more and more be reduced as an exterior necessity through the automation of production and the socialization of vital goods, which would finally give complete liberty to the individual. Thus liberated from all economic responsibility, liberated

from all the debts and responsibilities from the past and other people, humankind will exude a new surplus value, incalculable in money because it would be impossible to reduce it to the measure of waged work. The guarantee of the liberty of each and of all is in the value of the game, of life freely constructed. The exercise of this ludic recreation is the framework of the only guaranteed equality with non-exploitation of man by man. The liberation of the game, its creative autonomy, supersedes the ancient division between imposed work and passive leisure.

The church has already burnt the so-called witches to repress the primitive ludic tendencies conserved in popular festivities. Under the existing dominant society, which produces the miserable pseudo-games of non-participation, a true artistic activity is necessarily classed as criminality. It is semi-clandestine. It appears in the form of scandal.

So what really is the situation? It's the realization of a better game, which more exactly is provoked by the human presence. The revolutionary gamesters of all countries can be united in the SI to commence the emergence from the prehistory of daily life.

Henceforth, we propose an autonomous organization of the producers of the new culture, independent of the political and union organizations which currently exist, as we dispute their capacity to organize anything other than the management of that which already exists.

From the moment when this organization leaves the initial experimental stage for its first public campaign, the most urgent objective we have ascribed to it is the seizure of UNESCO [the United Nations Educational, Scientific and Cultural Organization]. United at a world level, the bureaucratization of art and all culture is a new phenomenon which expresses the deep inter-relationship of the social systems coexisting in the world on the basis of eclectic conservation and the reproduction of the past. The riposte of the revolutionary artists to these new conditions must be a new type of action. As the very existence of this managerial concentration of culture, located in a single building, favours a seizure by way of putsch; and as the institution is completely destitute of any sensible usage outside our subversive perspective, we find our seizure of this apparatus justified before our contemporaries. And we will have it. We are resolved to take over UNESCO, even if only for a short time, as we are sure we would quickly carry out work which would prove most significant in the clarification of a long series of demands.

What would be the principal characteristics of the new culture and how would it compare with ancient art?

Against the spectacle, the realized Situationist culture introduces total participation.

Against preserved art, it is the organization of the directly lived moment.

Against particularized art, it will be a global practice with a bearing, each moment, on all the usable elements. Naturally this would tend to collective production which would be without doubt anonymous (at least to the extent where the works are no longer stocked as commodities, this culture will not be dominated by the need to leave traces). The minimum proposals of these experiences will be a revolution in behaviour and a dynamic unitary urbanism capable of extension to the entire planet, and of being further extensible to all habitable planets.

Against unilateral art, Situationist culture will be an art of dialogue, an art of interaction. Today artists – with all culture visible – have been completely separated from society, just as they are separated from each other by competition. But faced with this impasse of capitalism, art has remained essentially unilateral in response. This enclosed era of primitivism must be superseded by complete communication.

At a higher stage, everyone will become an artist, i.e., inseparably a producer-consumer of total culture creation, which will help the rapid dissolution of the linear criteria of novelty. Everyone will be a Situationist, so to speak, with a multidimensional inflation of tendencies, experiences, or radically different 'schools' – not successively, but simultaneously.

We will inaugurate what will historically be the last of the crafts. The role of amateur-professional Situationist – of anti-specialist – is again a specialization up to the point of economic and mental abundance, when everyone becomes an 'artist', in the sense that the artists have not attained the construction of their own life. However, the last craft of history is so close to the society without a permanent division of labour, that when it appeared amongst the SI, its status as a craft was generally denied.

To those who don't understand us properly, we say with an irreducible scorn: 'The Situationists of which you believe yourselves perhaps to be the judges, will one day judge you. We await the turning point which is the inevitable liquidation of the world of privation, in all its forms. Such are our goals, and these will be the future goals of humanity.'

M71 Claes Oldenburg

I Am for an Art (1961)

Initially composed for the catalogue of the exhibition 'Environments, Situations and Spaces' at the Martha Jackson Gallery in New York in May – June 1961; revised for the opening of the large-scale environmental work, *The Store*, in his studio on East Second Street, New York, in December 1961. Published in *Store Days: Documents from The Store (1961) and Ray Gun Theater (1962)* (New York, 1967).

CLAES OLDENBURG (born 1929) is a Swedish-American Pop artist and sculptor. From the late 1970s he worked in close collaboration with his second wife, the Dutch-American art historian and sculptor Coosje van Bruggen (1942–2009). They specialized in outsize, absurdist public monuments, at once bizarre and commonplace – prefigured in Oldenburg's iconic *Lipstick (Ascending) on Caterpillar Tracks* (1969), installed at Yale – such as *Dropped Cone* (2001), an upside-down ice-cream cone, on top of a shopping centre in Cologne.

Oldenburg has made a career of making the ordinary extraordinary. He became a prominent figure in the Happenings of the late 1950s: anarchic, semi-scripted group performances making use of sculptural props and sets – New York versions of the experimental work of the Gutai (M66) – the cast assembled from the artist's friends and relations. These productions were his 'Ray Gun Theater'. In the 1960s he began making larger-than-lifesize soft sculptures (*Giant BLT*, *Giant Fagends*). The soft sculptures are his best trick. They meet all the basic needs. Some of them are unmistakably phallic – the food blenders, the toothpaste tubes. Others are based on female forms. *Raisin Bread, Sliced*, on the other hand, was conceived as a sort of Parthenon, and also suggested by a picture he saw of the Madeleine church in Paris turning into a loaf of bread. 'The piece has a lot to do with excrement and sex,' says Oldenburg. 'It also has to do with cutting.'

Oldenburg speaks infrequently and well. 'I am a magician. A magician brings dead things to life.' As per his manifesto, he is an artist who vanishes, an Andy Warhol in reverse, a standing reproach to fifteen minutes of fame. Quietly sophisticated and highly educated, he is a text-book case of the Pop art vision – the Pop art vibe and the Pop art jive. 'All I need is for something to stick in my mind. Like Henry Miller's nose. It has a strange, puffy quality. Then it begins to work within a scheme of resemblances. The nose metamorphoses into a fireplug; the plug into a coin phone box; the phone into a car.' His manifesto is a glorious fusion of Whitman and Dada.

<p style="text-align:center">★ ★ ★</p>

I am for an art that is political-erotical-mystical, that does something other than sit on its ass in a museum.

I am for an art that grows up not knowing it is art at all, an art given the chance of having a starting point of zero.

I am for an art that embroils itself with the everyday crap & still comes out on top.

I am for an art that imitates the human, that is comic, if necessary, or violent, or whatever is necessary.

I am for all art that takes its form from the lines of life itself, that twists and extends and accumulates and spits and drips, and is heavy and coarse and blunt and sweet and stupid as life itself.

I am for an artist who vanishes, turning up in a white cap painting signs or hallways.

I am for art that comes out of a chimney like black hair and scatters in the sky.

I am for art that spills out of an old mans purse when he is bounced off a passing fender.

I am for the art out of a doggys mouth, falling five stories from the roof.

I am for the art that a kid licks, after peeling away the wrapper.

I am for an art that joggles like everyone's knees, when the bus traverses an excavation.

I am for art that is smoked, like a cigarette, smells, like a pair of shoes.

I am for art that flaps like a flag, or helps blow noses, like a handkerchief.

IAm for an Art

I am for art that is put on and taken off, like pants, which develops holes, like socks, which is eaten, like a piece of pie, or abandoned with great contempt, like a piece of shit.

I am for art covered with bandages, I am for art that limps and rolls and runs and jumps. I am for art that comes in a can or washes up on the shore.
I am for art that coils and grunts like a wrestler. I am for art that sheds hair.
I am for art you can sit on. I am for art you can pick your nose with or stub your toes on.

I am for art from a pocket, from deep channels of the ear, from the edge of a knife, from the corners of the mouth, stuck in the eye or worn on the wrist.
I am for art under the skirts, and the art of pinching cockroaches.

I am for the art of conversation between the sidewalk and a blind man's metal stick.
I am for the art that grows in a pot, that comes down out of the skies at night, like lightning, that hides in the clouds and growls. I am for art that is flipped on and off with a switch.

I am for art that unfolds like a map, that you can squeeze, like your sweetys arm, or kiss, like a pet dog. Which expands and squeaks, like an accordion, which you can spill your dinner on, like an old tablecloth.
I am for an art that you can hammer with, stitch with, sew with, paste with, file with.
I am for an art that tells you the time of day, or where such and such a street is.
I am for an art that helps old ladies across the street.
I am for the art of the washing machine. I am for the art of a government check. I am for the art of last wars raincoat.
I am for the art that comes up in fogs from sewer-holes in winter. I am for the art that splits when you step on a frozen puddle. I am for the worms art inside the apple. I am for the art of sweat that develops between crossed legs.
I am for the art of neck-hair and caked tea-cups, for the art between the tines of restaurant forks, for the odour of boiling dishwater.

353

I am for the art of sailing on Sunday, and the art of red and white gasoline pumps.

I am for the art of bright blue factory columns and blinking biscuit signs.

I am for the art of cheap plaster and enamel. I am for the art of worn marble and smashed slate. I am for the art of rolling cobblestones and sliding sand. I am for the art of slag and black coal. I am for the art of dead birds.

I am for the art of scratchings in the asphalt, daubing at the walls. I am for the art of bending and kicking metal and breaking glass, and pulling at things to make them fall down.

I am for the art of punching and skinned knees and sat-on bananas. I am for the art of kids smells. I am for the art of mama-babble.

I am for the art of bar-babble, tooth-picking, beerdrinking, egg-salting, in-sulting. I am for the art of falling off a barstool.

I am for the art of underwear and the art of taxicabs. I am for the art of ice-cream cones dropped on concrete. I am for the majestic art of dog-turds, rising like cathedrals.

I am for the blinking arts, lighting up the night. I am for art falling, splashing, wiggling, jumping, going on and off.

I am for the art of fat truck-tyres and black eyes.

I am for Kool-art, 7-UP art, Pepsi-art, Sunshine art, 39 cents art, 15 cents art, Vatronol art, Dro-bomb art, Vam art, Menthol art, L & M art, Ex-lax art, Venida art, Heaven Hill art, Pamryl art, San-o-med art, Rx art, 9.99 art, Now art, New art, How art, Fire sale art, Last Chance art, Only art, Diamond art, Tomorrow art, Franks art, Ducks art, Meat-o-rama art.

I am for the art of bread wet by rain. I am for the rat's dance between floors.

I am for the art of flies walking on a slick pear in the electric light. I am for the art of soggy onions and firm green shoots. I am for the art of clicking among the nuts when the roaches come and go. I am for the brown sad art of rotting apples.

I am for the art of meowls and clatter of cats and for the art of their dumb electric eyes.

I am for the white art of refrigerators and their muscular openings and closings.

I am for the art of rust and mould. I am for the art of hearts, funeral hearts or sweetheart hearts, full of nougat. I am for the art of worn meathooks and singing barrels of red, white, blue and yellow meat.

I am for the art of things lost or thrown away, coming home from school. I am for the art of cock-and-ball trees and flying cows and the noise of rectangles and squares. I am for the art of crayons and weak grey pencil-lead, and grainy wash and sticky oil paint, and the art of windshield wipers and the art of the finger on a cold window, on dusty steel or in the bubbles on the sides of a bathtub.

I am for the art of teddy-bears and guns and decapitated rabbits, exploded umbrellas, raped beds, chairs with their brown bones broken, burning trees, firecracker ends, chicken bones, pigeon bones and boxes with men sleeping in them.

I am for the art of slightly rotten funeral flowers, hung bloody rabbits and wrinkly yellow chickens, bass drums & tambourines, and plastic phonographs.

I am for the art of abandoned boxes, tied like pharaohs. I am for an art of watertanks and speeding clouds and flapping shades.

I am for US Government Inspected Art, Grade A art, Regular Price art, Yellow Ripe art, Extra Fancy art, Ready-to-eat art, Best-for-less art, Ready-to-cook art, Fully cleaned art, Spend Less art, Eat Better art, Ham art, pork art, chicken art, tomato art, banana art, apple art, turkey art, cake art, cookie art.

add:
I am for an art that is combed down, that is hung from each ear, that is laid on the lips and under the eyes, that is shaved from the legs, that is brushed on the teeth, that is fixed on the thighs, that is slipped on the foot.

square which becomes blobby

M72 Georg Baselitz

Pandemonic Manifesto I, 2nd version (1961)

The Pandemonium Manifestos were originally issued (in German) in Berlin, the first in November 1961, the second in February 1962, under the names of Georg Baselitz and his friend the painter Eugen Schönebeck, in very limited editions. Manifesto II concludes, pithily, 'All writing is crap.' The second (shortened) version of Manifesto I was published in English in the catalogue of a retrospective at the Whitechapel Gallery in 1988, translated by David Britt. The text used here is a new translation by Baselitz himself.

GEORG BASELITZ (Hans-Georg Kern, born 1938) adopted the name of his home town, Deutschbaselitz, now part of Kamenz, in the former East Germany. By his own account, he has put a lot of effort into making provocative, ugly pictures. At his first one-man show, in 1963, he succeeded. *The Big Night Down the Drain* (1962–3), a larger than lifesize figure painting of a misshapen man brandishing his puce, truncheon-like phallus, caused an enormous fuss. The painting was confiscated by the public prosecutor. Even the police came, as the artist said with some satisfaction.

Baselitz has lived up to that early *succès de scandale*. The Pandemonium Paintings that match the Pandemonium Manifestos were inspired by the art of psychiatric patients discussed in Hans Prinzhorn's *Bildnerei der Geisteskranken [Artistry of the Mentally Ill]* (1922); by the tortured life and work of Edvard Munch – he of *The Scream* (1893) – a Baselitz favourite; and by the disturbing insights that emanated from the psychotic world of Antonin Artaud (1896–1948). Not coincidentally, Artaud himself wrote manifestos – 'there are too many manifestos and not enough works of art,' he complained in 1932, 'too many theories and no actions.' His 'First Manifesto for a Theatre of Cruelty' appeared soon after; a second swiftly followed. They were collected in *The Theatre and its Double* (1938), a vastly

influential text. 'Without an element of cruelty at the root of every spec-
tacle,' wrote Artaud, in words that entered the bloodstream of avant-garde
artists everywhere, 'the theatre is not possible. In our present state of
degeneration it is through the skin that metaphysics must be made to
re-enter our minds.'

Cruelty, for Artaud, was a physical, gestural unmasking, a stripping
away, an absolute determination to shatter the falsity that 'lies like a
shroud over our perceptions'. Here was a programme made for Georg
Baselitz, who felt a deep affinity for Artaud's work ever since he encoun-
tered the drawings on his first visit to Paris in 1961. Like those of other
alienated beings – how tempting to psychoanalyse Baselitz – Artaud's
drawings were attractive because they seemed to convert moral content
into energized forms. Their means were every bit as ugly as desired. 'I
have stippled and chiselled all the angers of my struggle,' Artaud wrote
in 1946, 'and these miseries, my drawings, are all that is left.' These
miseries may be a life's work. Baselitz's painting has inventiveness, and
wit; but it is deeply serious, like that of his contemporary R. B. Kitaj
(M89 and M98), and perhaps for some similar reasons. As Baselitz has
acknowledged, it is anchored in an 'unhealthy' history – German
history, and possibly his own.

Baselitz is a great reader, and at once an intellectual and a visceral
painter, who uses his head as well as his feet. 'I work exclusively on
inventing new ornaments,' he insists. But these ornaments are not mere
baubles. Typically they are upside-down – *Upside-Down Lenin* has recently
been added to the catalogue – turned on their heads, as if to invert, or
subvert, or empty. Baselitz is an ironist. Perhaps that is the only -ist he is.
Physically and psychologically, he stands outside. 'I proceed from a state
of disharmony, from ugly things . . . from feet that are too big.'

See also his 'Painters' Equipment' (M88).

★ ★ ★

The poets lay in the gutter
their bodies in the morass.
The whole nation's spittle
floating on their soup.
They have grown between mucous membranes

into the root areas of men.
Their wings did not take them to heaven –
they have dipped their feathers in blood,
did not waste a single drop while writing –
but the wind carries their songs
that unsettled the faith . . .

The poets still raise their hands. Demonstrate changes? Embitterments, impotences and negations don't reveal themselves through gesture. – About EMBARRASSMENTS! With a final truth in discharge, having broken with all those unable to wrap art in a SMELL.

The 'externals' have practised art-historical addictions, have spoken persistently of final strokes, have fallen in ecstasy too rapidly, have practised mystification with a collector's passion, have advanced through artistic performances. They stretched out on white bedsheets, did not rumple the beds of the survivors, they mistrusted the remains of the last homework, did not make apparent the sticky threads and have jeered at the infertile agitations. The rest of the story are examples. Blasphemy is with us, blastogenesis (blossoming of excrescences) is with us, paleness and blue are ours. Those escaped confinement to bed, their methods of simplification carried them ever higher on the crests of the waves, they found confirmation in the rock carvings in the Sahara, in the linear constructions of Egyptian reliefs or in the lycopod woods. No salute shall greet their friendliness here!

Geniuses have stretched to the sky – buried themselves in the liquid earth. The ice has broken underneath the misty labyrinth. Those are petrified who believe in fertility, who believe in it – who deny their fathers and venerate them. Fire furrows in the ice, crystal flowers, nets of needles, starry sky broken up.

Frozen nudes with skin crusts – spilled trail of blood. Bloated and deposited friendly ones. Perspective faces drawn by the moon on the rivers, faces on which the sewage waters drip. The toad that lives and licks the saliva of the singers. Crystal mountains glowing red. Homer, the water of your eyes in the mountain lake. Caught in the flourishes of the manuals who invented the method.

Conciliatory meditation – beginning with the contemplation of the smallest toe. On the horizon, in the most distant fog, one always sees

faces. Under the blanket, something is shivering and trembling, behind the curtain, someone is laughing. *You see in my eyes* nature's altar, the carnal sacrifice, remains of food in the cesspool-pan, emanations from the bedsheets, blossoms on stumps and on roots, oriental light on the pearly teeth of the belles, cartilage, negative forms, shadow stains and wax drops. Marching up of the epileptics, orchestrations of the bloated, warted, gruel-like, and jellyfish creatures, limbs and interlaced erectile tissue.

M73 Rafael Montañez Ortiz

Destructivism: A Manifesto (1962)

First published in *Rafael Montañez Ortiz: Years of the Warrior, Years of the Psyche 1960–1988* (New York, 1988).

RAFAEL MONTAÑEZ (RALPH) ORTIZ (born 1934) is an American avant-garde performance artist with a long pedigree in Destructivism. At the first Destruction in Art Symposium in London in 1966, co-organized by Gustav Metzger (see M69), Ortiz performed a series of seven public destruction events, including his celebrated piano destruction concerts, which were filmed by the BBC. Piano destruction became his speciality. He has given over eighty performances in museums and galleries all over the world, sometimes even as private commissions. No longer mere relics, his piano sculptures are now in the collections of major American museums.

At a retrospective at El Museo del Barrio in New York, in 1988, he performed a dual piano destruction, *Homage to Huelsenbeck*, which called for active audience participation in the destruction of the second piano. This homage underlined their mutual admiration, and a certain Dada lineage (see M29). In 1963 Hulbeck/Huelsenbeck had written, in his best Dada prose, 'Ralph Ortiz . . . is fascinated by things that are not or are not yet . . . When Ortiz wants to show us a mattress, he does not show a mattress but an object that is torn up by indefinable forces as they worked in time. What really plays an important role is the artist's thought of the man behind the mattress who has to fight his way through the jungle of his existence.'

See also Gustav Metzger's 'Auto-Destructive Art' (M69).

* * *

There are today throughout the world a handful of artists working in a way which is truly unique in art history. Theirs is an art which separates the makers from the unmakers, the assemblers from the disassemblers, the constructors from the destructors. These artists are destroyers, materialists and sensualists dealing with process directly. These artists are destructivists and do not pretend to play at God's happy game of creation; on the contrary, theirs is a pervading response to the will to kill. It is not the trauma of birth which concerns the destructivist. He understands that there is no need for magic in living. It is one's sense of death which needs the life-giving nourishment of transcendental ritual.

We who use the process of destruction understand above all the desperate need to retain unconscious integrity. We point to ourselves and confess, shouting the revelation, that anger and anguish which hide behind the quiet face is in service of death, a death which is more than spiritual. The artist must give warning, his struggle must make a noise, it must be a signal. Our screams of anguish and anger will contort our faces and bodies, our shouts will be 'to hell with death,' our actions will make a noise that will shake the heavens and hell. Of this stuff our art will be, that which is made will be unmade, that which is assembled will be disassembled, that which is constructed will be destructed. The artist will cease to be the lackey, his process will cease to be burdened by a morality which only has meaning in reality. The artist's sense of destruction will no longer be turned inward in fear. The art that utilizes the destructive processes will purge, for as it gives death, so it will give life.

Transcendence is for the living, not for the dead. It is the symbolic sacrifice that releases one from the weight of guilt, fear and anguish. It is the sacrificial action which releases and raises one to the heights. The sacrificial process in art is one in which a symbolic act is performed with symbolic objects for symbolic purposes, initiated by the need to maintain unconscious integrity.

The dynamics of our unconscious integrity is fantastic. It arranges content in terms of a thousand eyes for an eye, boils death and destruction for the trespasser, maybe not now, maybe not today, but some day, by God, we'll get even, even if it means headaches, allergies, ulcers, heart attacks, or a jump off a roof. Just you wait and see. Someday we'll all get even. 'Every dog has his day,' and when the real dog has his real day, what will he really do? Will he push a button and annihilate 200 million people,

push an old lady down the stairs, join the Ku Klux Klan, expose his privates in public, or simply walk the dog to defecate on the neighbour's lawn? When the need for unconscious integrity is actually worked out in the actual world with actual people, actual things occur. There is actual conflict and actual destruction. The real moving car driven by the real driver who does not really see the real child who in turn does not really see the real car while crossing the real street, is really killed, really dead. The police cover him with a real white sheet and draw a white chalk line around him. I didn't do anything. I just watched. I didn't even get sick. I didn't even throw up. I just got really afraid. The car was big and made out of steel, but I'll get even some day. There are other real possibilities, less drastic ones, possibilities which have a more essential displacement, a greater distance. The real car might have run over a real puppy or with a still greater symbolic distance, a real cardboard box. The real child might have simply bumped into a parked car, bruising himself slightly, or crashed his toy car into one of his toy dolls.

Just as displacement and distance are an essential and necessary artistic means which enable the artist to submerge himself in the chaos of his destructive internal life and achieve an artistic experience, so too it is essential that the encounter between the artist and his material be close and direct. The artist must utilize processes which are inherent in the deep unconscious life, processes which will necessarily produce a regression into chaos and destruction.

A displacement and parallel process exists between man and the objects he makes. Man, like the objects he makes, is himself a result of transforming processes. It is therefore not difficult to comprehend how as a mattress or other man-made object is released from and transcends its logically determined form through destruction, an artist, led by associations and experiences resulting from his destruction of the man-made objects, is also released from and transcends his logical self.

M74 George Maciunas

Fluxus Manifesto (1963)

First disseminated in 1963. Now available on the Internet.

GEORGE MACIUNAS (Jurgis Mačiūnas, 1931–78) was a Lithuanian-American artist who was the mobilizer and mainstay of Fluxus, a loose group or community of international artists who formed or coalesced in the 1960s. They were strongly influenced by the teachings of John Cage (1912–92) – composer of *4′ 33″* (1952), four minutes and thirty-three seconds of silence, performed by a full orchestra, complete with conductor – in particular his Experimental Composition classes at the New School for Social Research in New York in the late 1950s, and his ideas about the play of chance and indeterminacy in art. These ideas had influence across the avant-garde, through his companion and collaborator Merce Cunningham (1919–2009), the great dance-maker, and the artists Jasper Johns and Robert Rauschenberg.

George Maciunas was to Fluxus what Guy Debord was to the Situationist International (see M70). Many of those associated with Fluxus, however, were not amenable to any sort of discipline. Early adherents included Joseph Beuys, Dick Higgins, Nam June Paik, La Monte Young, Emmett Williams, Benjamin Patterson, Yoko Ono and Wolf Vostell (see M75). These artists wanted to close the gap between art and life, and also to democratize, or deglamorize, the creative process. When it came to art, anyone could play.

Play was indeed the operative word. Fluxus was big on 'the event'. Maciunas organized the first Fluxus Festival in Wiesbaden, Germany, in 1962, while he was working for the US Air Force as a civilian graphic designer (having absconded from New York to avoid the debt collectors). The event within this event was Philip Corner's *Piano Activities*. The score of that work invited a group of performers to 'play', 'scratch or rub' and

'strike soundboard, pins, lid or drag various objects across them'. In Maciunas's interpretation, the piano was completely destroyed – a performance (or at any rate an outcome) in tune with Destructivism (M73). This particular event was considered scandalous enough to be shown four times on German television. It also toured the Continent.

Maciunas himself was inclined to regard George Brecht's word event, *Exit*, as the epitome of Fluxus. This consisted solely of a card bearing the legend 'Word Event' and (below) 'Exit'. According to Maciunas: 'The best Fluxus "composition" is the most non-personal, "readymade" one, like George Brecht's *Exit* – it does not require any of us to perform it since it happens daily without any special performance of it. Thus our festivals will eliminate themselves (and our need to participate).'

Fluxus might have been called 'Neo-Dada'. Maciunas corresponded with one of the founders of Berlin Dada, Raoul Hausmann (see M32), who advised him to stick to the name Fluxus. There were points of continuity: the anti-art impulse (written into the manifesto), the subversive strain, the playful element, the weakness for the theatrical – all this had a certain congruence with daddy Dada. Fluxus in turn was an inspiration to others, among them the 'living sculptures' Gilbert and George (see M80).

Maciunas himself was not a well man. He bowed out with a 'Fluxwedding' in 1978, performed in a friend's loft in SoHo, New York. The bride and groom exchanged clothes.

★ ★ ★

Manifesto:

2. To affect, or bring to a certain state by subjecting to or treating with, a flux. '*Fluxed* into another world.' *South.*
3. *Med.* To cause a discharge from, as in purging.
Flux (flŭks). n. [OF., fr. L *fluxus* fr. *Fluere, fluxum* to Flow. See FLUENT: cf FLUSH n. (of cards)] 1. *Med.* **a** A flowing or fluid discharge from the bowels or other part esp., an excessive and morbid discharge; as the bloody *flux*, or dysentery. **b.** The matter thus discharged.

Purge the world of bourgeois sickness, "intellectual", professional & commercialized culture, PURGE the world of dead art, imitation, artificial art, abstract art, illusionistic art, mathematical art, – PURGE THE WORLD OF "EUROPANISM"!

2. Act of flowing: a continuous moving on or passing by, as of a flowing stream A continuing succession of changes.
3. A stream; copious flow; flood; outflow.
4. The setting in of the tide toward the shore. Cf. REFLUX
5. State of being liquid through heat; fushion. *Rare.*

PROMOTE A REVOLUTIONARY FLOOD AND TIDE IN ART,
Promote living art, anti-art, promote NON ART REALITY to be fully grasped by all peoples, not only critics, dilettantes and professionals.

7. *Chem & Metal.* **A** Any substance or mixture used to Promote fusion, esp the fusion of metals and minerals. Common metallurgical fluxes are silica and silicates; acidics, lime and limestone-based and fluorite neutrals. **b** Any substance applied to surfaces to be joined by soldering or welding, just prior to or during the operation, to clean and free them from oxide, thus promoting their union, as from

FUSE the cadres of cultural, social & political revolutionaries into united front & action.

M75 Wolf Vostell

Manifesto (1963)

Published in *Vostell Retrospektive 1950–1974* (Berlin, 1975).

WOLF VOSTELL (1932–98) was a German painter, a pioneer of video art and environment-sculptures, and a founder member of Fluxus (M74). He is supposed to have been the first person to incorporate a television in a work of art (in 1958).

His maxim was a word: *décollage*, which he noticed in the report of a plane crash in *Le Figaro*, 6 September 1954. In the world of air travel, *décollage* means take-off, but it also has art-world associations – if collage is scraps or fragments stuck together or assembled, then the opposite of collage is unstuck or disassembled. Vostell was intrigued. He appropriated the term as a summary articulation (or disarticulation: *dé-coll-age*) of his practice and his thinking about the creative process and the world. In 1966 he reflected: 'Life is *dé-coll-age* in that the body in one process builds up and deteriorates as it grows older – a continuous destruction. What shocked me so noticeably about the report in *Figaro* as opposed to those of all other aircraft disasters was the contradiction in one word, for *dé-coll-age* means the take-off of an aircraft as well as the tearing away from an adhesive surface. The flying body was *décollé* as much by take-off as by unsticking, one word included two or more contradictory happenings. Thus the accident is already in the automobile as it drives, the obsolescence is already prefabricated and built in. Events in the street and airports and supermarkets are more interesting and more significant for our time than those in a theatre or museum. Torn posters, erasures, distorted television pictures, happenings and action music contain many layers of information. The psychological truth and the why are contained and preserved in them.'

* * *

Décollage is your understanding

Décollage is your accident

Décollage is your death

Décollage is your analysis

Décollage is your life

Décollage is your change

Décollage is your reduction

Décollage is your problem

Décollage is your TV destruction

Décollage is your dirt

Décollage is your fever

Décollage is your sweat

Décollage is your skin

Décollage is your sudden fall

Décollage is your refusal

Décollage is your nerve

Décollage is your break

Décollage is your own disillusion

Décollage is your own failure (demise)

Décollage is your divestment

Décollage is your spot cleaner

Décollage is your dissolvent

Décollage is your resignation

Décollage is your pain

Décollage is your diarrhoea

Décollage is your revelation

Décollage is your own décollage

M76 Stan Brakhage

Metaphors on Vision (1963)

First published in *Film Culture* 30 (Autumn 1963).

STAN BRAKHAGE (1933–2003) was a legendary avant-garde film-maker. He was truly an artist in film: in his later years he no longer photographed, but painted (or scratched) straight on to clear strips of film – 'essentially freeing myself from the dilemmas of re-presentation'. Brakhage's films are radically experimental, usually non-narrative, often abstract, sometimes only a few minutes long. They are not the sort of films that are shown in the local cinema. In time-honoured fashion, his early work was greeted with derision; and much of the rest met with indifference. It is now recognized as the *œuvre* of a master – a non-traditional master – a sustained exploration of what he called 'moving visual thinking'. In film Brakhage was a profound thinker, a restless experimentalist, a stubborn visionary, steeped in the art of the past – Cézanne, as so often, was the touchstone – determined to make his own way in his own medium: his idiosyncratic songs of innocence and experience.

Brakhage could wax lyrical. He was also a kind of sage. In 'The Camera Eye', a nod to Vertov (M41), he wrote: 'And here, somewhere, we have an eye (I'll speak for myself) capable of any imagining (the only reality). And there (right there) we have the camera eye (the limitation of the original liar) . . . its lenses ground to achieve nineteenth-century Western compositional perspective (as best exemplified by the "classic" ruin) . . . its standard camera and projector speed for recording movement geared to the feeling of the ideal Viennese slow waltz, and even its tripod head . . . balled with bearings to permit it that Les Sylphides motion (ideal to the contemplative romantic and virtually restricted to horizontal and vertical movements) . . . and its colour film manufactured to produce

that picture postcard effect (salon painting) exemplified by those oh so blue skies and peachy skins.'

* * *

Imagine an eye unruled by man-made laws of perspective, an eye unprejudiced by compositional logic, an eye which does not respond to the name of everything but which must know each object encountered in life through an adventure of perception. How many colours are there in a field of grass to the crawling baby unaware of 'Green'? How many rainbows can light create for the untutored eye? How aware of variations in heat waves can that eye be? Imagine a world alive with incomprehensible objects and shimmering with an endless variety of movement and innumerable gradations of colour. Imagine a world before the 'beginning was the word.'

To see is to retain – to behold. Elimination of all fear is in sight – which must be aimed for. Once vision may have been given – that which seems inherent in the infant's eye, an eye which reflects the loss of innocence more eloquently than any other human feature, an eye which soon learns to classify sights, an eye which mirrors the movement of the individual toward death by its increasing inability to see. But one can never go back, not even in imagination. After the loss of innocence, only the ultimate of knowledge can balance the wobbling pivot. Yet I suggest that there is a pursuit of knowledge foreign to language and founded upon visual communication, demanding a development of the optical mind, and dependent upon perception in the original and deepest sense of the word.

Suppose the Vision of the saint and the artist to be an increased ability to see – vision. Allow so-called hallucination to enter the realm of perception, allowing that mankind always finds derogatory terminology for that which doesn't appear to be readily useable, accept dream visions, day-dreams or night-dreams, as you would so-called real scenes, even allowing that the abstractions which move so dynamically when closed eyelids are pressed are actually perceived. Become aware of the fact that you are not only influenced by the visual phenomenon which you are focused upon and attempt to sound the depths of all visual influence. There is no need for the mind's eye to be deadened after infancy, yet in

these times the development of visual understanding is almost universally forsaken.

This is an age which has no symbol for death other than the skull and bones of one stage of decomposition . . . and it is an age which lives in fear of total annihilation. It is a time haunted by sexual sterility yet almost universally incapable of perceiving the phallic nature of every destructive manifestation of itself. It is an age which artificially seeks to project itself materialistically into abstract space and to fulfil itself mechanically because it has blinded itself to almost all external reality within eyesight and to the organic awareness of even the physical movement properties of its own perceptibility. The earliest cave paintings discovered demonstrate that primitive man had a greater understanding than we do that the object of fear must be objectified. The entire history of erotic magic is one of possession of fear through holding it. The ultimate searching visualization has been directed toward God out of the deepest possible human understanding that there can be no ultimate love where there is fear. Yet in this contemporary time how many of us even struggle to deeply perceive our own children?

The artist has carried the tradition of visual and visualization down through the ages. In the present time a very few have continued the process of visual perception in its deepest sense and transformed their inspirations into cinematic experiences. They create a new language made possible by the moving picture image. They create where fear before them has created the greatest necessity. They are essentially preoccupied by and deal imagistically with – birth, sex, death, and the search for God.

M77 Stanley Brouwn

A Short Manifesto (1964)

First published in the *Institute of Contemporary Arts Bulletin* 140 (October 1964) in London.

STANLEY BROUWN (born 1935) is a Conceptualist artist who insists on withholding the details of his biography and even the reproductions of his work. This strategy may serve to demonstrate the disappearance of the author – much heralded but not much practised – not to speak of the work. It may also make a point about the impersonal nature of the creative process.

This is what we are permitted to know. Stanley Brouwn was born in Suriname. He lives and works in Amsterdam.

In addition, we know that he is obsessed with the idea of measurement (a common obsession among Conceptualists). Brouwn is interested in the poetry of the measurement, as Marx was interested in the poetry of the revolution. This touches on how measurement is used to represent reality, in particular corporeality – the body – his own and that of the next person. Vital statistics are more vital for Stanley Brouwn than for most. Recently he took on a portrait commission. It consists of an aluminium strip the exact length of the subject, laid on a trestle table, and labelled *portrait of mickey cartin body length 174.6 cm* (2006). In this portrait, the artist has taken the measure of his subject.

Brouwn emerged on the scene in a state of Fluxus (M74), ruled by the Happening, the performance, and the participatory activity. In 1960 he announced that all the shoe shops in Amsterdam were to be considered his exhibition. His seminal series *This Way Brouwn* (1960–64) was produced by asking passers-by to draw for him the way from A to B, and then stamping the drawings 'This Way Brouwn'. He has explored different countries' measuring systems; he has proposed short walks in

the direction of capital cities – *walk 4m in the direction of havana distance 7396584.7166m* (2005), measured from the very spot where you stand in the museum; he has artfully mapped his own coordinates. His work is dead-pan and readymade, bounded and grounded, yet out of this world. Stanley Brouwn's psycho-geography, as the Situationists might say (see M70), is a carefully calibrated leap of faith.

<p align="center">★ ★ ★</p>

4000 A.D.
WHEN SCIENCE AND ART ARE ENTIRELY
MELTED TOGETHER TO SOMETHING NEW
WHEN THE PEOPLE WILL HAVE LOST THEIR
REMEMBRANCE AND THUS WILL HAVE
NO PAST, ONLY FUTURE.
WHEN THEY WILL HAVE TO DISCOVER EVERYTHING
EVERY MOMENT AGAIN AND AGAIN
WHEN THEY WILL HAVE LOST THEIR NEED FOR
CONTACT WITH OTHERS . . .
THEN THEY WILL LIVE IN A WORLD OF ONLY
COLOUR, LIGHT, SPACE, TIME, SOUNDS AND MOVEMENT
THEN COLOUR LIGHT SPACE TIME
SOUNDS AND MOVEMENT WILL BE FREE

NO MUSIC
NO THEATRE
NO ART
NO
THERE WILL BE SOUND
 COLOUR
 LIGHT
 SPACE
 TIME
 MOVEMENT

M78 Derek Jarman

Manifesto (1964)

Unpublished. From a notebook kept at the Slade School of Art in London, dated Winter 1964 (when he was twenty-two).

DEREK JARMAN (1942–94) was a queer controversialist, as he might have said, canonized 'Derek of Dungeness of the Order of Celluloid Knights', 'the first Kentish saint since Queer Thomas of Canterbury', by the (male) Sisters of Perpetual Indulgence. He was also a writer, a painter, a stage designer, a film-maker, a gardener, a campaigner and a social reformer. In each of these roles he was startlingly innovative. In all, he was remarkably successful. Jarman was a polymath of radical vision and Ruskin-like reach; a pioneer in everything from set design to Super-8, pop video to protest. Still in the early 1980s he was one of the very few openly gay public figures in Britain. In 1986 he was diagnosed as HIV positive. So began an extraordinary creative period: 'late work' in every conceivable medium. Oncoming blindness seemed to fuel both the productivity and the ingenuity. *Fuck Me Blind* (1993) was one of a series of late paintings bathed in colour – the colour of blood. *Blue* (1993), his last film, consisted of a mesmerizing single shot of saturated blue, filling the screen, with a soundtrack of the artist's life and times and testament. *Chroma* (1994) was a kind of notebook of colour, beautifully turned, elegiac and true. 'Curled up in the crock of gold at the end of the rainbow,' it begins, 'I dream of colour. The painter Yves Klein's International Blue. Blues and distant song. The eye, I know, described by the fifteenth-century architect Alberti, "is more swift than anything". Fast colour. Fugitive colour. He wrote those words in his book *On Painting*, and finished it at 8.45 on Friday 26 August 1435. Then he took a long weekend . . .'

Derek Jarman was an inspiration – the most significant underground-overground artist-activist of his generation. Vasari would have had a field day with this life.

* * *

Tentative ideas for a manifesto after 1¹/₃ years at an art school.

It is evident that the arts have been ossified into respective spheres unnaturally, dancing, the opera house, the theatre, architecture, the concert hall, etc. Probably the least effective the art gallery, a structure perfected in the C19th.

Theatre, ballet and painting must be revived. This cannot be achieved separately. There must be intercommunication.

The genuine participating audience has been lost. Lack of audience reaction has been made a virtue.

There must be communal basis even if only from the artists themselves.

Fragmentation and the perverted cult of individuality at all cost is a force which has rendered the artist impotent.

Experiment of constructive communal sort is impossible under the present circumstance. What goes for experiment is part of the establishment.

One must abrogate part of one's individuality to a workshop.

Architecture has given in to urban strangulation. The architects are visually bankrupt. They spend their time on heating systems instead of on environment.

Rauschenberg breaks from the restrictions slightly with his radio, buckets and ballet costumes etc., but this is only a hesitant step.

Creativity unconfined by the words painter, sculptor. The painting school says you are not a painter. 'I'm proud.'

A space must be taken over in which men construct, perform, entertain, experiment.

It does not matter if it is a failure. Failures are to be desired as long as they are complete, stretched to their limits.

To build a group is almost impossible. Fragmentation has become so complete.

The audience must become participators, the creators. The artist must abrogate his mystery.

The idea of stage design is inadequate. The event must form a unity. The place for the haphazard must be retained but this must be built on. The happening cannot be a totality. Things must be constructed.

The old city is dying. What will take its place. The structures on which it is based are insecure. Should one give in to movement and noise or fight for the cloistered order?

Where is the sculpture? Sculpture cannot be monumental in its present form. There are no monuments except cartoon copies of elder statesmen erected by their friends. 'Where is the [Louise] Nevelson reredos'. Neither is it architectural. No good sculpture on any building in England. Only applied. The badge of office, the directors' wash basin. Few sculptors even attempt to form environment etc.

Down with the [William] Holford gentility in planning. Turn Piccadilly into one vast shimmering glass tunnel. 500ft high. 6 skyscrapers. Bridges to the island in the centre. And get Bridget Riley or kineticist to design the lights. Muzak, all types, from loud speakers. Sometimes Bach, sometimes Beatles.

Geodesic dance floor.

M79 Robert Venturi
Non-Straightforward Architecture: A Gentle Manifesto (1966)

First tried out in *Perspectiva: The Yale Architectural Journal* 9/10 (1965), then published in *Complexity and Contradiction in Architecture* (New York, 1966).

ROBERT VENTURI (born 1925) is an American architect and architectural theorist. *Complexity and Contradiction in Architecture* made an indelible impression on Western architectural thinking. It was probably the most influential writing on the subject since Le Corbusier's *Toward an Architecture* (M45) forty years before. Together with a later book, *Learning from Las Vegas* (1972), it continues to resonate, forty years after.

Venturi promises a gentle manifesto. In keeping with the genre, he is for some things and against others; in keeping with the gentleness, these are preferences rather than ukases. Non-straightforward is also non-strident. Rather cleverly, the argument for complexity and contradiction in architecture is bolstered by reference to the argument for 'ambiguity' in painting (citing Albers), 'difficulty' in poetry (citing Eliot), and 'inconsistency' in mathematics (citing Gödel): architecture is situated and corroborated as art and thought and practice.

Venturi is equally alert to its history. His parting shot, 'more is not less', is a contradiction (or complexification) of Mies van der Rohe's celebrated dictum, 'less is more'. Mies was a living legend – living in Chicago when Venturi's book was published – the last director of the Bauhaus (see M33). He is said to have based his architectural teaching on St Thomas Aquinas's proposition, 'Reason is the first principle of all human work.' His buildings are the acme of structural clarity and simple geometry. Mies, it is safe to say, was not a 'both-and' person. To controvert him, and subvert him, was a bold move. It signified the passing of the baton from modernism to post-modernism in architecture.

See also Coop Himmelb(l)au, 'Architecture Must Blaze' (M87) and Charles Jencks, '13 Propositions for Post-Modern Architecture' (M93).

<p style="text-align:center">★ ★ ★</p>

I like complexity and contradiction in architecture. I do not like the incoherence or arbitrariness of incompetent architecture nor the precious intricacies of picturesqueness or expressionism. Instead, I speak of complex and contradictory architecture based on the richness and ambiguity of modern experience, including that experience which is inherent in art. Everywhere, except in architecture, complexity and contradiction have been acknowledged, from Gödel's proof of ultimate inconsistency in mathematics to T. S. Eliot's analysis of 'difficult' poetry and Joseph Albers' definition of the paradoxical quality of painting.

But architecture is necessarily complex and contradictory in its very inclusion of the traditional Vitruvian elements of commodity [fitness], firmness and delight. And today the wants of programme, structure, mechanical equipment and expression, even in single buildings in simple contexts, are diverse and conflicting in ways previously unimaginable. The increasing dimension and scale of architecture in urban and regional planning add to the difficulties. By embracing contradiction as well as complexity, I am for vitality as well as validity.

Architects can no longer afford to be intimidated by the puritanically moral language of orthodox Modern architecture. I like elements which are hybrid rather than 'pure', compromising rather than 'clean', distorted rather than 'straightforward', ambiguous rather than 'articulated', perverse as well as impersonal, boring as well as 'interesting', conventional rather than 'designed', accommodating rather than excluding, redundant rather than simple, vestigial as well as innovating, inconsistent and equivocal rather than direct and clear. I am for messy vitality over obvious unity. I include the *non sequitur* and proclaim the duality.

I am for richness of meaning rather than clarity of meaning; for the implicit function as well as the explicit function. I prefer 'both-and' to 'either-or', black and white and sometimes grey, to black and white. A valid architecture evokes many levels of meaning and combinations of focus: its space and its elements become readable and workable in several ways at once.

Robert Venturi

But an architecture of complexity and contradiction has a special obligation toward the whole: its truth must be in its totality or its implications of totality. It must embody the difficult unity of inclusion rather than the easy unity of exclusion. More is not less.

M80 Gilbert and George

The Laws of Sculptors (1969)

Published in *Studio International* 179 (May 1970).

GILBERT [PROESCH] (born 1943) and GEORGE [PASSMORE] (born 1942) are self-styled 'living sculptures'. Their life is their art. Their art is their life. They have become a celebrity couple – it is tempting to say a commodity couple. They are their own brand. Their life together is less a sculpture than a performance, long sustained, complete with fairy-tale romance and cod mythology. They met on 25 September 1967, we learn, at St Martin's School of Art. 'It was love at first sight.' They got married in 2008. 'We thought it was probably about time.' The ceremony was witnessed by their two staff, Yi Gangyu and Keith. Afterwards they went to have an Indian meal. The life of the living sculpture is nothing if not routine.

Their career as a couple began while they were still students. They performed *The Singing Sculpture* on the steps of the Stedelijk Museum in Amsterdam in 1969. This involved covering their heads and hands in multi-coloured metalized powders, standing on a table, and singing along to Flanagan and Allen's old standard, 'Underneath the Arches', sometimes for eight hours at a stretch. The suits they wore became a kind of uniform. Their double act or double pact was sealed.

From then on they were always together: that was the point. Their views may be voiced by one or the other, but they speak as 'we'. What they say is banal: the banalities are dressed up in soundbites, as if rehearsed. Typically they are contrary, and often reactionary. 'We admire Margaret Thatcher greatly. She did a lot for art. Socialism wants everyone to be equal. We want to be different. We're also fond of the Prince of Wales: he's a gentleman.'

In art and life, and manifestos, Gilbert and George are a tease. 'All we

do we do for our love of art,' says George. 'All we've ever wanted is to be loved.' The unspoken words here would seem to be 'for ourselves'. But who are they?

See also 'What Our Art Means' (M83).

* * *

1. Always be smartly dressed, well groomed relaxed and friendly polite and in complete control.

2. Make the world to believe in you and to pay heavily for this privilege.

3. Never worry assess discuss or criticize but remain quiet respectful and calm.

4. The lord chisels still, so don't leave your bench for long.

M81 Mierle Laderman Ukeles

Maintenance Art Manifesto (1969)

Composed in October 1969, originally in two parts, the first entitled 'Ideas' (printed here), the second a description of a proposed exhibition. In conformity with these ideas, as part of an all-female travelling exhibition of avant-garde artists organized by Lucy Lippard, 'c.7,500' (1973), at the Wadsworth Athenaeum in Hartford, Connecticut, Ukeles performed a number of actions that became an important early work of what was known as Institutional Critique: she scrubbed the museum steps, polished museum display cases and locked the offices of museum workers.

MIERLE LADERMAN UKELES (born 1939) is Artist in Residence in the Department of Sanitation, New York City, a position entirely in keeping with her principles and practice as a Maintenance artist, a term she coined. 'After the revolution, who's going to pick up the garbage on Monday morning?' Maintenance art was informed by feminist politics – the politics of 'women's lib' (liberation), in contemporary parlance. The manifesto established a pithy and witty distinction between 'development' and 'maintenance'. Development was 'pure individual creation'; maintenance was 'keep the dust off the pure individual creation'. Development was an excitement; maintenance was a drag ('it takes all the fucking time, literally'). Needless to say, development was male and maintenance female – except that, in the circumstances prevailing at the time, it did need saying; and it needed saying in these terms in order to be heard.

Ukeles recalls writing the manifesto 'in a cold fury'. The impetus behind it was a cumulation of things, and experiences, triggered possibly by the experience of having her first baby the previous year, or rather by the response she encountered. She was an artist and an intellectual; suddenly she found that, as a mother, people had nothing to say to her.

'They didn't say, "How is it, to create life? How can you describe this amazing thing?" . . . It was like I was mute, there was no language. This is 1968, there was no valuing of "maintenance" in Western culture. Capitalism is like that. The people who were taking care and keeping the wheels of society turning were mute, and I didn't like it! . . . So I sat down and I said, "If I am an artist, and if I am the boss of my art, then I name Maintenance art." And really, it was like a survival strategy, because I felt like "how do I keep going?" I am this maintenance worker, I am this artist – I mean this is early feminism, very rigid, I was divided into two. Half of my week I was a mother, and the other half an artist. But I thought to myself, 'this is ridiculous, I am the one" . . . It wasn't just, "How am I feeling today?" It was saying, "OK folks, we have hit a certain point here, and from now on art has changed. Why? Because I say so."'

Seldom has the urge to manifesto been more compellingly expressed.

★ ★ ★

Ideas

A. *The Death Instinct and The Life Instinct.*

The Death Instinct: separation, individuality, Avant-Garde par excellence; to follow one's own part to death – do your own thing, dynamic change. *The Life Instinct*: unification, the eternal return, the perpetuation and maintenance of the species, survival systems and operation, equilibrium.

B. *Two basic systems: Development and Maintenance.*

The sourball of every revolution: after the revolution who's going to pick up the garbage on Monday morning?
Development: pure individual creation; the new; change; progress; advance; excitement; flight or fleeing.
Maintenance: Keep the dust off the pure individual creation; preserve the new; sustain the change; protect progress; defend and prolong the advance; renew the excitement; repeat the flight;
Show your work – show it again

Keep the contemporary art museum groovy
Keep the home fires burning
Development systems are partial feedback systems with major room for change. Maintenance systems are direct feedback systems with little room for alteration.

> *C. Maintenance is a drag; it takes all the fucking time, literally; the mind boggles and chafes at the boredom; the culture confers lousy status and minimum wages on maintenance jobs; housewives = no pay.*

Clean your desk, wash the dishes, clean the floor, wash your clothes, wash your toes, change the baby's diaper, finish the report, correct the typos, mend the fence, keep the customer happy, throw out the stinking garbage, watch out – don't put things in your nose, what shall I wear, I have no socks, pay your bills, don't litter, save string, wash your hair, change the sheets, go to the store. I'm out of perfume, say it again – he doesn't understand, seal it again – it leaks, go to work, the art is dusty, clear the table, call him again, flush the toilet, stay young.

> *D Art:*

Everything I say is Art is Art, Everything I do is Art is Art. 'We have no Art, we try to do everything well.' (Balinese saying à la [Marshall] McLuhan and [Buckminster] Fuller.)

Avant-garde art, which claims utter development, is infected by strains of maintenance ideas, maintenance activities and maintenance materials.

> *E. The exhibition of Maintenance Art, 'CARE,' would zero in on maintenance, exhibit it, and yield, by utter opposition, a clarity of issues.*

M82 Paul Neagu

Palpable Art Manifesto (1969)

Published in *Gradually Going Tornado!* (Sunderland, 1975), the catalogue
of an exhibition at the Sunderland Arts Cente, by Neagu and his Genera-
tive Art Group – a fictitious group who exhibited regularly.

PAUL NEAGU (1938–2004) was a Romanian sculptor and teacher who
settled in Britain in 1970. He considered sight to be an over-used sense,
as the manifesto makes clear. When he first exhibited the small-scale
sculptures he called 'tactile objects', in 1969, he suspended them from
the walls and ceiling of a darkened gallery. Visitors were invited to feel
their way around the room, experiencing the objects by touch. His 'palp-
able objects' are articulated constructions whose hinged or moving parts
were originally intended to be physically manipulated by the spectator.
They often incorporate boxes or compartments containing various tact-
ile substances such as fabrics or leather.

* * *

1. The eye is fatigued, perverted, shallow, its culture is degenerate,
degraded and obsolete, seduced by *photography*, film, television . . .

2. The eye is losing its primary role in aesthetic responses, while remain-
ing secondary in this respect.

3. Art must give up its purely visual aesthetic if it wants to survive specif-
ically as plastic art, and must move towards an organic and unified
aesthetic that will make use of senses that are still fresh, pure.

4. Let there be one public, palpable art through which all the senses,

sight, touch, smell, taste will supplement and devour each other so that a man can possess an object in every sense.

5. You can take things in better, more completely, with your ten fingers, pores and mucous membranes than with only two eyes.

6. These ideas are linked inseparably with the concept that art must function socially, yet never in a vulgarly naturalistic way.

7. Palpable art is a new joy for the 'blind', while for the 'clear-sighted' it is the most thoroughly three-dimensional study . . .

M83 Gilbert and George

What Our Art Means (1970)

Published in *Studio International* 179 (May 1970).
On Gilbert and George, see 'The Laws of Sculptors' (M80).

<center>* * *</center>

Art for All

We want Our Art to speak across the barriers of knowledge directly
to People about their Life and not about their knowledge of art. The
20th century has been cursed with an art that cannot be understood.
The decadent artists stand for themselves and their chosen few, laugh-
ing and dismissing the normal outsider. We say that puzzling, obscure
and form-obsessed art is decadent and a cruel denial of the Life of
People.

Progress through Friendship

Our Art is the friendship between the viewer and our pictures. Each
picture speaks of a 'Particular View' which the viewer may consider in
the light of his own life. The true function of Art is to bring about new
understanding, progress and advancement. Every single person on Earth
agrees that there is room for improvement.

Language for Meaning

We invented and we are constantly developing our own visual language. We want the most accessible modern form with which to create the most modern speaking visual pictures of our time. The art-material must be subservient to the meaning and purpose of the picture. Our reason for making pictures is to change people and not to congratulate them on being how they are.

The Life Forces

True Art comes from three main life-forces. They are: –

THE HEAD
THE SOUL
and THE SEX

In our life these forces are shaking and moving themselves into ever changing different arrangements. Each one of our pictures is a frozen representation of one of these 'arrangements'.

The Whole

When a human-being gets up in the morning and decides what to do and where to go he is finding his reason or excuse to continue living. We as artists have only that to do. We want to learn to respect and honour 'the whole'. The content of mankind is our subject and our inspiration. We stand each day for good traditions and necessary changes. We want to find and accept all the good and bad in ourselves. Civilization has always depended for advancement on the 'giving person'. We want to spill our blood, brains and seed in our life-search for new meanings and purpose to give to life.

M84 Douglas Davis

Manifesto (1974)

First published in the exhibition catalogue *Douglas Davis* (Syracuse, New York, 1974).

DOUGLAS DAVIS (born 1933) is an interactive artist who 'gorges' on the new media, to use his own word. His manifesto apes Apollinaire's calligrammes and Marinetti's words-in-freedom (see M11).

<p style="text-align:center">* * *</p>

for mind
TO
against physical
 FORGET
against physical
 VIDEO
against physical
 IS
against against art
 TO
against keeping minds down
 MAKE
against counting measuring calculating edit *burn the manuals*
for living
 MIND AND BODY
for ascending thin subtle awful mysteri
 DISCARDING NAMES
looking fresh immediate
direct to mind to direct

STOP THE NAMES
The Camera is a Pencil
a hand hold here

M85 Maroin Dib and others
Manifesto of the Arab Surrealist Movement (1975)

First published in English in *Arsenal: Surrealist Subversion* 3 (1976) in Chicago. Signed by Maroin Dib (Syria), Abdul Kadar El Janaby (Iraq), Faroq El Juridy (Lebanon), Fadil Abas Hadi (Iraq), Farid Lariby (Algeria) and Ghazi Younis (Lebanon).

The Arab Surrealist Movement was reconstituted in the early 1970s – these were the so-called second-generation Surrealists – but its origins date back to the early 1930s, when the Egyptian poet and theorist Georges Henein (1914–73) was a student in Paris. Henein was a significant cross-cultural negotiator. Together with the Egyptian painter Ramsès Younan (1913–66), he introduced Surrealism to Cairo. Inevitably, he was in close touch with André Breton (see M50 and M54); inevitably, the closeness did not last. The Egyptian Surrealists, who were also a section of the Fourth (Socialist) International, organized the Art and Liberty Group in response to the Breton / Trotsky Manifesto of 1938, 'Towards a Free Revolutionary Art' (M59). The Egyptian group produced a journal and some pamphlets, and put on several exhibitions. Curiously enough, it was probably the most active and longest-lived local chapter of the international federation for which Breton and Trotsky had called.

Henein broke with Breton after the war. The break was a reflection of personal and ideological differences, and perhaps also the predicament of Egyptian Surrealism – its cultural 'betweenness', as Henein put it – between East and West, Orient and Occident, centre and periphery, and, in linguistic terms, Egyptian and French. For all their professions of revolutionary solidarity, metropolitan French Surrealists were prone to an unreconstructed 'orientalism'. For them, Arab Surrealists were indeed the Other, marginal and unintelligible. In his person and his poetry Georges Henein stood athwart that perception.

in the distance you hear a great noise of eyebrows
by chance they are thieves
coming to free us from thieves' fear
pirates coming to free us from the storm
it's what's AFTER US coming to free us from the DELUGE

The 'Manifesto of the Arab Surrealist Movement' is strong meat.

* * *

With disgust we shove aside the dregs of survival and the impoverished rational ideas which stuff the ash-can-heads of intellectuals.

1) We incite individuals and the masses to unleash their instincts against all forms of repression – including the repressive 'reason' of the bourgeois order.

2)The great values of the ruling class (the fatherland, family, religion, school, barracks, churches, mosques and other rottenness) make us laugh. Joyously we piss on their tombs.

3) We spit on the fatherland to drown in it the fumes of death. We combat and ridicule the very idea of the fatherland. To affirm one's fatherland is to insult the totality of man.

4) We practise subversion 24 hours a day. We excite sadistic urges against all that is established, not only because we are the enemies of this new stone age that is imposed on us, but above all because it is through our subversive activity that we discover new dimensions.

5) We poison the intellectual atmosphere with the elixir of the imagination, so that the poet will realize himself in realizing the historical transformation of poetry:
 a) from form into matter;
 b) from simple words hanging on coat racks of paper into the desirable flesh of the imagination that we shall absorb until everything separating dream from reality is dissolved.
 Surrealism is nothing but the actualization of this surreality.

6) We explode the mosques and the streets with the scandal of sex returning to its body, bursting into flames at each encounter – secret until then.

7) We liberate language from the prisons and stock markets of capitalist confusion. It is plain that today's language, instead of being an agitational force in the process of social transformation and a vocabulary of revolutionary attack, is only a docile vocabulary of defence cluttered in the store of the human brain with one aim: to help the individual prove his complete subordination to the laws of existing society – to help him as a lawyer in the courts of everyday reality (that is, of repression).

Surrealism intrudes violently on this abject spectacle, annihilating all obstacles to 'the real functioning of thought' (André Breton).

When we write, our memory belches this language from the old world. It is a game in which our tongues become capable of recreating language in the very depths of the revolution.

Our Surrealism signifies the destruction of what they call 'the Arab fatherland'. In this world of masochistic survival, Surrealism is an aggressive and poetic way of life. It is the forbidden flame of the proletariat embracing the insurrectional dawn – enabling us to rediscover at last the revolutionary moment: the radiance of the workers' councils as a life profoundly adored by those we love.

Our Surrealism, in art as in life: permanent revolution against the world of aesthetics and other atrophied categories; the destruction and supersession of all retrograde forces and inhibitions.

Subversion resides in Surrealism as history resides in events.

M86 Rem Koolhaas
Delirious New York: A Retroactive Manifesto for Manhattan (1978)

First published in *Delirious New York* (New York, 1978).

REM KOOLHAAS (born 1944) is a Dutch architect, architectural theorist, urbanist, Harvard professor and global guru. According to *Time Magazine*, he is one of The World's Most Influential People. When it comes to urbanism, Koolhaas talks the talk and walks the walk. He celebrates the 'chance-like' nature of city life: 'The City is an addictive machine from which there is no escape' – a dictum with a dash of Le Corbusier and his 'machine for living' (see M45). Against the programmatic prescriptions of modernist architecture, he advocates 'cross-programming', that is to say the introduction of unexpected functions, such as running tracks in skyscrapers, or hospital units for the homeless in public libraries. He has built, *inter alia*, the Seattle Public Library (minus hospital units), the Netherlands Embassy in Berlin, and the Prada store in Beverly Hills.

His ambition is as stretching as his intellect: 'To keep thinking about what architecture can be, in whatever form.'

Like almost everything Koolhaas has done, *Delirious New York* and its attempt to epitomize modern urbanism (or urban modernism) as 'Manhattanism' is an influential project. It has even spawned imitators. Stephen Verderber's *Delirious New Orleans* (2009) may not match the high-concept Koolhaas, with his phrase-making and his word-coining and his italic-ecstatic style, but that is a tall order. Delirious is contagious, it seems. Where next for the city of conjecture?

See also Coop Himmelb(l)au, 'Architecture Must Blaze' (M87), Lebbeus Woods, 'Manifesto' (M90) and Charles Jencks, '13 Propositions of Post-Modern Architecture' (M93).

* * *

Manifesto

How to write a manifesto – on a form of urbanism for what remains of the twentieth century – in an age disgusted with them? The fatal weakness of manifestos is their inherent lack of evidence.

Manhattan's problem is the opposite: it is a mountain range of evidence without manifesto.

This book was conceived at the intersection of these two observations: it is a *retroactive manifesto* for Manhattan.

Manhattan is the twentieth century's Rosetta Stone.

Not only are large parts of its surface occupied by architectural mutations (Central Park, the *Skyscraper*), utopian fragments (Rockefeller Center, the UN Building) and irrational phenomena (Radio City Music Hall), but in addition each block is covered with several layers of phantom architecture in the form of past occupancies, aborted projects and popular fantasies that provide alternative images to the New York that exists.

Especially between 1890 and 1940 a new culture (the Machine Age?) selected Manhattan as laboratory: a mythical island where the invention and testing of a metropolitan lifestyle and its attendant architecture could be pursued as a collective experiment in which the entire city became a factory of man-made experience, where the real and the natural ceased to exist.

This book is an interpretation of that *Manhattan* which gives its seemingly discontinuous – even irreconcilable – episodes a degree of consistency and coherence, an interpretation that intends to establish Manhattan as the product of an unformulated theory, *Manhattanism*, whose programme – to exist in a world totally fabricated by man, i.e. to live *inside* fantasy – was so ambitious that to be realized, it could never be openly stated.

Ecstasy

If Manhattan is still in search of a theory, then this theory, once identified, should yield a formula for an architecture that is at once ambitious *and* popular.

Manhattan has generated a shameless architecture that has been loved

in direct proportion to its defiant lack of self-hatred, has been respected exactly to the degree that it went too far.

Manhattan has consistently inspired in its beholders *ecstasy about architecture*. In spite – or perhaps because – of this, its performance and implications have been consistently ignored and even suppressed by the architectural profession.

Density

Manhattanism is the one urbanistic ideology that has fed, from its conception, on the splendours and miseries of the metropolitan condition – hyper-density – without once losing faith in it as the basis for a desirable modern culture. *Manhattan's architecture is a paradigm for the exploitation of congestion.*

The retroactive formulation of Manhattan's programme is a polemical operation. It reveals a number of strategies, theorems and breakthroughs that not only give logic and pattern to the city's past performance, but whose continuing validity is itself an argument for a second coming of Manhattanism, this time as an explicit doctrine that can transcend the island of its origins to claim its place among contemporary urbanisms.

With Manhattan as example, this book is a blueprint for a 'Culture of Congestion'.

Blueprint

A blueprint does not predict the cracks that will develop in the future; it describes an ideal state that can only be approximated. In the same way this book describes a *theoretical* Manhattan, a *Manhattan as conjecture*, of which the present city is the compromised and imperfect realization.

From all the episodes of Manhattan's urbanism this book isolates only those moments where the blueprint is most visible and most convincing. It should, and inevitably will, be read against the torrent of negative analyses that emanates from Manhattan about Manhattan and that has firmly established Manhattan as the *Capital of Perpetual Crisis*.

Only through the speculative reconstruction of a perfect Manhattan can its monumental successes and failures be read.

[. . .]

M87 Coop Himmelb(l)au

Architecture Must Blaze (1980)

Text accompanying *Blazing Wing Action Object* (1980), an architectural Happening in Graz, and a realization of the manifesto's injunction that architecture should be hot – 'hot as a blazing wing' – in Graz, a steel frame suspended in the air incorporating flaming gas jets. The boundary between architecture and sculpture, creation and installation, is apt to be an artificial one, as Gropius suggested long ago (see M33).

Coop Himmelb(l)au is an international architectural design cooperative (a coop) based primarily in Vienna. Founded in 1968 by Wolf Prix (born 1942 in Vienna) and Helmut Swiczinsky (born 1944 in Poznan), its name invites word play or word association. A literal translation of the variant Himmelblau is sky blue, which might suggest blue-sky thinking or building, and boundless imagination. A literal translation of the variant Himmelbau is heaven construction or heaven building, which speaks for itself. In this context, however, the bau inevitably recalls the Bauhaus (see M33) – now become the Baucoop, or the Himmelhaus.

Coop Himmelb(l)au made its name in Deconstructivism, as witnessed at a celebrated exhibition, 'Deconstructivist Architecture', organized by Philip Johnson and Mark Wigley at the Museum of Modern Art in New York in 1988. The architects represented read like a roll call of the most venturesome in the profession: Peter Eisenman, Frank Gehry, Zaha Hadid, Coop Himmelb(l)au, Rem Koolhaas (see M86), Daniel Libeskind, Bernard Tschumi. Not all of these are or were strict Deconstructionists. Indeed, a strict Deconstructionist may be a contradiction in terms. For Charles Jencks (M93), it is more a syndrome than a movement; a series of tactics designed to shift architecture away from the mantras of modernism ('form follows function', 'purity of form', 'truth to materials') and the autocrats whose motto is 'efficiency, economy and expediency', as Coop Himmelb(l)au put it in another manifesto, 'The Future of Splen-

did Desolation' (1978). Deconstructivism wanted to subvert modernism – deconstruct it – and to rethink the functional, structural and spatial aspects of buildings. Some of this rethinking drew inspiration from the philosophical or metaphysical concerns behind Jacques Derrida's literary 'deconstruction' – the notions of presence and absence, trace and erasure – as, for example, in Daniel Libeskind's Jewish Museum in Berlin. Peter Eisenman actually collaborated with Derrida on an entry in an architectural design competition. (It did not win.) Some was rather less intellectual. Frank Gehry has said of Eisenman: 'The best thing about Peter's buildings is the insane spaces he ends up with . . . All that other stuff, the philosophy and all, is just bullshit as far as I'm concerned.'

Bullshit or bluff, all these architects knew their art history. Jencks has noted how architects now produce suggestive and unusual shapes as a matter of course, 'as if architecture had become a branch of Surrealist sculpture'. Cubism, Futurism and Constructivism all went into the mix. Gehry's Vitra Design Museum in Weil-am-Rhein takes apart the classic white cube of modernist art galleries and puts it back together again like a Cubist sculpture. Eisenman's Wexner Center for the Arts in Columbus, Ohio, is a castle (or elements of a castle) mixed with a three-dimensional grid; in a quintessentially Deconstructivist gesture, some of its columns do not reach the ground. A Dada architect, if one exists, would surely envy that gesture.

Coop Himmelb(l)au for their part speak of 'the fractalization of objects', but seem to hark back to Malevich (M24) and Rodchenko (M31 and M44) in their quest for radical simplicity in geometric forms and abstract assemblages. Their attention is now focused on the creation of public space through architecture. The urban chessboard is for them a thing of the past. Buildings are no longer chess pieces or objects, but 'urban transistors' capable of amplifying the spaces around them. Architecture must blaze. It must also hum.

See also Robert Venturi, 'Non-Straightforward Architecture' (M79), Rem Koolhaas, 'Delirious New York' (M86), Lebbeus Woods, 'Manifesto' (M90), and Charles Jencks, '13 Propositions of Post-Modern Architecture' (M93).

* * *

You can judge how bad the seventies were by looking at its uptight architecture.

A democracy of opinion polls and complacency thrives behind Biedermeier façades. We have no desire to build Biedermeier. Not now or any other time. We are tired of seeing Palladio and other historical masks. Because with architecture, we don't want to exclude everything that is disquieting.

We want architecture that has more. Architecture that bleeds, that exhausts, that whirls,

and even breaks.

Architecture that lights up, stings, rips, and tears under stress.

Architecture has to be cavernous, fiery, smooth, hard, angular, brutal, round, delicate, colourful, obscene, lustful, dreamy, attracting, repelling, wet, dry and throbbing.

Alive or dead.

If cold, then cold as a block of ice.

If hot, then hot as a blazing wing.

Architecture must blaze.

M88 Georg Baselitz

Painters' Equipment (1985)

Dated 12 December 1985, Derneburg. Given as a lecture at the Rijksakad-
emie van beeldende kunsten, Amsterdam, on 1 October 1987, the Royal
Academy of Arts, London, on 1 December 1987, and the École Nationale
Supérieure des Beaux-Arts, Paris, on 28 February 1991. First published in
German, *Das Rüstzeug der Maler*; original handwritten manuscript
published in *Georg Baselitz: Neue Arbeiten* (Cologne, 1987).

(For biographical details about Baselitz see his 'Pandemonic Manifesto
I' (M72).)

<p style="text-align:center">* * *</p>

A question and its answer. Are the painters still those painters who are
painting the great cave? Do they paint the buffalo on the wall as hunger,
the eagle as freedom, and the woman with a big bottom as love? Do they
paint the buffalo as the table that magically sets itself? Have they mean-
while left the cave, cleared out of the community, and forgotten all those
universal, comprehensible agreements, because magic does not still
hunger, because flying does not work and yearning for love does not
breed love? Have they traded the cave for some other place? Propagand-
izing about needs, 'What does man need?' feeds upon a yearning for
freedom and the fear of death and entices us into taking another way,
off the painters' course. The smart ones, hotshots, innovators, activists
– in the forefront madmen and hotspurs – have remained within their
own skulls. They proclaim plucky mottos: paintings should stick in the
throat, eyelids should be nailed down, and hearts grabbed with pliers.
Fish bone, air raid and separation. Well, one still sits together around
the fire, warms up the studios, has had enough to eat, and is in love. On
battered canvases are those sumptuous ornaments filled with jumbled

lines and rich colours; crystalline galleries hang over the frames. All that once stood erect, the still life, has been knocked over, the landscape has been seized and uprooted, the interiors tangled, and the portraits scratched and pierced. Painting became music. Surrealism won. Everything durable has been kicked out of the paintings. Now, the tone goes right through walls, the line stands upside down. Are the painters now unhappy and freezing? They dance and celebrate with their friends, they invite their fathers and drink Capri with them. A black painting is as white as the sky. The colours in the dark cave are aglow. Light is superfluous. Everything is utterly different, anyway. The paraphernalia of Venus, Zeus, the angels, Picasso were invented by the painters, as were the bull, the roast chicken and the lovers. The pear-wood palette became a pail, the brush a knife, an axe and a club. The largest paintings are larger, and the smallest are smaller than ever before. Someone painted a painting weighing five hundred pounds. A Chinese handwalked over the canvas. A Norwegian painted 168 acres of birch wood on one and one-half square inches of canvas. This is not the way I want to continue. Hygiene, I mean religion, is employed. Discipline is one thing, education another, and meditation, too. Intoxication is used to prepare or to stabilize an attitude. Some eat well, others purify themselves through fasting. While I see no point at all in bustling around, in being confused, zap, zap, my friend between New York and Cologne makes the best paintings in his trouser pocket, where his canary sits. Does one see more of the world by climbing a ladder, does one see still more by lying down flat on the field and by sticking one's nose in the ground? Either way. The difference between a German and an Italian apple tree is enormously large. In Tuscany in the garden I made photos of such trees. Back home in Germany I was terribly excited by these exotic apple trees, these unpaintable fairy-tale-tree-inventions. I realized that I did not want to paint an apple tree at all. I was still under the mother and had stuck out only my nose. The world had not opened up, the secret remained hidden within the object, but now there was confusion. This is an experience, but not of the kind that broadens your mind through shifting horizons. The first la-la sounds and the first dot-dot-comma-dash are indeed vehement creations for the one who makes them. This is not theory. I composed *Fidelio*, I know precisely that as a six-year-old I conducted this very piece; hare and dog I painted when I was eight years old, signing them 'AD' [Albrecht Dürer?]. One of

these watercolours is in Vienna, in the Albertina, the dog is lost. In order to remember, and perhaps to also build up my past, I painted for example, in 1969, the forest, for I am convinced that *The Hunters at Rest in Wermsdorf Forest* was painted by me in my eighth year at school in Saxony. The painting is smaller than the memory. In front of me, on the table, there is a silver thermos coffeepot with warm coffee. This pot would not mean anything to me were it not that I see myself reflected in it. Thus, I am reminded of my self-portrait with the large hand in the foreground – it hangs in Vienna. There is true Surrealism there, but only because I once again know exactly that at that time I had fair short hair and not these dark curls. My long cherished plan is to paint pictures behind the canvas. I do not want to hide behind the canvas, but want to stand upright before it. The painters' equipment for this act of painting are arms that are too short. Anatomy fails. By 1993, some painters will surely have an arm eighteen inches longer and will make this 'behind-the-canvas-picture'. That's me. Therefore, I paint today, 16 November 1985, this sort of Futurism and sign it with the date 1993. All that which lies behind the painter also lies before him. Ever since I fell on a frozen lake with my head hitting hard on the ice, a singing tone has remained inside my skull. This was a totally unproductive act, which proves the thesis of the unreproducibility of experience. Only recently did this sound vanish from my head; it was erased when I heard the lingering sound after a drum roll in Bruckner's Second Symphony. As if by psychic interference, the air rushed out of my ear. Such acts (falling on ice) do not belong to the painters' equipment. Here, nature has different plans. Suppose one paints an apple tree; meanwhile it grows dark, night falls, one stops painting. On the following day, one paints over this apple tree a still life. Is one off target? On the third day, one paints a portrait over it; one paints like that as long as one wants one thing on top of another. If someone now comes and asks what are you doing, I would immediately answer, a . . . , because that is how I do it. No one forces the painter into a society whose doctrine demands phoney paintings, in which the good draws examples of political madness for the picture book of the bad. If I paint the table that magically sets itself, I'll eat it up myself. My wife gently strokes my head. The painting will never be finished, my dear, should the painter fall from the ladder. The white contour ignites a black background. The Spanish painters are good lighting engineers. The inventor of the large theatre

spotlight is Velázquez. I ran away from his lighting rehearsal. Such a focused light makes me feel dizzy. Maybe it was wrong to run away, for now I miss this equipment. I must pull together the mush of paint with a rope. Like snakes, the ends of the rope are lying in the sun, the black adder lies on top, on top of the still life. There, on the painting, drawing is precise where it matters and where it equally matters the line is blurred, it lurches and disappears into darkness. I am not lying – right now, I see Marat in the bathtub, the painting by David. Actually, what I see better is the arm with the pen in the hand, the pendulum arm, the hour has come, the new era. The arm with its hand is by Rosso, that painting where in the background Moses rages. It is impossible for Rosso's model to have been still alive at the time of David, but it is the same arm; therefore, Rosso and David are one and the same. This ARM is equipment. Reincarnation is nonsense. Equipment also comprises GREEN and RED DOTS on the garland in the Tomb of Priscilla painted by Renoir. I was standing by and was working on the dance step. Many painters were in that cave. The woman with the tambourine was not yet there. The dead need the best paintings, that is art history, one can add that the paintings are in the darkness. Everything I am saying here is positive, what is bad should be left aside. These are the points to be enumerated: ALL PAINTERS ARE LIVING; PASSION MAY BE THERE; HYGIENE; COLOUR, e.g. RED; ALL THINGS IN THE PAINTINGS, e.g. NOTHING IN THEM AT ALL; LINE, it can shoot into the eye from the background, from the bottom of the canvas, or even right through the canvas; ORNAMENT, braided, twisted, wound, even falling, can also be as SNAKE or ROPE; DOT as DOT as SPOT as PILE, like FLAT-CAKE, also flies sometimes across the plane of the canvas; the PLANE itself, impossible to imagine everything, e.g. as HAIR, as BODY, as CHEST of a hero, as GREEN EYE or even as CHRISTMAS TREE, as OCEAN, if possible, not in perspective; NARRATION, here, for instance, the MYTH of the Trojan Horse would be of interest; MUSIC – in Rembrandt's family group in Brunswick a cello is played deep yellow; NUMBERS, MODULE, PROPORTION, not the example with the ladder, but rather Eskimo and iceberg, cyclops behind the rock; of course also everything invented by painters, such as CHIMNEY, HOUSE, LOCOMOTIVE, PYRAMID, PAVEMENT, WINDOW-CROSS; also THINGS WITHOUT ANGLES, as FIRMAMENT and SEA OF

STARS. A better or worse life is not contained here, among the equipment. Illusions belong to the interpreters. The most beautiful of Modigliani's painted nudes has no skin, no flesh, no teeth. One cannot go so far and say that paintings have these things. In this list, as you will have noticed, the motif is missing, it is not included for the following reason: David's painting with the murdered Marat in the bathtub is as obviously just as much a cave painting as is a painted Etruscan tomb. Can paintings actually be seen by others? The great cave is dark, the paintings can hardly be seen. The tombs of the Etruscan or Egyptian are pitch dark, one does not see the paintings at all. Thus, the painter painted paintings that no one can see. Again, Renoir has not bungled in the Tomb of Priscilla, as we now see on close examination, although he could never have assumed that we ever were going to see it. Why did he do it then? The viewer was invented by the public, not by the painters. Only the changed civilization, another cultural imperative, brought this painting to light. All the dead had once been alive. Thus, this painting is an epitaph. The buffalo with the arrowheads is here the dead Marat, and the little ink sponge is, without question, the roll in the still lifes, or else the table that magically sets itself. If we look at the costumes of the people, the rich garments and draped fabrics, the interior of the room, the bathtub, we can say that David had one foot in ancient Rome. This is shifted civilization, not developed towards something better, just shifted. The motif in David's mind is the cave with the cavemen and their still-intact, unabashed agreement that the buffalo and the roll feed both the living and the dead. No painter goes hunting for motifs, that would be paradoxical, because the motif is in the mind of the painter, the mechanism that thinks. Everywhere in every painting the buffalos and rolls are an expression of the motif. Our instincts tell us what to do with them. Our yearning needs pictures. There is a knock on the door. 'Come in!' Enter a painter, as I can readily recognize from the stain of the paint on his trousers and from his dirty fingernails. 'May I sit down?' 'Sure.' 'Want to talk about . . . ?' 'Why not.' He notices the thermos coffeepot on the table between us. 'Could you give me a cup of coffee?' If he fails to recognize the Parmigianino but thinks only about the coffee in the pot, he is certainly a realist and completely depraved. It might at least occur to him that perhaps the pot is empty. As a matter of fact, it is in the meantime empty. Thus, all I can do is answer, 'I'm afraid not, because this is my self-portrait

out of which you want to drink coffee.' After all, I do not want to confuse him too much by first complicatedly explaining to him that there is no more coffee in the pot. He answers, quite unexpectedly, 'You can't fool me like that. I see what I know.' To which I respond, 'You probably want to find the motif in my studio.' He is a practical person, he loves beauty, he would like to warm himself up with coffee, then he wants to present his programme and fraternize with me. Anyway, he answers totally perplexed, 'Oh, there's no nude model here.' Now I know he is lying, because for nude drawings he needs a sketch pad, which he has not brought with him. What now? I decide to tell him nothing about the equipment and tersely answer, 'No sibyl has stepped between us.'

M89 R. B. Kitaj

First Diasporist Manifesto (1989)

Published as *First Diasporist Manifesto* (London, 1989).

R. B. KITAJ (1932–2007) liked to say that he was born in Chagrin Falls, because it sounded more poetic than Cleveland, Ohio. Kitaj aspired to poetry, among other things. He spent much of his life in Britain, after a spell as a merchant seaman and a formidable artistic education at the Akademie der bildenden Künste in Vienna, the Cooper Union in New York, the Ruskin School of Drawing in Oxford and the Royal College of Art in London – 'where, in the first week, I began my constant friendship with the amazing Hockney' – David Hockney, who appears as 'dh' in his second manifesto (M98). Kitaj apprenticed himself early to what he called 'the primacy of artistic craziness': passionate commitment, deep immersion, fierce self-scrutiny. His career is a monument to the dedicated artist-life. He grew crazier with each passing year.

Kitaj had a strong sense of artistic transmission, or filiation. He saw himself as part of a long European tradition, 'in the aura of Cézanne and other masters', as he put it in an exhibition at the National Gallery in London in 2001–2. He was a magnificent draughtsman. His drawing master, he said, was Degas. This was not entirely fanciful. At the Ruskin School he was a pupil of Percy Horton, who was a pupil of Walter Sickert, who was a pupil of Degas. Ultimately, however, Cézanne was the man. 'In the mysterious way of love,' declared Kitaj, 'Cézanne singles me out.' Artists create their precursors, as Borges slyly said.

As his manifestos testify, Kitaj's is an art of high seriousness. Even its joy is serious. Unfashionably, he believed that art could bear witness; and in his own inimitable fashion he bore witness to the terrible twentieth century – the Shoah, the Terror, the camp, the pit. He wrote in his first manifesto: 'We learn about life and its events by uncovering ourselves

. . . The timeless Beckett may also be paraphrased: (Art), that double-headed monster of damnation and salvation . . . I even suspect art can mend the world a little.'

Diasporist art was a school invented by Kitaj himself. It has a kind of catch-all, DIY quality. Perhaps the best explanation he ever provided lay in an analogy with Claude Lévi-Strauss's celebrated notion of *bricolage*, or the eclectic and ever-changing composition of cultural forms. 'Lévi-Strauss called *bricoleur* what I call diasporist,' Kitaj wrote in his second manifesto (2007), 'the handyman who recycles the rags and bones of the myths and life-histories of the race of man, bringing what one can into one's life, and in my case my painting life.'

See also the 'Second Diasporist Manifesto' (M98).

* * *

Since this is a manifesto, albeit not a very aggressive one (I haven't read Breton or Lewis or Marinetti and such since I was eighteen), I want it to be somewhat declarative because I think art and life are fairly married and I think I owe it to my pictures to put their stressful birth with some idiosyncratic precision.

What I owe to my pictures, I guess I owe to my readers, mostly to those few attentive or curious enough to interest themselves in the peculiar genesis of these disputed works I call Diasporist.

Like an ageing bear, I am not often brave or cunning. I try to proceed from my cave with caution because I tend to blot my copybook, as the English say. Out I come at the wrong season, when the world is bemused daily by Jews and their Holocausts, past and pending. As if that were not enough, I just read in an art column that the time for manifestos has passed. So I thought I'd write one, the Belated Bear stumbling forward, brandishing his paintbrush, into the tunnel at the end of the light . . .

In my time, half the painters of the great Schools of Paris, New York and London were not born in their host countries. If there is nothing which people in dispersion share in common, then my Diasporist tendency rests in my mind only and maybe in my pictures . . . but consider: every grain of common ground will firm the halting step of people in dispersion as surely as every proof of welcome has encouraged émigrés before in cosmopolitan centres. Rootedness has played its intrinsic and subtle part

in the national art modes of Egypt, Japan, England, Holland and the high Mediterranean cultures and city-states. I want to suggest and manifest a commonality (for painting) in dispersion which has mainly been seen before only in fixed places; but, not unlike painters who leave those centres or those modes, such as Cézanne, who left Paris behind for his epochal old-age style at home, or Picasso who left (classical) Cubism in the lurch, Diasporists also exchange their colours, for instance, to the extent that they begin to feel at home somewhere, or practise within a School. Or indeed, refuse what I say here . . .

If a people is dispersed, hurt, hounded, uneasy, their pariah condition confounds expectation in profound and complex ways. So it must be in aesthetic matters. Even if a Diasporist seems to assimilate easily to prevailing aesthetics, as he does in most currents of life, the confounding, uneasy side of his nature may also be addressed, that deeper heart, as magical as anything the Surrealist or Mystical Abstractionist ever sought within himself. I can only posit a new aesthetic for myself (to recreate myself) because I don't want to become a mouthpiece for the traditions of general art, and because some things in dispersion (ancient or modern) have come of age now for me. As the quasi-Diasporist Gauguin said, 'I wish to establish the right to dare anything.'

Aside from the always still endangered Jews (in a Masadic Israel and in Diaspora), there are other resounding Diasporists – Palestinians prominent and suffering among them. Israel Zangwill (1864–1926) placed the Armenians at the 'pit of Hell', and in 1920 bowed before their 'higher majesty of sorrow'. There is a Black African Diaspora as terrible and outstanding as any other, which has disturbed my thoughts since early boyhood. Murderous Stalinism and Pol Potism must have all but unsung Diaspora trails of their bloody own. What is left of these dispersed peoples finds as little peace as Ahasuerus himself. If the art of these Diasporists, as they emerge from historical fog, is not touched by their separate destinies, God help them. He has so often not.

Like most human events, Diasporism is not clear-cut, hard or fast (many movements in art are not), neither in its usual and historic explications nor in the meanings I have begun to feel for myself as a painter. As a Diasporist painter, like the Realist, the Cubist, the Expressionist and other painters, I would resist exacting codification (rightly). Nor can I

speak cogently for even more complex and speculative realms of the painter's make-up, for 'internal exile', the condition of the self-estranged sexual Diaspora and such. The Diasporist appears among émigrés and refugees, among the heirs of Surrealism, Naturalism, Symbolism and other aesthetics, among the home-grown, among nationalists and internationalists, pariahs and patriots, in every polyglot matrix, among the political and religious as well as those who do without politics and religion or are uncertain. *In the end, the Diasporist knows he is one*, even though he may one day settle down and sort of cease to be one. Many do not settle and that is a crux which will affect and, I think, effect the art. If human instincts for kin and home are primordial, as they so often seem, the Diasporic condition presents itself as yet another theatre in which human, artistic instinct comes into play, maybe not primordial (?) but a condition, a theatre to be treasured. As I write these words, I also know that if Diasporists become treasured, their theatre will close, and open under a new sign and name, maybe with a curse upon it.

Diasporism is my mode. It is the way I do my pictures. If they mirror my life, these pictures betray confounded patterns. I make this painting mode up as I go along because it seems more and more natural for me, so natural that I think I've been a Diasporist painter from the start without knowing and then slowly learnt it in a twilit period, until it began to dawn on me that I should act upon it. Diasporist painting is unfolding commentary on its life-source, the contemplation of a transience, a *Midrash* (exposition, exegesis of non-literal meaning) in paint and somehow, collected, these paintings, these circumstantial allusions, form themselves into secular *Responsa* or reactions to one's transient restlessness, un-at-homeness, groundlessness. Because it is art of some kind, the act (of painting) need not be an unhappy one. Although my Diasporist painting grows out of art, as, for instance, Cubism or Surrealism did, it owes its greatest debt to the terms and passions of my own life and growing sense of myself as a Diasporist Jew. I have spent half my life away from my American homeland, that most special Diaspora Jews have ever known. Until now, I've only rarely painted there and I set down these first exilic ruminations still from a bittersweet abroad, but written in my homesick, American tense, haunted by the music of Diaspora.

I've always been a Diasporist Jew, but as a young man I was not sure what a Jew was. I was unaware that such questions were debated within

Jewry, even in the Knesset itself. Jews were Believers, I thought, and I assumed you were whatever you believed in, that if you became a Catholic or an atheist or a Socialist, that's what you were. Art itself was a church, a universalist edifice, an amazing sanctuary from the claims and decrepitude of modern life, where you could abandon self and marry painting. My friend Isaiah Berlin says: 'A Jew is a Jew like a table is a table.' Now, that interests me greatly, but the thing was blurred in my youth. This was, I learned later, a classic assimilationist pose. My maternal grandfather had been a Socialist Bundist in Russia, on the run from Tsarist police. He passed on his religious scepticism to my mother, who brought me up as a freethinker with no Jewish education. Ours was a household full of secular Diasporists who seemed to be Jews only by the way. It would be many more years before I learned that the Germans and Austrians who did what they did in that time, when I was playing baseball and cruising girls, made no distinctions between Believers or atheists or the one and a half million Jewish infants who had not yet decided what they were when they got sent up in smoke. One third of all Jews on earth were murdered in my youth. It is well known that a Silence fell upon our world for some years after what Winston Churchill called 'probably the greatest and most horrible crime ever committed in the whole of the history of the world'. It was *the* break with traditional evil, its own archetype, someone said. The classic texts on the Holocaust are fairly recent and as I got around to them and the paradox of Jewishness began to enthral me, the Diasporist painter in me started to grow alert, after a numbing, morbid period. The mystery of dispersion now seems to me as *real* as any located School known to art. I didn't know it at first, but I had stumbled upon a tremendous lesson, taught long ago by many conflicting personalities both Jewish and Gentile (Sartre, etc.), by such absorbing figures as Ahad Ha'am (1856–1927), that it is Jewishness that condemns one, not the Jewish religion. It became reasonable to suppose that Jewishness, this complex of qualities, would be a presence in art as it is in life. In Diaspora, life has a force of its own. So would Diasporist painting, never before particularly associated with pariah peoples. For me, its time has come at last.

M90 Lebbeus Woods

Manifesto (1993)

First published in Andreas Papadakis (ed.), *Theory and Experimentation* (London, 1993).

LEBBEUS WOODS (born 1940) is an American architect and artist. He is a genuine visionary, simultaneously architectural and political – one of the few to talk politics, and moreover to think politics in the practice of his profession. 'Architecture is a political act, by nature. It has to do with the relations between people and how they decide to change their conditions of living. And architecture is a prime instrument in making that change – because it has to do with building the environment they live in, and the relations that exist in that environment.'

Woods is the avant-garde of the avant-garde. He is a proponent of experimental architecture. He sees this as reimagining the future – which is to say, our social and political relations – through architecture. To that end he is interested in the specifics, as he says, in *'this is what it looks like'*.

What it looks like to Woods tends to look out of this world to the rest of the profession (not to mention the public). His designs and drawings are reminiscent of Duchamp crossed with Piranesi. It is no coincidence that he is credited as the 'conceptual architect' for *Alien 3* (1992), or that his 'Neo-Mechanical Tower (Upper) Chamber' (1987) was plagiarized for the set of the Interrogation Room in *Twelve Monkeys* (1995). He has proposed a tomb for Einstein – a space station – inspired by Boullée's *Cenotaph for Newton* (1784). His intermittent blogs are fascinating. His ideas for buildings are routinely ignored. What Lebbeus Woods builds is more intangible. It is something akin to social capital – call it architectural wherewithal. Yet he is in this world, with a passion. After the disaster is his *métier*. In 1993, he went to war-torn Sarajevo. Invited to design a new Electrical Management Building, he proposed various recon-

struction projects, including 'freespaces', without predetermined function, 'crucibles for the creation of new thinking and socio-political forms, small and large'.

Woods may be shunned in municipal planning offices, but he has a devoted following elsewhere. As the creator of BLDGBLOG has written, 'Woods's work is the exclamation point at the end of a sentence proclaiming that the architectural imagination, freed from the constraints of finance and buildability, should be uncompromising, always.' This wish for Woods is perhaps not a million miles from the vision that Rem Koolhaas has of himself. Koolhaas and Woods: the dream team?

The fragment of quotation deployed in his manifesto-poem, 'melt into air', is freighted with significance. It comes from a bravura passage in *The Communist Manifesto*: 'Constant revolutionizing of production, uninterrupted disturbance of all social conditions, everlasting uncertainty and agitation distinguish the bourgeois epoch from all earlier ones. All fixed, fast-frozen relations, with their train of ancient and venerable prejudices and opinions are swept away, all new-formed ones become antiquated before they can ossify. All that is solid melts into air, all that is holy is profaned, and man is at last compelled to face with sober senses, his real conditions of life, and his relations with his kind.' The message of this passage was explicated for a new generation in a book of dazzling brilliance and deep compassion by Marshall Berman, *All That Is Solid Melts Into Air* (1983), whose subtitle encapsulated his theme, 'The Experience of Modernity'. Berman's inspirational work must surely have spoken to Woods, in the common struggle 'to make ourselves at home in this world, even as the homes we have made, the modern street, the modern spirit, go on melting into air'.

See also Gropius, 'What is Architecture?' (M33), Rem Koolhaas, 'Delirious New York' (M86) and Charles Jencks, '13 Propositions of Post-Modern Architecture' (M93).

* * *

Architecture and war are not incompatible. Architecture is war. War is architecture.

I am at war with my time, with history, with all authority that resides in fixed and frightened forms.

Lebbeus Woods

I am one of millions who do not fit in, who have no home, no family,
no doctrine, nor firm place to call my own, no known beginning or
end, no 'sacred and primordial site'.
I declare war on all icons and finalities, on all histories that would
chain me with my own falseness, my own pitiful fears.
I know only moments, and lifetimes that are as moments, and
forms that appear with infinite strength then 'melt into air'.
I am an architect, a constructor of worlds, a sensualist who worships
the flesh, the melody, a silhouette against the darkening sky. I cannot
know your name. Nor can you know mine.
Tomorrow, we begin together the construction of a city.

M91 Dogme 95

Manifesto (1995)

Dated 13 March 1995, Copenhagen; promulgated on 22 March 1995 at a conference on *Le cinéma vers son deuxième siècle* in Paris. Lars von Trier was called upon to speak about the future of film. Instead, Marinetti-like, he showered the audience with leaflets announcing the creation of Dogme.

Dogme was an avant-garde movement founded by the Danish film directors Lars von Trier (born 1956) and Thomas Vinterberg (born 1969), dedicated ostensibly to purifying film-making. Actually it gives every appearance of being dedicated to publicizing Lars von Trier and his friends. According to a press release from the Dogme Secretariat, it was wound up in 2002: 'The manifesto of Dogme 95 has almost grown into a genre formula, which was never the intention.'

Lars von Trier has been well described as the oldest *enfant terrible* in the business. He made a film called *Antichrist* (2009), and called Ingmar Bergman, the patron saint of art-house film-makers, 'a stupid pig'. When it comes to self-publicity, he has form. Indeed, his very name has form. Following in the footsteps of Erich von Stroheim and Josef von Sternberg, he awarded himself the 'von'. More to the point, perhaps, he has a habit of issuing manifestos to coincide with the release of his films, or possibly his feelings, a habit only encouraged by Dogme ('dogma' in Danish). On 6 May 2000, he founded the 'Dogumentary' movement with his uncle and a couple of others. On that day they published four manifestos: 'Defocus', 'Respect for the Public', 'Dokumentarisme' and 'The Moment is Found', followed a little later by 'The Dogumentary Manifesto' itself. Loyalty to the genre is one thing. Profligacy is another.

There is something bogus about Dogme. Dogme scorn is synthetic, just as Dogme style is derivative, borrowing from the great Danish director Carl Dreyer and from David Lynch, the post-modernist Surrealist of *Blue*

Velvet (1986) and *Twin Peaks* (1990), who brings Magritte to the masses, as David Thomson says. Lars von Trier apes Jean-Luc Godard. The ghost of Godard hovers over the Dogme manifesto, and before Godard, a genuine revolutionary, Dziga Vertov (see M41). The manifesto smacks of fakery and frivolousness. All that scoffing is like naughty children writing swear words in the snow.

The opening flourish, 'countering "certain tendencies" in the cinema today', swipes at a famous manifesto-essay by François Truffaut, 'Une certaine tendance du cinéma français', in the canonical journal *Cahiers du Cinéma* (1954). Truffaut established an opposition between what he called, with heavy irony, 'the tradition of quality' (according to the received wisdom of the superannuated) and, on the other hand, the *cinéma d'auteurs*, which was widely misunderstood or ignored. Truffaut and his friends championed the latter. According to this thesis – elevated to *la politique des auteurs* – the *auteur*, the true author or creator of the film, is the director. In the *cinéma d'auteurs* it is the director who puts his individual stamp on a film – not so much his personality as his sensibility, or moral code; and as he makes more films, so he creates an *œuvre*, a body of work by the same hand and eye and ethic. The director, in short, is the artist of the cinema. Such directors as Robert Bresson and Jean Renoir (son of the painter) were idolized by the 'New Wave' who came after them for precisely that reason.

For Dogme, all this is leprous, to use a Vertov word. 'The auteur concept' is dismissed as 'bourgeois romanticism' and therefore 'false' – a rhetorical procedure reminiscent of the Stalinist. Vertov did it better: 'We rise against the collusion between the 'director-enchanter' and the public which is submitted to the enchantment . . . We need conscious people, not an unconscious mass, ready to yield to any suggestion. Long live the consciousness of the pure who can see and hear! Down with the scented veil of kisses, murders, doves and conjuring tricks! Long live the class vision! Long live the Kino-Eye!'

See also the Stuckists' 'Remodernist Manifesto' (M97).

* * *

DOGME 95 is a collective of film directors founded in Copenhagen in spring 1995. DOGME 95 has the expressed goal of countering 'certain tendencies' in the cinema today.

DOGME 95 is a rescue action!

In 1960 enough was enough! The movie was dead and called for resurrection. The goal was correct but the means were not! The new wave proved to be a ripple that washed ashore and turned to muck.

Slogans of individualism and freedom created works for a while, but no changes. The wave was up for grabs, like the directors themselves. The wave was never stronger than the men behind it. The anti-bourgeois cinema itself became bourgeois, because the foundations upon which its theories were based was the bourgeois perception of art. The auteur concept was bourgeois romanticism from the very start and thereby . . . false!

To DOGME 95 cinema is not individual!

Today a technological storm is raging, the result of which will be the ultimate democratization of the cinema. For the first time, anyone can make movies. But the more accessible the media becomes, the more important the avant-garde. It is no accident that the phrase 'avant-garde' has military connotations. Discipline is the answer . . . we must put our films into uniform, because the individual film will be decadent by definition! DOGME 95 counters the individual film by the principle of presenting an indisputable set of rules known as THE VOW OF CHASTITY.

In 1960 enough was enough! The movie had been cosmeticized to death, they said; yet since then the use of cosmetics has exploded.

The 'supreme' task of the decadent film-makers is to fool the audience. Is that what we are so proud of? Is that what the '100 years' have brought us? Illusions via which emotions can be communicated? . . . By the individual artist's free choice of trickery?

Predictability (dramaturgy) has become the golden calf around which we dance. Having the characters' inner lives justify the plot is too complicated, and not 'high art'. As never before, the superficial action and the superficial movie are receiving all the praise. The result is barren. An illusion of pathos and an illusion of love.

To DOGME 95 the movie is not illusion!

Today a technological storm is raging of which the result is the elevation of cosmetics to God. By using new technology anyone at any time can wash the last grains of truth away in the deadly embrace of sensation. The illusions are everything the movie can hide behind. DOGME

95 counters the film of illusion by the presentation of an indisputable set of rules known as THE VOW OF CHASTITY.

The Vow of Chastity

I swear to submit to the following set of rules drawn up and confirmed by DOGME 95:

1. Shooting must be done on location. Props and sets must not be brought in (if a particular prop is necessary for the story, a location must be chosen where this prop is to be found).
2. The sound must never be produced apart from the images or vice versa. (Music must not be used unless it occurs where the scene is being shot.)
3. The camera must be hand-held. Any movement or immobility attainable in the hand is permitted. (The film must not take place where the camera is standing: shooting must take place where the film takes place.)
4. The film must be in colour. Special lighting is not acceptable. (If there is too little light for exposure the scene must be cut or a single lamp be attached to the camera.)
5. Optical work and filters are forbidden.
6. The film must not contain superficial action. (Murders, weapons, etc. must not occur.)
7. Temporal and geographical alienation are forbidden. (That is to say that the film takes place here and now.)
8. Genre movies are not acceptable.
9. The film format must be Academy 35 mm.
10. The director must not be credited. Furthermore I swear as a director to refrain from personal taste! I am no longer an artist. I swear to refrain from creating a 'work', as I regard the instant as more important than the whole. My supreme goal is to force the truth out of my characters and settings. I swear to do so by all the means available and at the cost of any good taste and any aesthetic considerations.

Thus I make my VOW OF CHASTITY.

M92 Michael Betancourt

The ——————— Manifesto (1996)

Disseminated on the internet, in webzines and newsgroups; at once a
manifesto and an interactive piece of net art, inviting readers (or visitors)
to fill in the blanks, according to their own predilections; the text pillaged
from Tristan Tzara's Dada manifestos (see M28 and M36).

MICHAEL BETANCOURT (born 1971) is an American critical theorist,
art and film historian, video-maker and animator. He pays attention to
detail (or form): each ——————— of the ——————— Manifesto must
follow the prescribed number of – (twelve).

<p align="center">* * *</p>

<p align="center">Today ——————— itself is obsolete. In documenting art

on the basis of ———————: we are human and true

for the sake of ———————, ——————— and

———————. At the crossroads of the lights, alert,

attentively awaiting ———————.</p>

If you find it futile and don't want to waste your time on a
——————— that means nothing, consider that here we
cast ——————— on fertile ground. Here we have a right
to do some prospecting, for we have ———————.
We are ghosts drunk on energy, we dig into ———————.

<p align="center">We are a ——————— as tropically abundant as

———————, which is the art of making

——————— established as ——————— on a

canvas before our eyes, yet today the striving for

——————— in a work of art seems ———————</p>

to art. Art is a ——————— concept, exalted as ———————, inexplicable as life, indefinable and ———————. The work of art comes into being through the ——————— of the elements.

The medium is as ——————— as the artist. Essential only is the forming, and because the medium is ———————, any ——————— whatsoever will ———————.

——————— is the name for such art. ——————— stands for freedom ——————— changes meaning with the change in the insight of those who view it. Every artist must be allowed to mould a picture out of ———————. The ——————— of natural elements is ———————, to a work of art. Instead, it is the artist who ——————— to produce ———————, in order to make a better art.

M93 Charles Jencks
13 Propositions of Post-Modern Architecture
(1996)

A summary of the post-modern movement in architecture, for his students at UCLA.

CHARLES JENCKS (born 1939) is an architectural historian and theorist, a landscape architect and designer (creator of the thirty-acre Garden of Cosmic Speculation at his home in Scotland), a furniture designer, and a sculptor. He is the leading commentator on post-modern architecture. He is also the mobilizing force behind Architects Against War, composing an open letter in opposition to the Iraq War in 2003. 'Not to take a stand, as a profession, amounts to silent complicity' in an immoral war – a strongly argued case. The letter was co-signed by Richard Rogers, Terry Farrell, Zaha Hadid, Frank Gehry and Rem Koolhaas (M86), among others.

As Jencks surely knew, his propositions are the very opposite of unexceptionable. 'Architecture necessitates ornament', for example, sounds innocuous enough, but touches on an almost theological dispute. For those prepared to argue against the purity, clarity and simplicity of modernism, and in favour of non-straightforward architecture, as Robert Venturi put it (M79), then ornament (or pattern, or post-modern allusion) might find its place in the most economical and functional of buildings – Venturi's concept of 'the decorated shed'. For Deconstructivists (M87), of course, ornament is neither here nor there; what matters to them, they assert, is altogether more fundamental. Their concern is geometry, not frippery. These positions have a long history. A hundred years ago the Austrian architect Adolf Loos wrote a famous article entitled 'Ornament and Crime'. Loos did not mince words. Ornament was 'degenerate'.

Ornament, it transpires, is an essentially contested concept. The manifesto demands blood, as Charles Jencks has observed.

See also Robert Venturi, 'Non-Straightforward Architecture' (M79), Coop Himmelb(l)au, 'Architecture Must Blaze' (M87), and Lebbeus Woods, 'Manifesto' (M90).

* * *

General Values

1 Multivalence is preferred to univalence, imagination to fancy.
2 'Complexity and contradiction' are preferred to over-simplicity and 'Minimalism'.
3 Complexity and Chaos theories are considered more basic in explaining nature than linear dynamics; that is, 'more of nature' is nonlinear in behaviour than linear.
4 Memory and history are inevitable in DNA, language, style and the city and are positive catalysts for invention.

Linguistic and Aesthetic

5 All architecture is invented and perceived through codes, hence the languages of architecture and symbolic architecture, hence the double-coding of architecture within the codes of both the professional and populace.
6 All codes are influenced by a semiotic community and various taste cultures, hence the need in a pluralist culture for a design based on Radical Eclecticism.
7 Architecture is a public language, hence the need for a Post-Modern Classicism which is partly based on architectural universals and a changing technology.
8 Architecture necessitates ornament (or patterns) which should be symbolic and symphonic, hence the relevance of information theory.
9 Architecture necessitates metaphor and this should relate us to natural and cultural concerns, hence the explosion of zoomorphic imagery, face houses and scientific iconography instead of 'machines for living'.

Urban, Political, Ecological

10 Architecture must form the city, hence Contextualism, Collage City, Neo-Rationalism, small-block planning, and mixed uses and ages of buildings.

11 Architecture must crystallize social reality and in the global city today, the Heteropolis, that very much means the pluralism of ethnic groups; hence participatory design and adhocism.

12 Architecture must confront the ecological reality and that means sustainable development, Green architecture and cosmic symbolism.

13 We live in a surprising, creative, self-organizing universe which still gets locked into various solutions; hence the need for a cosmogenic architecture which celebrates criticism, process and humour.

M94 Werner Herzog

Minnesota Declaration (1999)

Made at the Walker Art Center, Minneapolis, Minnesota, 30 April 1999.

WERNER HERZOG (Werner H. Stipetić, born 1942) is a wandering German film director, transplanted to the United States, most famous for his epic parables of human endeavour, at once bizarre and breathtaking, involving opera in the jungle and boats in the trees: *Aguirre, Wrath of God* (1972), *The Enigma of Kaspar Hauser* (1974), *Fitzcarraldo* (1982). In art and life he is not shy of a challenge, aesthetic, logistic and other. He once promised to eat his shoe if the tyro director Errol Morris completed a project on pet cemeteries. In 1978, when the film appeared, Herzog cooked and ate his shoe, an event later incorporated into another documentary, *Werner Herzog Eats His Shoe* (1980), by the suspiciously named Les Blank. Such an event would have been a source of much pleasure to Gutai (M66) and to Fluxus (M74).

Herzog himself is a documentary film-maker of compelling power and originality. Nonetheless, he has queried the label, and his declaration addresses among other things the doctrinal questions that still bedevil the documentary form, most fundamentally the disputed boundary between fiction and non-fiction. The same Errol Morris has called his own film about the torture and abuse at Abu Ghraib, *Standard Operating Procedure* (2008), a non-fiction horror movie – borrowing possibly from Truman Capote's celebrated 'non-fiction novel', *In Cold Blood* (1966) – and Herzog's documentaries might well be seen as non-fiction genre movies (adventure stories, fairy stories, myths and legends), upholding a distinction between fact and truth, as he puts it, rather than fact and fiction. Herzog has conceded that his declaration is 'somewhat tongue-in-cheek', but he is deadly serious about his principles. Like Malevich (M24), or Kandinsky (M8), or Newman (M64), Herzog is an artist in search of the

absolute – a lesser artist, perhaps, but a stronger walker. ('Tourism is sin, and travel on foot virtue.') His belief in 'the deeper strata of truth in cinema' is an expression of that quest (and an inspiration to others). For Herzog the consequence is clear: 'So for me the boundary between fiction and "documentary" simply does not exist . . . Both take "facts", characters, stories, and play with them in the same kind of way. I actually consider *Fitzcarraldo* to be my best "documentary" . . .'

In the declaration he takes aim at the documentary style (or ethic) of *cinéma-vérité*, which purports to avoid all artifice and artificiality, transparently capturing actuality, otherwise known as 'real life' – the life lived, as it were, behind the back of the camera – an impulse traceable to Vertov and *Kino-pravda* (M41).

The 'Minnesota Declaration', like the 'Dogme Manifesto' (M91), is deliberately provocative, as its author has admitted. It succeeds admirably in that purpose. As a manifesto it is at once succinct and expressive. Whatever conclusion is reached about the issues it raises, the ecstatic truth of Werner Herzog will linger in the memory long after the shrivelled truth of accountants has crawled under a stone.

<p style="text-align:center">★ ★ ★</p>

Lessons of Darkness

1. By dint of declaration the so-called Cinéma Vérité is devoid of vérité. It reaches a merely superficial truth, the truth of accountants.

2. One well-known representative of Cinéma Vérité declared publicly that truth can be easily found by taking a camera and trying to be honest. He resembles the night watchman at the Supreme Court who resents the amount of written law and legal procedures. 'For me,' he says, 'there should be only one single law: the bad guys should go to jail.'

Unfortunately, he is part right, for most of the many, much of the time.

3. Cinéma Vérité confounds fact and truth, and thus ploughs only stones. And yet, facts sometimes have a strange and bizarre power that makes their inherent truth seem unbelievable.

4. Fact creates norms, and truth illumination.

5. There are deeper strata of truth in cinema, and there is such a thing as poetic, ecstatic truth. It is mysterious and elusive, and can be reached only through fabrication and imagination and stylization.

6. Film-makers of Cinéma Vérité resemble tourists who take pictures amid ancient ruins of facts.

7. Tourism is sin, and travel on foot virtue.

8. Each year at springtime scores of people on snowmobiles crash through the melting ice on the lakes of Minnesota and drown. Pressure is mounting on the new governor to pass a protective law. He, the former wrestler and bodyguard, has the only sage answer to this: 'You can't legislate stupidity.'

9. The gauntlet is hereby thrown down.

10. The moon is dull. Mother Nature doesn't call, doesn't speak to you, although a glacier eventually farts. And don't you listen to the Song of Life.

11. We ought to be grateful that the Universe out there knows no smile.

12. Life in the oceans must be sheer hell. A vast, merciless hell of permanent and immediate danger. So much of a hell that during evolution some species – including man – crawled, fled onto some small continents of solid land, where the Lessons of Darkness continue

M95 Billy Childish and Charles Thomson

The Stuckist Manifesto (1999)

Dated 4 August 1999, this founding manifesto was first published as a pamphlet by the Hangman Bureau of Inquiry, and on the Stuckist website, signed by Childish and Thomson. At the foot of the manifesto is a brief announcement: 'The following have been proposed to the Bureau of Inquiry for possible inclusion as Honorary Stuckists: Katsushika Hokusai, Utagawa Hiroshige, Vincent van Gogh, Edvard Munch, Karl Schmidt-Rotluff, Max Beckman[n], Kurt Schwitters.'

The Stuckists were founded by the co-signatories of this manifesto, the artists BILLY CHILDISH (born 1959), who left in 2001, and CHARLES THOMSON (born 1953), who remains the major-domo, to promote figurative painting in opposition to conceptual art. The Stuckists mobilized against the so-called Young British Artists (YBAs) and their patron Charles Saatchi, and against the Turner Prize and its patron Nicholas Serota, on account of the art and the artists who have won it. Their name derives from an outburst by Tracey Emin, who was shortlisted for the Turner Prize that same year, for *My Bed*, complete with the detritus of her life. The outburst was directed at Billy Childish, her ex-boyfriend: 'Your paintings are stuck, you are stuck! Stuck! Stuck! Stuck!' If Damien Hirst's dead sheep was truly the Stuckist *bête noire*, Tracey Emin's unmade bed ran it a close second. The name . . . stuck.

By their own account, Stuckism is a non-movement. Unlike some of their predecessors, the Stuckists are not anti-art but anti-ism. Charles Thomson has provided an account of their genesis and modus operandi: 'The Stuckists group was co-founded in 1999 at my instigation by myself and Billy Childish (who has since called me the founder and himself "the excuse") with eleven other artists in the first show. There had been ongoing connections of various kinds between these people for up to

twenty years, so some degree of cohesion existed. When other artists contacted us out of the blue wanting to join, we found the solution of telling them to found their own Stuckist group with a variant title, as in the Melbourne Stuckists, for example . . .

'All such groups are independent and self-directed with no obligations or requirements, other than those they choose for themselves. There is by default some degree of affirmation of the founding ethos of Stuckism, and by implication a link with the original Stuckists group. However, half the members of the latter have left by now and it hasn't functioned for a long time as a group as such, though its historical place does give a certain cachet for those founding members [Philip Absolon, Frances Castle, Sheila Clark, Eamon Everall, Ella Guru, Wolf Howard, Bill Lewis, Sanchia Lewis, Joe Machine, Sexton Ming, Charles Williams].

'Stuckism works by individual initiative and ad hoc collaboration. From the second show (in 2000) onwards, artists outside the founding group have been included in exhibitions. In the Stuckists' Punk Victorian show at the Walker Art Gallery in Liverpool in 2004, there were thirty-seven artists, including some from abroad and some not formally in a Stuckist group. I curate shows and work with a core of artists . . . My concern is with the art, and Stuckism is a vehicle for that, not the priority.'

The art, however, gets tangled in the agit-prop. The Stuckists make a nuisance of themselves. That is their *raison d'être*: it is what they are for. As a body, or a cause, they may be irremediably marginal, and yet from time to time they have been surprisingly effective. Their very existence is a tonic. Perhaps there is a space for the English arrière-garde after all. Wyndham Lewis (M17) should be living at this hour. Blasting and blessing can still find its place in conformist Britain. BLAST novelty. BLAST ego-art. BLAST my bed. BLESS authenticity. BLESS the amateur. BLESS content. Long live the cup of tea!

See also their 'Remodernist Manifesto' (M97) and 'The Other Muswell Hill Stuckists' Founding Manifesto' (M100).

<p style="text-align:center">* * *</p>

Against conceptualism, hedonism and the cult of the ego-artist.

1. Stuckism is the quest for authenticity. By removing the mask of cleverness

and admitting where we are, the Stuckist allows him/herself uncensored expression.

2. Painting is the medium of self-discovery. It engages the person fully with a process of action, emotion, thought and vision, revealing all of these with intimate and unforgiving breadth and detail.

3. Stuckism proposes a model of art which is holistic. It is a meeting of the conscious and unconscious, thought and emotion, spiritual and material, private and public. Modernism is a school of fragmentation – one aspect of art is isolated and exaggerated to the detriment of the whole. This is a fundamental distortion of the human experience and perpetrates an egocentric lie.

4. Artists who don't paint aren't artists.

5. Art that has to be in a gallery to be art isn't art.

6. The Stuckist paints pictures because painting pictures is what matters.

7. The Stuckist is not mesmerized by the glittering prizes, but is whole-heartedly engaged in the process of painting. Success to the Stuckist is to get out of bed in the morning and paint.

8. It is the Stuckist's duty to explore his/her neurosis and innocence through the making of paintings and displaying them in public, thereby enriching society by giving shared form to individual experience and an individual form to shared experience.

9. The Stuckist is not a career artist but rather an amateur (*amare*, Latin, to love) who takes risks on the canvas rather than hiding behind ready-made objects (e.g. a dead sheep). The amateur, far from being second to the professional, is at the forefront of experimentation, unencumbered by the need to be seen as infallible. Leaps of human endeavour are made by the intrepid individual, because he/she does not have to protect their status. Unlike the professional, the Stuckist is not afraid to fail.

10. Painting is mysterious. It creates worlds within worlds, giving access to the unseen psychological realities that we inhabit. The results are radically different from the materials employed. An existing object (e.g. a dead sheep) blocks access to the inner world and can only remain part of the physical world it inhabits, be it moorland or gallery. Ready-made art is a polemic of materialism.

11. Post-Modernism, in its adolescent attempt to ape the clever and witty in modern art, has shown itself to be lost in a cul-de-sac of idiocy. What was once a searching and provocative process (as Dadaism) has given

way to trite cleverness for commercial exploitation. The Stuckist calls for an art that is alive with all aspects of human experience; dares to communicate its ideas in primeval pigment; and possibly experiences itself as not at all clever!

12. Against the jingoism of Brit Art and the ego-artist, Stuckism is an international non-movement.

13. Stuckism is anti 'ism'. Stuckism doesn't become an 'ism' because Stuckism is not Stuckism, it is stuck!

14. Brit Art, in being sponsored by Saatchis, mainstream conservatism and the Labour government, makes a mockery of its claim to be subversive or avant-garde.

15. The ego-artist's constant striving for public recognition results in a constant fear of failure. The Stuckist risks failure wilfully and mindfully by daring to transmute his/her ideas through the realms of painting. Whereas the ego-artist's fear of failure inevitably brings about an underlying self-loathing, the failures that the Stuckist encounters engage him/her in a deepening process which leads to the understanding of the futility of all striving. The Stuckist doesn't strive – which is to avoid who and where you are – the Stuckist engages with the moment.

16. The Stuckist gives up the laborious task of playing games of novelty, shock and gimmick. The Stuckist neither looks backwards nor forwards but is engaged with the study of the human condition. The Stuckists champion process over cleverness, realism over abstraction, content over void, humour over wittiness and painting over smugness.

17. If it is the conceptualist's wish to always be clever, then it is the Stuckist's duty to always be wrong.

18. The Stuckist is opposed to the sterility of the white wall gallery system and calls for exhibitions to be held in homes and musty museums, with access to sofas, tables, chairs and cups of tea. The surroundings in which art is experienced (rather than viewed) should not be artificial and vacuous.

19. Crimes of education: instead of promoting the advancement of personal expression through appropriate art processes and thereby enriching society, the art school system has become a slick bureaucracy, whose primary motivation is financial. The Stuckists call for an open policy of admission to all art schools based on the individual's work regardless of his/her academic record, or so-called lack of it.

We further call for the policy of entrapping rich and untalented students from at home and abroad to be halted forthwith.

We also demand that all college buildings be available for adult education and recreational use of the indigenous population of the respective catchment area.

If a school or college is unable to offer benefits to the community it is guesting in, then it has no right to be tolerated.

20. Stuckism embraces all that it denounces. We only denounce that which stops at the starting point – Stuckism starts at the stopping point!

M96 Takashi Murakami

The Super Flat Manifesto (2000)

Published in a bilingual book, *Superflat*, originating in an exhibition at the Museum of Contemporary Art, Los Angeles, in 2000.

TAKASHI MURAKAMI (born 1963) is a contemporary artist who takes all available media as his purview, blurring the boundaries between high and low culture, art, graphic design, fashion, animation and illustration. Murakami is simultaneously creating and merchandising. He wanted to get rich quick, and he succeeded. The gravy-train now seems almost unstoppable; François Pinault, a collector with a craving for kitsch, is already on board. In 2008, *My Lonesome Cowboy* (1998), a sculpture of a masturbating boy, sold at auction at Sotheby's for $15.2 million.

Murakami is adept at citing precedents and creating precursors, usually self-aggrandizing. He has a Ph.D. from the Tokyo National University of Fine Arts and Music. He 'references' Pop art with postdoctoral or preternatural facility. In 1996 he founded the Hiropon factory, a studio with assistants to produce his work, now big business. 'The factory' references Andy Warhol. He also makes his repackaged products available to all other markets in the form of paintings, sculptures, videos, T-shirts, key rings, dolls, toys, mobile phone holders, and $5,000 limited edition Louis Vuitton handbags. In effect, he has his own store. 'The store' references Claes Oldenburg (M71). Of course, Murakami is post-Pop; he is post-most. He emerges as a sort of cut-price Jeff Koons – remorselessly contemporary, appallingly cutesy, absurdly cool.

'Super flat' is his trademark. Super flat is a style or a sensibility, according to taste, or perhaps to pocket. Flatness in art has been around since the fresco, but 'flatness' as a doctrine or a prejudice references Clement Greenberg (see M69), who appropriated it and mobilized it in the era of Abstract Expressionism, to champion Barnett Newman (M64) and his brothers.

Murakami's notion of super flatness developed from *Poku*, a compound of Pop and *otaku*. Loosely, *otaku* is alienated Japanese youth, obsessed with *anime* (animation) and *manga*. Murakami has expressed hope in a cultural revival led by *otaku*. There is the germ of an idea here about authentic Japanese culture, as opposed to 'a shallow appropriation of Western trends' – the question of Japaneseness, raised in a rather different register by Murakami's countryman Takamura Kōtarō a century earlier (M4).

* * *

The world of the future might be like Japan is today – super flat.

Society, customs, art, culture: all are extremely two-dimensional. It is particularly apparent in the arts that this sensibility has been flowing steadily beneath the surface of Japanese history. Today, the sensibility is most present in Japanese games and anime, which have become powerful parts of world culture. One way to imagine super flatness is to think of the moment when, in creating a desktop graphic for your computer, you merge a number of distinct layers into one. Though it is not a terribly clear example, the feeling I get is a sense of reality that is very nearly a physical sensation. The reason that I have lined up both the high and the low of Japanese art in this book [*Superflat*] is to convey this feeling. I would like you, the reader, to experience the moment when the layers of Japanese culture, such as Pop, erotic Pop, otaku, and HISism [HIS is a discount travel agency], fuse into one.

Where is our reality?

This book hopes to reconsider 'super flatness', the sensibility that has contributed to and continues to contribute to the construction of Japanese culture as a world-view, and show that it is an original concept that links the past with the present and the future. During the modern period, as Japan has been Westernized, how has this 'super flat' sensibility metamorphosed? If that can be grasped clearly, then our stance today will come into focus.

In this quest, the current progressive of the real in Japan runs throughout. We might be able to find an answer to our search for a concept about our lives. 'Super flatness' is an original concept of Japanese who have been completely Westernized.

Within this concept seeds for the future have been sown. Let's search the future to find them. 'Super flatness' is the stage to the future.

M97 Billy Childish and Charles Thomson

Remodernist Manifesto (2000)

Dated 1 March 2000; published as a pamphlet and on the Stuckist website, like the original.

The epigraph to this manifesto, and to some extent its theme, 'towards a new spirituality in art', harks back to Kandinsky's influential work of a century before, *On the Spiritual in Art* (see M8). On the other hand, 'towards' – a favourite gambit of manifesto-writers – looks forward, hopefully.

Remodernism is not exactly all the rage, but it has found an echo elsewhere. Jesse Richards has published a Remodernist Film Manifesto (2008), for example, calling for a 'new spirituality in cinema', characterizing Remodernist film-making as a 'stripped down, minimal, lyrical, punk kind of film-making', and castigating Dogme (M91), among others, for their multiple heresies.

On the Stuckists, see their founding manifesto (M95).

<p style="text-align:center">* * *</p>

Remodernism

'towards a new spirituality in art'

Through the course of the 20th century Modernism has progressively lost its way, until finally toppling into the pit of Post-modern balderdash. At this appropriate time, the Stuckists, the first Remodernist Art Group, announce the birth of Remodernism.

1. Remodernism takes the original principles of Modernism and reapplies them, highlighting vision as opposed to formalism.

2. Remodernism is inclusive rather than exclusive and welcomes artists who endeavour to know themselves and find themselves through art processes that strive to connect and include, rather than alienate and exclude. Remodernism upholds the spiritual vision of the founding fathers of Modernism and respects their bravery and integrity in facing and depicting the travails of the human soul through a new art that was no longer subservient to a religious or political dogma and which sought to give voice to the gamut of the human psyche.

3. Remodernism discards and replaces Post-Modernism because of its failure to answer or address any important issues of being a human being.

4. Remodernism embodies spiritual depth and meaning and brings to an end an age of scientific materialism, nihilism and spiritual bankruptcy.

5. We don't need more dull, boring, brainless destruction of convention, what we need is not new, but perennial. We need an art that integrates body and soul and recognizes enduring and underlying principles which have sustained wisdom and insight throughout humanity's history. This is the proper function of tradition.

6. Modernism has never fulfilled its potential. It is futile to be 'post' something which has not even 'been' properly something in the first place. Remodernism is the rebirth of spiritual art.

7. Spirituality is the journey of the soul on earth. Its first principle is a declaration of intent to face the truth. Truth is what it is, regardless of what we want it to be. Being a spiritual artist means addressing unflinchingly our projections, good and bad, the attractive and the grotesque, our strengths as well as our delusions, in order to know ourselves and thereby our true relationship with others and our connection to the divine.

8. Spiritual art is not about fairyland. It is about taking hold of the rough texture of life. It is about addressing the shadow and making friends with wild dogs. Spirituality is the awareness that everything in life is for a higher purpose.

9. Spiritual art is not religion. Spirituality is humanity's quest to understand itself and finds its symbology through the clarity and integrity of its artists.

10. The making of true art is man's desire to communicate with himself, his fellows and his God. Art that fails to address these issues is not art.

11. It should be noted that technique is dictated by, and only necessary to the extent to which it is commensurate with, the vision of the artist.

12. The Remodernist's job is to bring God back into art but not as God was before. Remodernism is not a religion, but we uphold that it is essential to regain enthusiasm (from the Greek, *en theos* to be possessed by God).

13. A true art is the visible manifestation, evidence and facilitator of the soul's journey. Spiritual art does not mean the painting of Madonnas or Buddhas. Spiritual art is the painting of things that touch the soul of the artist. Spiritual art does not often look very spiritual, it looks like everything else because spirituality includes everything.

14. Why do we need a new spirituality in art? Because connecting in a meaningful way is what makes people happy. Being understood and understanding each other makes life enjoyable and worth living.

Summary

It is quite clear to anyone of an uncluttered mental disposition that what is now put forward, quite seriously, as art by the ruling elite, is proof that a seemingly rational development of a body of ideas has gone seriously awry. The principles on which Modernism was based are sound, but the conclusions that have now been reached from it are preposterous.

We address this lack of meaning, so that a coherent art can be achieved and this imbalance redressed.

Let there be no doubt, there will be a spiritual renaissance in art because there is nowhere else for art to go. Stuckism's mandate is to initiate that spiritual renaissance now.

M98 R. B. Kitaj

Second Diasporist Manifesto (2007)

Published as *Second Diasporist Manifesto* (New Haven, 2007), a manifesto-poem in 615 free verses, ending: 'You've been reading a long unfinished poem called HOW TO DO A JEWISH ART.'

The 'Second Diasporist Manifesto' has a formal dedication: 'To precursor manifestoists Tristan Tzara (Sammy Rosenstock) and Marcel Janco, Jewish founders of DADA' (see M28 and M29).

For biographical details of Kitaj, see his 'First Diasporist Manifesto' (M89).

* * *

1. If I say 'Jewish Art' to people, even dear friends, Jewish or not, it's like saying 'The world is round' in 1491. Each new painting of mine sails off where there be monsters.

2. I am my own kind of freethinking Jew, a painter who intends and wills a new kind of Jewish Art because doing that excites me anew every day in heart and mind and avant-garde romance. I never tire of it and I study and paint all day til bed at 8 PM with a Jewish or art book. No more women except (see 20).

3. <u>I believe my art is Jewish if I say it is</u> (pace Duchamp). I am Jewish Art in my soul's desire to paint radical pictures, on my own personal Diasporist terms at the limit-points of Jewish Modernism, where Kafka, Celan, Proust, Freud, Soutine, Philip Roth and a few hundred other Jewish radicals have gone before me, but almost no painters. I feel I may be alone in this, but who cares? I do sometimes! But I'm usually not lonely.

4. The Jewish Diaspora can inspire art as much as Consumer Society does, or Art for Art's Sake does, or French Theory does, or the Black Tragedy can, or Duchamp's legacy does, or the sadness of Israel-Palestine can, or the popular concept of boxes at intervals can, or Mother Nature does, or the Christian Passion has, etc. <u>It just depends on what one wants to do with one's life</u>. Seize the day!

5. This Jew paints a Jew, or 2 Jews: [his wife] *Sandra and me*, for instance. Painted in a Jewish state of mind and being, in a partly Jewish Diaspora milieu, in a personal Jewish history. If it didn't thrill me to paint about Jews, I'd drop it and paint less vulnerable, volatile stuff, maybe. An art critic once wrote that I ought to calm down and paint still life. Fuck him. No don't! Jewish still life is something I'll try.

6. <u>PAINT THE OPPOSITE TO ANTI-SEMITISM: Treasure Jews as Holy Fools</u>.

7. <u>Do for Jews what Morandi did for Jars, or what Mondrian did for straight black lines</u>.

8. <u>Draw as well as any Jew ever did</u>. Die trying.

9. Study the Jews, as Kafka did, despite the fact that he deplored his inadequate Jewish upbringing. We inadequate Jews inspire me to die studying Jews in my pictures. Tell it <u>Slant</u> wrote the quasi-Christian Miss Em[ily Dickinson], Hermit of Amherst, my best poet. I hear you Ms D!

10. <u>Assimilate and Don't in painting</u>! Admix lessons from Host Art with stubborn Jewish Questions. Beware correct assimilation (with Host modes) in my art. That's too dull for me and historically dangerous, and murderous for those Jews who want to merge with mainstream, conventional host cultures in symbiosis. Learn to paint against the grain of Art Assimilation. It's fun! Make new friends and killer-enemies!

11. <u>Take the Jewish Question where it's never or hardly been before</u>, into easel-painting in a 21st Century ecstasy and quietude and limit-experience. Run scared; that's life.

12. Things Jewish are things that we speak of only among ourselves, cautioned Freud. One of my greatest art crimes (or Jewish DADAisms) is that I shatter that great glass in art! Many Jews in the Art Scheme are

<u>closed</u> to the Jewish Question in art. They cleave to universalist ideals, which is OK by me too. To wish to be widely liked is not a bad thing. <u>Our hosts expel us anyway. Picture it</u>! America will be OK though, for historically nervous Diasporists, <u>I guess</u>. America sure means well by us.

13. Some of my Jewish Art can look just as irrational and difficult as the Diasporist traditions of Kafka, late Celan, DADA, absurdist Existentialism, unorthodox Surrealism, and <u>the Unconscious</u> (as in Freud's <u>Phylogenetic Fantasy</u>, his wild <u>Ancestor-Mystery of Origins</u> or his <u>Family Romance</u>). In other words, these difficult pictures of mine are Modem Art, etc. Tell it <u>Slant</u> is good (see 9). But in old age I've begun to do little paintings, easier to grasp.

14. Freud's Free Association = my Jewish brushstrokes, in a freed-up mood.
The painter as Jewish Analysand, minimizing concentration for the sake of life enhancement (Berenson's ultimate Diasporist term).

15. Infinite interpretability, infinite lights shine in every world, says Scholem on Kabbalah. Fitful Commentary waits patiently by some of my pictures as it does in <u>thousands of years of Jewish Commentary</u>. Painter: 'I'll comment on my painting in writing and be damned!' Critic: 'No! I'll comment but not you!' More later (til death) on this art war that I like to fight. Audiences love to hear what the painter has to say about his pictures. <u>Everyone</u> comments on pictures, both movies and stillies. Fuck those who say that the painter shouldn't tell anything about his painting. Lots of Modern Art needs a little help and gets it. Old Art too. (See 65.)

16. An art of <u>Jewish Secularism/Personal Judaism</u> as a somewhat new kind of painting art whose motto can be: 'I am a deeply religious non-believer . . . This is a somewhat new kind of religion.' – *Einstein, my new kind of Jewish Art Saint.* See my painting 'The Physicist' (1999). Christian Art depicts its saints from St John to Liz and Jewish Art can begin to as well. Better late than never. Strangely, both John and Liz are Jews!

17. Always study Scholem's Kabbalism for my painting art because of his Kabbalism's aura of taboo, renewal, unreason and lots more. <u>Scholem belongs to my own kabbal of Jewish art historians</u>. Top drawer, with

Panofsky, Greenberg, Berenson, Schapiro, Warburg, etc. I appointed Scholem very special good for a Jewish Art in the making, so I lie on their couches a lot for the Jewish Talking Cure. For Hysterical Art Pictures. Sometimes the sick pictures get better but still neurotic. I'm tempted to add Levinas and Scholem and Benjamin to my personal gang of art guys. Yes, add them! Wittgenstein too, rashly and illogically! But he's also an Art Saint whose <u>Remarks on Colour</u> and other prose-poems I try to study. See my 'Wittgenstein' pictures, circa 2005.

18. Scholem said he considered Kabbalah as one of the possibilities for Jewish survival in history. Paint for that uncanny survival! I don't know exactly why. If my painting survives past me, please score one against the death of easel-painting, but time is running out fast for me so <u>I DO JEWISH SURVIVAL ART</u> like mad, but don't hold your breath.

19. <u>Intend in painting an ingathering of Jewish attributes</u>, from everywhere and imagination.

20. <u>Find in painting: SANDRA LOVE UNION as a Jewish Mysticism</u>. I mean, seek communion with her in pictures. I can report some success, believe it or not. We were together 26 yrs plus <u>NOW</u> in our Diasporist paintings called <u>LOS ANGELES</u>. She's back! (See 21.)

21. Keep to a personal path to Jewish Mysticism: <u>SANDRA-SHEKHINA</u>. For painting, this path leads me <u>to the female aspect of God, called Shekhina</u> by the Jews. (See 28.)

22. The gates of exegesis are never closed, said Scholem. They are open also for an advanced painting art of modern life and ideas in a new century. (See 15.)

23. Try to do Jewish painting as <u>far-fetched beyond limits</u> as my 2 favourite modern pictures: Picasso's *Demoiselles* (1907), called his <u>Manifesto</u>, which was hated at first (Matisse called it a hoax), and Matisse's Chicago Bathers (1916). These 2 are still more radical avant-garde for me than any painting (or art!) done since. Invent a <u>Jewish Radical</u> (Radical Jewish) figure! Or figure style. Too late for me at 74? Well try harder! Vincent became Van Gogh in his last 2½ yrs! Not me. Too many pills. Too far gone in absurd ambitions. Cul[l] Jewish sources for help. And talk to Sandra.

24. The period roughly 1880–1932 (ending with my birth) absorbs me more than any other era. The Jews were almost free and art freed itself up. A doomed Jewish modernism, a wondrous thing to behold, with Kafka, Proust and Freud at its heart of hearts, has long been my holy shul where my art learned many of its Jewish-inflected tricks, lessons and experiments for my right now (2007). Maybe there's still time for a radical Jewish leap in art as absorbing as what was going on in 1906 as Cézanne died. With 2008 coming up, don't die just yet!

25. SHOAH. After 1945, every Jew is left maimed, more or less, as is my Jewish Art. Paint in the hard-to-see shadow of that Passion only rarely. I wasn't there, nor was God.

26. Scholem finds in the Zohar: 'a passion for the association of ideas which is pushed to an extreme.' Follow that Warburg-Breton passion in art. I always have! Many art fundamentalists hate TOO MANY IDEAS ART. I'm always accused of 'big ideas'. I hope it's true! Keep pushing to a tragic-comic Jewish extreme.

27. Recently a Jewish-American painter aged about 50, asked me: 'Aren't you squeamish?' He meant my public overkill about my Jewish Art. My grandmother, who had fled pogroms, would have shushed me with the same question. Yes, I am squeamish. But somehow this Manifesto had to get written about an art that had to get made. At least I tried, but I died too soon.

28. DEVEKUT! This highest ideal of the mystical life, this Communion with God, seems within my reach – the reach of a Jewish Art no less! It goes something like this: I have come to believe fitfully in my Sandra as Shekhina – the female aspect of God according to Kabbalah (via Scholem). Devekut, essentially a private, ascetic communion in denial of the values of this world (I'm about to leave), is a value of contemplative, not of active, social life, says Scholem. I have been slowly withdrawing from the social world for many years anyway. Sandra is, therefore, not only made in the image of God, but as Shekhina, she's the aspect of what is called God, to which I cleave (DEVEKUT) in painting her.

29. I also try to practise devekut (see 28) when I speak to Sandra each day.

This gives me courage to do an art in her image, which cleaves to her in devekut (communion).

30. The original 17 members of Freud's psychoanalytic circle were all Jews. Many of them thought of psychoanalysis as a Jewish movement or the Jewish Science. Some of each of them and others later may be new players, 100 yrs later, in my own psychological game of art, on my very own absurd couch. These ancestors had their own special ideas, like painters do. So we'll see what I can learn from them. Painters create their precursors! Adler, Abraham, Ferenczi, Groddek, Stekel, Rank, etc. most of them split from Freud over special ideas. To each his own Jewish mind-set. They are, like, little masters in art.

31. A Jewish State and a Jewish Art are both taboo for many people, including quite a few Jews. (See 27.) Try to paint in that Empty Quarter (Taboo) as an IDEA, on a recalcitrant canvas on my easel. Address TABOO ART. See my 'Arabs and Jews' pictures for noble attempts. (See 40.) Arabs and Jews are a nervous breakdown I fear.

32. Remember my School of London Jews: Auerbach, Kossoff, Freud – in the smithy of my Jewish soul, back home in America, thank God. The distance! I'll never see them again! It's been 10 yrs since I left London forever, no going back, and I look at their pictures every day in Los Angeles, trying to pick something up for my art and keep looking and remembering. Those 3 are my favourite living painters. Plus dh [David Hockney]. I closed the School of London in 1996 but I don't think many people noticed. SCHOOL CLOSED!

33. Levinas for painting. Face to Face. The Face of the Other. Think of him as a rare Jewish angel of face-souls. Give them some visual conversation. Keep reading his thrilling books for ethical art energies, etc. Speaking of (Jewish) energies, I've later come across this line by Wittgenstein: 'The face is the soul of the body,' written in 1932, the year I was born. I've always agreed with that sovereign face idea, for art. Above all Cézanne: 'The goal of all art is the human face' (said to Vollard).

34. Try to study a Torah portion each day (Robert Alter's new Torah). In my Studio. Why? Just do it Kitaj!

35. 'My strongest human bond.' – *Einstein on his relationship with the Jewish*

people. <u>My</u> bond is with many, many particular Jews and their Jewish Question, fated in my painting art to be ancestors and harbingers. <u>Of course, many Gentiles living and dead, are mine too</u>, like painters x, y and z, and their host traditions.

36. I am a scholar only of my own pictures. I read a helluva lot for them. Every read, every book is an erotic passage, a pleasure-principle infusing and radicalizing my cursed art.

37. Jewish Art: <u>Jew on the Brain</u>. Some days perseverance to the point of madness. I will die soon enough doing my inadequate, obsessional Jewish studying and painting. Extase! Hopeless! Isolated (good)! A form of art suicide in the Art Scheme. 'Live Dangerously' (Nietzsche?).

38. <u>Reading Jewish books is to me what reading trees is for a landscape painter</u>.

39. The (Levinas) CARESSING HAND, the CARESS as my BRUSH-STROKE painting Sandra and the <u>Other</u>. I'm never quite sure who Levinas means by the magical Other! Mostly I paint myself as Other.

40. <u>Arabs and Jews! Solve it as art, as a Holy Fool</u>.

41. Saul Bellow believed strongly in the soul and its eternity. So do I (at last). Practise a Jewish Soul Art. (More on this later . . .) . . .

42. Study Rabbi Jesus and his <u>much</u> later Christian painters, in my books now because I don't travel anymore. Glance at Rabbi Paul, briefly.

43. Scholem wrote to Benjamin: 'Nothing quite compares with the attraction of working out an incisive interpretation of a text.' How very deeply Jewish. I do <u>painting</u> interpretation (of a subject) first of course and then <u>its</u> commentary: Keep doing it and drive people nuts! Half my pictures don't get a commentary (from me). They just float into the Diaspora as Silent Pictures, most often journeyman pictures.

44. <u>Angels</u> fly through the imaginative worlds of Kafka, Benjamin and Scholem, as they do in such painters as Giotto, Fra Angelico, Blake, Klee and hundreds of others, including me. I need Jewish angels in my paintings, especially Sandra. Angels and God are always avant-garde, unpredictable. Always ahead of me too. Rembrandt even painted God

as an Angel sitting next to Abraham. It's the source of my next painting (summer 2005).

45. Study the Besht (Baal-Shem Tov), contemporary of Sir Joshua Reynolds PRA. The Besht transformed 'alien' or distracting thoughts into essentials to the technique of mystical prayer (see 51). On a few of my days, mystical prayer = painting.

46. A great sage, contemporary of Chardin, Rabbi Nahman of Bratslav (from the Ukraine of my grandparents), who found controversy, conflict and torment uplifting, edges briefly into sight for my controversial, conflicted paintings and their discontents. His long ago Hasidism, like some painting, is disguised as ecstasy. Ecstatic torment as sometime Jewish Diasporist painting trait. Soutine was best at it. Think what a Jewish Degas would do!

47. Nahman said: 'How would it be possible that they not oppose me? I have taken an entirely new path, one which no man has walked before.' Walk the Jewish Taboo in pictures! I mean the Taboo which refuses the concept of a new Jewish art, saying that it's not correctly universal enough.

48. Nahman said: 'Even one who has no desire to quarrel, but prefers to dwell in peace, is drawn into controversies and battles.' One could say that again and again.

49. Aside from the Jews at least 2 other peoples are always in deep trouble it seems to me: Blacks and Very Poor People. I hope to dare to keep that bold idea somewhere in my Jewish Aesthetic as I make my Jewish pictures. Can I paint a little canvas meant to be about utterly bad poverty? Then another one? It would take nerve, moral nerve.

50. Study Zohar as a spiritual game for modern easel-painting; also Bahir. Two great Jewish Songs of the South. Like Van Gogh sang there for only 2½yrs! I wonder if he knew that Kabbalah was born there?

51. The Name of God is SANDRA in my art. I am the Master of God's Name in my own painting. The original Master was the Baal-Shem Tov (Besht) and, by the way, the founder of Hasidism. Buber's book on the Besht is yet another text for Jewish Art no less. Just began (May 2005) a

Self-Portrait as the Master of God's Name. Going sort of well so far I think? I can't push it past unfinish yet in 2006.

52. PAINT THE OPPOSITE OF ANTI-SEMITISM: 'The rats are underneath the piles, the jew is underneath the lot.' – T. S. Eliot
 Hi, Tom. Fuck you in my art each day.

53. 'Certainly there are great differences with the Aryan spirit.' – *Freud to Ferenczi upon the breakup with Jung.* What differences for art spirit? This is a crucial and winning question for painting, with Jewish answers, I hope and intend.

54. Wittgenstein told friends to make themselves good, and not to look away from themselves. Goodness as a supreme quality in subjective, unworldly, confessional painting.

55. Message to Kitaj: Skip Marx, Marxists and Marxist Benjamin because that doesn't interest me. Gorge on what can be understood in the rest of difficult Benjamin, especially on Surrealism, Scholem, Paris, Kafka and Benjamin's own Jewish Soul. My Benjamin paintings – they were advance guards on my way to a Jewish Diasporist Art.

56. PAINT THE OPPOSITE OF ANTI-SEMITISM – as James Joyce did. This great philosemite influenced my painting deeply as early as high school. He loved 'the society of the jewesses.' He saw the Jews as a sister race to the Irish. Joyce's Bloom is always alive in me and my art.

57. Emulate the Jewish Joke on my canvas now and then. See 'My Fourth Jewish Abstract,' and its Commentary. I haven't read Freud's book on jokes yet (2004). Leo Rosten is the Scholem of Yiddishkeit; depend on him and the lost art of my grandparents.

58. I'm too old to study Talmud seriously but I love having some volumes of Steinsaltz's English Talmud lying around my studio to dip in and to remember that 50 yrs ago I was the first to introduce my own written Commentary onto the surfaces of my paintings. Ever since then, I've done Commentaries about some of my pictures, an ancient Jewish visual form on each page of Talmud. 'Jewish intellectualism,' as Dr Goebbels (D.Phil, Heidelberg) put it. Do it for easel-painting. (See 60.)

59. 'Nationalities want to pursue their own goals, not to blend.' – *Albert Einstein*

I love being in my own country in my last years. My country is the American Diaspora of the Jews. One of my desires here is not to assimilate in symbiosis with the regular art blend but to listen to my strange Jews and IDEA (Panofsky) appearing in my pictures beyond assimilation. Don't do International Art! (same Zeitgeist styles or ethos everywhere). (See 10.) It dulls the tribal genius of Nationalities. Thanks Al.

60. My painting likes a Jewish title, like SANDRA for instance, and it also likes a brief Commentary (MIDRASH), since the painting is Jewish. I write that commentary in blood and art – heresy. Most people prefer to hear what the painter has to say about his own picture anyway. Then general Commentary erupts – pro and con – and sometimes war which kills. (See 15.)

61. What does a Diasporist painting look like? Don't ask. I wish it looks like my pictures, but I fear their primitive nature. As in Cézanne: 'I am the primitive of a new art.' But I'm no Cézanne! He was a god. At first, Cubism looked only like the paintings of two painters; then four or five; then a few hundred. By then I would start all over again from Diasporist scratch. Serious answer later.

62. Take for painting: 'One would have to read the works of Franz Kafka before one could understand the Kabbalah today.' – *Scholem*
 Kafka is my favourite Jewish artist – *Kitaj*
 Re-do Kafka after the Shoah, Gulag and Modern Art.

63. I am K. and a great Jewish Painting is the Castle I never seem to realize. But keep trying! Start this painting later today (4 September 2004)! K Enters the Castle! Wow! Later: 'K ENTERS THE CASTLE AT LAST' is out there in the Art Scheme at last (2004).

64. Test in painting: 'the clear consciousness of our inner identity (as Jews), the intimacy that comes from the same psychic structure.' – *Freud (age 70) to his B'nai B'rith Lodge*.

65. The Diasporist Exegetical Tradition. Tell what happened! Tell about one's own picture! Or don't.

M99 Austin Williams and others
Manifesto: Towards a New Humanism in Architecture (2008)

Launched on 3 July 2008, at the London Festival of Architecture, as 'a return to the radical avant-gardism of the past but with a clear eye on the future'. Signed by Alastair Donald, Richard J. Williams, Karl Sharro, Alan Farlie, Debby Kuypers and Austin Williams (Director of the Future Cities Project).

The signatories comprise MANTOWNHUMAN, a ginger group of practitioners and commentators dedicated to stimulating debate about the function and possibilities of architecture and to shaking up the architectural profession.

As a manifesto, 'Towards a New Humanism in Architecture' is an exceedingly self-conscious production. The title is patterned on Breton and Trotsky, 'Towards a Free Revolutionary Art' (M59), on its seventieth anniversary (and no doubt Le Corbusier, known in its first translation as 'Towards a New Architecture' (M45)). More surprisingly, the flavour of some of the analysis, even the voice, is distinctly Trotsky-like. The manifesto paints a striking picture of a profession crippled by servility – a term dear to Trotsky and a condition to gladden his heart. More surprising still is the spectre of Marx. 'Where once the aim was to intervene – to plan and design the world according to human ends – today architects find solace in simply describing the world.'

The tone is belligerent, not to say arrogant (a word the manifesto is not afraid to use), as if mimicking the Futurists. Austin Williams, the principal author, has invoked the founding Manifesto of Futurism (M1) for its emphasis on 'courage, audacity and revolt', drawing a comparison with their own emphasis on the need for 'confidence' and 'daring'. There is a kind of absolutism about this manifesto, borrowed from Marinetti, who borrowed from elsewhere. According to Rimbaud, one should be absolutely modern. According to ManTowNHuman, one should be absolutely confident.

Austin Williams has also highlighted Sant'Elia's 'Manifesto of Futurist Architecture' (M19), 'for his sense of agency and transformation'. 'THINGS WILL ENDURE LESS THAN US,' proclaims Sant'Elia. 'EVERY GENERATION MUST BUILD ITS OWN CITY.' So say ManTowNHuman.

* * *

For the first time in human history, half the world's population lives in cities. And yet, instead of cheering this historic urban moment, the sound of hand-wringing is deafening. At home and abroad, arbitrary limits on what and how we develop betray the current exhaustion of architecture and urbanism, and its diminished sense of future possibilities. In the developing world there are parochial fears of the pace of rapid urbanization. In the West too, we are constantly told to slowdown: the urban renaissance has become an eco-town. It is clear that modernity, reason and the notion of progress itself have come under intense attack from those disdainful of the humanist aspiration to transform the world. While we at the Manifesto: Towards A New Humanism In Architecture welcome the potential for greater human activity, they warn of the dangers of population growth; where we praise technological innovation, they bemoan the use of energy; where we demand more, they insist on less. We need to challenge this, our age of architectural angst. It's time to challenge the tawdry and compromised architecture born of the contemporary paradox of urban low horizons. Instead, we must seek a new humanist sensibility within architecture – one that refuses to bow to preservation, regulation and mediation – but instead sets out to win support for the ambitious human-centred goals of discovery, experimentation and innovation. This is a cry for dissent, critical thinking and open-minded enquiry to be the foundation for a new metropolitan dynamic. While architecture is enjoying a resurgence in the media, in popular opinion and within mainstream party political discourse in the UK, architecture has never been more vacuous, pliant, parochial and insular. After decades in disfavour, architects have now become all too comfortable with their new approval rating and aim to maintain that cosy position at all costs. The almost total lack of creative tension within architecture further fuels its impotence and loss of direction. Today, there

seems only to exist the 'radical' architecture of deference: architects who rarely challenge the brief; who blithely replicate government social programmes; wilful in their instrumentalism and meekly incorporating 'behaviour change' guidelines. It is an architecture that accommodates to environmental criteria without any recognition that by so doing, the needs of humanity have become secondary to nature – or even believing that a debate about this is needed. We have a neutered profession of tick-boxing, pro-regulatory managers in which design is reducible to a mere spreadsheet monitored by self-satisfied, self-certified carbonistas. Architecture may have reached its zenith in formal acceptability, but it is at a nadir in terms of meaningful content. With half the world's population living in cities, where is the sense of exhilaration in the creative urbanization of a planet for 7, 8 or 9+ billion? Such a dynamic moment in history demands maximum engagement, but architecture has become paralysed in its growing acceptance of the Malthusian environmental orthodoxy that humanity is a problem. Rather than an opportunity for creative improvement, rapid urbanization is frequently presented as symbolic of the problems of over-population and the dangers that this creates for communities and the environment. Lacking the confidence to impose principles, ideals and a sense of purpose, architects commonly defend virgin green fields over the expansive reach of the metropolis. 'Sprawl' and 'suburbia' have become euphemisms for irresponsible expansion as opposed to a presentation of a social dynamic. Defensive self-loathing does nothing for a 'creative' profession that is supposed to revel in building more – and more often. Whether celebrating 'alternative urbanism' (i.e. sustainable subsistence in 'developing' world villages and slums); deploring the unreconstructed dynamic of megacities of the emergent developing world; or fawning over the single iconic building in the West, the redundancy of current Western ideas about the city is manifest.

As architectural visions for the city self-consciously retreat, it is little surprise that symbolic representations emerge: from the simplistic paeans to Barcelona or Copenhagen, to the desperate and deadening desire to recreate the caricatured urbanity of the Victorian city. Everywhere local identities take precedence. At root, architecture has lost its capacity for meaningful engagement with society in the here and now, and has retreated into irony – a self-referential world where 'subversive' in-jokes are endlessly

recycled. Today pluralism and relativism are rife, where once we might have acted on universal values underpinned by a rigorous methodology. Such is the legacy of a battery of postmodern texts that have succeeded in inculcating a belief that progress is a myth, human endeavour is detrimental, and knowledge is relative, that we now have a profession dominated by fear of meaningful intervention and content to seek prestige in aesthetic 'statements'. Yet, seductive as the canvas might appear filled with 'subversively' constructivist shapes, a vision for the city of tomorrow remains strangely absent.

In a world where possibilities are deemed to be limited, designers happily occupy the frontline of the pseudo-political quest for social engagement. Architects and architecture now frequently fulfil the roles of community counsellor, urban memory estrangement therapist, firm-but-friendly policeman, environmental taskmaster or social capital builder, rather than as a means of creating structures for a new century. When urban planners talk of 'creating communities', whose 'community' values are they regurgitating? Architects now feel morally justified in interfering in personal choices and boast of the need to change people's behaviour. In reality, citizens' private lives and personal choices, however non-conformist, should be their own business.

Meddling in the quotidian is everywhere, but it is the desire to shape the world of tomorrow that is missing. Where once the aim was to intervene – to plan and design the world according to human ends – today architects find solace in simply describing the world. Statistics, graphs and models are used not only to describe what is, but to dictate what will be allowed. The failure to mount a challenge represents a retreat from the pursuit of what could be – it is a retreat, where hiding behind complexity, climate chaos and community consensus avoids us having to impose humanity's vision on the world around us. Architects and designers regularly censor themselves as to what we might be allowed to do, and consequently call into question what we mean by achievement and progress. This is pathetic. The architectural profession seems currently to welcome constraint and uncertainty as if it feels unable to think, act or feel for itself unless justified by a performance indicator. Today's ironic decadence delights in self-definition: creating a self-referential architecture of amorphous shapes, algorithms and fractals that reinforce the anti-humanist, pseudo-religious notion that truth is a mathematical/scientific

exercise that can lead the way. It is humans – not disembodied abstractions – that have the capacity to create a meaningful world.

Rather than celebrate the city as liberating us from the backwardness of the parochial, the city and its inhabitants are now presented as something to be tamed. Nowadays, Western societies are more likely to look to the future with trepidation than anticipation. Ambitious, free vision – that which goes beyond the pernicious lexicon of sustainability – is lacking. From a mystical attitude to 'mother nature', to a creeping wariness of society; from a suspicion of the 'new' or the 'ambitious' to more widespread uncertainty about 'the future', fear has become an all-encompassing state which envelops and then undermines the architectural imagination. Most worrying is the extent to which architects have become afraid of freedom. With contemporary fears used to justify and even celebrate the imposition of limits, constraints on ambition and impositions on how to behave in a prescriptively 'responsible' manner, the architect now dutifully accepts the stultifying social strictures of risk, precaution and the moral disease of self-restraint.

Experimentation, unless within certain narrowly defined parameters, is presented as being potentially – inherently – dangerous. Caution, precaution, introspection and stasis are everywhere. With precaution pervasive, social dynamics have become reversed. The pursuit of innovation capable of extracting more from less is only permissible nowadays if justified as a way of minimizing society's impact on the planet. Whatever happened to maximizing one's impact on the planet? Today, innovation, experimentation and modern methods of construction are parodies of what they could be, bogged down in the demand that through the course of their development, no harm be done to the environment.

We, at ManTowNHuman, see potential gains: rather than potential harms. We are optimists but we realize that establishing a truly progressive credo of societal efficiency, experimentation and resource exploitation will not be easy in a time when seeking to elevate 'the human' currently plays second fiddle to the regressive Puritanical worship of the environment.

We, in ManTowNHuman, believe that a more critical, arrogant and future-oriented cadre of architects and designers can challenge the new eco-centred, bureaucratic, anti-intellectual, fragmentary, localizing consensus and in this way can lay the ground rules for overcoming the

cosy rut in which architecture now finds itself. To do so requires a stance against the prevailing culture of pessimism, so that a new, more exciting, more challenging, more assertive architecture can emerge as part of a more strident society.

This will only come about if architects are prepared to kick against the mainstream orthodoxies that infect and misinform current practice. Importantly this means creating a case for architecture that dissents from our current precautionary, risk-averse, climate-infatuated culture. We believe that to realize a new, human-centred architecture we must have the confidence to assert a belief in human creativity. Only through architectural autonomy from the directional diktats of pseudo-independent policy-wonks can there be created a freedom for designers to challenge the limitations of the current all-pervasive mantra of sustainable development.

We assert the right to experiment with new forms, processes and materials, regardless of their environmental provenance. We fundamentally oppose those who downplay aesthetics in the service of the so-called natural world, but, in the service of the human-centred world, we do not wish to decry the creation of buildings that prioritize human utility and functionality irrespective of aesthetic sensibilities. We suggest that architects should dare to fail. Good architecture need not have an ethical 'good'. 'Good' architecture need not be 'responsible'.

Architects must become confident in architecture for architecture's sake, asserting their trained eye for design rather than falling back on clichéd cod-scientific justifications. A starting point is the need for critical faculties and architectural tongues to be sharpened.

We advocate a challenge to the externally (and self-) imposed restrictions on debate, dialogue and design in order that new architectural possibilities might emerge. In the process of so doing we can truly aspire to move the city forward.

Summation

For: An architecture that imposes its will on the planet.
Against: Architecture that 'treads lightly on the earth'.

For: Creative tension: robust assertive architecture.

Against: Ideology-lite architecture where social policy initiatives, participation, consultation and engagement are lauded for the sake of the process.

For: Extending the frontiers of architecture: Dare to know . . . Dare to act . . . Dare to fail.
Against: The precautionary principle in architecture – the imposed and self-imposed limits to design.

For: A new internationalism – dynamic architecture for an integrated planet: an end to all restrictions on the global flow of people, goods and ideas.
Against: The new parochialism – passive architecture, self-sufficient villages, slow cities.

For: Architecture as discipline – for the autonomous exercise of professional judgement and the defence of integrity.
Against: Architecture to discipline – the instrumentalization of design for therapeutic or interventionist objectives.

For: Building more – in the knowledge that we can, and should, always rebuild later.
Against: A culture in decline that questions whether we should be building at all.

M100 Edgeworth Johnstone, Shelley Li and others
The Founding, Manifesto and Rules of The Other Muswell Hill Stuckists (2009)

Issued on 20 February 2009, the centenary of the founding Manifesto of Futurism (M1), by The Other Muswell Hill Stuckists (not to be confused with the original Muswell Hill Stuckists), an independent group with close affiliations with Stuckist central, in the person of Charles Thomson (see M95). Published online and on A4 card with a linoprint headline. Signed by Edgeworth Johnstone, Shelley Li and The Other Muswell Hill Stuckists, with Charles Thomson as co-author.

As their moniker might indicate, The Other Muswell Hill Stuckists have a sense of humour.

On the Stuckists, and the YBAs, see 'The Stuckist Manifesto' (M95).

* * *

In order to redress upon its centenary the artistic and philosophical deficiencies of the first manifesto of the useless Futurists, The Other Muswell Hill Stuckists declare as follows:

1. The Other Muswell Hill Stuckists defy and accept the centuries in order to exist in the present, which is an appreciation of the past and a design for the future.

2. The Buddha does not distinguish between Muswell Hill, New York, Moscow, Venice or Crouch End.

3. Neither do The Other Muswell Hill Stuckists.

4. Our only good art teachers were in primary school, where we were encouraged to express ourselves with paint. We reject everything we

have been told about art since then, in order to complete the circle of learning.

5. To be a Stuckist is to be free of being stuck and to recognize that all art is conceptual, except conceptual art.

6. The Other Muswell Hill Stuckist does not necessarily live in Muswell Hill, and knows that a horse has four legs.

7. To be challenging in art today presents no challenge at all. To be revolutionary in art today is to be a reactionary. To be unconventional is to conform. All the barriers that need to be broken have been broken already. The need today is to find out and affirm what is valuable, in the face of contempt.

8. People cannot escape from their essential needs and emotions, although they might pretend they do. This leads to a craving to be a celebrity.

9. Stuckism is a 21st century art movement. Without it, artists are bleached whale bones on the beach of a tourist resort.

10. The Other Muswell Hill Stuckists are in general agreement with the Stuckist Manifesto and are not ashamed of this.

11. The Other Muswell Hill Stuckists are not elitists or political. We denounce dismal and depressing urban landscapes, sexism, Fascism, Futurism, nationalism, militarism, patriotism, non-renewable energy sources, white wall galleries, starvation, violent assaults, built-in obsolescence, the glorification of war, the decline of libraries and museums, the nocturnal vibration of the arsenals, and factories suspended from clouds.

12. Painting is the medium of yesterday; and of today; and of tomorrow.

13. Painting pictures is a human communication in a pre-packaged world of uniformly sized, tasteless tomatoes and so-called art which is afraid to be vulnerable, make mistakes and do anything apart from replicating in a gallery something that is commonplace everywhere else.

14. Running is not art. Scrunching up a sheet of paper into a ball is not art. Sticking blu-tack on the wall is not art. People who think it is need to get out more.

15. The Other Muswell Hill Stuckists demonstrate against the Turner Prize in order to restore dignity to the national museum of British art.

16. The Other Muswell Hill Stuckist is usually not a member of the Groucho Club, and is not expected to know what it is.

17. We are hoping to put an end to banal art.

18. We hit out at the likes of modern artist Tracey Emin.

19. YBA means you'll believe anything.

20. We aim to replace Post-modernism with Remodernism using paint to express experience, intellect and emotion. Stuckism is the future of art. It stands for integrity and creativity, and is against the tins of shit in art galleries all over the world.

PENGUIN MODERN CLASSICS

DESIGN AS ART
BRUNO MUNARI

How do we see the world around us? This is one of a number of pivotal works by creative thinkers whose writings on art, design and the media have changed our perceptions forever.

Bruno Munari was among the most inspirational designers of all time, described by Picasso as 'the new Leonardo'. Munari insisted that design be beautiful, functional and accessible, and this enlightening and highly entertaining book sets out his ideas about visual, graphic and industrial design and the role it plays in the objects we use everyday. Lamps, road signs, typography, posters, children's books, advertising, cars and chairs – these are just some of the subjects to which he turns his illuminating gaze.

'Munari has encouraged people to go beyond formal conventions and stereotypes by showing them how to widen their perceptual awareness'
International Herald Tribune

PENGUIN MODERN CLASSICS

THE MEDIUM IS THE MASSAGE
MARSHALL MCLUHAN

How do we see the world around us? This is one of a number of pivotal works by creative thinkers whose writings on art, design and the media have changed our perceptions forever.

Marshall McLuhan is the man who predicted the all-pervasive rise of modern mass media. Blending text, image and photography, his 1960s classic *The Medium is the Massage* illustrates how the growth of technology utterly reforms society, personal lives and sensory perceptions, so that we are effectively shaped by the means we use to communicate. This concept and ideas such as rolling, up-to-the-minute news broadcasts and the media 'global village' have proved decades ahead of their time.

'One of the most acclaimed, most controversial and certainly most talked-about of contemporary intellectuals' *The New York Times*

'In the tumult of the digital revolution, McLuhan is relevant anew' *Wired*

Penguin Modern Classics

ON PHOTOGRAPHY
SUSAN SONTAG

How do we see the world around us? This is one of a number of pivotal works by creative thinkers whose writings on art, design and the media have changed our perceptions forever.

Susan Sontag's groundbreaking critique of photography asks forceful questions about the moral and aesthetic issues surrounding this art form. Photographs are everywhere. They have the power to shock, idealize or seduce, they create a sense of nostalgia and act as a memorial, and they can be used to identify us or as evidence against us. Here Sontag examines the ways in which we use these omnipresent images to manufacture a sense of reality and authority in our lives.

'A brilliant analysis of the profound changes photographic images have made in our way of looking at the world, and at ourselves' *Washington Post*

'The most original and illuminating study of the subject' *New Yorker*

Penguin Modern Classics

WAYS OF SEEING
JOHN BERGER

How do we see the world around us? This is one of a number of pivotal works by creative thinkers whose writings on art, design and the media have changed our perceptions forever.

John Berger's *Ways of Seeing* changed the way people think about painting and art criticism. This watershed work shows, through word and image, how what we see is always influenced by a whole host of assumptions concerning the nature of beauty, truth, civilization, form, taste, class and gender. Exploring the layers of meaning within oil paintings, photographs and graphic art, Berger argues that when we see, we are not just looking – we are reading the language of images.

'A slap in the face of the art establishment ... *Ways of Seeing* revolutionized the way that Fine Art is read and understood' *Guardian*

'There is nothing distanced about Berger. He handles thoughts the way an artist handles paint' Jeanette Winterson

PENGUIN MODERN CLASSICS

AMERICA
ANDY WARHOL

Andy Warhol carried a camera with him everywhere he went and, taken from ten years of extraordinary shots, his *America* aspires to the strange beauty and staggering contradictions of the country itself. Exploring his greatest obsessions – including image and celebrity – he photographs wrestlers and politicians, the beautiful wealthy and the disenfranchised poor, Capote with the fresh scars of a facelift and Madonna hiding beneath a brunette bob. He writes about the country he loves, wishing he had died when he was shot, commercialism, fame and beauty.

An America without Warhol is almost as inconceivable as Warhol without America, and this touching, witty tribute is the great artist of the superficial at his most deeply personal.

'He created his own universe and became its star' David Cronenberg, *Guardian*

'He understood our obsession with celebrity culture better – and sooner – than anyone else' Alison Jackson, *Sunday Telegraph*

PENGUIN MODERN CLASSICS

THE ANDY WARHOL DIARIES
EDITED BY PAT HACKETT

Saturday, July 13, 1985
'That night Jack Nicholson introduced Bob Dylan and called him
"transcendental". But to me, Dylan was never really real – he was just
mimicking real people and the amphetamine made it come out magic'

Andy Warhol kept these diaries faithfully from November 1976 right up to his
final week, in February 1987. Written at the height of his fame and success, Warhol
records the fun of an Academy Awards party, nights out at Studio 54, trips between
London, Paris and New York, and even the money he spent each day, down to
the cent. With appearances from everyone who was anyone, from Jim Morrison,
Martina Navratilova and Calvin Klein to Shirley Bassey, Estée Lauder and
Muhammad Ali, these diaries are the most glamorous, witty and revealing writings
of the twentieth century.

'Cruel, sexy, and sometimes heartbreaking ... Warhol is no neutral observer, but a
character in his own right' *Newsweek*